THE LONG LIFE OF MAGICAL OBJECTS

THE MAGIC IN HISTORY SERIES

The Magic in History series explores the role magic and the occult have played in European culture, religion, science, and politics. Titles in the series bring the resources of cultural, literary, and social history to bear on the history of the magic arts, and they contribute to an understanding of why the theory and practice of magic have elicited fascination at every level of European society. Volumes include both editions of important texts and significant new research in the field.

THE LONG LIFE
OF MAGICAL OBJECTS

A STUDY IN THE SOLOMONIC TRADITION

ALLEGRA IAFRATE

THE PENNSYLVANIA STATE UNIVERSITY PRESS
UNIVERSITY PARK, PENNSYLVANIA

Library of Congress Cataloging-in-Publication Data

Names: Iafrate, Allegra, 1985– author.
Title: The long life of magical objects : a study in the Solomonic tradition / Allegra
 Iafrate.
Other titles: Magic in history.
Description: University Park, Pennsylvania : The Pennsylvania State University
 Press, [2019] | Series: Magic in history | Includes bibliographical references
 and index.
Summary: "Examines a series of powerful artifacts traditionally associated with
 King Solomon, largely via extra-canonical textual sources—Solomon's ring,
 bottles to contain evil forces, the so-called Solomon's knot, a shamir, and a flying
 carpet—and traces their varying cultural resonances"—Provide by publisher.
Identifiers: LCCN 2019005847 | ISBN 9780271083667 (cloth : alk. paper)
Subjects: LCSH: Magic. | Solomon, King of Israel—Miscellanea.
Classification: LCC BF1621.I23 2019 | DDC 133.4/3—dc23
LC record available at https://lccn.loc.gov/2019005847

A version of chapter 2 was previously published as "Solomon, Lord of the Rings:
Fashioning the Signet Power from Electrum to *Nuḥās*," *Al-Masāq* 28, no. 3 (2016):
221–41.

A version of chapter 3 was previously published as "'Il demone nell'ampolla':
Solomon, Virgil, Aeolus, and the Long Metamorphosis of Rain Rituals and
Wind-Taming Practices," *Revue de l'histoire des religions* 234, no. 3 (2017): 387–425.

The Pennsylvania State University Press is a member of the Association of
University Presses.

It is the policy of The Pennsylvania State University Press to use acid-free paper.
Publications on uncoated stock satisfy the minimum requirements of American
National Standard for Information Sciences—Permanence of Paper for Printed
Library Material, ANSI z39.48–1992.

To Anna and Cesare

CONTENTS

ILLUSTRATIONS

TABLES

ACKNOWLEDGMENTS

My interest toward magical objects dates back to the fall of 2005, when I was lucky enough to attend a wonderful course taught by Francesco Orlando at the Università di Pisa. The research for this book has been made possible thanks to the generous support of the Kunsthistorisches Institut in Florenz–Max-Planck-Gesellschaft. I am particularly indebted to all the members of the library staff and the colleagues who made my stay so enjoyable and fruitful. I would also like to thank Ellie Goodman, the anonymous reviewers, and the editorial board of Penn State University Press, who welcomed the book proposal with enthusiasm and brought it to completion, and John Morris, who has enormously contributed to improving it. I am furthermore grateful to all those people, museums, and institutions that have granted me the rights to publish the images or made them easily available, particularly Les Enluminures, the MET of New York, the Walters Art Gallery of Baltimore, and antiquarian Giovanni Pratesi. I would also like to express my deepest gratitude to Hazim Alabdullah, Ra'anan Boustan, Francesco Dei, Damien Labadie, Tzvi Langermann, Matteo Martelli, Heba Mostafa, and Roberto Tottoli for their help with Arabic, Hebrew, and Syriac, and to Emma Abate, Nitzan Amitai-Preiss, Marina Benadduci, Sandro Bellesi, Carmen Belmonte, Grazia Biondi, Simone Bonicatto, Piergiorgio Borbone, Francesca Borgo, Jean-Patrice Boudet, Rachel Boyd, Danielle Buschinger, Anna Caiozzo, Filippo Callegaro, Richard Camber, Mario Carassai, José Carrasquer Zamora, Alice Cavinato, Daniele Conti, Augusto Cosentino, Florent Coste, Jean-Charles Coulon, Claudia Daniotti, Dick Davis, Maria Di Martino, Zev Farber, Margherita Farina, Fabrizio Federici, Sonia Fellous, Francisco de Asís García García, Cristina Giardini, Matilde Grimaldi, Arianna Gullo, Olivia Labadie, Shari Lowin, Rosa Lupoli, Henry Maguire, Elena Paulino Montero, Giuliano Mori, Jacques-Noël Pérès, Marta M. Perilli, Orso Maria Piavento, Alessandro Poggio, Egisto Sani, Alessandro Savorelli, Vladimir Shelestin, Fabio Sparatore, Jeffrey Spier, Chiara Storti, Mariano Tomatis, Julien Véronèse, Steven Weitzman, and Gerhard Wolf, who have contributed to the essays collected in this volume in many different ways. Above all, I would like to thank my husband, Cesare—always my first and most precious reader.

SOLOMON'S CABINET OF CURIOSITIES:
OBJECTS FROM AN UNCANONICAL COLLECTION

> How objects are handed on is all about story-telling. . . . There is no easy story in legacy.
> What is remembered and what is forgotten? There can be a chain of forgetting, the rub-
> bing away of previous ownership as much as the slow accretion of stories.
> —Edmund de Waal, *The Hare with Amber Eyes: A Hidden Inheritance*

If we imagined we were invited to the court of the legendary King Solomon
and allowed to wander around freely, we would find that everything he owns
has been created with the most exquisite workmanship, that the throne room
is full of moving automata,[1] that the library is rich in poems, proverbs, and
dangerous books,[2] that the greenhouse hosts several interesting species,[3] and
that the gardens are full of animals with which the king often converses.[4]

However, every sovereign worthy of the name also has a treasure chamber
that he opens only on special occasions, displaying the marvels of its contents
to some distinguished guest. If we were granted the honor of reaching the
innermost part of the palace, we would discover that Solomon also possesses a
most peculiar and fascinating collection of things that he has acquired over
time, through the gifts of Jews, Christians, and Muslims, of peoples coming
from Persia, Palestine, Ethiopia, Egypt, Spain, and many more places, which
have added to the original biblical legacy of the king: a shining ring used to
control demons; a mysterious set of bottles to constrain evil forces; an endless
knot or seal with similar properties; a *shamir*, known for its almost supernatu-
ral ability to cut through stone; and a flying carpet, which can bring the sitter
anywhere he desires.

These objects can be considered part of an uncanonical collection, both in a
literal and a metaphorical sense. In fact, neither the Bible nor the Qur'ān,
canonical texts par excellence, ever mentions any of these pieces in relation to
Solomon.[5] Their attribution to the king of Israel occurred later on, thanks to

the attraction exerted by a parallel tradition, exemplified textually by the pseudepigraphic Testament of Solomon, a famous handbook of demonology probably compiled in Jerusalem during Constantinian times.[6] The Testament of Solomon is the explicit source for the appearance of a Solomonic ring, for the seal impressed by it (hence the knot), and for the bottles. In a broader sense, it is also the cultural basis (the breeding ground, in a way) for the creation of the other objects mentioned above, since they all depend, although in different measures, on Solomon's direct encounter and exchange with demons. What they all have in common is a sort of supernatural quality, a special power, which could broadly define them as "magical objects" (see chapter 1). As such, they have entered our imagery: Sauron's ring of power, Aladdin's lamp, and the magic carpet are but recent metamorphoses of more ancient Solomonic memories.

The series of pieces I present here, however, is uncanonical in a different respect as well. Although they all share this demonological liaison, and thus have strong and consistent traits in common, each of their singular and specific stories follows a very different path and takes the reader quite far, in both time and in space, from its initial (or ideal) chronological beginnings. It is for this reason that I evoked, right from the start, the notion of a cabinet of curiosities. My collection, not unlike a *Wunderkammer* of the past, gathers together exotic, peculiar, even explicitly odd elements, and I can imagine that the overall effect of reading through the various chapters might induce, from time to time, a slight bewilderment on finding apparently weird juxtapositions of elements and in following a not necessarily linear, chronological succession of events. Depending on the object under examination and on the angle adopted, I chose, in telling these stories, to move either forward or backward in time, and some-times I have stretched my account over a longer arc of narration, going beyond the immediate context of Solomonic relevance.

This approach derives in part from the very genesis of this book, which is the fruit of ongoing research into the pervasiveness and influence of the figure of Solomon during the Middle Ages. When I set out to investigate this set of Solomon-related objects, I was not yet fully aware that they shared a deep inner consistency; I was convinced that most of them had ended up "belonging" to King Solomon as a result of a series of accidental superimpositions. Only later did I realize that they could be fruitfully juxtaposed and compared. In this sense, the term "collection," meaning the result of the gathering of different elements, seems all the more appropriate. Each chapter can be therefore con-sidered a sort of lengthy catalogue entry for one of the items found in this imaginary cabinet and can be read and appreciated independently.

However, taken together, these essays make up a cohesive body of research that illuminates different aspects of the Solomonic tradition in a cross-cultural perspective. Reaching well beyond the specific focus of medievalists, they should also be of interest to a broader audience. This work can, in fact, be read as a study on both the reception of the figure of Solomon and, from a different angle, the impact of certain objects and their inherent aesthetic, morphological, technical, and poetic qualities. The chapters can thus be considered as case studies illuminating the way in which "magic" manifests itself, by being embedded in the very material of the object (chapter 2), in its function (chapter 3), in its shape (chapter 4), in its most distinctive property (chapter 5) or intrinsic quality (chapter 6).

At a more practical level, the book tries to answer some other questions. What are magical objects and how do they enter our imagery? Who was the first lord of the rings? How can a lamp entrap a genie? Why are knots so intriguing? What is the *shamir*, the mysterious entity capable of cutting the hardest of materials? Where does the flying carpet come from?

This research is a journey across the often-legendary traditions circulating among Christians, Jews, and Muslims between late antiquity and the Middle Ages, but it is also a way to discover that the origins of many of the things that still fascinate us nowadays are deeply rooted in that Mediterranean past.

1

MAGICAL OBJECTS AND WHERE TO FIND THEM

Definitions belong to the definers—not to the defined.

—Toni Morrison, *Beloved*

The Solomon to whom I have referred in the introduction is not the biblical figure but a sort of metahistorical character who, not unlike Alexander the Great or Virgil,[1] is heir to a superimposing body of legends and peculiar traits that need to be understood in a diachronic perspective.[2] My choice to analyze items that have been attributed to Solomon *over time* rather than at a precise moment is not exempt from criticism, since it is obvious that this Solomonic label gives only an apparent consistency to the pieces haphazardly collected in his imaginary cabinet. The reason behind this choice, however, becomes clear if we consider the necessity of factoring into the research two fundamental elements: time and space, particularly in relation to the age-old and thorny issue of what magic is and how we should define it.[3]

One can refer to "magic" in either a popular or a technical sense. The former, however, is unsatisfying, while the latter is still problematic. As Brian Schmidt recently put it in *The Materiality of Power*, "the term, nay, the very concept 'magic,' while perhaps self-evident at some intuitive or ephemeral level, remains an ever-elusive, sly creature of impressive adaptability and agility."[4] Whether we adopt a strictly philological analysis of the occurrences of the term—as has been attempted by, among others, Bernd-Christian Otto and Michael Stausberg, Jan Bremmer, and several scholars in the recent *Cambridge History of Magic and Witchcraft in the West*—or whether we follow the substance of it, across its mutating definitions (shamanism, fetishism, witchcraft, sorcery, the occult, totem, *mana*, taboo, etc.), as Peter Pels did in his introduction to *Magic and Modernity*, there remains, as Pels noted, a substantial opacity owing to the terms in which the problem was originally posed. On the one

hand, the definition of "magic," "religion," and "science" is the product of a typically Western approach; on the other, it is not an easy task to follow the specific developments that "magic" (and related categories) brought about.[5]

While scholars have always tried to offer a comprehensive view of the matter by defining its borders, some of the solutions chosen to overcome or circumvent this problem in recent times follow a more pragmatic approach: renouncing the search for a comprehensive theory and adopting working definitions based on practical cases, without presuming to provide overarching grids valid for all times and cultural contexts. This was the approach, for instance, chosen by Andrew Wilburn in *Materia Magica*; similarly, in his analysis of Israelite magic, Schmidt defined magic as something encompassing the idea of ritual actions and the manipulation of objects, the dynamic relationship with religion, and a substantially private dimension.[6]

For the time being, I will be employing a similarly operative approach, considering a magical object to be any item endowed with powers that are superior to its inherent physical conditions, without discussing the agency that granted those powers or the way in which it came to acquire them. What seems evident is that the definition of magic is not static but changes depending on where we stand. If we look at them now, for instance, the ring of power, the bottles for demons, the knot/seal, the *shamir*, and the flying carpet all evoke magic or supernatural domains.[7] However, if we situate our lens closer to their first historical occurrence, the impression becomes more blurred: some of them appear as distinctively divine pieces, while others should be seen as technological or artistic wonders. A similar change of perspective occurs if we first consider them as the fruit of the cultural and religious tradition that produced them and then successively move away and regard them from the point of view of a competing religious actor, which might consider them as just fables.

In order to operate these chronological shifts and to play with the emic-etic pair,[8] one would therefore need not just a random magical object, but something that has survived long enough to be considered in its broad historical development and that has a substantial comparative dimension. By virtue of their Solomonic attribution and of their consequent long lives,[9] the ambiguously magical objects I have grouped together in this collection can therefore be fruitfully considered along these two different trajectories and will, I hope, offer different answers than those provided by an accurate, but necessarily more limited, historical sample.

Finally, there is the problem of discussing a set of pieces that, despite their illusory claim to materiality as objects, do not exist now and, if they ever did exist, did not do so in the exact form in which I consider them in this research. For this reason, I do not necessarily look at them from the point of view of

archaeology but through their progressive metamorphosis from real or likely objects to literary entities—things that can have a perfect existence in our imagination without necessarily requiring a physical counterpart in everyday life.[10] Literary magical objects, however, seem to be profoundly different from their physical counterparts. They are more numerous, they multiply without necessarily following philological criteria, and even when they have absolutely nothing in common with real specimens, their power and effectiveness do not appear diminished or affected, not to mention that they often represent something different from what they appear to be. It would therefore seem inaccurate to analyze the Solomonic items here presented from the perspective of materiality: it is one thing to write the cultural biography of an object; it is another to draft the biography of a fictitious one. Even if these two operations appear formally similar, their content will appeal to different audiences and attain alternative goals.

Nonetheless, even if all the objects I have grouped here do find a place in textual sources first and in literature, legendary accounts, or sci-fi novels afterward, none of them can be properly defined as *imaginary*. They all sprang from very tangible, historical contexts and were showed and employed, touched and discussed, even if they ended up spending most of their longer afterlives in textual, immaterial domains. This peculiar condition makes them hybrid entities and justifies, I think, a sort of multiple investigation, which contemplates them from the perspective both of the history of literature and of the history of art, magic, religion, and science—considering that it is in these contexts that they originally were shaped. What I am attempting, then, is a collection of cultural biographies of a series of metamorphic objects.

As seen, the terms used provisionally to refer to the target of this study (Solomonic magical objects) do not appear firmly established and seem to encompass an altogether elusive category. This ambiguity, this sensation of a methodological weakness, is, however, the fundamental premise for this research. Since the terminology appears problematic and somewhat unsatisfying, it may be more fruitful, for once, to begin by analyzing a small sample—in this case, five specimens—to see if it is possible, by working backward, to extract more solid principles. Maybe the study of objects can offer us a better insight into how we perceive magic in things, rather than vice versa.

Having established that any more specific conclusion about magical objects should be deferred to the end of this analysis, we can now turn to the second undertaking announced in the title of this chapter: finding them. I am proposing this quest mostly in a historiographical sense, with the idea of tracing the occurrence of magical objects (or of comparable types of items) in extant

scholarship. The collection of pieces I will discuss, however, covers a fascinating area, where, as said, religious studies, art history, anthropology, and literature all intersect. This partial superimposition is all the more relevant because, in recent years, a growing number of scholars in all these fields, fascinated by the novelties brought about by the so-called material turn (originally developed in the fields of archaeology and anthropology), are increasingly studying objects and the stories they can tell from a perspective that puts things, rather than human beings, at the center of their investigations.[11] The very notion of "materiality" can be considered, as Daniel Miller has argued, both at a colloquial level, where *material* implies the sheer idea of artifacts, but also, in a richer philosophical sense, as a conceptualization of culture itself, with implications ranging from economics to aesthetics.[12]

This fragmentation is evident in several ways: many of the scholarly works that will be mentioned in this chapter are collections of essays regarding specific objects, or case studies often lacking internal consistency. The reason behind this formal choice, I think, is to render the complexity, multiplicity, and diversity of the situations encountered by various scholars when addressing this specific issue. The impossibility of tackling and comprehensively discussing all the multifaceted sides of reality, however, despite the unconfessed yet, I think, extant desire to offer a solid grasp of it, inevitably confers on most of these studies, no matter how well researched, the air of potpourris, of *Wunderkammern* in the best cases, but also, in more extreme ones, of peculiar *cadavres exquis*.[13] My own research is no exception; when, at the beginning, I claimed for my collection a place within an ideal cabinet of curiosities, I was well aware that, despite a certain consistency, the material presented is also partially exposed to random historical and cultural correspondences.

Despite its inherent limitations, I cannot ignore the present critical context. The current debate about materiality is both fierce and widespread, and it would be a tantalizing goal to summarize and discuss all the shifts and turns and the diverging positions among the disciplines concerned. Such a task, which would be well beyond the scope of this chapter, has been brilliantly carried out by previous scholarship, to which I will often refer. Furthermore, trying to account for the development of a specific historiographical debate in relation to each field is made more difficult by the growing and necessary tendency to construct studies in a substantially comparative way, in which, although the focus is held in common, the methodology and the interest ultimately lie in different places. Nonetheless, I will attempt to give a sense of where the scholarship is going, in order to better situate my own research—without, however, any pretension to exhaustiveness.

A Look at Magical Objects in Literature

"I am nothing but a corpse now, a body at the bottom of a well," declares the first character encountered at the beginning of *My Name Is Red*, the novel by Nobel Prize–winning author Orhan Pamuk.[14] It is a cadaver—a necromantic object by definition, an entity suspended between life and death, in transition between full subjectivity and sheer matter, in communication between two worlds—that begins the story, a story that evokes, right from its title, the real voice we should be listening to, the red ink through which written narration itself is made possible.[15]

In literature, magical objects abound and thrive, and scholars in the field have traditionally taken a deep interest in them. In literary or narrative form, in fact, these items seem to have enjoyed greater theoretical success than they have in the field of history of religion. The reasons seem manifold. The first, of a merely practical nature, is that texts have more easily preserved the memory of an incredible number of items that, whether representing the faithful description of existing pieces or not, still hold a place in our imaginary, mostly thanks to the fact that we can read about them.[16] In contrast to actual magical pieces, which sometimes cannot be easily identified, especially if we lack the original context of provenance, described objects have an intact vitality and an intense performing power that appears lost or highly compromised in many surviving specimens. To put it in another way, the literary remains of magical objects are both effective and enduring, since their power of evocation does not necessarily depend on the materiality of the objects themselves, but rather on their capability of *evoking* a certain set of material features, also by way of poetic or synesthetic means. Thus, the power of evocation inherent in any object is indifferent to its actual existence. Furthermore, literary objects do not need to be real or realistic to exist. Their quality and their power can therefore be enhanced or decreased, or completely invented—suspension of disbelief guaranteeing full success to this process.

We would make a mistake, however, if we were to treat literary objects as faithful representations of reality, since literature does not necessarily speak *of* or *to* reality but, more often, to other literature. Thus, objects in this domain usually stand for something else or are endowed with a metaphorical or a symbolic value, or charged with a narrative or rhetorical function, which certainly makes them worthy of specific analytical effort. They are in fact seldom investigated as objects per se, but as elements of a larger semiotic system, taken into account not for what they are but for what they mean. In this case, their material features appear even more evanescent, sometimes as descriptive pretexts with ekphrastic purposes,[17] other times as entities functional to another aim,

such as the notion of objective correlative[18] or that of deus ex machina, which, even at a superficial etymological level, betrays the presence of a physical device within the narrative or the psychological development of a plot or literary description.

Finally, the very nature of certain literary mechanisms facilitates the natural propagation of elements without any specific need for consistency or accuracy; the description of any object can be changed, adapted to a new context, elaborated with utter freedom. In this way, things can migrate and wander freely across different realms, acquiring or losing new meaning and easily crossing the barriers of time, space, and culture that any good story can open. For historians of literature, then, their interest lies also in the fact that they can represent visible traces of successive waves of reception; they are indexes of tradition.

These and certainly many more other elements make objects, whether magical or not, interesting to scholars of literature. The Italian writer and critic Italo Calvino declared that "around the object there forms a kind of force field that is in fact the territory of the story itself. We might say that the magic object is the outward and visible sign that reveals the connection between people or between events. It has a narrative function."[19]

The centrality of the object, understood as a veritable magnet for the unfolding of the plot, is not surprising from Calvino's perspective, particularly if we consider that he himself was deeply fascinated by the *Orlando Furioso* of Ludovico Ariosto (1474–1533), which describes the adventures, fights, and love stories of knights and damsels and continuously revolves around the quest for and loss of magical tools, such as rings, shields, and flying horses, that often constitute the fundamental narrative engines.[20]

Given the recognized importance attributed to (magical) objects in this field of study and their pervasiveness at different levels and with a variety of functions, I have dedicated part of this chapter to some notable conceptualizations of magic (and similar themes) proposed by literature scholars. While, interestingly, the examples I will be discussing were all produced within a formalist-structuralist context, it is not my intention to embrace a priori the paradigms proposed by these scholars and blindly project them onto the items I will be discussing, since doing so would create a substantial risk of circularity. Nonetheless, as a sort of experiment, I did try to put my examples in some of these grids to see if some useful considerations could be discovered.

Propp's Magical Agents

As early as 1928, the Russian scholar Vladimir Propp, in his seminal *Morphology of the Folktale*, discussed the role of magical entities within narrative forms.

He did not speak of magical objects but of a slightly broader category, which came to include them and which he termed "magical agents."[21] Propp never really defined the magical quality of these agents but indicated a series of things and entities that could fall within it, such as animals, objects out of which magical helpers appear, objects possessing a magical property, and qualities or capacities that are directly given, such as the power of transforming into animals, and so on.

He noted that when it came to this category of magic, "living things, objects, and qualities, from the morphological point of view, founded upon the functions of the *dramatis personae*, must be examined as equivalent quantities," and if he made a terminological distinction between magical helpers (living things) and magical agents (objects and qualities), it was only out of the practical need to distinguish them.[22] Nonetheless, he also remarked that while certain helpers are able to fulfill many different functions (five being the maximum number he identified), objects are, instead, "specific helpers," since they can perform only a single task. He never openly stated whether this reduced power depended, ultimately, on the perceived ontological difference between an object and a living being—the former being understood as intrinsically more elemental and thus more limited—although this seems quite likely. What is certain is that even within the domain of magic, there persists a sort of hierarchy, which seems to mirror the structural complexity of the carriers of such power, a sort of parallel to the traditional subdivision of the world into human, animal, vegetal, and inanimate beings.

Propp also indexed "magical agents" among his famous functions, putting them under the letter F and listing nine possible scenarios through which such items could be made available to the hero.[23] Although he was referring to the structure of folktales, his categorization could also be applied to most of the sources of our Solomonic objects.[24]

Let us begin with the ring. The founding episode, as mentioned, is rooted in the Testament of Solomon, a pseudepigraphic work attributed to the king of Israel and compiled, probably during the fourth century in Jerusalem, in a cultural milieu strongly affected both by Christian and Jewish communities. In a famous passage, King Solomon prays to God to give him power over the demons and receives from the Archangel Michael "a ring, which had a seal, engraved on a precious stone," through which he would be able to "imprison all the demons, both female and male," and build Jerusalem through their help.[25]

This episode could easily be deconstructed by adopting some of the functions indicated by Propp: we have a hero, Solomon; a villain, embodied by a demon; the presence of a helper, that is, God through his angel; and a magical agent, represented by the ring, which is gifted to Solomon in order to subject

evil forces and make him succeed in his intended task. If we look closely, moreover, this passage also constitutes the textual basis for the later codification of the magical seal, which is the formal ancestor of the knot. Here, such an idea is inextricably linked to the ring, the seal being its impression, but later on it will become an autonomous sign, often identified with the five-pointed star, another embodiment, as we will see, of the Solomonic knot.

The Testament of Solomon also sets the premises for the magical transformation of a third object in our list: a container that, once sealed by the ring, becomes a prison the demon cannot escape from. And even if this vessel is not magical per se, at least not initially, it is inextricably linked to the ring, thus becoming a partial extension of its power. Solomon, in fact, casts the demon Kynopegos "into a broad, flat bowl," over which he pours "ten receptacles of seawater." He orders the top side to be fortified with marble, and "asphalt, pitch, and hemp rope" to be spread around over the mouth of the vessel. Finally, the object is "sealed . . . with the ring" and "stored away in the Temple of God."[26]

In a similar way, the Babylonian Talmud, the authoritative commentary of Jewish law, in a highly narrative passage, describes how Solomon forces the demon Ashmedai to reveal the location of a wondrous tool called a *shamir*, which is credited with the supernatural power of cutting through any stone or hard material. Solomon sends his servant Benaiahu on a quest for it; the *shamir* is obtained by deceiving its custodian. Benaiahu, in fact, found "a woodpecker's nest with young in it, and covered it over with white glass. When the bird came it wanted to get in but could not, so it went and brought the *shamir* and placed it on the glass. Benaiahu thereupon gave a shout, and it dropped [the *shamir*] and he took it, and the bird went and committed suicide on account of its oath."[27]

Even in this case we recognize the presence of a hero (in theory Solomon but materially his servant), a chain of unwilling helpers (embodied by a demon that nevertheless provides the information and by the unaware bird that is tricked), a quest, and a magical agent.

Even if these episodes are not constructed in an identical way, they contain a certain structural similarity, which echoes quite well some of the typical situations studied by Propp:

F[1] (the agent is directly transferred: transference), ring
F[8] (the agent is seized: seizure), *shamir*

As far as the flying carpet is concerned, the sources connecting it to King Solomon are numerous, and it is difficult to say which is the most authoritative. The chronicle by al-Ṭabarī, for instance, mentions a giant rug that sustains the

king and his entire court as it travels rapidly from one place to the other, and similar descriptions also occur in some later Jewish midrashim. Other texts relate the ability of Solomon to fly through the air, carried by an eagle, by a throne, or by demons, or directly supported by the winds. All these episodes seem to represent successive variations on the same theme.

Solomon's flight is the focus of chapter 6; here I will only remark that this exact set of motifs is listed by Propp under G (spatial transference): "*The hero flies through the air* (G¹): on a steed; on a bird; in the form of a bird; on board a flying ship; on a flying carpet; on the back of a giant or a spirit; in the carriage of a devil; and so forth."[28]

So, in the following Proppian terminology, the flying carpet could be indexed thus:

G¹ (the hero is transferred through the air), flying carpet

If we apply Propp's template to the sources that mention our Solomonic pieces, we find that only four of what we have provisionally termed magical objects "behave" as such at a formal level. The fifth one, while not falling precisely within this category, does nonetheless take a recognizable shape. In fact, magical agents (F), as Propp defined them, are not just magical items, but are considered within the *active* relationship between hero and helper; if the flying carpet were to be gifted or found or bought, then it could be considered part of the category, but as a sheer means of transportation, although clearly magical, it falls under a different type (G).[29] Propp conceives magic as a pervasive quality of the structure of the fairy tale; what differentiates it, then, is its use within the narration, not its intrinsic quality.

Todorov's Fantastic

In *The Fantastic: A Structural Approach to a Literary Genre* (1970),[30] Tzvetan Todorov defined a theory of literary genres by analyzing a series of textual examples that confronted the characters (and/or the reader) with a situation apparently challenging natural laws. The fantastic was the name he assigned to the initial hesitation felt in response to such an occurrence, which could either be explained in rational terms, thus falling into the category of the "uncanny," or remain supernatural, thus being ascribed to the "marvelous."

Magic is not fully conceptualized in his analysis. In one case, Todorov explicitly aligns it with the Maussian definition of the concept, thus giving the word a well-defined and technical overtone.[31] This could be the reason why he preferred

"fantastic," "uncanny," and "marvelous" in his formalization of the genres: magic was already deeply charged by an intense scholarly debate and had come to be defined in quite specific terms, and thus was not a neutral category, one easy to use. On the other hand, there seems to be some unsolved terminological oscillation, since Todorov refers to it in a very loose manner, almost as if it were an actual synonym of "marvelous": "We generally link the genre of the marvelous to that of the fairy tale," he writes, and, as an example of what he means by "marvelous," he immediately mentions the "magical gifts of the fairies."[32] For this reason, I believe I can use Todorov's analysis of the fantastic to contextualize my own research.

Todorov himself provides an ideal link to this possibility by referring directly to folktales, which were also the starting point of my own discussion. This is not surprising if we consider that there is a sort of uninterrupted scholarly line from Propp to Lévi-Strauss, from Lévi-Strauss to Todorov, and from Todorov to Francesco Orlando, whose work I will discuss in the next section.[33] Moreover, since I have decided to provisionally indicate as "magical objects" those exceeding their intrinsic physical features, Todorov's analysis of the marvelous as something that does not seem to respond to natural laws also appears applicable to our case.

If, as we did above, we were to analyze our collection of objects on the basis of Todorov's system, we would be confronted with yet another result: the flying carpet would fall into the category of the instrumental marvelous, "the gadgets, technological developments unrealized in the period described but, after all, quite possible";[34] the *shamir* would probably fall into the scientific marvelous, in which "the supernatural is explained in a rational manner, but according to laws which contemporary science does not acknowledge"; and the rest of the objects would fall into the pure marvelous.[35]

According to Todorov, there is a subtle yet fundamental difference between the instrumental and the scientific marvelous and the pure marvelous: the former two are only apparently marvelous, since in the end they find a rational explanation of some sort, while the latter maintains its full supernatural character. If we were to consider magic only as the pure marvelous, we would therefore have to conclude that, even in this case, our set of objects should be divided into two types, making a substantial distinction between the carpet and the *shamir* on one side and the rest on the other.

Instrumental marvelous: flying carpet
Scientific marvelous: *shamir*
Pure marvelous: ring, bottles, knot

Exactly as before, we come out with two groups but with a conflicting sub-division, since this inner partition works along different principles. In fact, if Propp's research tackled the problem of breaking up the morphology of the tale—its inner development—Todorov instead addressed the issue of classify-ing the different genres within literature (and objects have a function in that process) in relation to a varying degree of rational explanation. While magic plays a role (and not a marginal one) in both of these systems, it is apparent that it is called on to answer questions of different kind and scale, regarding, respectively, the mechanisms and constants informing the narrative level and the relationship between the perception of natural and supernatural elements in literature. This discrepancy tells us that, no matter how accurate we consider the analytical grid employed, the outcome of any research depends on where we place the emphasis of our study.

At this point, there seems to be room to criticize some of the definitions proposed by Todorov, since, arguably, the technological awareness of modern readers implies a strong etic view on the matter. But one should consider that the hesitation between rational and supernatural is experienced first and fore-most by the intended audience of the time in which the story was crafted, a typical emic concern. If we reconsider the analysis just made under this light, then, we find that all objects belong to the pure marvelous, since the listener/reader has no way of knowing about the future development of science or tech-nology. In other words, if we take the definition of "instrumental magic," we can decide in its favor only *retrospectively*, from where we stand; in turn, some-thing that now still sounds "pure marvelous" could be termed instrumental fifty years from now.

One final element of Todorov's analysis that might prove of interest is the possibility, intrinsic to language, of suggesting or creating marvels, either through poetic or allegorical means. Todorov dedicates two chapters to this possibility and to the inner distinctions between these categories.[36] He also hints at it while discussing his taxonomy, in relation to what he calls the "hyperbolic marvelous," which is, however, only an apparent form of the marvelous, easily detectable and produced by a figurative use of language. This observation, as we will see in the course of the book, will assume rele-vance in the discussion of some of the proposed cases: metaphors will be taken literally, as in the case of the *shamir* and of its powers, or of the recog-nized Solomonic ability to control the winds, which becomes transformed into the actual possibility of flying (on a carpet or by other means). In both cases, the obtained result will be a sudden (and quite successful) shift toward magic.

Orlando's Obsolete Objects

In Francesco Orlando's *Obsolete Objects in the Literary Imagination: Ruins, Relics, Rarities, Rubbish, Uninhabited Places and Hidden Treasures* (1993), the center of speculation regards "things in the material sense of the word—physically, concrete things presented on the imaginary plane of reality of the various literary texts," particularly if outworn, unusual, and outdated.[37] Orlando's research, arising from his fascination with lists of apparently incongruous stuff, led him to the analysis of literature as a repository of the outmoded and the historically superseded, or, in the Freudian terminology so dear to the author, as the "seat of a socially institutionalized return of the repressed."[38] Literature and poetry provided a space where the fundamental imperatives of reality, such as rationality or functionality, could be freely transgressed.[39]

Orlando, however, stressed the importance of the relationship between man and things within the literary domain and further claimed that literature, as "a testimony to the past, . . . possesses something that cannot be compared with any other kind of document that . . . historians work with, because it is both something more and something less than those other documents."[40] Particularly interesting, in this regard, is the notion of time, which emerges from his analysis not just as a metahistorical but as a sort of logical constant.[41]

If such an approach makes Orlando's work extremely relevant to my research, given his deep interest in objects, his focus on magic is no less pertinent. While the title of his book—a list in its own right—does not explicitly mention it, magic certainly holds an important place within his analysis, constituting one of those fields where the transgression of the imperatives of reality finds full realization: "Magic's figurative and symbolic logic will flee from physical or chemical functionality; and its choices will appear (rightfully so, I would say) strange as far as secular rationality is concerned." It is for this reason that, according to Orlando, "the list of magical objects may be called the prototype or archetype of all the various lists of strange things—inasmuch as figurative and symbolic logic are more intrinsic to the phenomenon of literature than the logic proper to science and the functional."[42]

In Orlando's theoretical system, "magic-superstitious" becomes one of the ingredients that, depending on its concentration, can determine a shift between two of the branches into which he subdivides his theoretical tree diagram representing the twelve "images of nonfunctional categories."[43] Unlike the previous two examples, it is not really possible to apply Orlando's theory to our sample of objects, since they remain opaque to it by all equally falling within

the supernatural. However, as seen, some useful analytical elements can still be gathered from his speculation.

In particular, the notion of "removal" is quite effective in our case, although I do not necessarily intend it in a Freudian sense: most Solomonic objects nowadays are literary entities par excellence, although some of them originally were not. A good example of this mutation is discussed by Marina Warner in *Stranger Magic*, which analyzes the theme of magic in the *Arabian Nights*, where the manifestations of Solomonic objects (or some of their embodiments) are numerous.[44] Throughout the chapters of her study, in fact, we find both the flying carpet and the bottles, and the figure of Solomon is discussed in his capacity as master of jinn, a theme that lies at the core of the supernatural transformation of most of these items. The *Nights*, therefore, represent a late repository for traditions that were already well established, but it is through this collection that, arguably, most of these items have survived, acquired renown, and reached us, while losing the most distinctive historical or religious features that characterized them originally.

Anthropology and Magical Objects

Magical objects have not enjoyed uniform treatment in the rich body of studies produced over the last two centuries. This is so even from a terminological point of view, since their labeling has ultimately depended on the value (sacred, religious, magical, protoscientific, etc.) that different theories attributed to the definition of magic and religion and to their relationship, and on whether the angle of analysis chosen was rationalist, pragmatic, or emotionalist, according to a recent categorization of cognitive matrix employed by Jesper Sørensen,[45] or evolutionist, social, and cultural, according to the more traditional lexicon. Despite these varying approaches, it will be useful to briefly synthesize some of the positions taken by traditional scholarship. This is meant to be not a complete critical overview of magic within the field of social science, since others have already attempted such a task quite successfully,[46] but a synthesis of different views specifically concerning magical objects or their attributed properties. The scholarship has typically considered four main aspects: (1) the notion of fetish, which defines the object as a sort of physical vessel for a spirit; (2) the transfer of power and properties of things through sympathetic magic; (3) the identification of magical objects with "elements of a grammar"; and (4) the identification of magical objects with indexes of psychological perception. Additionally, since the 1990s, owing to the growing interest in the notion of agency, an increasing number of scholars are now

focusing on objects as (5) entities capable of acting or exerting an influence also at a physical level, through bodily practices and sensible perception, or through those processes deemed capable of transferring or attributing agency, that is, rituals.

This brief outline within the field of anthropology indicates a progressive shift from more idealistic or symbolical critical views—contexts in which the aspect of materiality was marginal, when not actually irrelevant, to the understanding of these objects—to studies that have come more and more to reconsider it as a fundamental and central feature of analysis.

Fetish, or Exerting Power Through Things

At the starting point of this journey, around 1871, we find the reflections of Edward Burnett Tylor, one of the fathers of social anthropology, in his *Primitive Culture*. In the second volume, mostly dedicated to animism, he reports how the Portuguese in West Africa, noting the veneration paid by the local inhabitants "to certain objects, such as trees, fish, plants, idols, pebbles, claws of beasts, sticks and so forth, very fairly compared these objects to the amulets or talismans with which they were themselves familiar, and called them *feitiço*, or 'charm,' a word derived from Latin *factitius*, in the sense of 'magically artful.'"[47]

Tylor was resorting to a category, the *fetish*, originally introduced in scientific debate by De Brosses in his *Du culte des dieux fétiches* (1760) and discussed at an early stage by Auguste Comte and Herbert Spencer.[48] Tylor distinguished between animism, "the doctrine of spirits in general," and the more specific subcategory of fetishism, "the doctrine of spirits embodied in, or attached to, or conveying influence through, certain material objects." He also stated that, although any object can become a fetish, not all powerful objects necessarily are fetishes, since some could simply be signs, tokens, symbolic charms, or wondrous ornaments, highly valued for other reasons. To class something as a fetish, one would need the recognized intervention of a spirit or demon, which can be embodied in it or act or communicate through it, so that the object "is treated as having personal consciousness and power, is talked with, worshipped, prayed to, sacrificed to, petted or ill-treated."[49] Tylor acknowledged that such a view was typical not only of the cultures of Africa encountered by the Portuguese; hints of a similar "primitive" approach found parallels in European folklore, as traces of an ancient mentality superseded by the progress of civilization. By way of example, he listed several instances, variously mentioned in classical and medieval sources, of demons or spirits entrapped in closed vessels, or ancient ventriloquism practices, a theme that will particularly resonate in the chapter dedicated to the bottles of Solomon.

Ever since its first appearance, the notion has enjoyed enormous success and considerable terminological ambiguity.[50] W. G. Aston listed five different categories for which the label *fetishism* was normally employed.[51] The most widespread was the third one, a material object identified as "the permanent or temporary abode of a spirit," which substantially corresponded to the definition proposed by Tylor.

Moreover, as Van der Leeuw stated in the third chapter of his *Religion in Essence and Manifestation*, dedicated to things and power and, in general, to the broader notion of fetishism, "among potent things, *tools* assume a prominent place." It is through their power, in fact, that the primitive craftsman is able to complete his task. Van der Leeuw, interestingly, used the example of the sacral dimension of the smith, who "wields a power which he certainly understands how to employ, but of which nevertheless he is not the master. . . . In the grips and blows of the tools, then, there dwells not only the strength of arms or legs, but also a specific power residing within the implements themselves."[52]

This reflection about working tools will be of particular interest in discussing the *shamir*, which, as I will try to show, experiences a veritable metamorphosis from a technical to a magical dimension. But Van der Leeuw's insight about the inner power of certain materials, particularly metal, and the almost sacral dimension of smithwork will also resurface with particular relevance in the chapter dedicated to the ring of Solomon.

Despite the evidently touchable dimension of the fetish, which certainly involves its weight, medium, appearance, and so on, its materiality has been somewhat undermined by traditional scholarship. On the one hand, according to most critical views, the fetish works principally because it is imbued with some sort of spirit or essence, which is what makes it really powerful. In this sense, even if its material aspect is undeniable, it still appears as a marginal, residual component, as the inevitable physical feature of nothing but a subsidiary vessel.

The second indirect limitation to materiality comes from Hegel, who considered the power inherent to the fetish as a sheer projection of the individual.[53] Hegel was convinced that "here, in the Fetich, a kind of objective independence as contrasted with the arbitrary fancy of the individual seems to manifest itself: but as the objectivity is nothing other than the fancy of the individual projecting itself into space, the human individuality remains master of the image it has adopted."[54]

This view has not remained unchallenged. The Africanist Albert de Surgy, for instance, who dedicated two monographic issues of *Systèmes de pensée en Afrique noire* to the fetish,[55] objected, based on his field observations, to this approach: "Far from being the result of a passive objectification to which

certain subjects would unconsciously surrender, it [the fetish] is the fruit of a work of objectification requiring appropriate tools and allowing, under the control of the will, to act upon irrational or emotional levels otherwise difficult to control."[56]

The anthropologist Jean Bazin has objected even more strongly to Hegel's approach, reversing the relationship of man-projection-object and showing how a thing, particularly if deemed peculiar or rare—thus by virtue of its morphological features—can introduce a certain order and therefore be "creative" (of a narrative, a myth, a religion, etc.), without representing a reflection of man's own power.[57] This latter position, however, as we will see, is the outcome of a substantial change of attitude toward objects and their inherent powers that appeared in scholarship only around the 1990s. Until then, as the following sections make apparent, the focus of research touched on other aspects.

Sympathetic Magic I: Transferring Power Through Things

James Frazer, who was deeply influenced by Tylor's evolutionary approach in the drafting of his *Golden Bough* (1890), did not dedicate to fetish objects a comparable extended analysis. Regarding the category of objects exerting power, we more often find scattered references to amulets and talismans.[58] Frazer was concerned with the passing of properties (good and bad) among objects, or between man and object, a theme in turn connected to the broader question of taboos and purification.[59] That then fitted well with his overall approach to magic, which he explored through two fundamental principles, enounced at the beginning of his work and sustained with several examples throughout: the law of similarity and the law of contagion. The former, which he also called "homeopathic" or "imitative" magic, states that "like produces the like"; hence the magician can obtain any effect by imitating it. The latter states that "whatever one does to a material object will affect equally the person with whom the object was once in contact, whether it formed part of his body or not."[60] Traces of sympathetic transmission are quite evident, as we will see, in the story of the Solomonic ring and, as a consequence, in the bottles sealed by it.

The fact that Frazer resorted to the idea of "laws" to describe magic is relevant; he was in fact convinced that, although ruled by a chain of events in which causes and effects tended to be confused, magic was a sort of "bastard" science, whose underlying principles were consistent but based on wrong assumptions.

Émile Durkheim's premises were very different from those of Frazer, whom he strongly criticized. He did not consider magic an independent phenomenon,

but something strictly connected to religion. It is most likely for this reason that in his *The Elementary Forms of Religious Life* (1912) he almost never refers to magical things or magical objects. Rather, he makes a distinction between sacred and profane things.[61] The line of demarcation, according to Durkheim, was a matter of social acknowledgment, something that was attained through rituals recognized by a community or a clan.[62] Sacred things could—and usually were—created out of ordinary ones, but such a passage between one world and the other was determined by society.[63] Magic, in this scenario, played a sort of parallel role to the sacred, and the difference, Durkheim notes, was not always easily detectable; magic had "its ceremonies, sacrifices, lustrations, prayers, chants and dances as well. The beings which the magician invokes and the forces which he throws in play are not merely of the same nature as the forces and beings to which religion addresses itself; very frequently, they are identically the same."[64] While noting a substantial identity between religious and magic interdictions and rituals, Durkheim still deemed the shift from one category to the other necessary, and he ascribed this process to an often imperceptible passage between the individual and the collective, the socially accepted and the personal endeavor.

Marcel Mauss, while pursuing the sociological angle inaugurated by his uncle Émile Durkheim in *L'Année sociologique*, resorted in his own work, *A General Theory of Magic*—originally written in collaboration with Henri Hubert and first published in 1902–3 in that review, before being republished as an autonomous work—to some of the principles that Frazer had enounced, and further elaborated on the notion of sympathetic magic. Mauss identified three different principles: "Things in contact are and remain the same—like produces like—opposites work on opposites,"[65] which he respectively termed the "law of contiguity," the "law of similarity," and the "law of opposition." He thus partially expanded on Frazer's conclusions by adding other elements and considerations. In particular, he explained that contiguity corresponded to "the identification of a part with the whole. The part stands for the complete object. Teeth, saliva, sweat, nails, hair represent a total person. . . . Separation in no way disturbs the contiguity." Mauss observed that this principle of indivisible essence applies both to people and to things, which means that "in magic the essence of an object is found in a piece of it, as well as in the whole," so that "each object contains, in its entirety, the essential principle of the species of which it forms a part." For this reason, the separation of a portion from its whole does not affect the intrinsic property of the object, whether whole or in a fragmentary state. In discussing the many ways in which the law of contiguity worked, Mauss concluded that "both individuals and objects are theoretically linked to a seemingly limitless number of sympathetic associations" and

that magic could be performed on any of the connecting points of this broad and invisible net. He also introduced a few limitations to this principle, noting that the law of contiguity does not work by spreading all the qualities from one person to an object but only "a [s]ingle transmissible quality," a partial set of features, usually localized in a recognizable spot.[66]

Mauss then proceeded to elucidate the law of similarity and its principles ("like produces like, *similia similibus evocantur* and like acts upon like"). He underlined the fact that "a simple object, outside all direct contact and all communication, is able to represent the whole," and stressed the necessary abstraction process implied in all these operations, since the similarity between the *similia* was often just an accepted convention. He noted how this kind of operation implied a certain degree of symbolic representation, which meant that one could, for instance, indicate "love by a knot" or understand as the real wind that "found enclosed in a bottle or goatskin, tied in knots or encircled by rings." Exactly as happened with contiguity, even similarity worked on the basis of limitations and restrictions; in regard to objects, this meant that magicians were concerned with transferring or choosing single qualities (color, texture, weight, etc.) for their rituals. Mauss concluded that magical imagination had to be "uninventive to such an extent that the small number of symbols which have been thought up have been put to manifold uses," and, by way of example, he stated that "magical knots are required to represent love, rain, wind, curing, war, language and a thousand other things," a conclusion that will find perfect confirmation in the chapter dedicated to the Solomonic knot.

Finally, as a corollary, consequence, and necessary counterpart of the law of similarity, Mauss described the notion of opposition: "When likes evokes likes it drives away the opposite," which means, as a result, that "opposite drives away opposite" or, again, that "opposite drives out its opposite by evoking its equivalent."[67]

While distinguishing these three laws,[68] Mauss realized that there were several points of contact and superimposition and concluded that these were, in the end, three aspects of the same idea, that is, a sort of magical pantheism, implying that the entire universe is contained in everything, and all apparently separate aspects are actually part of a unique whole.[69]

Sympathetic Magic II: Transforming Objects into Words

Mauss's analysis brought about another consequence. In exploring the conventional nature of the symbolic system encompassed by magic and physically embodied through a network of meaningful associations between things and properties, objects, and various entities, Mauss posited that sympathetic logic

worked because of an underlying taxonomy, based on different classifications (color, shape, sex, etc.); it functioned because, in the end, it was a sort of classifying system of collective representations regarding "phenomena that are comparable to those of language."[70] In this view, physical things acted "more as incantations than as objects with properties, since they are really kind of materialized words" (literally, *mots concrets* or *mots réalisés*). Marcel Mauss transformed magical objects into grammatical elements.[71]

Other scholars applied this approach, eventually taking the reflection to a different level and exploring the magical nature of language.[72] Bronisław Malinowski, in his essay "Magic, Science, and Religion" (1925), while recognizing the importance of choosing specific material objects endowed with appropriate characters ("substances best fitted to receive, retain and transmit magical virtue"), insisted that the real power ultimately resided in the spell, which, according to him, was the most important element in magic. The efficacy of the formula usually depended on its phonetic effects, on the use of certain words to prompt emotional response, and on the mythological allusions implied in the setting.[73]

Malinowski pursued this same approach at length in the second volume of his *Coral Gardens and Their Magic* (1935), where he elaborated the notion of "verbal missile." This work had an enduring influence on Stanley Tambiah, who further developed the topic in his own work, which was also based on the philosopher of language John Austin's reflections during the 1950s about "performative utterances."[74]

Robin Horton, in "African Traditional Thought and Western Science," closely followed Mauss and, on a practical level, E. E. Evans-Pritchard and his seminal fieldwork among the Azande.[75] Horton maintained that "magical objects are the preliterate equivalents of the written incantations which are so commonly found as charms and talismans in literate but prescientific cultural milieu."[76] In comparing African belief and Western scientific attitude, Horton concluded that their approach toward reality was substantially opposite. The former attributed to words an immense power, the ability to deeply affect reality and control the things they stood for; the latter, instead, considered words as tools in the service of explanation and prediction.[77]

The understanding of magic as a semiological system was a polygenetic phenomenon, developing in parallel and independently from Mauss's reflections. In *Fundamentals of Language* (1956), the linguists Roman Jakobson and Morris Halle, for instance, noted that the two laws enounced by Frazer corresponded to the two fundamental polarities of language: "The development of a discourse may take place along two different semantic lines: one topic may lead to another either through their similarity or through their contiguity.

The metaphoric way would be the most appropriate term for the first case and the metonymic way for the second."[78] Twenty years later, this parallelism was further developed by the ethnologist Edmund Leach in *Culture and Communication*, a sort of handbook for anthropologists on the decoding process of culture, considered as a complex system of communication elements. Leach noted that "Frazer's bastard scientist-magician plays around with iconic symbols (which depend upon metaphor) and signs (which depend upon metonymy)" and explained the operation through which magic supposedly worked in linguistic terms.[79]

Regardless of the varying approaches, some quite pragmatic and functionalist, others definitely more symbolic, this irruption of semantics has necessarily limited the impact of magical objects as material entities in traditional scholarship by reducing them to reifications of abstract ideas or by attributing their power to the force of words previously conveyed upon them.

Magical Objects as Indexes of Psychological Perception

Malinowski pursued his approach to the performativity of language in another direction as well, which would have interesting consequences for the field of psychology. In "The Problem of Meaning in Primitive Languages" (1923), he applied the paradigm he had devised for ethnography to the field of linguistics, and particularly to the development of language. He noted that a child could obtain things (food, an object, etc.) or make them happen (have his diaper changed, make his mother appear, etc.), simply by making a clamor. In other words, "to the child, words are therefore not only means of expression but efficient modes of action. . . . Thus infantile experience must leave on the child's mind the deep impression that a name has the power over the person or thing which it signifies."[80]

Malinowski, furthermore, instituted a parallelism between "the infantile formation of meaning and the savage or illiterate meaning," since, he observed, they shared a similar attitude toward the way in which reality could be magically manipulated through language: "The word gives power, allows one to exercise an influence over an object or an action. . . . The word acts on the thing and the thing releases the word in the human mind."[81]

Such a comparison could not have been possible without the previous studies of Lucien Lévy-Bruhl, particularly *How Natives Think* (1910) and *Primitive Mentality* (1922), dedicated to the study of causality in primitive mentality, and investigating two main kind of mindsets, that of "primitives," mystical and prelogical, and the more scientific one, typical of Western, modern thought.[82] Lévy-Bruhl considered magic a sort of underlying logic for primitives, deemed

unable to rule out abstract thinking and thus living in an equally enchanted world where causality unfolded in substantially different ways and along principles diverging from those normally applied by modernity.[83] He remarked that it was not a mere question of *associating* magic or occult properties with powerful objects, but of a "polysynthetic" perception: "The mystic properties with which things and beings are imbued form an integral part of the idea to the primitive, who views it as a synthetic whole. It is at a later stage of social evolution that what we call a natural phenomenon tends to become the sole content of perception to the exclusion of the other elements, which then assume the aspect of beliefs and finally appear superstitious."[84]

In a rather similar way, although on a completely different level, Malinowski argued that at an early stage of development of the individual, inanimate and animate beings are often put on the same level (the milk bottle / the mother); babies can in fact be fond of an object or get angry at it, expressing the same range of reactions shown toward a person. Such "personification of objects, by which relevant and important things of the surroundings release the same emotional response as do the relevant persons," tends to disappear progressively, once the child shows the ability to sort out reality and distinguish among persons, nutritive objects, and things.[85]

Very similar theories were proposed a few years later (1925) by Swiss psychologist Jean Piaget, known for his studies on the cognitive development of children. Piaget introduced the notion of the symbolic stage, in which it is possible to distinguish between physical and psychological, self and others, nature and culture: "What the magical stage itself shows, in opposition to the later stages, is precisely that symbols are still conceived as participating in things."[86] It thus represents this presymbolic moment of formation of adult consciousness.[87]

In *Totem and Taboo*, Freud's "omnipotence of thoughts" theory added another tile to the mosaic, and, following his approach, many scholars have come to identify this condition as a feature distinctive of primitives, children, or mentally disturbed subjects, since magic makes perception contradictory and reality unsteady, and it breaks the boundaries of a certain and well-established objectivity.[88] Magical thinking has been therefore equated, in many respects, with psychic immaturity.[89]

French anthropologist and sociologist Bruno Latour moved along a similar pathway, although we could say in an opposite direction. While never openly using the word "magic" in his *We Have Never Been Modern* (1991), Latour connected the shaping of the very idea of modernity with the ability to operate a conscious distinction between the categories just underlined, basically between magic and science. Such a process of "purification," that is, the effort

of separating human beings and nonhumans, corresponds, in Latour's words, to the "modern critical stance" and lies at the core of what he termed "the modern Constitution," which, as he argued, was problematic and paradoxical: "The modern Constitution as a whole had already declared that there is no common measure between the world of subjects and the world of objects, but that same Constitution at once cancelled out the distance by practising the contrary."[90] Latour argued that despite the effort to reach some sort of steady identity, by separating nature from culture, men from things, society has never been modern and lives in a world permeated by "hybrids," where these distinctions are nothing but illusions.

That the notion "magic" was indeed central to Latour's overall reflection about the paradoxes of modernity is evident from his earlier *The Pasteurization of France* (1984), in which he made the parallel clear: "The world is no more disenchanted than it used to be. . . . How can we speak of a 'modern world' when its efficacy depends upon idols?"[91] His critique of modern thought is no less telling: "If magic is the body of practice which gives certain words the potency to act upon 'things,' the world of logic, deduction and theory must be called 'magical': but it is *our* magic."[92]

Objects and the Call of Agency

As noted in the previous sections, magical objects have been considered by scholars as signs or indexes of something else, in logical and psychological terms, but almost never in regard to their physical essence. It was to be expected that, sooner or later, materiality would claim its revenge. It did so as a consequence of Latour's own reflections.

While acknowledging the importance of the traditional antinomies, Latour, as seen, ended up questioning the very notion of modernity. His approach brought him and other scholars of the Centre de Sociologie de l'Innovation of the École nationale supérieure des mines de Paris, such as Michel Callon and John Law,[93] to the creation of a new paradigm, which has come to be known as actor-network theory (originally *acteur réseau*), or ANT, terms that Latour would have preferred to replace with the expression "sociology of translation."[94]

According to Law, writing years after the first theorization, this approach mostly pertained to the semiotics of materiality, and it implied that entities took form and acquired attributes in virtue of their relationship with each other; they had no inherent qualities in themselves. According to actor-network theory, therefore, "essentialist divisions are thrown on the bonfire of the dualisms. Truth and falsehood. Large and small. Agency and structure. Human

and nonhuman. Before and after. Knowledge and power. Context and content. Materiality and sociality. Activity and passivity."[95]

As far as our theme is concerned, this had an interesting consequence, since objects were not distinct from subjects but worked together and recipro-cally influenced each other, being not discrete entities but integral part of complex "assemblages," as in Gilles Deleuze and Félix Guattari's famous defi-nition.[96] A meaningful and often quoted example is that of the gun, which, far from being a neutral tool, ends up shaping the very perception of the man holding it and interfering with his actions, thus actively transforming and influencing him.[97]

This is one of those instances in which the notion of human agency, that is, the will to act independently—which since Descartes had always been consid-ered a prerogative of the subject—is openly challenged and redistributed, an obvious consequence of blurring the definition of human and nonhuman, subject and object.

Interestingly, during the same period, the notion of agency and its relation-ship to objects was the main focus of another anthropologist, Alfred Gell, whose *Art and Agency*, published posthumously in 1998, is now considered a classic of the discipline. Framing his work as an anthropological investigation of the role of art in society, or, as he himself put it, defining the anthropology of art as the theoretical study of "social relations in the vicinity of objects medi-ating social agency,"[98] Gell put artworks at the center of the relationship between their creators and their recipients, as effective mediators, social agents, endowed with the same power persons have. He suggested that a veritable enchantment could be produced through "technical virtuosity" and that people reacted to works of art as if they were living beings. Gell, moreover, instituted a direct parallel between the artist and the magician, defining each of them as someone capable of creating a powerful effect on the recipient, through his work.[99] It would not be inaccurate to say that, in many circumstances, Gell considered artworks to be like magical objects, an assertion already made, in a way, by Walter Benjamin.[100]

Within this theoretical framework, materiality was particularly important. According to Gell, the so-called abduction of agency—that is, the process of inference operated by the viewer on the meaning, power, or intentions of the maker—could be carried out only by virtue of the physical presence and appearance of the art object, and it was moreover strictly exercised "within the material world"; despite this, Gell never attributed any independent agency to objects, but always a secondary, mediated, or residual one, by acknowledging that agency is "inherently and irreducibly social" and showing skepticism toward what he called "material-culture mysticism."[101]

This fundamental limitation of the agency, intended as a derivative, projected feature, has led scholars such as Tim Ingold and Martin Holbraad to go even further and formulate more decisive assertions of the "full emancipation of things" and of their "affordances," and to overcome the unsolved dualism between persons and objects.[102]

Despite the different approaches chosen by Latour and Gell (the former dedicated to the history of science, the latter to art), and their not entirely coinciding conclusions, it is clear that the attribution of agency to objects, no matter whether mediated, projected, or somehow shared, has been a first and fundamental step toward the retrieving of materiality in anthropology, with consequences in recent and contemporary academic endeavors.[103] One could point, for example, to the French group Matières à Penser,[104] related to Jean-Pierre Warnier, and, in the English-speaking world, to the *Journal of Material Culture*, established in 1996, or the work carried out at UCL.[105]

Back to the Fetish: Analyzing the Power of Objects Through Ritual

After 150 years of general debate, the theme of magical objects seems to have come full circle in anthropology; recently, Jean-Pierre Albert and Agnieszka Kedzierska-Manzon dedicated the methodological introduction of an issue of *Archives de sciences sociales des religions*, significantly titled "Des objets-signes aux objets-sujets," to the problematic status of those objects (Magic? Sacred? Ritual?) that "contribute together to induce the experience of a modification of the world, of the access to a universe where actions and things are endowed with a power exceeding that normally acknowledged by pragmatic rationality: a universe which substantially encompasses the religious sphere."[106]

Albert and Kedzierska-Manzon acknowledge the terminological difficulty of indicating these charged objects, variously defined over time as *fétiches*, *autels sacrificiels*, *dieux-objets*, *choses-dieux*, *objets fort*, and so on. In a way, the old categories of traditional anthropology are still there, even if the debate has reached a higher degree of sophistication and awareness. Despite the usual ideological and terminological issues, they find a common denominator among all these disparate typologies in identifying these objects as altered by a ritual. In this way, everyday things acquire a new status, provided that certain social conditions necessary to produce such a newly perceived efficacy exist.

It is interesting to read this conclusion in parallel with the perspective of Jesper Sørensen, who dedicates to the theme of ritual action and to magical objects several pages of *A Cognitive Theory of Magic*: "The redundancy found in magical ritual often . . . effectively removes all symbolic, or referential, meaning

from the utterance by repetition and thereby transforms the word from a symbol with reference to a kind of object believed to have direct efficacy."[107] This approach ultimately depends on the cognitive theory of ritual advanced by McCauley and Lawson in their *Rethinking Religion* (1990).[108] Sørensen, however, is particularly interested in applying the paradigm to the field of magic, as an attempt to trace a set of overarching elements and principles that can be considered shared, at a cognitive level.

The insistence on the material aspects of ritual and on the physical component is stressed throughout his study, with particular attention to the case of Azande magic, which Evans-Pritchard had analyzed eighty years before.[109] Building on this work, Sørensen discusses the elements necessary to ascribe magical agency in rituals, namely, agent, action, and object, which, combined, "constitute a schematic 'action representation system' structuring the representation of an action as an experiential gestalt in the blend."[110] Sørensen maintains that "an object can be responsible for the ritual efficacy, no matter who wields it, and almost in whatever manner it is wielded," and lists different kind of object-based agencies, the first related to the origin of the piece (being part or having touched an agent from the sacred space), the second depending on belonging to a recognized category of magical objects, the third working "by virtue of perceptual resemblance or similarity" to elements in the sacred space.[111] Interestingly, in tracing these three possibilities, he resorts back, yet again, to the notion of metonymic and metaphorical counterpart connections, depending on Frazer's and Mauss's reflections.

It is also noteworthy that it is through the analysis of fetish and of ritual that anthropologist Webb Keane elaborates his influential definition of "semantic ideologies," a notion that, as we will see, is often invoked by theorists of New Materialism. In an essay published as early as 1998 in an edited volume significantly titled *Border Fetishisms*,[112] Keane used material collected while studying the relation between Dutch Calvinist missionaries and the Sumbanese population of Indonesia to better understand the "boundaries between persons and things" and "to determine the status of language in human activities."[113] He realized that material objects were not simply fetishes but acted as signs of immaterial, spiritual entities, as well as that no material object could "unambiguously determine and delimit [its] semiotic and practical functions" without being subjected to the power of language, of which Keane remarked the substantial material quality.[114]

This set of observations, derived from Keane's own fieldwork, eventually led him to the writing of his often-quoted essay "Semiotics and the Social Analysis of Material Things," whose goal was "to open up social analysis to the historicity and social power of material things, without reducing them either to being

only vehicles of meaning . . . or ultimate determinants."[115] For Keane, semiotic ideology is not just about signs but about "what kinds of agentive subjects and acted-upon objects might be found in the world."[116]

In the introduction to one of the sections of the *Handbook of Material Culture* (2006), which he edited, Keane thoroughly discusses such a fundamental relationship between subjects and objects.[117] He analyzes social theory's four basic understandings of the relation between the two: production (as derived from Marxist theory), representation of and for subjects (via the way opened by Émile Durkheim, Marcel Mauss, and Max Weber), development of subjectivities in relation to objects (mostly in psychological and psychoanalytic terms), and extension of subjects through objects (on the basis of Alfred Gell's and Bruno Latour's works).[118]

He then proceeds to underline two notable aspects inherent to the notion of materiality: the latent possibilities embedded in any object, whose relative importance may be detected or change over time, and the "vulnerability of even the most meaningful things to brute causality."[119] He stresses, moreover, the importance of positing the existence of objects in a condition that is substantially independent of human experiences in order to allow the possibility of unforeseen consequences. A scenario governed by manmade projections, expectations, or needs would in fact limit the unrealized future possibilities inherent to any objects or reduce them to depending only on human intervention: "Objects may thus convey into the world of socially realized meanings the indexical traces of causal processes that remain otherwise unexpressed."[120]

While Keane departed from objects and rituals to substantially reinstate the materiality of language, Jean Bazin, as early as 1986,[121] invoked a return to the "choses-dieux" to reflect on their ontological status through rituals. In so doing, he basically claimed the centrality of physical objects in the very act of creation of a sacred dimension. He, too, recognized things as mediators but remarked that, as such, they were "objets du culte," not "de culte," thus also criticizing the tendency of European ethnographers to interpret fetishism as an aberrant, idolatrous practice that understood the object as inhabited by a spirit, in a sort of dualistic but altogether fictitious understanding of the phenomenon. He proposed instead that all beings could be ideally arranged on a hierarchical echelon ("échelle hiérarchique") depending on their degree of individuation: in this sense, a boulder was "more" than a pebble, a lion was more than a partridge, and a sovereign, in view of his uniqueness, was radically different from each of his subjects. Along this ideal continuum, spanning from the specific to the singular ("du particulier au singulier"), the divine would occupy one of the two extremities, being the most singular thing of all.[122]

The singularity, even the morphological peculiarity, of a rock within a land-scape (thus, a recognizable, special, physical quality) can spark curiosity, inter-est, veneration; it can become the core of a social organization, like a village; and it can finally contribute to establishing a whole narrative, including legends and myths. The sacred thing is a sort of singular body creating and re-creating a microcosm, or even a force field, Bazin stated, curiously resorting to the same image that, in an altogether different context, Italo Calvino had employed to define magical objects.[123]

Through his analysis, Bazin therefore underlined the physical dimension of mythopoesis and, in a way, dissolved what he considered the only apparent dualism of matter and spirit of the magical object, which traditional scholar-ship had always remarked and found problematic. According to Bazin, there was no real need to posit a distinction between matter and spirit, since the sacred thing was, came to be, or ended up being understood as a sum of singu-larities, a rare and unique entity, which therefore defined an ontology where sacredness was inherent to matter.[124]

Art History and the Efficacy of Objects

Art historians have been receptive to the call of materiality in many ways, by variously responding to the intellectual solicitations of scholars such as Martin Heidegger, in his investigation of the very essence of things (their "thingness"); Michel Foucault, in his shattering of established taxonomical categories of thought, through the conditions of possibility of different historical notions of episteme; Walter Benjamin, in his famous critique of the mechanical reproduc-ibility of artworks and their consequent loss of aura; Jean Baudrillard, in his analysis of objects as signs within a consumeristic society; Pierre Bourdieu, in his theorization of the ability of things to shape human beings as social actors; and the discussion of the agency of objects in general, and works of art more specifically, by the already mentioned Bruno Latour and Alfred Gell, to name just some of the most influential.[125]

This wave of interest, as we have seen, was often sparked by scholars from different disciplines (philosophy, anthropology), which is not surprising if we consider that art history, as George Kubler underlined, should put at the center of its investigations quite tangible things,[126] and in many different ways the studies just mentioned placed special emphasis on precisely the ontological, social, aesthetic, and semiotic features of those very things.

In the 1990s, the work of David Freedberg (on which Gell himself had built) and of Hans Belting[127] inaugurated the so-called *Bildwissenschaft*, in which, as

Horst Bredekamp defined it, "first, art history embraced the whole field of images beyond the visual arts, and, secondly, it took all of these objects seriously,"[128] thus also proposing an analysis that went beyond the sheer aesthetic dimension of objects or their usual categories of appreciation.[129] Such a paradigmatic change helped prepare the field for a broader and less dogmatic approach to artifacts, which ended up merging as well with the new tendency arising as a consequence of Latour's and Gell's theories. As Gerhard Wolf has recently put it, however, while the new focus on things, matter, and materiality arose in the same decades in both the humanities and the social sciences, none of these events depended on *Bildwissenschaft*, having a different conceptual framework altogether; "theory and the material turn were not promoted with the publication of a few authoritative books, as in the case of image studies; they were rather at a certain point simply *there*, and scholars started to engage with them in various ways. This is also because of the fact that these 'turns' are far from being homogeneous affairs or movements."[130]

As a consequence of these varying responses, the focus of the discipline has taken a different path: reconsidering the relationship of men and the role of art in response to objects;[131] stressing the role of perceived agency;[132] investigating artifacts as commodities, particularly along their itineraries of trade, and more and more within the context of cross-cultural encounters, cultural history, and global history;[133] but also questioning the way in which the itineraries of these objects are told and presented from the curatorial perspective of modern museums, which need to mediate in complex and subtle ways the inevitable narratives of appropriation, plunder, and colonization that surround many of the pieces held in their collections, thus requiring a certain ethnographical and anthropological awareness.[134] And sometimes, of course, these approaches tend to superimpose and mingle when they touch on common issues, although from different angles.[135]

Magical objects, in this rich context, are still scarcely represented, even if some recent studies have opened the way to a new and quite fruitful approach. An excellent case in point is "Images at Work" (2016). Edited by Hannah Baader and Ittai Weinryb and published as a special issue of *Representations*, it originated from an international conference that took place in 2010 at the Kunsthistorisches Institut in Florence. The broader framework of the volume is the exploration of "efficacy," that is, the ability of crafted objects "to influence the human and nonhuman worlds" through their "operational qualities."[136]

The study is particularly interesting not only because it moves the focus of investigation away from the usual field of miracles operating in the Christian cult context, but because it is one of the more comprehensive and perceptive attempts at categorizing efficacy by matching and discussing various case studies

in comparison with the different theoretical approaches to the matter that have been unfolding over time. Persis Berlekamp's essay on the talismanic power of representations of lions and dragons, for instance, is particularly useful for the discussion in chapter 4 of this book regarding the theme of knots.[137] More generally, in their programmatic introduction, Baader and Weinryb underline several elements that are especially relevant to the methodological setting of my own work, elements that recur as well in some of the materials that I will be presenting here. First is the undeniable relation between the excellent workmanship of a certain piece and its recognized effectiveness. Second is the shift between fluid categories, or, as Baader and Weinryb put it, the fact that "every potentially efficacious object that possesses the ability to influence the natural world can be demoted from its magical, efficacious status to become, at very best, a work of art that simply displays the skills of an artist or maker," and vice versa. Third is the need to push the investigation beyond the "merely iconographical" level and the related importance of texts, set in parallel to objects, as sources capable of unraveling different hermeneutical potentialities.[138] Last is the fundamental notion of distance or of extraneousness to the instance of creation of the object itself, since efficacy does not necessarily correspond to that phase but is attributed, recognized, or attached to the object afterward, typically by someone who is foreign or alien to it.[139]

The Material Side of Religion

The interest in objects has also been taking hold in the field of religious studies since as early as 1995, when Colleen McDannell published her *Material Christianity*,[140] and is exemplified by *Material Religion: The Journal of Objects, Art, and Belief*, established in 2005.[141] Also worth mentioning is Brent Plate's significantly titled *The History of Religion in 5½ Objects* (2014) and his more systematic theoretical endeavor dedicated to the categorization of *Key Terms in Material Religion* (2015).[142] This growing trend can be placed within the broader effort to recontextualize religion within the field of material studies, which is well summarized and subtly analyzed in a dense article by Sonia Hazard, who lists and discusses three main methods.[143] Hazard, however, shows some skepticism toward the work done in the field so far, not because she criticizes the material turn per se, but, on the contrary, because she finds that the results obtained—some of which certainly quite important—still incline toward a substantial anthropocentrism. Against this she invokes, on the basis of the idea of "assemblages" introduced by the "New Materialism" of Deleuze and Guattari in the 1980s,[144] a "fourth approach," which "rejects a priori oppositions

between subjects and objects,"[145] arguing that "material things possess a remarkable range of capacities that exceed the purview of human sense or knowing, and therefore insist[ing] that the materiality of material things them-selves must be carefully considered, not merely interpreted for their implica-tions on human concerns."[146]

Following a somewhat parallel ideological trend is George Ioannides, who is similarly concerned with establishing a "relation between human and nonhu-man as reimagined to ethically engage and respect the latter's agential power and nonanthropocentric anthropomorphism."[147] In this he follows Jane Ben-nett in her pathbreaking *Vibrant Matter: A Political Ecology of Things* (2010), as well as other scholars who invoke, in essence, a Neo-Animistic conception of life and society, an "enchanted" world—an approach that, however, seems no less dogmatic than the one it intends to criticize.[148]

Particularly active in the discussion and interested in bringing it to its extreme methodological consequences is Peter J. Bräunlein, who recently did a thorough review of all the positions in the field and proposed three perspec-tives:[149] Webb Keane's semiotic ideologies—"anything that enters into actual semiotic practice functions within perceptible experience by virtue of its mate-rial properties";[150] André Drooger's methodological ludism,[151] on the basis of which Bräunlein suggests carrying out "experiments with consciousness or altered forms of perception ... not as a form of consciousness disorder, but as an experimental way of subject-object-nature-culture dissolution"; and an overall approach modeled more toward an aesthetics of religion, "sensory per-ception, the body and the media" as a connective concept.[152]

In the field of religious studies, by contrast, despite the great wealth of learned works on magic, magical objects have long escaped the direct interest of scholars, who have preferred to focus on text editions, analysis of the figure of the magician, and the history of ideas.[153] This neglect can likely be explained not only by the more idealistic orientation of the discipline, as well as the difficulty in precisely assessing material remains, but by the need to establish the boundaries of magic itself: from this perspective, objects may be seen as representing nothing but the physical means through which a set of rituals can be performed. This is not to say that magical objects have not been con-sidered, of course, but their role and function has usually been discussed either in relation to theoretical systems or as illustrating the customs, beliefs, behaviors, and symbolic apparatus of certain civilizations. They have more often been seen as elements of a semiological network and less often as physi-cal artifacts; their material aspect has been accounted for mostly with refer-ence to the medium in which they were realized, which often determined benign or evil effects.

In the essay mentioned above, Peter Pels wrote about the inextricable and unavoidable relationship between magic and modernity. He showed that, despite the effort at relegating magic toward an alterity (temporal, exotic, methodological) and thus implicating its fundamental distance (in terms of time, culture, rationality) from the present, people today constantly reshape an antithesis, which is only apparent. Magic does belong to modernity.[154] If Pels identified contemporary forms of enchantment in practices of representation, commodification, and discipline, it is nonetheless quite possible to recognize a further aspect of this substantial connection in the methodological approach embraced by certain scholarship as a sort of polemical counterapproach. The theme of magic is ideal for New Materialism, which, in its more extreme forms, tends to look at the world as a newly enchanted place, in reaction to a hyper-rational view of reality and as a way to overturn the ideological premises that have informed the Western modern mentality until now, and as "a mode," as Styers would put it, "of subversion and cultural critique," variously oriented toward a social, gender-like, ecological, economic, or emotional perspective. As Styers remarks, "social theorists ... have themselves operated as magicians";[155] not dissimilarly, several scholars of religion seem to be striving for a sort of "magical turn" in the field, in an effort to counterbalance or maybe respond to the threat offered, in different and opposed ways, by "a global ecological crisis" and by "a digital revolution that blurs the boundaries between the real and the virtual," as Bräunlein states.[156] Placing materiality back at the center of speculation seems all the more relevant in such a context.

Christopher Wood, however, has recently criticized this tendency in scholarship, defining it as "materialist, anti-humanist and anti-hierarchical" and underlining how "life of things, actor-network theory and object-oriented ontology" represent means to "restore credence to pre- or nonmodern anthropomorphisms and animistic psychological habits." According to Wood, "the deepest aim of the new, counter-Enlightenment animism may not be so remote from those of traditional animisms, namely, to persuade each other that we participate in something greater than ourselves: if not a cosmos, then an ecology or a system."[157]

In other words, the progressive purification or transformation of language can often lead to opaque, if not actually contradictory, results or to the replacement of one set of terms with another, only apparently better or more neutral. It does not seem entirely coincidental that such a committed criticism comes from a historian of literature. The privilege of having objects speak from a first-person perspective, as we have noted, has been a prerogative of that realm, although as an evident and recognized form of rhetorical, poetical, or narrative

convention. Nevertheless, the notion of "speaking" objects has been quite suc-
cessfully employed for at least two decades.

In his *Theorie des Bildakts*, for instance, Horst Bredekamp underlines how
the ability to elicit a reaction from the viewer/maker, to create a direct engage-
ment, has been granted to artifacts in all cultures and times. And such an
interactive relationship has been made explicit precisely through inscriptions
formulated from a first-person, internal perspective, which sets objects (bells,
weapons, portraits, doors, cups, etc.) within an "I"-speaking dimension, on the
level of active subjects, of agents. Far from considering such a feature as an
extreme and condensed form of physical prosopopoeia, or a mere index of the
artist's social awareness,[158] Bredekamp sets it at the very core of his theory,
suggesting that artifacts are not representations of reality, but an active and
autonomous part of it. "I"-inscribed objects therefore make explicit that hidden
potential ("Latenz") that any apparently unanimated entity carries—the ability
to exert an effect on human beings despite, or possibly in virtue of, their very
inert materiality.[159]

In turn, in his well-known *What Do Pictures Want?* (2005) and in an earlier
article with almost the same title (1996), W. J. T. Mitchell resorted to the per-
sonification of images as sentient entities, defining, however, the concept of
"image-as-organism" as a "verbal and a visual trope, a figure of speech, of vision,
of graphic design." When asked whether he really *believed* that images want
things, he stated that he did not, but also stressed the fact that "human beings
. . . insist on talking and behaving as if they *did* believe it,"[160] while also remind-
ing us that traditionally this fascination, this belief, has been attributed by
anthropologists to the "savage mind" of primitive societies, "by art historians to
the non-Western or pre-modern," by "psychologists to the neurotic or infantile
mind," and by "sociologists to the popular mind," a tendency that we have seen
well expressed in the previous sections of this chapter.[161]

A Disenchanted Approach

No matter how fascinating or how imbued with significance and agency,
objects, of course, lack self-reflexivity, and as much as we try to set them at the
center of our speculation, we cannot expect them to write their own autobiog-
raphies. Any attempt at such an experiment, however evocative in method-
ological terms, represents just another projection of the writer's own ideas, a
more or less successful exercise that would further narrow the already thinning
line between history and narrative.[162] As anthropologist Laurajane Smith and
other scholars note,[163] in the end, "objects want nothing."[164] However, in light of

some current statements, it will probably not be long before scholars, as new shamans, offer insights into the long-neglected topic of magical objects, considering that it is precisely in relation to magic that the well-known *agency* of things can better be seen at work. Magical devices, books, and amulets are literally enlivened: they act, harm, bind, threaten, soothe, sometimes speak through formulae, predict the future, give answers, and are credited with having (and indeed have) a direct effect and impact on human beings, in a system where the "bundling," the "entanglement," the "hybridization" of objects and subjects is much more visible than in many other instances, and definitely more *effective*.[165]

It is to be hoped that any approach envisioned as filling this historiographical gap, deprecated and acknowledged by various scholars, will follow strict philological criteria. Positive signs already exist. A growing number of publications dedicated to the theme are already appearing, since "material" and "materiality"—two of the catchwords of the moment—are definitely on the rise, and there seems to be a distinct trend toward associating them with "magic."[166]

Two books with virtually the same title have recently appeared: *The Materiality of Magic: An Artefactual Investigation into Ritual Practices and Popular Beliefs* (2015), edited by Ceri Houlbrook and Natalie Armitage, and *The Materiality of Magic* (2016), edited by Jan Bremmer and Dietrich Boschung.[167] Both are quite interesting collections of case studies, although the former is more engaged in conversation with current historiography and openly addresses "the significance, importance, relevance" of materiality in relation to magic, the "physical substance and tangibility of . . . artefacts concerned with magic," the supposed oxymoronic relationship between "materiality" and "magic," and issues of current methodology, while also tracing a useful historiographical framework with a distinctive archaeological approach.[168] Conversely, Bremmer and Boschung's volume gathers various essays regarding amulets, figurines, dolls, rings, inscriptions, and so on, covering a range of items from ancient Egypt to postmedieval times, but its involvement in the debate triggered by the scholars of the material turn appears not too theory-oriented, showing instead mild skepticism: "As things became more important in our lives, sooner or later, the scholars followed. One need not necessarily accept the vocabulary of 'the agency of things' in order to understand that things have an increasing impact in our lives."[169]

A third, fascinating case, which exemplifies quite well the current interest in the studies, is the already mentioned *The Materiality of Power* (2016) by Brian Schmidt, a dense volume dedicated to Israelite magic. While demonstrating perfect awareness of the ongoing theoretical debate and declaring his intellectual debt to part of this tradition, Schmidt ultimately prefers a practical

approach, defined by sound methodological limits, showing what I find a quite refreshing attitude.[170]

My own work overtly regards objects and the way in which a certain power can materially manifest itself through them. It thus appears to be perfectly inscribed within the trend I have been outlining. My ambition is not to unveil the inner agency of things, however, nor am I able or willing to fully abandon the anthropocentric categories that characterize my method. My sample is constituted by artifacts that, no matter how deeply perceived, at least initially, in magical, apotropaic, or divine terms, can also easily be framed in sheer human categories, as manmade things, tools, decorations, pieces of furniture.

Moreover, like others, I find this postcolonial anxiety about imposing anything on anything or anybody, let alone a name or a categorization—as a terrible echo of that primordial act entrusted to Adam, according to which naming is owning and controlling[171]—an untenable approach, if only for sheerly practical reasons. Any analytical effort requires taxonomies of some kind, however imperfect, politically biased, or socially charged.

Despite my limited enthusiasm for New Materialism, I have found it useful to briefly trace the story of magical objects from an idealistic to a progressively more material approach, since the latter approach has some aspects potentially useful for my own work. It is undeniable that this aspect is becoming central in our lives, and, far from demonizing it, we should study and understand it.[172] The chapters of this book, as noted in the introduction, are dedicated to five objects that have traditionally been associated with Solomon (although, as we will see, not only with him). In reconstructing their textual and historical vicissitudes, I have often found that their perceived magical quality resided in or was inextricably linked to a specific material feature. The ring, for instance, is a good case in point to illustrate the intrinsic power of certain media: metals like copper, iron, and electrum are not neutral but tend to evoke, in specific historical circumstances, a network of symbolical associations. A similar medium-related aspect is present in the discussion of the bottles constraining evil spirits, but even more distinctive seems to be the relationship instituted between the ability to entrap, due, in this case, to the primary function attributed to these items: they are containers or vessels that can hold water or air inside. Chapter 4, dedicated to the intricate story of Solomonic knots, deals with several historical issues but could also be seen as a sort of meditation on shape, since the notion of a closed, intertwined, and often infinite pattern is once more the premise for a device meant to act as a prison for demons. Materiality also manifests itself—and in an extreme form—in chapter 5, devoted to the *shamir*, a mysterious tool variously identified with a plant, a stone, and a worm. Even in this case, when the very physical definition of the object appears

all the more elusive or even changing, the power of the object neither diminishes nor vanishes; on the contrary, it seems to gain strength precisely because it is able to endure the progressive metamorphosis of its aspect without losing any of its efficacy, which resides, this time, in its main known property, the ability to cut through the hardest substances. Finally, there is the story of the carpet, which represents materiality in yet another form, in coming to embody the physical substratum required by the progressive passage from language to matter, and thus becoming the crystallization of a metaphor, at an earlier stage, but also investing quite tangible aspects, such as weight and flexibility, that is, the issue of quality, at a later one.

Of course, themes such as material, form, function, property, and quality are not the only keys to reading these essays, which together, in my view, exemplify the fascinating process of the telling and retelling of culturally intermingled traditions and their reciprocal interrelations. They can work also as clues for indirectly tracing a story of the magical fashioning of objects through recognizable material indexes.

Conclusions

In dealing with a series of objects that one would instinctively perceive or define as "magical," such as those presented in the following pages, it is almost impossible to escape the need to define their nature. Moreover, since talking about objects and their materiality has nowadays become particularly in vogue in the humanities, as a partial consequence of the so-called material turn and of the success of thing-theory, one must necessarily confront this tendency. This chapter therefore represents an attempt at creating a sort of historiographical awareness—more like a sketched map—to better frame the question. Reflecting on magic, as many scholars have shown, is yet another way to investigate our own idea of modernity and self-perception, since the notion has ended up being relegated to that vast and ambiguous territory set around our own self-definitional borders, threatening or questioning reasonable behaviors, socially admissible practices, and even established methodological theories. In presenting my overview, I have tried to distance my study from a too strongly theory-oriented approach, in the conviction that it is more fruitful to adopt a more practical, experimental approach, without renouncing conventional categories of analysis, which, however limited and necessarily biased, still provide useful results. The chapter is also a tentative synthesis of the definitions crafted in some of the fields of study that our objects may have intersected through their long lives and

a tentative summary of some methodological clues emerging from some of the studies analyzed, notably the following:

1. The centrality of magical objects within the "force field" of narration
2. The substantial equation between a magical object and a similar but often disembodied quality
3. The limited, specific nature of magical objects compared to other, more complex agents, which seems to be confirmed by the fact that each of them can perform one and only one task, usually connected to its form or function
4. The recursive morphological traits shared by culturally distant texts (e.g., a Russian tale and the Testament of Solomon), which hand down an identical *dynamics* of the action, despite the different perceived status of the object (divine vs. magic) within the text itself
5. The understanding of literature as the ultimate repository for the memory of physical objects, after a "removal" from reality (here not necessarily intended in a Freudian sense)
6. The different degrees in the perception of magic, depending on the knowledge, competence, or credulity of the listener, a shift operating also throughout time
7. The disruption of the boundary between human mind and surrounding matter, perception and reality, subject and object, because of the fantastic (= hesitation toward the supernatural)
8. The creation of magic through the figurative use of language
9. The exercise of power on the outer world through things, agents, tools, elements
10. The similarity, in terms of perceived power, between working tools and magical objects
11. The transmission of properties and qualities through physical objects via different principles (contiguity—similarity—opposition)
12. The limited quality of such a transmission (usually reduced to a single property)
13. The process of abstraction underlying the laws of sympathetic logic, which implies the use of a symbolic (and limited) system of representation
14. The relationship between similarity vs. contiguity / metaphorical vs. metonymical
15. The possibility for magical objects to act as physical embodiments of spoken (or written) charms
16. The identification of magical objects as indexes of "otherness"

17. The nonneutral nature of objects, capable of influencing their surroundings by virtue of their physical features and the reactions they elicit by virtue of the social, economic, and cultural context in which they are found/created
18. The perceived active nature of magical objects (agency)
19. The openness of objects to future and yet unimagined interpretations
20. The acknowledgment of a rare, unique, special physical trait as a sign of the creative power of objects
21. The physical creative force of objects in mythopoesis
22. The direct relationship between the recognized level of workmanship and the efficacy of an object
23. The fluid shift between ordinary and magical objects, depending on circumstances and viewers
24. The importance of a combined approach of textual sources and material aspects to understand efficacy
25. The relationship between distance (chronological/cultural, etc.) and the perception of efficacy

As stated, the conclusions just drawn are meant to be not the basis of a consistent theory but a useful set of working tools, which will resurface from time to time in the analysis in the next few chapters. By singling them out through the reflections of earlier scholarship, I have also tried to provide the historiographical background through which they were progressively shaped and enounced. Of course, this list does not exclude the possibility of further additions and adjustments.

2

THE SIGNET RING

One Ring to rule them all, One Ring to find them,
One Ring to bring them all and in the darkness bind them.

—J. R. R. Tolkien, *The Lord of The Rings*

Austrian scientist and Nobel Prize winner Konrad Lorenz (1903–1989) titled his famous work on the behavior of animals *Er redete mit dem Vieh, den Vogeln und den Fischen*, a line from *Der Heilige und die Tiere*, a poem by J. V. Widmann (1842–1911) about St. Francis of Assisi.[1] The line refers to Solomon, who, like the saint, was said to understand the language of animals and birds. Unlike the friar, however, who had it as a natural gift, the power of the king of Jerusalem derived, as noted in the previous chapter, from a ring, brought to him by an archangel. It is for this reason that in the translations of Lorenz's book, which enjoyed enormous success worldwide, the title often, like the English *King Solomon's Ring*, refers explicitly to the ring. In his introduction, in fact, the founder of modern ethology stated that he did not need King Solomon's device to understand the language of jackdaws and greylag geese and proceeded to illustrate their habits through his studies and experience.[2] Although the reference to Solomon in his title was only a brilliant pretext for introducing the theme of communication among animals and the power of human observation in an evocative way, Lorenz contributed enormously to the modern perception of what the ring of Solomon was and what it could do.

Both Lorenz and Widmann before him based their knowledge of the ring on the vast treasure of learned and popular literary traditions, directly influenced by motifs derived from the corpus of Jewish midrashim, which over time had merged into German language and folklore. It is interesting to note, however, that this connection between the ring and the animals, which, to our modern eyes, is its most fundamental and most renowned feature, does not

correspond to the original power embedded in the object, at least according to the most ancient sources.

Rings bringing good luck to their wearers or directly connected with healing were widely employed during late antiquity, although the study of the corpus of such items has been carried out unevenly.[3] The first occurrence of a ring performing an exorcism in the name of Solomon is a first-century mention by Josephus.[4] The text, while certainly attesting a tradition of Solomonic exorcisms performed through rings, does not necessarily imply the existence of a ring of Solomon.[5] That does not appear in written form until the Testament of Solomon, a demonology handbook in Greek, whose original nucleus was probably compiled between the third and fourth centuries in a Christian context, and whose complex historical development is still the focus of an intense scholarly debate.[6] In this first explicit textual mention, the ring is described as an object endowed with a strong binding power: it is the signet ring of Solomon, which he uses to exert his will on the demons, to imprison them.[7]

The idea embodied in the ring, therefore, stood as a powerful formal and physical obligation, not only as a symbolic one. The Testament of Solomon describes it as a "daktylídion échon sphragídas glyphēs líthou timíou," that is, a signet ring (literally, a small ring, since it was usually worn on the little finger) having a seal engraved on a precious stone, a set of features quite common to the typology of the object in question.[8]

In the course of late antiquity and in Christian perception, therefore, the ring had nothing to do with animal language but served as a legal symbol for the Solomonic power over supernatural entities. Over time, however, the story of the ring was transmitted across different religious and cultural contexts: various details were added, and others were completely altered, thus mutating the material and symbolic features of the first recorded object. Moreover, despite the scantiness of the details provided by the earliest historical and pseudohistorical descriptions of the ring, the original nucleus developed through later additions into a full, self-standing tale.

The goal of this chapter is to illustrate this metamorphosis. In doing so, I will follow the comparative approach inaugurated by Joseph Verheyden a few years ago.[9] I will be focusing in particular on the constituting material of the ring since I am convinced that this is by no means secondary (it is often the only element recorded in the otherwise very meager descriptions we have) and that it sheds light on the functions attributed to the object.[10]

I will begin with some well-known eyewitness descriptions handed down by Christian pilgrims who visited Jerusalem during the fourth century, and I will compare them with other accounts mostly pertaining to the Islamic tradition, with a few incursions into the Jewish world. Although the former texts quite

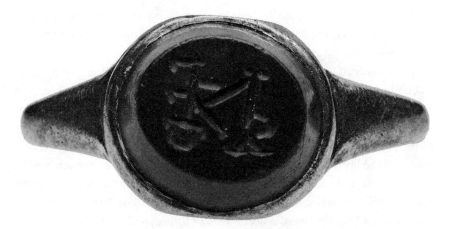

Fig. 1 Gold ring set with red jasper intaglio engraved with a monogram, Roman, mid-third century. © Les Enluminures (now private collection, United States).

likely refer to something that did exist, whereas the others are narrative evocations of an almost mythical object, I will treat them alike. It can be argued that, from a methodological point of view, there is not much difference between the imagined device of Jewish and Arabic sources and the purposefully crafted relic shown to Christian pilgrims. All texts, in fact, represent equally meaningful attempts to fashion the Solomonic ring of power in the most effective way. Since neither the Bible nor the Qur'ān explicitly mentions the object, there was ample room to craft a powerful device.[11] I will therefore try to highlight not the reality of the thing in itself but its symbolic ontology by showing what kind of importance the alleged constituting material of the ring could hold in the eyes of contemporaries and what functions were associated with it in the different narratives.

An Electrum Relic

In one of the earliest pilgrim accounts that has come down to us, dated around 333–34 CE, it is reported that in Jerusalem, in the proximity of the pools of Bethesda,[12] whose waters had been renowned for their curative powers since the first century, there was a crypt or cave where Solomon bound demons ("est ibi et cripta, ubi Salomon daemones torquebat").[13] According to Augusto Cosentino, this cave was, in all likelihood, a sanctuary holding various "Solomonic relics," a site where exorcism rites were performed and people healed.[14] Not much is known of this site, but it is indeed possible that the textual mention

of the Solomonic ring in the Testament of Solomon could reflect the presence of an actual ring, used for actual purification/exorcism rites, performed in Jerusalem in the name of Solomon.[15]

What is certain is that the object makes a breakthrough from the realm of fiction to that of reality, appearing for the first time in the account of Egeria in 381, where it is described as being on display for Christian travelers in the chapel erected on Mount Golgotha, thus constituting the core of the pilgrimage experience: "Then they go on to a deacon who stands holding the ring of Solomon and the horn with which the kings were anointed. These they venerate by kissing them, and till noon everybody goes by, entering by one door and going out through the other, till midday."[16] As has been argued, the object acted almost as an Old Testament relic, in a phase in which Christian imperial and ecclesiastic powers explicitly claimed the heritage of biblical kingship.[17]

In the extended, sixth-century version of the *Breviarius de Hierosolyma*, originally a fourth-century short topographical description of Jerusalem, this display is reaffirmed: "There is the horn with which David was anointed, and Solomon. And there too is the ring with which Solomon sealed the demons. It is made of electrum [*de electro*]."[18] Not far from where the object was kept, in the adjacent church of the Holy Sepulchre, were other Solomon-related pieces: "Around this apse stand twelve quite marvelous columns of marble, and on these columns are twelve silver bowls [*hydriae*] in which Solomon sealed the demons."[19]

Despite the fragmentary nature of this passage and its paucity of detail, our observer does mention the constituting material of the ring, saying that it was made of electrum. In an early study on the topic, Bellarmino Bagatti translated the word as *ambra* (amber),[20] a choice made possible by the fundamental ambiguity of the Greek term *electron*, which could be rendered, both in Latin and in Greek, as either "amber" or "electrum," the latter being an alloy of silver and gold, well known since antiquity in the Mediterranean world[21] and originally used for making coins.[22] The genesis and development of this confusion seem to have been clarified by philologists, and the context usually helps decide the correct meaning of the word in antiquity. At a later phase, especially in Latin-speaking contexts, "electrum" was employed fairly consistently to refer to metal, while amber was indicated by terms such as *sucinum*, *ligurium*, and *glaesum*.[23]

The reason for this progressive diversification probably depends in large measure on the use of the word in the Latin Bible. It is employed already in the Septuagint in the description of Ezekiel's vision to indicate the peculiar shining and glowing hue, similar to that of fire, of the four creatures seen by the prophet (Ez. 1:4–5) and of the throne and glory of God (Ez. 1:27–28). Both

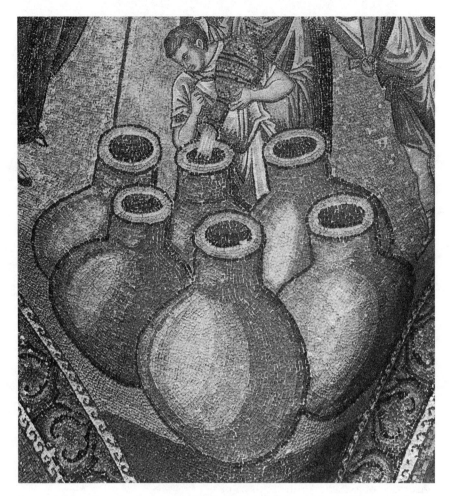

Fig. 2 Mosaic depicting hydriae being filled with water during the wedding at Cana, Chora Museum, Istanbul, 1315–21, detail. Photo © Egisto Sani.

passages originally used the mysterious Hebrew *ḥashmal*, which, however, is a *vexata quaestio* of Hebrew exegesis, being variously understood as the color of burnished copper, torches, lightning bolts, rainbows, and so on.[24]

Most English translations of the Old Testament, reflecting the same ambiguity, give the term as "amber," but a few, such as the New International Version, choose "glowing metal."[25] Although much rarer, the latter is certainly closer to the meaning attributed to it by the first Christian commentators on the vision, such as Jerome (ca. 347–419). There is enough evidence among the writings of Christian fathers, in fact, to show that they saw "electrum," almost unequivocally, as the alloy of gold and silver.[26]

The notion of a noble substance with a double composition, employed to indicate the divine radiance, caused a successful wave of symbolic interpretations, which, as early as the third century, equated it with the two substances of Christ's nature and expanded on the comparison.[27] Even before this Christian interpretation, however, the double nature of electrum was almost proverbial, often being employed, as a sort of exemplary comparison, in juridical texts to illustrate similarity or difference of genus.[28] The later theological development was thus probably a natural outcome of a notion relatively widespread during late antiquity and already deeply embedded in the perception of most Christian writers.

Such an intrinsic feature did not resonate simply at a symbolic level but must have retained a distinct aesthetic value. Altering the proportions of silver and gold in the alloy, in fact, could result in different hues of the metal.[29] Electrum, therefore, could vary greatly in terms of hue and brilliance, and it was certainly possible to obtain peculiar and specific effects, depending on the balance of the two components, as a very interesting description in the epistles of Bishop Avitus of Vienne (ca. 470–ca. 523) clearly demonstrates: "Let its colour be of the kind which equally and discreetly draws pinkness from gold, glitter from silver, preciousness from each of them, brightness from torches, and which is given value by an artful pleasantness of green in the middle."[30]

The bishop's letter confirms that, at a date not too far from that in the *Breviarius*, the components of a ring could indeed include electrum, and such a choice could reflect a considered aesthetic decision. Here, however, it is not the hoop that was made of this material but, it appears, the bezel for a green stone. The union of electrum and gems was probably not uncommon at the time, for the chromatic reasons underlined by Avitus.[31]

The pilgrim who described the Solomonic ring, then, dwells on a detail whose connotations were probably not neutral for Christian viewers of the time. And even if we cannot be sure what the ring looked like, in view of the paucity of details given, we know that its material could evoke the unique effulgence of divinity and the double nature of Christ, who was heir to Solomon by direct lineage and, like him, a powerful exorcist. Moreover, the material of the ring produced a characteristic range of hues, thus making it an object beautiful to look at. As an object worthy of Christian veneration, therefore, it was certainly loaded both with the aesthetic and the theological overtones just discussed.

However, the reason to fashion Solomon's ring from electrum possibly depended on other factors that shed light on the rather ambiguous status of the object, which was at the same time not only a relic but a magical device. According to the definitions offered by various scholars, such as Georg Luck,

"magic" regards that set of operations and tools obtaining an effect perceived as supernatural, while acting outside of the boundaries of recognized religious orthodoxy. The only difference between a miracle and an effective charm, therefore, lies in the agency invoked to perform it.[32] All this could apply to the ring of Solomon, which, without ever being mentioned in the Scriptures, had acquired legitimacy within orthodox Christian praxis thanks to its role in purification, baptismal, and exorcist practices.

Electrum Bottles

The presence of electrum is an indirect yet telling sign of a more complex and nuanced story, in which syncretic beliefs and alchemical knowledge mingle together, thus showing that the Solomonic ring exhibited to the pilgrims had undergone dense historical and symbolic stratification. In his rich work on Solomon, Pablo Torijano has listed two meaningful occurrences of this material,[33] both drawn from the Syriac version of book 12 of one of the alchemical works by the renowned Egyptian scholar Zosimus (third–fourth centuries), entirely dedicated to electrum.[34] Zosimus, instructing his pupil Theosebia, provides various examples related to the power and effects of the material. Two of these are particularly relevant to us. The first refers to Alexander the Great, the second more directly to Solomon. Zosimus relates that Alexander had made a mirror of electrum, and explains, drawing on Gnostic doctrine, that the material allowed the viewer to gain the purity and perfection of the Holy Spirit. Alexander had resorted to the same material to protect his land from lightning, burying electrum coins in the ground, and Zosimus says that in his time people continued to find coins displaying Alexander as a horseman, which they used as protective amulets.[35]

Leaving aside the story of the mirror, there are at least two different elements of interest to us in this story. The first is its protagonist. As has been pointed out in various studies, Alexander shares many aspects of his legend with Solomon, and it is common to find several parallelisms between the two figures, who both act as magnets for traditions with striking similarities.[36] It could be only a coincidence, then, but it is noteworthy that Solomon was often associated, throughout late antiquity, with coins displaying a horseman, usually employed as amulets against various demons.[37] While it is difficult to be conclusive on this point, it is not unlikely that the existence of such an apotropaic tradition related to Alexander could have influenced or strengthened the creation or diffusion of a similar one linked to Solomon.

The second point I would like to underline here is the apotropaic function attributed to coins. As has been well demonstrated, this kind of object, particularly when no longer in use, was often credited with talismanic powers.[38] Electrum coins were particularly common between 600 and the 330s BCE.[39] Under Philip II and his son Alexander, however, different coinage metals came to be used in the Thraco-Macedonian region.[40] The episode related by Zosimus, therefore, could be an indirect echo of a specific historical situation: as a result of the substitution of the monetary system, the old electrum coins, now useless, were abandoned or buried in large hoards, thus favoring their later discovery and transformation into powerful devices. However, the story could also have originated from the discovery of pieces dating back to Alexander displaying the horseman iconography, which recurs, for instance, on four-*chalkoi* pieces issued by the king (although these are usually made of bronze). It is interesting to note that these coins display a thunderbolt under the legs of the horse as a mint mark, and it is not unlikely, I think, that such an iconographic detail could have prompted the association with the metal's protective function against lightning.[41]

In conclusion, Zosimus's description seems to take into account a combination of different likely historical factors. What is certain, in any case, is that electrum, in late antiquity, must have been perceived as an old-fashioned metal, something peculiar and uncommon. Whatever the precise origin of this tradition, Zosimus's text clearly reflects common beliefs in the protective and talismanic power of electrum. Such a notion could ultimately depend on the situation just outlined: it was the perceived antiquity of the metal and its rarity that made it special.[42] It seems to me, then, that, while losing its place as a coinage material, the metal retained a degree of prestige in certain contexts.

The second episode recounted by Zosimus is a natural continuation of these premises. The alchemist describes the making of seven special bottles—the same number as the planets—meant to act against demons, fashioned by Solomon from electrum and inscribed with a special formula.[43] This tradition, as Zosimus specifies, came from Jerusalem, and the technical term used to describe them was originally Hebrew. As will be explained more fully in the next chapter, all of this seems to imply a tradition of talismanic vessels used against demons, well established among the Jews or, perhaps more accurately, coming from Jerusalem. At first sight, the most paradigmatic parallel that comes to mind is that of the so-called magic bowls, inscribed both in Hebrew and in Aramaic and often directly associated with King Solomon and his demon-repelling powers. Nevertheless, surviving examples are made of clay, not metal, and are always bowls.[44] Magic bottles are not so attested, as far as I am aware.[45]

The Syriac term employed by the alchemist to indicate the bottle is *qwl'* (sing. *qūlō*, pl. *qūle*), which literally denotes a "pitcher, an ewer, a cruse"[46] or a "*hydria, lagena.*"[47] Zosimus also states that the high priests in Jerusalem had always taken ("myablīn") these bottles, according to Scripture ("b-meltō pšīṭṭō"), from the inferior abyss ("thūmō") of Jerusalem.

According to Jewish tradition, the Temple of Jerusalem was founded on such an abyss (*tehom* in Hebrew) and represented a sacred lid over the primordial waters of chaos that arose at the deluge. During the festival of Sukkot, the priests had to draw water with a golden pitcher and make a libation on the altar, probably as a rain and fertility ritual.[48] This dense theological situation mirrored a factual reality: as we will see in the next chapter, Jerusalem does stand on hollowed-out ground, under which runs subterranean water.

Despite there being no direct connection between the Sukkot ritual and the demons, it is not impossible that such an idea developed at a later stage. It is to be noted that the *tehom*, in the first centuries of the Christian era, was considered to be the dwelling place of demons (Luke 8:31, Rev. 17:4) and that the Testimony of Truth, a second/third-century Gnostic text found at Nag Hammadi in Egypt, reports a trace of a tradition that seems to represent the missing link between the Sukkot tradition and Zosimus's account, describing "seven waterpots" containing demons imprisoned by Solomon and abandoned in the Temple of Jerusalem.[49]

All this holds a certain relevance since, as we saw above, a sixth-century source states that in Jerusalem, not far from where the ring was kept, were also twelve containers in which demons had been sealed up by Solomon. Despite a few differences,[50] it seems possible that the combined mentions of electrum as a Solomonic material and of the vessels for evil spirits in Jerusalem, recorded by pilgrims, were somehow connected to the magic practices described by Zosimus and by the Testimony of Truth before him. Maybe, when the Christians began to stage baptism rituals, they incorporated a more ancient Jewish tradition, linked to the power embedded in the chthonian waters of the city, and visually repeated the custom of drawing water with special pitchers, progressively altered in favor of a narrative concerning demons.

Behind the staging of the ring in Jerusalem, therefore, we have indisputable traces of a tradition connecting the king of Israel with the amuletic and alchemical powers of electrum, which in turn could be associated with pagan figures like Alexander and which furthermore appeared inextricably linked to a ritual of recognized Jewish provenance. The Christian signet ring of Solomon, then, was not only a highly revered piece but also a densely charged item, which needs to be understood as an object set at the intersection of various cultural and historical threads, whose subdued glow could recall Christ's

double nature but could also emanate from the divine light of the biblical God
or represent the last pale ray of Jupiter's ancient glare.

The Ring in Islamic Sources

After the conquest of Jerusalem by the Sasanians in 614, no more is heard of the
Solomonic ring or of the other relics kept in the Basilica.[51] Pilgrimages are sud-
denly interrupted by historical events, and the ring never resurfaces in Chris-
tian sources afterward. However, it appears later on in Arabic texts, where it
represents one of the most recognized emblems of Solomon's kingship. This
object, as we will see, differs in physical appearance from that described in the
previous section, which would suggest that the electrum ring seen by Christian
pilgrims left no lasting or direct impression on the Islamic tradition. The Mus-
lims conquered Jerusalem in 638, and the memory of the Solomonic relic could
easily have been effaced by the traumatic destiny of the city.

The ring is never openly mentioned in the Qurʾān. However, sura 38:34 bears
a trace of a tradition according to which Solomon possessed a signet ring,
which he lost owing to a mysterious "sin." This loss caused an interruption in
his reign and his partial exile, with consequences and details that vary accord-
ing to the version reported. The story, which is only hinted at in the Scriptures,
was well known and discussed by Muslim commentators[52] and paralleled in
Jewish midrashim,[53] since most elements already circulated during late antiq-
uity and even before.[54]

Despite its elusive presence in the Scriptures, however, the ring plays a
prominent role in the episodes regarding the life of the prophet Sulaymān
handed down in those narrative traditions, known as *Tales* or *Lives of the
Prophets* (*Qiṣaṣ al-anbiyāʾ*), which tied into the information provided by the
Scriptures' folkloric and anecdotal material, often derived from midrashic
accounts and filtered through Jewish sources.[55]

The word used for the ring in Arabic is usually *khātam* or *khātim*, which
indicates in a technical sense the signet ring and parallels the Hebrew *kho-
tam*.[56] One of the earliest descriptions of it can be found in the *Kitāb al-Taʾrīkh*
by ʿAbd al-Malik ibn Ḥabīb (709–835), who reports that Solomon's *khātim* was
made of sapphire of the strongest white silver and its luster was like lightning
("kān min yāqūta ʿashadd baīḍāan min al-fiḍḍa wa-lamaʾnhu mithal al-barq
al-khāṭif").[57]

The most detailed written source concerning the ring in the Islamic world,
however, is the work of al-Kisāʾī (eleventh–twelfth centuries), which ties together
various traditions. In an account that closely parallels that in the Testament of

Solomon,[58] al-Kisāʾī says that it once belonged to Adam and was brought down from heaven by an angel and given to Solomon, who had prayed for wisdom. The writer describes it. On each of its sides ("jānib") is an inscription, which he reports,[59] explaining its specific power in relation to four different categories of creatures: shayṭāns; animals of deserts and seas; kings of the earth, to the east and to the west; and trees, plants, mountains, and seas.[60] In other words, the ring can exert its power over the entire creation, here presented synthetically as vegetal, animal, human, and demonic worlds. Such an idea is already partially implied in the early pseudepigraphic tradition related to Solomon. The Testament of Solomon, as seen above, offers a full catalogue of demons, all subjected to him, thus establishing and giving credit to a branch of this tradition. Similarly, in the Bible itself we can find the textual background instituting Solomon's relationship and control over all aspects of creation, of which, the Scriptures say, he knew most secrets (1 Kgs. 4:31–33).

Despite the detailed description provided by al-Kisāʾī, the actual appearance of such a powerful device remains somewhat elusive.[61] Al-Kisāʾī, in fact, resorts mostly to metaphorical language to show that he is dealing with an inhuman object, coming from heaven and really not directly comparable to anything on earth. So we learn that the *khātam* glows like the "kawkab al-durrī" (the shining star or pearly star)—a well-established topos in the Islamic world[62]—and its brilliance blinds the human gaze, but he never openly mentions any precious stone, although such a glow could have implied it. He also says that it is perfumed like musk, the distinctive fragrance of the Muslim paradise (Qurʾān 83:25–26) and a feature not unheard of in the Islamic world in connection with rings.[63] Even the inscriptions on the ring have a sort of dematerialized quality, since they are written without the use of a quill ("bi-ghayr qalamin"). It seems clear, then, that the words on the ring are the fruit of godly intervention, because they can be read even though they were not physically engraved on it. Such a lack of detail will give rise, within the Islamic tradition, to various interpretations of how the seal was inscribed, prompting the creation of different typologies of magical Solomonic paper seals.[64]

The most striking feature of this early description of the object, therefore, lies precisely in this ethereal essence, this lack of a distinct or recognizable physicality, which ends up defining it as strictly divine. Allah operates and exerts his power through something whose matter cannot be singled out or described. In this sense, this early account is close to that handed down by Jewish sources. In the Babylonian Talmud (Gittin 68b), in fact, the only physical feature reported about the Solomonic ring is that it was engraved with the name of God; the compiler of the text did not seem interested in evoking any other specific detail. What mattered, in both cases, was really the

ineffable quality of the letters and of the inscriptions—an unsurprising feature,[65] considering that the mystic power of the alphabet, the strength of scriptural quotations, and the evocation of God's names and attributes play a key role in all the magical and apotropaic practices of the Semitic peoples.[66]

Even though these early accounts focus more on the importance of the message inscribed on the ring than on the symbolic significance of its constituting material, some of the details in al-Kisā'ī's description seem to bear an indirect trace of a quite tangible historical tradition. I am referring to the custom, made known to the Arabs through Sasanian courtly practices and successively appropriated by 'Abbāsid caliphs, of differentiating the seals of the ruling sovereign in relation to the destination of the message. It is known that the 'Abbāsid bureaucracy, in perfect continuity with Sasanian practices, employed signet rings that varied in terms of gems and shape according to the final recipient of the document.[67] As al-Mas'ūdī relates, Khosrow I had a seal for the revenue department, a red hyacinth engraved with the word "justice"; for the estates department, a turquoise engraved with the word "development"; for the council, a blue hyacinth inscribed with the word "deliberation"; and for the postal service, a red hyacinth engraved with the word "equity."[68]

In my opinion, the idea of imagining an all-encompassing ring of majesty, the four sides of which could exert different authority on all levels of creation, could be a symbolic echo of this chancellery tradition. Despite its immaterial, divine quality, then, the Solomonic ring could be indirectly compared to the official signet ring of the rulers of the time, whose power over men and lands could thus be implicitly reinforced, although an echo of a more antiquarian approach could also be suggested.[69]

Given the premises of immateriality mentioned above, it is interesting that an often-reported tradition states that the Islamic ring of Solomon was made of two metals, each of which could exert its power on a different type of creature: iron on evil spirits, copper on good ones.[70] The source for this statement seems to be a passage in Edward Lane's renowned description of Egypt. Lane, however, does not make any direct reference to a specific written source and appears to be reporting an oral tradition, possibly drawn from hearsay.[71] This detail on the materiality of the ring finds no direct confirmation in Arabic classic literature, that is, in the principal collections regarding the lives of the prophets. However, it is not entirely a late invention but seems to be based on the evolution of an element reported as early as the tenth century.

Already in the *Baḥr al-'ulūm*, a Quranic commentary compiled by Abū al-Layth al-Samarqandī (944–83), in reference to Qur'ān 27:27–30, a passage describing how Solomon entrusts an ant with a letter for the queen of Sheba, the writer reports the importance of the seal for an authoritative message. He

explicitly affirms that whenever Solomon wrote to shayṭāns, he sealed the letter with iron; writing to jinn, he used *ṣufr* (which could be translated as "brass," "copper," or even "gold"); for men, he used clay; and for kings, silver.[72]

A trace of the same tradition, although briefer and not identical, is reported in a slightly later source, the *tafsīr* by al-Thaʿlabī (d. 1035), which, given its fame, is probably the ultimate source for the later and broader diffusion of this description.[73] Al-Thaʿlabī states, "Then Solomon imprinted his signet on a seal. For the devils, he used to impress his seal on brass, while for the other jinn he would do so on iron. When he impressed his seal, it flashed like dazzling lightning and by Divine decree no jinni or devil could see it and not obey him."[74]

It is probably this text that most shaped the opposition jinn/shayṭāns and their respective correspondence with metals. We have further traces of this tradition. During the twelfth century, for instance, the encyclopedic work by Ibn ʿAsākir registers such a detail, further enriching the ring description.[75] The tradition on which he draws seems quite similar to that of al-Thaʿlabī, since the two metals used for the seal impression are *ḥadid* (iron) and *nuḥās* (copper/brass) and not *ḥadid* and *ṣufr*, as in al-Samarqandī. However, Ibn ʿAsākir adds one further detail, saying that the ring was also *fixed* with copper and iron, the verb used being *irsakh*, from the root *r-s-kh* ("establish," "fix," "embed," "plant," "stabilize," etc.), thus possibly referring to the bezel.

It seems clear, therefore, that in a process of progressive modification, the idea of a ring made of two metals gained popularity and, even without a precise parallel in classical literature, became part of a widespread, mostly oral tradition.[76] Despite constituting elements being different than in earlier traditions, it is interesting to investigate the symbolic implications of these metals with respect to the medium on which the seal was impressed, which, as seen, was an element of interest in the tenth and eleventh centuries. The choice of clay/silver with respect to men/kings can be easily explained in terms of the quality of the materials (humble for normal people, noble for sovereigns) and corresponds with current practices, since silver or even golden bullae are attested in diplomatic exchanges.[77] But the idea of sending a message to spirits or demons through metal is no less likely, since magic practices in antiquity, widespread across the Mediterranean area and used particularly by, among others, the Jews, required that the spell or incantation had to be incised on a metal sheet (usually lead, copper, silver, or even gold) and often "sealed" with special signs, which bound the demons.[78] The description of the Solomonic ring, therefore, mirrors quite closely magic rituals in use and superimposes on them the functions of a royal signet.

The distinction between the metals used for jinn and for shayṭāns requires further explanation. This analysis, however, is made difficult by the complexity

of Arabic metallurgic terminology, particularly when it comes to the term "brass/copper." For instance, while al-Samarqandī uses the term ṣufr, al-Thaʿlabī uses nuḥās, which the English translation quoted above translates "brass" but which could also mean "copper."[79] The ancient metallurgic lexicon in Arabic is characterized by a strong and persistent ambiguity, since a single word could be used to indicate different materials or alloys, and despite the great expertise in metalworking typical of the Islamic world, there was often little precision in describing the actual components.[80]

A term that is often translated "copper" and strongly resonates with Solomonic implications is qiṭr. The Quranic passage (34:12) reporting how the jinn built for Solomon a fountain of liquid copper ("ʿayn al-qiṭr"), probably echoing the biblical reference to the "sea of molten brass" (1 Kgs. 7:23–26 or 2 Chr. 4:2–5), exemplifies this point. Although the Quranic word employed in the passage is qiṭr, early commentators on the Qurʾān and various lexicographers (such as al-Bayḍāwī, d. 1286, or ibn-Manẓūr, 1232–1311) established a correspondence between qiṭr and nuḥās, a word that is indifferently translated as "brass" or "copper."[81]

Nuḥās, in turn, was also a metal associated with Solomon, as the pervasive overtones in "The City of Brass" (Madīnat al-nuḥās) demonstrate.[82] The tale, collected in the Arabian Nights, concerns an expedition dedicated to recovering the vessels in which Solomon had sealed the jinn, defined in the text as "qamāqim min al-nuhās."[83] Are these qamāqim the last link of a translation chain that began with the magical electrum bottles described by Zosimus? Considering that the original, oral nucleus of the tale was particularly widespread in Maghreb and that Zosimus attests the presence of these bottles also in Egypt, such a hypothesis seems not unlikely. However, the manuscript tradition of the Arabian Nights is fairly late and does not allow too precise a comparison.[84]

Metal Power

Let us go back to the Islamic ring. Given the pervasive terminological ambiguity and the frequent association of Solomon with the world of metallurgy, it is not easy to determine whether the discrepancy between the metals reported by various authors with respect to seals and the material over which they were impressed, and the subsequent confusion resulting from different English translations of these terms implies a substantial unity of vision or a nuanced interpretation. Thus, the search for meaningful parallel textual traditions that could illuminate this metallurgic symbolism cannot be based

on a strict terminological identity, since some of these terms could be used synonymously. In the following paragraphs, therefore, I will list some examples that will help broaden our understanding of the constellations of meaning attributed to various metals in certain circumstances. Far from settling the matter once and for all, however, these may complicate the frame of reference.

First of all, it is important to establish that in all these descriptions, jinn and shaytāns are mentioned in opposition to each other, as positive against negative forces, obedient versus rebellious creatures, despite the fact that traditionally such a distinction is not always so clear-cut or easily drawn.[85] The two metals, therefore, seem to have been chosen accordingly: iron as something strong enough to counteract evil powers, copper/brass as something apt for more benign recipients. Behind this assertion probably lay the same long-standing alchemical conception of electrum, which probably spread through the Arabic world through Greek science. The seven standard metals (gold, silver, copper, tin, lead, iron, and mercury) were directly associated with the planets and their influences. Iron was, not surprisingly, the metal of Mars, given its highly military potential, while copper (nuḥās here) had long been associated with Venus and was thought to have more benign effects.[86] The choice of the union of these two opposed metals may thus have ultimately depended on this planetary symbolism.

A ḥadīth attributed to the Prophet Muhammad specifically concerns the material from which signet rings had to be fashioned.[87] The Prophet criticized a man for wearing a signet ring of yellow copper (shabah), which was considered "the adornment of the inhabitants of hell." Muhammad recommended making it of silver instead, and using a very small quantity. According to this tradition, allegedly reported by one of the companions of the Prophet and handed down by the authoritative collection just quoted, by the end of the ninth century neither iron nor copper was considered proper for fashioning a signet ring. In the words of Muhammad, the former was connected to idolatry, while the latter evoked hell. The reference to yellow copper seems to have nothing to do with the Solomonic copper seen above. Muhammad's criticism of it possibly derived from its apparent similarity to gold, which was considered utterly inappropriate and excessive; this could explain the reference to idolatry.

The reference to iron seems more pertinent to our case. I think it can be seen as suggesting the chains confining those residing in hell. Iron is seen here in its capacity of constraining evil powers; the "adornment of the inhabitants of hell" could be a contemptuous and sarcastic remark toward those beings who wear iron for their faults, possibly a direct echo of a scriptural passage (Qur'ān 22:19–22).

Moreover, in the Islamic world to this day, iron is endowed with a strong power against jinn (meant, in this case, as negative forces),[88] as seen in various areas of the Maghreb.[89] In this, medieval Muslim society is similar to many others that, in far removed chronological and geographical contexts, also relied on the apotropaic effects of iron.[90] Such a system of beliefs, in fact, seems to lie at the core of the evolution of human society in general, as recent anthropological research has emphasized, showing, for example, how the origin of the tale "The Smith and the Devil"—whose original nucleus is common to all the peoples of the Indo-European language family—goes back to the Bronze Age.[91] In the tale, the protagonist strikes a deal with the devil, who, in exchange for his soul, makes him capable of welding materials together. However, thanks to this new set of abilities, the man is able to entrap and enchain the devil himself, preventing him from collecting his debt. This set of ideas clearly had much to do with the discovery and mastery of certain metalworking techniques and their role in the establishment of political, military, and economical supremacy.[92] Iron, therefore, for reasons that are rooted not only in history but in the anthropological development of most human societies, is seen as the most suitable material to keep away evil forces, and it could certainly grant the possessor of the ring the desired effect.

A second interesting passage, which seems to be a direct echo of the one just mentioned, is to be found in al-Ṭabarī's chronicles. The historian tells that the Prophet, wanting to write to other sovereigns, was advised to use a personal signet ring if he wanted them to respect him. He had one made of iron, but the Archangel Gabriel ordered him to take it away. The second was copper, but again Gabriel ordered its removal. The third was silver, which the angel finally found acceptable.[93] This episode, which is almost a narrative enactment of the principles contained in the ḥadīth discussed above, and which is certainly connected to the same ideological tradition, uses, however, the term nuḥās, not shabah, thus demonstrating, once again, that terminological precision is not to be expected.

If the properties of certain metals could be considered inappropriate as the personal symbol of a righteous man, their special allure could hold a different meaning in other circumstances. To a Muslim audience, the connection between these two metals could have further textual implications and a distinct scriptural resonance. In the Qur'ān, 18:94–97, Alexander the Great constructs a barrier between two mountains in order to keep away Gog and Magog, who, although human and not supernatural beings like jinn or shayṭāns, nonetheless represented the ultimate eschatological enemy.[94] The sacred text describes this wall as made of iron coated with copper (qiṭr this time) and specifies that it would allow nobody to pass. It seems safe to conclude that the

combined mention of these two elements would have immediately evoked, to any Muslim audience, a sense of inviolable protection and defense.

There seem to be traces, therefore, that show how, in order to better exemplify the original idea of a ring extending its power over multiple creatures or contexts, the object could be imagined either as having four sides, and successively four stones, or as imprinting on different materials but also, over time, as having been made from those very same materials. These small differences are not evident in the written accounts, but they have left a mark in the long-lasting tradition regarding the ring, and they probably reflect actual usage in diversifying the signet depending on the recipient of the message.

Unsurprisingly, the Islamic ring of Solomon mirrors well-known practices of talisman making in late antiquity. As a magical object, like the Christian one, it is no different from the normal instruments of magicians or exorcists of the time, but it represents a perfect synthesis of recognizable features, combining the characteristics of a regal signet.

A Note on Animal Language

Before concluding, I would like to touch on a final aspect of the powers attributed to the object and, in particular, its role with respect to animal language, which, as noted at the beginning of this chapter, is now considered its most distinctive feature.[95] Because of the different chronological phases in which the signet was imagined and depending on the tradition into which it ended up being incorporated, some major differences can be seen in the role played by the ring in the broader narrative context surrounding King Solomon.

As we have seen, the ring is a postbiblical creation, but evidence of its existence predates the Qur'ān and several rabbinic commentaries. Whereas in the Christian world it appeared as a physical embodiment and as a response to specific ritual and liturgical necessities, and thus ceased to exist once these were no longer pressing concerns, the idea behind it was already in existence before Islam was a religion; therefore, various narrative traditions regarding notable rings of antiquity had time to coalesce and stratify, incorporating accretions of different cultural provenance. This possibly explains why the Christian ring is represented by limited occurrences, whereas the Muslim one is enriched by several narrative elements, woven together into more complex episodes of religious relevance. I refer here to the episode, often mentioned by Muslim authors and partially evoked by the Qur'ān itself, of the loss and recovery of the signet of Solomon in the belly of a fish. The narrative is shaped mostly along the lines of Polycrates's story, reported by Herodotus (484–25 BCE), of

how the tyrant of Samos (r. 538–22 BCE) threw his ring into the sea and miraculously recovered it a few days later in the entrails of a fish that was offered to him.[96]

For insight into the most imaginative details of the signet story, therefore, it is to the rich body of textual variants surrounding the Islamic and Jewish ring that we should turn. Interestingly, in this corpus nothing is said of a direct connection between the ring and animal language. The metamorphosis was probably caused by the superimposition of different factors. In the first place, the question likely depended on an erroneous reading of the following biblical passage: "He would speak of trees, from the cedar that is in the Lebanon to the hyssop that grows in the wall; he would speak of animals, and birds, and reptiles, and fish" (1 Kgs. 4:33).[97] In rabbinical exegesis, Solomon did not speak about animals and birds, but *to* them (Midrash Song of Songs 1:9), an idea circulating previously in the so-called Syriac Apocalypse of Baruch (77:25).[98]

This idea finds direct parallels in the Qur'ān, where Solomon is explicitly engaged in dialogue with an ant (27:18–19) and with a hoopoe (27:20–35). These passages prompted a rich body of exegesis aimed at clarifying what kinds of creatures he could understand and speak to, as well as what exactly language was and what kind of rationality it implied, considering that, by his own admission, Solomon had been taught the language of birds ("manṭiq al-ṭāiri"), as in Qur'ān 27:16.[99]

We find mentions of this exceptional talent also in the collection of epistles written by the Brethren of Purity, a circle of Muslim philosophers probably active in Iraq around the tenth century, who referred to a broad variety of different religious and textual sources in their writings. According to their version, the king had been granted his talent directly by God.[100]

Neither in Islamic nor in Jewish texts, however, whether scriptural, philosophical, or exegetical, is a parallel or direct connection between the ring and Solomon's understanding of animal language ever made. Such a connection, one could argue, is the last link of a long chain ultimately deriving from the notion, explicit since the Testament of Solomon (6.5, 12.4), that the ring gave the king power over demons, some of which, like Ephippas, appeared in the form of winds. In the Islamic tradition, in fact, jinn often take the form of airy spirits (Qur'ān 21:81; 34:12), and they were controlled by the ring, as we have seen. Considering that birds and jinn in the form of winds could all be perceived as airy spirits, it is possible that the power of the ring became extended beyond its original feature, finally encompassing the animal world. However, this explanation appears pointlessly complicated.

More simply, one could imagine that, since each of the signet's sides, as we saw above in al-Kisā'ī's description, could command a specific segment of creation,

including beasts and birds, the giving of such a command implied a sort of communication between the sovereign and his subjects.[101] Whereas the superimposition of these threads may have contributed to the development of the tradition as we know it, it should be emphasized that the legend mentioned by Konrad Lorenz must be the product of a late elaboration that finds no direct textual support in most classical and medieval sources.

Conclusions

Despite the transformation of the ring of Solomon over time from an exorcism device into a tool for universal translation, and the diverging aspects peculiar to each religious tradition, the sources analyzed show a subterranean continuity. While the electrum ring of Christian sources may seem to have nothing to do with the glowing but immaterial object of Islamic ones, on closer inspection, one cannot consider the ring without the medium on which it is called to impress its mark, be it vases, bottles, or metal sheets. And here one can better perceive the traces of at least one possible shared nucleus, developing around the intrinsic power of certain metals, particularly along the trajectory *ḥashmal—electrum—nuḥās*. This trajectory, tentatively suggested here, was, if originally extant, lost in successive waves of translation.

3

BOTTLES FOR THE DEMONS

Ipse etiam quandoque fui servire coactus
germano cuidam, crystalli in corpore clausus
sed me barbatus tandem fraterculus illis
exemit vinclis, et fracto carcere fugi.

—Marcellus Palingenius Stellatus, *Zodiacus Vitae*

In the final scene of *I Married a Witch* (1942), a romantic comedy directed by
René Clair, Veronica Lake—the witch of the title—lures the spirit of her father,
the wizard Daniel, into a whiskey bottle and corks him inside. Daniel, who up
until then had strongly opposed his daughter's marriage to a mortal man on
whom he had sworn eternal vengeance, can do nothing but resign himself to
spending the rest of his days drunk and harmless inside the container. The
final twist of the story represents, in a humorous key, the final link in a long-
established chain of tropes featuring demons entrapped in various containers,
such as flasks, bottles, phials, decanters, or even lamps.

This chapter is a sort of complement to the story of the electrum containers
discussed above. Although there are several points of intersection, this seg-
ment of the tradition has enjoyed a quite independent development.

The motif is widespread enough to feature in the Aarne-Thompson motif-
index of folktales: the spirit in the bottle (no. 331),[1] the most popular example of
which is probably the Brothers Grimm's "Der Geist im Glas."[2] It has inspired
various literary works outside the domain of oral or anonymous tradition, such
as Robert Louis Stevenson's "The Bottle Imp" (1891) and André-Réné Lesage's *Le
Diable boiteaux* (1707), which in its turn was partly based on the Spanish work
El Diablo cojuelo (1641) by Luis Vélez de Guevara.[3] Folklorists note that the motif
is first documented in Europe in the Middle Ages, having an Oriental origin
(Jewish and Arabian).[4] As I will show, this latter point is not entirely accurate.

Fig. 3 Devil's buoy employed for Magiotti's
experiment, reproduced in Athanasius Kircher, *Magnes,*
sive de arte magnetica (Rome: Vitalis Mascardi, 1654).

Most of these stories could be inscribed in the larger theme of the covenant
with the devil, since, despite many variations, the imprisoned spirit tends to
grant wishes or to favor its possessor, until something else occurs and the
protagonist finds himself at the devil's mercy, following the well-established
Faust topos. What I am mostly interested in here, however, is the relationship
between the demon and its receptacle, a theme that partially emerged in con-
nection with Solomon's power to constrain demons.

Interestingly, bottles *et similia*, after enjoying a particularly enduring rela-
tionship with evil spirits, seem to have acquired some of their special traits.
This familiarity is reflected, in some languages, in the names of various con-
tainers that, for different reasons, are endowed with peculiar features. Such is

the case, for instance, with the so-called Cartesian diver, or "Diavoletto di Cartesio"[5] (i.e., Cartesian devil), a small buoy, often made in the shape of a devil, which alternatively floats and sinks in a bottle used to measure the pressure of liquids, described during an experiment in 1648 by Raffaello Magiotti, who invented it.[6] The iconography of the devil in relation to the experiment was apparently introduced by Athanasius Kircher in 1654.[7]

Similarly, most amateur magicians know the trick called the "devil's flask" or the "devil's bottle" (originally "Bologna bottle"), performed with a special container made using a peculiar heating process. Almost unbreakable from the outside, but extremely fragile on the inside, the bottle can be struck forcefully without shattering or destroyed with a very gentle touch, depending on where it is hit.[8]

It is also well known that certain mediums used bottles filled with phosphorus during séances to produce a peculiar glow thanks to the chemical reaction caused by air once the bottles were uncorked,[9] and that such bottles were used for magic effects.[10] Finally, it should not be forgotten that in modern times the evocation or depiction of the devil on a bottle is frequently chosen for commercial reasons, to promote the sale of alcohol.[11]

The analysis I propose here, therefore, begins with a reconstruction of some notable examples of this line of interest, through which I aim to demonstrate that the cliché of the demon in the bottle does not represent the mere visualization of a standard wizardry tool; I am convinced that originally there was a deeper and more archaic concern at play, springing from the desire to control natural forces, particularly winds, which were entrapped in leather bags, but that, at a certain moment, this idea mingled in the Western tradition with the more recent habit of associating solid vessels and evil spirits, which developed mostly from the end of the first century CE onward.

My investigation follows a long arc of centuries, beginning in modern times and proceeding backward through history. For the first part of my analysis, and in consideration of the abundance of material at my disposal, I have chosen to follow the apparition of demons in bottles mostly in the literature and history of the Italian Peninsula,[12] where they seem to have been especially popular, as indirectly attested by the expression *avere il diavolo nell'ampolla* (literally "to have the devil in the flask"). While not much in use anymore, it is registered by paremiology and lexicography on the basis of textual occurrences going back at least to the fourteenth century, that is, almost to the origin of the Italian vernacular language itself.[13]

I will then try to show how this topos penetrated European culture in the course of the Middle Ages through magic and legendary traditions widespread in the Mediterranean area. Although the single elements had been known since

ancient times, they crystallized in the form better known today and enjoyed broad circulation, first thanks to the association with the figure of Virgil as a necromancer, but ultimately through the mediation of King Solomon, who, from late antiquity onward, was strongly associated with the domain of demonology.

"Avere il diavolo nell'ampolla"

The *Vocabolario della Crusca* explains the proverbial expression *avere il diavolo nell'ampolla* as describing someone who is hard to fool, being endowed with sagacity and perspicacity, capable of foreseeing the consequences of actions. Such a notion depended on the belief that necromancers, who were often credited with the possession of containers full of certain devils, could obtain from them knowledge of things to come.

We owe to Adolfo Albertazzi (1865–1924), a writer, teacher, and scholar belonging to the circle of Carducci in Bologna, one of the latest incarnations of such a tool. His 1918 short story "Il diavolo nell'ampolla" (translated as "The Devil in the Decanter"), which appeared in a collection by the same title,[14] is a humorous tale about a mischievous and stubborn demon that ends up being entrapped by chance in the water decanter of a lawyer who, from that day on, never loses a case.[15] After a lifetime of illicit profits, however, the lawyer repents and leaves the decanter, with its dangerous content, to a venerable friar, hoping that he might be able to dispose of the evil spirit without any harm. In an ironic twist, however, the friar himself ends up being possessed after breaking the decanter for not-so-pious reasons. After all sorts of exorcisms are attempted, to no avail, the demon is eventually forced to make a hasty and definitive escape owing to the soporific effects of a learned lecture, given by a celebrated German scholar visiting the convent, on the history of comparative demonology from late antiquity onward. Excessive erudition, Albertazzi seems to warn us, is worse than any black magic.

One reason Albertazzi chose these elements for his tale was that the flask with its demon had come to be considered a distinctive tool of wizards and necromancers, turning into a recognizable iconographical feature, as in a painting by Pier Dandini.[16] At some level the popularity of such an idea, at least visually, may also have been reinforced by the strong formal similarity to the alembic in which alchemists staged various transformation processes and in which they aimed at creating the *homunculus*, which was represented as a small creature closed in a vessel. The theme was made famous through the writings attributed to Paracelsus, and eventually through Goethe's *Faust*, but had already been in subterranean circulation for several centuries.[17] However,

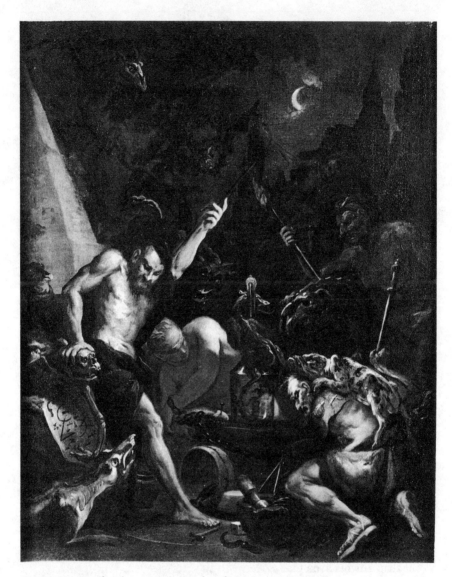

Fig. 4 Pier Dandini (1646–1712), *Witchcraft*, ca. 1700. Private collection, Florence. Photo © Sandro Bellesi.

despite the possibility of visual and cultural intersection between these themes, the story of the demon in the bottle, as I will show, probably grew and developed independently.

Such stories had not always been material for a good joke; on the contrary, they could be the cause of some serious allegations, as the case of the poet Alessandro Tassoni (1565–1635) demonstrates. The celebrated author of *La Secchia Rapita* (The Stolen Bucket), a mock-heroic poem published in 1622, was accused

of having a flask complete with a demon. The event is well documented, and it has recently been reconstructed in detail through archival sources.[18] We have an account of the episode in Tassoni's own hand, in a three-page letter dated February 9, 1602, addressed to the vicar of the Inquisition of Modena but possibly never sent. In the letter, Tassoni describes all the facts, declares his innocence, and explains how the absurd accusation took shape. Entrusted with the legacy of the late Girolamo Poliziano, he had found among Poliziano's possessions a glass ball with a glass demon inside. He explained that such objects were produced in Murano and could contain all sorts of figures, such as oxen, donkeys, or a Zanni, one of the typical characters of Venetian popular theater, and were exported around the country. The ball had probably been acquired through a certain Bastaglia, who was known for such commerce. It had been the object of some laughter among the poet and the maidservants, who joked that the deceased kept a demon in a flask. The rumor that Tassoni had subsequently taken possession of it had begun to spread, since the item was never included in the inventories. Tassoni, for his part, declared that he had given it to a child for his amusement and had lost trace of it.[19]

If the Tassoni episode, oscillating between ignorance, misunderstanding, and defamation, appears amusing to our eyes, its consequences might have been very serious indeed. In the *Sacro Arsenale, ouero Prattica dell'officio della Santa Inquisizione*, the earliest practical handbook for inquisitorial officers in the vernacular, the first definition of "maghi, streghe, incantatori e simili" (wizards, witches, bewitchers, etc.) concerned precisely those who imprisoned demons in rings, mirrors, medals, bottles, and other things;[20] a very similar description occurs in the exorcism handbook written by the Observant friar Girolamo Menghi in 1586,[21] whose very phrasing seems drawn directly from the condemnation of people adoring demons in vessels in the papal bull *Coeli et terrae creator Deus*, issued by Sixtus V a year before and almost immediately translated into Italian.[22]

Unsurprisingly, given this scenario, in the century and a half preceding the Tassoni incident, and in parallel with these publications, several trials were held in the area of Modena against people who were accused of having a *sfera vitria* or a *balla vitria* containing a demon.[23] Suspicion toward bottles and their dangerous contents was extremely widespread, probably as much as the habit of owning one. Various sources underline how this was popular both among common people—particularly credulous women, who were prone to mistaking an innocuous toy for a sinister magic tool—and among more learned figures.[24]

The question was a matter of some debate: Francesco Diacceto (1531–1595), for instance, in his *Sopra la superstizione dell'arte magica* (1568), dedicates a lengthy passage to a detailed demonstration of how, in rational, philosophical,

and theological terms, it was not possible for an incorporeal spirit to be imprisoned within physical boundaries, unless a superior agency was involved. Thus, according to this view, the bottle, as a repository, was considered almost fortuitous and not especially binding.[25]

The custom was accepted and in common use in the courts. In a 1495 letter to Duke Ercole d'Este, the court astronomer of Ferrara, Giovan Maria de Albricis, describes to his prince a series of events to come related to the passage of a specific constellation, allegedly revealed to him by certain spirits that he kept enclosed in small flask.[26]

The topos of the necromancer with such an object seems to have crystallized by the fourteenth century, as demonstrated by a poem by Franco Sacchetti dedicated to all sorts of magic practices.[27] Traces of this idea are clearly attested in an anonymous description of the battle of Montaperti (1260), probably a fourteenth-century interpolation. According to the compiler of the account, the *condottiero* of the Florentine troops had been foretold his death in the battle by a demon kept in the familiar container.[28]

The story of the demon and its vessel generally seems to oscillate between two poles: the danger of damnation and the harmlessness of a joke. It does not seem a coincidence that the theme is mentioned either in comic texts, by authors who make it the target of laughter, irony, or ridicule,[29] or in trial documents and spiritual handbooks, written, as we have seen, by those in charge of the salvation of souls. What appears to be condemned, in this latter case, is always belief in the object, not the effectiveness of the thing in itself, which is usually doubted when not explicitly denied.

Moreover, in several cases the vessel is included in lists also containing mirrors, apparently implying that it was equated or confused with a genre of divination known as "scrying," which was based on the reading of polished surfaces, such as blades, glass, fingernails, and stones, but also water reflected in translucent containers.[30] An erudite note by Paolo Minucci to the *Malmantile* by Lorenzo Lippi seems to confirm that, at least in certain instances, this was the idea behind the bottle.[31]

According to these methods, one could predict the future thanks to the indistinct and vague images perceived on the object. It is not difficult to see how the idea of a vessel containing a liquid could be included in this category. However, despite this association, the bottle containing the demon seems to differ slightly in various respects from the typology of divination. Even if the demon does provide answers about the future to its master, thus working as a divination method, it does so by actively responding, not by acting as a passive image requiring interpretation. The speaking demon, forced to answer to its owner because it is subject to him, performs a function similar to that of the

genie in the lamp (which formally belongs to the same category of the entrapped demon) by granting a wish, in most cases a wish for knowledge.[32]

It is important to underline this dialectic process of wishing/granting between the master and his enslaved demon, as well as the speaking dimension of such a relationship, since these are features that, as I will demonstrate, lie at the core of the original crystallization of the topos, at least in its most famous and successful form. Further research in Italian texts may yield other examples, but the selection proposed should be sufficient to show an uninterrupted continuity from the Middle Ages to recent times.

Virgil Magus and the Cumaean Sibyl

While the practice of keeping a demon in some sort of vessel is well attested, medieval handbooks of practical magic do not register it in a more precise way until quite late.[33] Nor is it included in the classification of various types of *magi* compiled by Isidore of Seville, who summarizes most practices known from classical antiquity (*Etymologiae* 8.9–35). This ostensible omission is remarkable, even bizarre. Magic, by definition, is a very conservative genre, guaranteeing faithful transmission over time. However, despite innumerable texts explaining the details of various demon-binding techniques, and the evidence above concerning vessels, there is nothing that explicitly clarifies the technical means by which a necromancer was supposed to entrap a demon in a flask, not even in the treatise on how to create and conjure a *spiritus familiaris*, which would seem to represent its closest parallel.[34] Therefore, while the topos is safely established and represents one of the most distinctive features of the wizard from the late Middle Ages and through the Renaissance, we have not many sources explaining the details of its origin. This absence is revealing in itself. It seems to suggest that the notion of a demon in a bottle has always been transmitted as a sheer trope without ritual, as the fruit of a narrative rather than a magical tradition. For this reason, I believe it is important to find a strong textual example lying at the origin of this chain and whose impact may have helped the diffusion and penetration of the idea in Western culture.

The examples I have compiled halt at the fourteenth century, at least in Italian sources. However, meaningful traces of the same tradition, predating those listed so far, can be found in previous literary traditions and constitute, in my view, a fundamental junction point of such a transmission process. Some thirteenth-century medieval romances attest that the poet Virgil, who had a postclassical reputation as a magician,[35] possessed or entrapped one or more demons in bottles, exactly as Solomon did.[36] Given Virgil's popularity during

the Middle Ages, he probably acted as a prototype for the necromancer with the enslaved demon, an idea that spread far and wide thanks to its recurring presence in the literature of various countries.

These fundamental passages, however, provide only a partial answer to our question. How and why did Virgil end up possessing such a peculiar tool? Greek and Roman literature do not abound with demons in vessels. However, there is one notable exception, and a particularly meaningful one, given the setting of the story. I refer to the episode of the Sibyl, as told by Petronius in his *Satyricon* (48.8).[37] Trimalchio, at the end of the dinner, reports that he had seen the Sibyl in Cumae imprisoned in a flask hanging from the ceiling, surrounded by children scornfully asking her what she wished, to which she replied that she only wished to die. The episode has remained famous in Western literature, inspiring writers, philosophers, and poets into the twentieth century.[38]

Considering the strong historical and literary relationship between Virgil, who had given voice to that very Sibyl in the *Aeneid*,[39] and the fact that most medieval legends surrounding the poet developed in the geographical area between Naples and Cumae, gaining strength through local reminiscences, the story of Virgil's demon, transmitted by medieval romances, could possibly represent the last metamorphosis of the entrapped Sibyl, whose story had been in circulation ever since the end of the first century and was repeated through late antiquity. However, despite this cultural and geographical proximity, it is difficult to prove this hypothesis with certainty since, as we will see below, the demon seems to have entered Virgil's legend mainly through a different channel. That, at least, is what most texts seem to imply.

The peculiar abode of the Sibyl and its possible parallel and precedents were studied by Campbell Bonner in an article published in 1937.[40] After inscribing the episode in the broader imp/bottle motif, Bonner enumerated other sources of comparison. Works that echoed or somehow paralleled the *Satyricon* episode, and could thus help explain its etiology,[41] included Pausanias's *Description of Greece* (10.12.8), Pseudo-Justin's *Cohortatio ad Graecos* (chap. 37), and Lucius Ampelius's *Liber Memorialis* (8.16), which, in different ways, between roughly the second and fourth centuries CE, attested the idea that in Cumae a vessel was preserved containing the mortal remains of the woman. These sources differ when it comes to the container, speaking of a cinerary urn, a bronze bottle, or a cage, and Bonner suggested that "it would be no great stretch of pious fancy to suggest that the voice of the seeress still spoke from her ashes, and the next step, that she was still living, a tiny atom, in an urn or a bottle, might follow readily enough."[42]

While advancing this extremely reasonable hypothesis, however, Bonner tentatively suggested that the Sibyl in the bottle could represent yet another

manifestation of the captive-demon folklore motif. He realized that the origin of the theme was much more ancient and quite widespread outside the Graeco-Roman world, noting that it could perhaps be related to the idea of the confinement of the winds in a sack, a motif that appears as early as the *Odyssey* (10.1–79), or that of Pandora's *pithos*, described by Hesiod (*Op.* 90–95), in which Zeus had shut up plagues and diseases. He also referred to the numerous examples in Arabic texts of entrapped jinn. Bonner was therefore inclined to consider the Sibyl story as the embodiment of a widespread folk motif whose actual origin was difficult to clarify, having both classical and Oriental parallels.

Bonner concluded that even if stories involving demons or evil spirits (in the form of winds and plagues) entrapped in jars could be traced back to Homer and Hesiod, and were therefore not unknown to the classical tradition, such stories were more common in the Judeo-Christian tradition, where (as seen in the previous chapter) the motif was strongly associated with Solomon, and in Arabic literature, particularly some tales from the *Arabian Nights*.[43]

Interestingly, a similar conclusion was advanced in 1872 by Domenico Comparetti, who underlined how numerous thirteenth-century accounts describing Virgil and the demons show direct traces of Solomonic magic. In all these narrations, the Solomonic channel of transmission was usually made explicit, leading him to conclude that to Virgil were attributed the features of a well-known legend "of rabbinic and Muslim origin . . . a story that appears in the *Arabian Nights*."[44]

Neither scholar insisted any further on this point or tried to better clarify the origin of the motif in these sources. Comparetti was not interested in that specific aspect: undoubtedly, traditions related via Arabic sources were one of the main sources of the magic repertoire of the Western world, and it was not surprising to find lines of tangency there. In turn, Bonner suggested that that line of research should be pursued by scholars with a better knowledge of Hebrew. However, he did tentatively posit the existence of a common ancient narrative nucleus ("such a story may once have been current") that could keep together the Eastern sources dealing with Solomon while explaining the tragic destiny of the Cumaean Sibyl.[45]

I am convinced that Bonner's thesis deserves close attention and further clarification and that some of his intuitions need to be inscribed in a more complete scenario. In the next section, I will therefore analyze the Solomonic tradition, correctly evoked by both these scholars, in order to show how and why winds, demons, and bottles came together, thus becoming, in the first stage, one of the most recognizable features of Solomon as an exorcist and, as a consequence, a successful tool of any well-respected necromancer.

Entrapping Demons in the Testament of Solomon

Solomon's demon-repelling powers are attested since the first century, but he is explicitly known for entrapping them in closed vessels or containers from the second/third centuries onward. Our main source for this is the Testament of Solomon, the famous handbook of demonology. This text, frequently discussed in terms of its textual, linguistic, and cultural origin, can be defined as a veritable catalogue of spirits, which are introduced, described by their evil deeds, and finally subjugated by Solomon by virtue of the authority given by his signet ring.

The possibility of controlling demons through such an object can be inscribed in a broader context of learned magic, functioning thanks to the recognized power of words. The exorcist/wizard establishes a relationship with the evil spirit that is no different, in a way, from that created between two contracting parties or, perhaps even more appropriately, between the law and someone called to act in compliance with it. The ring is used to impress a seal and to validate a binding contract, usually written on a metal or papyrus sheet or on any other valid medium. The demon is compelled to respect the provisions of the spell lest he be punished by a penalty that the wizard has the ability to enforce. The power of Solomon's ring lies in the essence of what it stands for: it constitutes the visual representation of a supreme agency that demons are bound to obey. Behind this kind of spell we can recognize a typology of magic with a highly structured approach, based on the recognition of a common principle of authority, which creates a sort of dialogue between the world of men and that of demons, which, although not to be trusted, are considered capable of interacting on a basis of parity and of understanding the legal implications of breaking a contract.[46]

The idea of entrapping demons in a closed space appears, by contrast, to be more intuitive and less refined than the system just described. The entire discourse is based on a preverbal framework of action. The constraints in this case are just physical, never logical or ethical. If the ultimate goal is the same— taming the evil spirit—the means through which this action is performed are very different. Here the demon is too dangerous to be dealt with; it only needs to be sealed away, entrapped, enclosed. All this appears to derive from a more primordial, archaic level of interaction with uncontrolled forces. These two approaches are both present in the Testament of Solomon and are often combined. However, I consider the fact of binding the demons through the ring and entrapping them in bottles as different manifestations (in technical terms), and such an intrinsic difference argues in favor of a distinct chronological and possibly cultural origin.

My interest, as said, lies in the relationship between the demon and the abode to which it is sometimes confined. It is therefore to this latter aspect, the entrapping, that I will now turn. Our text provides two different types of physical demon prison: a leather bag and a *phiale*, a flat water vessel usually employed for drinking. Although both methods might appear quite similar at first sight, since they are both meant to physically entrap bodiless or protean demons, respectively wind- and waterlike, I will argue that they represent the evolution of different paths, from distinct origins. In my opinion, the former is much more ancient and seems to be broadly shared by the Semitic peoples, while the second is the result of a much more specific concern, historically defined. Despite their independent genesis, their inclusion in the Testament of Solomon has contributed to flattening the original distinction. The conflation of these two motifs and their partial superimposition as similar techniques has contributed, in my view, to the final crystallization of the bottled-demon topos.

But the Testament of Solomon offers yet another element, which helps comprehend not only the entrapment of demons within containers of various kinds but also the relationship between evil forces and divination, which is one of the distinctive feature attributed to these bottles over time. The text provides an answer. In at least two cases,[47] Solomon's supernatural helpers predict the future for him. In Testament of Solomon 22:13–15, he explicitly asks by virtue of what power they are able to foresee events to come: "Then I ordered Ornias to be brought to me again and I said to him, 'Tell me how you know that the young man will die in three days.' He responded, 'We demons go up to the firmament of heaven, fly around among the stars, and hear the decisions which issue from God concerning the lives of men.'"[48]

Ephippas, Aeolus's Bag, and Wind-Taming Techniques

In chapter 22 of the Testament of Solomon, the king of Arabia asks Solomon for help in getting rid of a demon-wind harshly blowing in the region. Solomon sends a servant boy with his ring and orders him to entrap the spirit in a leather flask. That accomplished, the flask is brought to Jerusalem, where the demon, named Ephippas, is interrogated and helps Solomon lay the cornerstone of the Temple.[49]

Such an episode appears quite meaningful both because of its geographical setting and because of the technique employed for capturing the demon, which corresponds to that employed by various cultures to control winds. It does not seem a coincidence that the episode takes place in Arabia, an area where we observe a strong continuity with regard to the wind-demon motif. A few centuries after this source, in fact, the Qur'ān attests that Solomon was explicitly

given power over winds and over jinn (21:81; 34:11), an unsurprising fact considering that jinn are, again by scriptural definition, born of the fire of the scorching desert wind (15:27). There is consensus among scholars that the jinn originated in a pre-Islamic phase, and their presence is already attested in the beliefs of the Arabian tribes, as the passage in the Testament of Solomon seems to confirm.[50] The text does not dwell on this specific aspect, having an altogether different focus, but the overall setting of the scene clearly draws on a body of extant convictions rooted in Arabian lore.

The method adopted to capture the demon, enclosing it in a leather flask, has a long history and a broad diffusion, representing another motif indexed in the Aarne-Thompson list (C322). In the text, the focus of the episode is on the capture of a demon, but, originally, I think, the bag motif probably developed in connection with wind-taming techniques and should therefore be ascribed to a set of archaic practices dealing with the control of natural forces.[51] This theme has been the subject of various studies that have underlined how the custom of controlling winds, either by enclosing them in a bag or by restraining them through a series of knots,[52] or by using both methods together, is particularly widespread.[53] Certain scholars consider it a polygenetic motif, developed independently in various sailing societies worldwide,[54] whereas others have traced a partial filiation of motifs, explaining the Aeolus episode (*Odyssey* X.1–79) as deriving from practices attested in northern Europe, where a strong sailing tradition clearly accounted for the development of such a motif.[55]

It is not my intention to disentangle the intricate question of the reciprocal influences of the story in anthropological terms, but I think it is worth dwelling on the figure of Aeolus, who, like Solomon, but many centuries before, was said to rule over the winds and to have entrapped them in a bag.[56] A comparison between the Homeric episode and the Testament of Solomon passage might seem far-fetched, considering the context of compilation and their relative chronology, but an indisputable continuity of themes can be traced between these two figures, not only during late antiquity but possibly even before. The National Museum of Copenhagen and the Kelsey Museum of Archaeology of the University of Michigan, for instance, hold two magic gems to be employed against colic, whose iconography probably depends on a third-century monetary type from Syria, representing a satyr with a wine bag. The current scholarly reading, however, posits a reinterpretation of the satyr type as Aeolus, here not simply as ruler of the winds but, more likely, as a personification of a demon capable of upsetting the belly (the leather bag) with spasms (figuratively interpreted as entrapped winds).[57]

But the points of tangency between Aeolus and Solomon are not limited to a late historical phase. On closer inspection, the common elements appear not only numerous but striking, possibly reaching back to an ancient cultural stratum. To my knowledge, such a comparison has seldom been made, and the first to call attention to an embryonic parallelism was Gabriel Germain in his *Genèse de l'Odyssée* (1954).[58] Germain dedicated a long analysis to Aeolus, showing how most of the features characterizing him should be ascribed to a type of primitive king-sage or king-priest, whose main activities and powers respond to the needs of an archaic society. Germain proposed that the bag of winds, the *'askos*, corresponds to the "soufflet de forge," the forging bellows that was the main tool of the blacksmith, since, in antiquity, such an instrument was actually made from animal skin.[59] Not only is Aeolus in control of natural elements such as winds, but this ability seems to hint at his dominion over metalworking techniques as well.[60] He lives on a floating island, in a palace surrounded by bronze walls, a topos shared by various mythical figures, including Hephaestus himself, whose origin the scholar traces back to the "Orient suméro-sémitique," where the motif of the bronze wall and the dominion over winds are both to be found.[61] As supporting evidence of such a connection in Semitic culture, Germain mentions the Quranic passages referenced above that ascribe to Solomon control over winds (21:81, 34:11) and metalwork (34:12). The latter is also explicitly stated by the Bible, both in reference to the giant brass basin (1 Kgs. 7:23–26, 2 Chr. 4:2–5) and regarding in general the furnishing of the Temple interior, described extensively in the same chapters.

The leather bag–winds–metals trajectory here outlined looks utterly convincing to me, since it also helps explain the subterranean logic tying together several cultural elements ascribed to Solomon that might appear disconnected at first glance. To the examples listed by Germain can be added the nonscriptural but undoubtedly meaningful evidence of "The City of Brass," discussed in chapter 2, a mythical city described in the *Arabian Nights* that contains a series of Solomonic bottles. Not unlike Aeolus's palace, the city is surrounded by an astonishing bronze/brass wall, and it is filled with metal marvels, including automata that call to mind those built by the goldsmith god Hephaestus in his own metal abode. The whole rich theme of Solomonic automata, moreover, constitutes a further development of this notion, connecting together wind and metalworking competences, since this specific class of objects could indeed be endowed with a voice, provided by air pumped through them by a bellows.[62] The semantic constellation that Germain has traced for Aeolus seems therefore to apply to Solomon as well. I am not suggesting that there is a direct link between these two figures, but it is interesting how a certain set of features

typical of an archaic king-magus can be found several centuries later applied to the figure of Solomon. This evidence seems to represent the outcome of a survival and transmission process of much more ancient origin.[63]

Nevertheless, this represents only one part of the story. It seems possible to trace a similar path following the elements leather bag–winds–demons. As we have seen, the Qur'ān bears testimony, as does the Testament of Solomon a few centuries before, of a tradition that, according to the beliefs of the peoples of pre-Islamic Arabia, identified winds and demons. It seems possible to stretch this association farther back in time in the Semitic world. The Bible, in fact, appears to provide more ancient traces of such a connection. The most famous episode is probably that of the witch of Endor (1 Sam. 28), who, interrogated by King Shaul about his destiny, raised for him the spirit of dead Samuel. The necromancer is described in the Hebrew text as "a woman with an *ob*," and the word *ob* has posed several hermeneutical issues for later interpreters.[64] Literally related to "hollow sound," it can be variously translated. The Brown-Driver-Briggs lexicon lists four different meanings: "skin bottle" (Job 32:19), "necromancer" (Lev. 19:31, 20:6, 20:27; Deut. 18:1; 1 Sam. 28:3, 28:7–9; 2 Kgs. 23:24; Isa. 8:19, 19:3, 2 Chr. 33:6; 2 Kgs. 21:6), "ghost" (Isa. 29:4), and "necromancy" (1 Chr. 10:13).[65]

There seems to be a considerable semantic difference between the first meaning and the three later developments of the word, which are clearly interrelated. There is, however, a definite connection. The idea behind it is acoustic. The necromancer is someone capable of making spirits talk, and the voice they produce is a hollow sound, probably similar to that made by the wind when entering a leather skin. This explains why various biblical interpreters, in order to translate the periphrasis indicating the witch, have chosen "ventriloquist," someone speaking from his belly, which in the Bible is equated to a wineskin (Job 32:19). When Isaiah speaks of necromancers the first time (Isa. 8:19), he insists on the muttering quality of their voice, and he reinforces the sonic dimension of their action in another passage, stating that it is similar to the voice of a ghost coming from the ground and whispering through the dust (Isa. 29:4).

It is to be wondered whether such a strong link between the sound made by air in a leather bag (or blowing from the hollow cavities of the ground) and the voice of a spirit is intended only on a metaphorical level. It could in fact have originated in the ancient custom of imprisoning the wind in a sack.[66] The Bible provides no clear evidence that the wind was considered an evil spirit,[67] but in nearby Mesopotamia the terrible wind demon Pazuzu, one of the worst creatures in the Babylonian pantheon, gives us ground to propose tentatively that such a connection existed at some point.[68] Pazuzu is a demon of pestilence,

spreading contagion by blowing around mephitic air. However, he is not originally Babylonian; based on the etymology of his name, scholars have posited that his origin is Semitic, and that he was introduced to Babylonian mythology no earlier than the Iron Age.[69] Pazuzu is never explicitly entrapped in a sack, but his very existence and his likely origin may represent indirect evidence of the specific tradition that resurfaces among the tribes of Arabia.

All these, of course, are just small fragments of a discourse that is almost entirely lost to us, but they seem to favor a particular interpretation: that ancient Semitic people shared a common belief associating evil spirits and winds. This notion, more subdued in the Bible, seems indirectly supported by the term *ob* and by the semantic field associated with it. In the Islamic world, the connection is more evident, since the Qur'ān retains explicit traces of it, although it does not mention the leather bag as a possible means of constraint. That appears instead in the Testament of Solomon, where it apparently represents a remnant of this ancient custom. As seen at the beginning of this section, the idea of constraining the wind is widespread and is one of the themes relevant in broad anthropological terms.[70] Nevertheless, concerning Solomon, it is plausible that such material merged and was ascribed to him through a direct filiation via the Semitic heritage that he shares.

Kynopegos, the "Recycling" Process of Sukkot Bottles, and Healing Practices

Probably more famous than the leather flask is the theme of Solomon's bottles, which were connected, at least originally, to water demons. While the previous case is more problematic, given its ramifications and anthropological parallels, the core of this tradition, as mentioned in the previous chapter, appears to be rooted in a specific historical context and strongly anchored to the city of Jerusalem, even if its successive development loses the traces of its origin. Solomonic bottles, as seen, are mentioned only in a few apparently unrelated texts, different in scope, compilation context, and chronology. Nevertheless, they all seem to develop from a common cultural nucleus. Testament of Solomon 16:1–7, which will be the starting point of our analysis, treats the episode in connection with the capture of the sea-demon Kynopegos, which takes the shape of waves and causes shipwrecks.[71] As seen, Solomon puts him in a *phiale*, along with ten jugs of seawater, seals the mouth of the vessel with asphalt, and orders it to be deposited in the Temple.[72] The solid quality of the vessels described in this example (like those that captured the wind) appears to be useful for entrapping a demon taking liquid form, or broadly identified with the medium it lives in. Interestingly, even the materiality of these containers

has been altered by a series of changes. What we now tend to imagine as a bottle was originally a drinking vessel, a *phiale*, which then became a hydria or a *qwl*, basically a large water jar. What counted, in the end, was that it could contain liquids. There seems to be a continuity concerning water demons: "The Fisherman and the Bottle," a tale collected in the *Arabian Nights*, stages the recovery of a bottled-up jinni in the sea, but even before then, the demon Ashmedai is often shown in close relationship with deep water/wells/cisterns, as in the Babylonian Talmud (Gittin 68b). This could be a faint echo of the original use of the bottle, which developed in connection with water.

Parallel to the description of the Testament of Solomon, as seen in chapter 2, is the account provided by the Testimony of Truth, a second/third-century Gnostic text found in Nag Hammadi in Egypt, and the Syriac Zosimus. Although the two latter texts are not at all related, they seem to refer to a common tradition, which was clearly circulating in Egypt in Gnostic contexts during the same chronological arc between the second and the fourth centuries. In the dungeons of the Temple of Jerusalem, there were allegedly water vessels said to contain demons. As anticipated in the previous chapter, according to Jewish tradition, the Temple of Jerusalem was founded on the *tehom*, the abyss that sealed the waters of primeval chaos and acted as a sort of sacred threshold over it. As such, it was the core of Sukkot celebrations as performed during the second Temple period. The Mishna indicated that during Sukkot the priests had to draw water with a golden pitcher for seven days and make a libation on the altar, probably as a rain and fertility ritual.[73] This dense theological situation mirrored a factual reality: Jerusalem does stand on hollowed-out ground under which run subterranean waters, part of which had been channeled from the Gihon spring into the Siloam stream by King Hezekiah in 700 BCE. Quite interestingly, the ritual of Sukkot required seven pitchers, one for each day of the celebration, and it was performed until 70 CE, when the Temple was destroyed by the Romans. Considering the centrality of the Temple and its altar for the reasons mentioned above, the celebration of Sukkot underwent major changes following the destruction of 70 CE, as Tannaitic sources demonstrate.[74] Since the Temple could no longer be used, the libation ceremony was abandoned in favor of a series of prayers that were meant to have a similar effect on rain.

The Testimony of Truth, therefore, seems to evoke a consequent scenario. The seven ritual water pots may still have been lying forgotten in the subterranean chambers (or at least their memory was still lingering) in the ruins of the edifice, and it would not be surprising if, in the course of the Roman dominion over Jerusalem, someone might have seen them (or evoked their presence). Of course, there is no need to posit the factual presence of these

vessels; what counts is that their presence was established in historical memory, and their provenance was deeply imbued with symbolic implications.

Nevertheless, the Sukkot rituals just described had nothing to do with controlling demons, and originally the bottles were not meant to be used in that way. It is not impossible, however, that such an idea developed immediately after the celebration ceased to be performed. As seen in the previous chapter, the *tehom* was already considered to be the dwelling place of demons toward the end of the first century of the Christian era, when Revelation (17:41) and the Gospel of Luke (8:31) were compiled. It therefore seems likely that the association between the subterranean water of Jerusalem, demons, and the pitchers began to take shape only after the destruction of the Temple, maybe around the end of the first century. However, the presence of Solomon seems to owe to an altogether different tradition.

It will be remembered that close to the pools of Bethesda[75] there was a crypt or cave where Solomon bound demons.[76] From archaeological research, we know that the place was already a healing site, visited by many invalids, in the first century BCE, when an *asklepeion* was built in the area.[77] The Solomonic cult was thus, as often happens, built on an already established tradition, and it is possible that during the transition process Solomon acquired some of the traits and powers of the Greek demigod Asklepios. According to the same source, there is a strong link between the waters of the city and a subterranean dimension of cult, although these pools are not related to those of Siloam. It therefore seems to me that at some point these two traditions merged and some confusion occurred. The two Gnostic sources mentioned above, in fact, seem to bear traces of a superimposition. They preserve the elements of the number of ritual bottles abandoned in the Temple, the subterranean waters of the *tehom*, Solomon, the bottles, and the high priests—elements that, as seen, probably referred to different pools and to chronologically and culturally distinct rituals: a Jewish fertility festival and a Judeo-Christian exorcism/healing tradition.

As we know, the Solomonic bottles reappear in the sixth-century revision of the so-called *Breviarius de Hyerosolyma*.[78] Following a more definitely Christian symbolism, the number of containers mentioned in this latter source is not seven but twelve. These water pitchers were set in a context where baptismal practices were held, thus openly crediting the rite with a strong purification effect against demonic possession. We do not know how early these pitchers were set in the church, or and how and whether this new location represented an update of the rituals taking place in the crypt/cave close to Bethesda.

Further, abbreviated traces of the same tradition that connect Solomon with bottles containing demons resurface later on in other Greek sources. Once

more, we owe these later occurrences, virtually unknown to the scholarly world, to Bonner, who traced them in the *Disputatio cum Herbano Judaeo*, possibly a sixth-century text by Gregentius, bishop of Taphar; in the *Life of Saint Philip of Agyrium*, a famous exorcist, handed down by twelfth-century manuscripts but possibly dating from around the tenth century; and in an eighteenth-century text published by McCown as an appendix to his translation of the Testament of Solomon.[79]

Extant evidence suggests that, while there is nothing that explicitly connects Solomon with bottles before the end of the first century CE, there is much afterward, as "The City of Brass," discussed in the previous chapter, demonstrates. The story not only mentions a city surrounded by a bronze wall but revolves around an expedition leaving Damascus during the seventh century in order to retrieve the Solomonic bottles containing the entrapped jinn.[80] Interestingly, the original nucleus of this tale was composed in the Maghreb, probably around the ninth century, and the city in which the bottles are eventually found is in Egypt,[81] yet another trace of how the story of the Solomonic bottles enjoyed wide circulation in the same area for centuries, even after late antiquity. The account collected in the *Nights* seems to represent the last and possibly most popular outcome of the tradition I have outlined, this time set in the Islamic world. And it is through this account that it came to be known also in the Western world, although it is not there that it originated.

Conclusions

The theme of the spirit in the bottle and of the leather bag are both listed in the Aarne-Thompson index (331 and C322). As such, they enjoy a broad chronological and geographical diffusion, and, as frequently happens with this kind of motif, it is difficult and often not methodologically correct to trace a precise path of filiation, since some of these stories could have a polygenetic origin. My contention, however, is that the story of the devil entrapped in a container, so popular in the Western world, although possibly paralleled in examples from distant peoples, can be traced back to a specific historical moment, probably beginning at the end of the first century CE, during which different traditions regarding the entrapment of demons in closed vessels began to circulate more broadly. The description of the Sibyl in the *Satyricon* seems to represent a segment, however independent, of such a process, paralleled by traditions that began to explicitly ascribe these techniques to Solomon in the same arc of centuries and were collected together in the Testament of Solomon. This famous handbook of demonology contributed enormously to the notion that

the king of Israel, in his capacity as an exorcist, could force demons into various containers and oblige them to perform a series of deeds. The text, a repository of materials of different provenance and chronology worked together in a way that does not always allow precise recognition of cultural threads, represents, in my view, the coming together of the various elements in the story.

As I have tried to demonstrate, for instance, the two apparently similar episodes of the imprisonment of the water demon Kynopegos and of the wind demon Ephippas, respectively in a *phiale* and in a leather bag, represent the point of arrival of two distinct and distant stories. The former probably combines the bottles once used for the Sukkot ritual, the demons living in the abyss under Jerusalem, and long-standing healing practices of the city, while the latter depends on the ancient Semitic tradition of identifying winds, demons, and pestilences and trying to control them. Through the partial superimposition of these themes in the Testament of Solomon, then, the late antique Solomon acquired a series of features typical of the king-priest of archaic societies, features shared by mythical figures such as Aeolus, that ended up being repeated and transmitted through several midrashic, folkloric, or legendary accounts circulating about him in the Middle Ages.

In this way, this nucleus of motifs penetrated, as a strong and consistent topos, European culture, either through direct filiation or through the parallel mediation of Virgil, who had inherited the vessel and its dangerous contents through legends that had been attached to him at least since the thirteenth century. The demon entrapped in the decanter thus became the symbol of the necromancer par excellence, even if its origin and the complex chain of passages leading to its creation were partially erased in the process. Nevertheless, the demon is no different from a message enclosed in a bottle, which finally comes ashore when wind and water cease their fury: if opened carefully, the bottle can still be read as a trace of a longer and much more adventurous story.

4

MUCH ADO ABOUT KNOTTING

Questo è un nodo avviluppato,
questo è un gruppo rintrecciato.

—Gioacchino Rossini, *Cenerentola*

What is Solomon's knot? If we do a quick internet search for it, the visual response to our query is an endless series of variations on a shape consisting of two closed loops, doubly interlinked to create an interlace, displayed in media of all kinds (stone, textiles, mosaics, etc.), depicted or engraved by peoples from Europe, America, Africa, and Asia ever since the Paleolithic, as one can easily verify by consulting the very rich visual repertoires put together by Umberto Sansoni and by Pippo Lo Cascio in recent years (see fig. 5, no. I).[1]

Given such a broad diffusion, both chronological and cultural, a second set of questions arises. How, when, and why was such a shape associated with the king of Israel, considering that scriptural sources never mention it? Was it simply a popular name? And even if it was, what is its genesis in relation to the symbol?

To my knowledge, the expression *Salomosknoten* appears for the first time in the scholarly literature in 1889, in a short essay by M. W. von Schulenburg.[2] Schulenberg remarked that in the Italian region of Liguria the sign, referred to as *nodo di Salomone*, appeared on doorways and walls of several houses, and a knot tied in a very similar shape, called *pie' di pollo* (literally "chicken's foot"), was also employed by sailors, who attached it to masts for protection during storms (see fig. 5, no. II).[3]

In 1918, Leite de Vasconcelos dedicated a monograph to the *Signum Salomonis*, a label under which he collected a catalogue of the numerous occurrences of *pentalfa* and *hexalfa* (five- and six-pointed stars traditionally associated with Solomon), particularly, but not solely, in Portugal and Spain (see fig. 5,

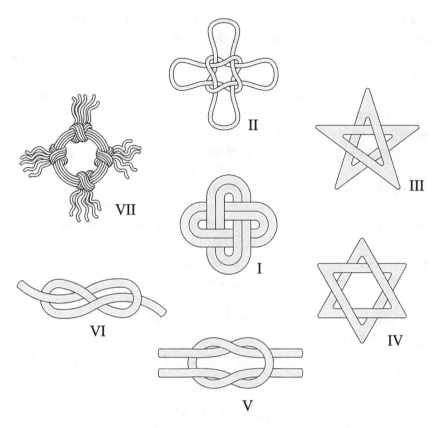

Fig. 5 Solomonic knots. I: swastika-pelta, guilloche knot, Kramo bone, double link, etc. II: pie' di Pollo (after M. W. von Schulenburg, "Der Salomonsknoten," *Mittheilungen der anthropologischen Gesellschaft in Wien* 19 [1889]). III: five-pointed star, Solomon's seal, *pentalfa*, etc. IV: six-pointed star, Solomon's seal, *hexalfa*, David's shield, David's star, etc. V: Hercules' knot, reef knot, square knot, etc. VI: Savoy knot, figure-eight knot, etc. VII: Tolentino's emblem (after Paolo Uccello, *La Battaglia di San Romano*). Drawing by Matilde Grimaldi.

nos. III–IV). He mentioned Schulenburg's article in a short appendix significantly titled "Nó de Salomao" (knot of Solomon), thus probably contributing to the formalization of both expression and shape within the Solomonic repertoire of symbols at a scholarly and international level.[4]

From these two early contributions it would appear that the name of the knot must originally have been peculiar to the folklore and ethnographic tradition of the Italian Peninsula.[5] This, as my survey will confirm, almost certainly depends on the fact that the expression can be traced back to medieval Italian. Nevertheless, on a scholarly level, it was soon adopted and translated into various languages: the widespread presence of this specific shape in various

cultures likely made it useful to have a conventional term for reference. In fact, there is no univocal definition for this shape, which is also known as "swastika-pelta," "guilloche knot," and "Kramo bone," depending on the scholarly or ethnographic tradition of reference. Despite the interest in the knot as such, however, few scholars have speculated on the origin of what must have seemed to be a popular etymology, and in no recent publications is there any evident interest in clarifying the association between the current name and its shape. Its conventional nature is widely accepted.

This chapter is a tentative effort at filling that gap and reconstructing the double history of the knot, from both a terminological and a morphological point of view. I will show that, roughly between the thirteenth and the seventeenth centuries, the label "Solomon's knot" did not always correspond to what is nowadays defined as such but could also refer to other shapes and different notions: magical constraint, love bond, metaphor for intricacy, geometric device, or symbol of infinity; while, on the other hand, the shape had a long history as a decorative pattern, apotropaic device, and sign of infinity, noted by anthropologists and art historians in a wide variety of contexts.

In other words, while the *shape* of what we nowadays call Solomon's knot had long been in existence, its current *name* did not originally refer to that specific pattern, although it was that pattern that ended up being recognized and made popular under that name. As will emerge from the following overview, the first examples suggesting or proving a precise correspondence between the expression and the pattern date from the early seventeenth century—although it certainly must have occurred earlier—and even then a certain degree of ambiguity was tolerated.

Despite the wealth of visual examples of what we now define as Solomon's knots, then, it would be inaccurate to assume that that name was used at the time of the knot's depiction or representation. We should therefore be careful about extending or attributing distinctive Solomonic overtones to a visual document every time we spot a Solomon's knot. The symbol certainly held a deep meaning, but it was not a fixed one and was not always or necessarily related to the king of Israel, even when, by chance, we find it associated with him. The association between Solomon and "his" knot, therefore, is purely fortuitous, and it is no more meaningful than its appearance in combination with other figures.[6] We also need to consider that, while the expression almost certainly began to be used during the Middle Ages, the shape falls into the category of timeless, universal symbols. Originally, however, as Kitzinger has convincingly demonstrated, the function of this specific knot was probably like or equivalent to that of the cross, of which it can represent an evident morphological variation.[7]

My research is set at the intersection of these two very different narratives, with the idea of establishing the point of contact between the historical and the anthropological line. Because of the lack of consistency surrounding most of the documentable history of the knot, it is important to look at what both visual and textual sources tell us in combination with each other. It is only by cross-referencing these approaches that one can more safely establish what Solomon's knot meant at a given point and how it was represented. In order to avoid ambiguity, whenever I refer to the shape itself considered from a mor-phological point of view, I will call it a "double link," following the terminology employed by mathematicians in knot theory.[8] My definition is of course no less conventional than any other, but, by privileging the morphological aspect of the shape, it should, I hope, be less culturally charged, and thus less representa-tive or evocative of a specific historical or symbolic tradition.

I have chosen to follow the chronological order of the texts, aligning the documented, written evidence of the expression. Some leaps are tolerated whenever there is a later example that, by way of analogy, can confirm and strengthen an earlier occurrence. On the basis of a visual comparison between these sources and actual knots, I have therefore attempted to establish a safer correspondence between shape and name. What emerges is that, despite its specific and monogenetic origin, "knot of Solomon" became a category encom-passing different shapes, all coexisting at the same time, particularly from the late fourteenth century onward. What they usually had in common, with the rare exception of the metaphorical nuance of the expression, was the notion of infinity and circularity, which found symbolic applications in dif-ferent domains.

A King of Bonds: Riddles, Demons, and Pillars

Before proceeding, a further methodological premise needs to be stated. The difficulty of ascertaining what was meant by the expression *nodo di Salomone* (or *nodo Salamone*) and when exactly knots and Solomon were tied together depends, in my view, on various factors. The first is the apparent lack of Latin sources, though these are attested for terms employed to indicate other Solo-monic symbols, such as five- and six-pointed stars. The short answer to how these two symbols were defined is that *signum* referred to the five-pointed star, also known as a pentacle (Latin *pentagulum*), and *sigillum* to the six-pointed star,[9] although a certain degree of ambiguity, confusion, superimposition, and substantial interchangeability still exists to this day (fig. 5, nos. III–IV).[10] For our purposes, what matters is that five- and six-pointed stars were perceived as

similar Solomonic symbols and usually employed as apotropaic devices, related to exorcism practices or wealth talismans.

The expression *signum Salomonis* (sign) is known from at least late antiquity,[11] while *sigillum Salomonis* (seal) is explicitly mentioned as early as the late twelfth–early thirteenth centuries.[12] In general, as demonstrated in a seminal contribution by Bénoît Grévin and Julien Véronèse, the magical lexicon is permeated by a high degree of uncertainty, and terminological superimpositions are frequent.[13] However, the presence of Solomonic "signs" and "seals," compared with the total absence of Solomonic "knots" in Latin sources, suggests that the expression *nodo Salamone* must have been coined relatively late. As we shall see, in fact, its earliest known textual occurrence is in Dante (1265–1321). This means either that a new symbol had come to be associated with the king of Israel in the Italian context or that the expression was a synonym for something already known in Latin under a different term (sign, seal, etc.). In other words, *nodo Salamone* could have either been a neologism or a translation.

Besides the terminological difficulty, there is a certain overall semantic ambiguity surrounding the figure of Solomon, who was intrinsically linked to the field of knots for a variety of reasons. The Bible called on him to exert his wisdom in intricate matters and to solve the riddles posed by the queen of Sheba. In Latin, the verb *solvere*, like equivalent words in many other languages, has the double meaning of "untie" and "solve," which helps us understand how easily these metaphorical *nodi* could later become physically tangible, or vice versa.[14]

To prove this point, it is useful to quote a passage from *Ravenna Cosmography*, an anonymous text compiled around 700 CE. In the course of a long explanation regarding the hours of light and darkness, the author finds himself incapable of solving an apparent contradiction between biblical explanation and direct observation. To resolve this dilemma, he introduces his concluding remarks with this sentence: "Ego denique relinquens aliquas alias altercationes dico, quod—certissime non bene—solvo Salomonem."[15]

It would be fascinating to imagine that *salomon* had become a common noun, acquiring the meaning of knot in a figurative sense. The editor of the text, however, reasonably emends the sentence by inserting "<nodum aemulans>" after "solvo." The sentence would therefore translate as "Leaving aside all other discussions, I say I solve this issue [*nodum*]—although probably not well—in a Solomonic way," a direct and quite comprehensible reference to the biblical episode of the judgment of Solomon (1 Kgs. 3:16–28).[16]

Another fundamental field of semantic proximity, as mentioned above, is that of exorcism, with which Solomon was strongly related since late antiquity,

although the source of this tradition is not to be found among canonical sources.[17] This context is once more characterized by verbs of binding and releasing, tying and loosing. Solomon could rule over the demons because, quite literally, he was able to secure their actions by physically imprisoning them, and the technical terminology of the practice is informed by terms such as *ligacio*, *vinculum*, and *clavis*.[18] This aspect is particularly relevant since, as we will soon see, the five-pointed star, or sign of Solomon, was understood as a type of knot.

As scholars in various fields, from anthropology to art history, have convincingly argued, knots are endowed with a certain ambiguous power, capable of blocking and imprisoning if tied.[19] Through their shapes, knots can evoke labyrinth patterns, visual nets meant to distract, confuse, and imprison the demonic entities that hover, invisible, above any human activity.[20] They also bear traces of the ancient cosmological iconography of the menacing dragon with a knotted body (which represents the nodes of the moon's orbit, that is to say, the two points where the circle of the moon's orbit intersects with the ecliptic of the earth, thus creating eclipses).[21] In many cultures, knots are conceived as traps for demons, and we know that labyrinths were associated with Solomon for the same purpose.[22] The field of entanglements and interlaces, being particularly dense with demonological implications, was immediately relevant for the development of the Solomonic tradition.[23] Even wind-taming practices, as seen in the previous chapter, often involved knots.

Finally, another link between knots and King Solomon is the feature—initially typical of Cistercian architecture, but widespread in various Romanesque contexts—of decorating pillars at church entrances with seemingly infinite knots.[24] As Walter Cahn has demonstrated, this idea had its origin in the ancient custom of associating a pillar with a knotted band with sacred ground.[25] This practice acquired distinctive Solomonic overtones when, in response to the Crusades, a need to imitate symbolically the meaningful sites of Jerusalem began to be felt in Christian Europe. One of the most important landmarks to undergo such a symbolic-mimetic effort was the alleged porch of Solomon's Temple, characterized by a set of twisted and knotted columns.

While in time this feature would become a simple decorative device, part of an established architectural repertoire, its direct association with Solomon was still recognized and sought after, as the example of Würzburg's cathedral demonstrates. Here the two knotted pillars that once stood in the façade are inscribed "Jachin" and "Boaz," the names that, according to the Bible, were given to the two giant columns that Solomon designed for the Temple of Jerusalem. Moreover, as Ioli Kalavrezou-Maxeiner has convincingly argued, the textual description in the Bible regarding the decoration of these pillars was ambiguous. One

possible suggestion was a knot-like decoration, which was therefore represented in line with the iconography of the knot of Hercules, which had long been connected with sacred contexts and whose shape was perpetuated by medieval Christian architecture (see fig. 5, no. V).[26]

Therefore, building on Cahn's and Kalavrezou-Maxeiner's contributions, I would suggest that the migration of the knotted column from the Holy Land to Europe—used to indicate the resonating presence of the Jerusalem Temple—could have inaugurated a second segment of this Solomonic tale: the shift of the knot from the pillar to its symbolic patron. It is not difficult to imagine that the peculiar and fascinating protuberances sculpted on several columns, visible to all in various medieval churches, must have prompted a genuine wave of curiosity, not dissimilar to that striking any passerby today. The intricate knot, with no end and no apparent beginning, could perhaps be explained as "the knot of the pillars of Solomon," thus ending up being termed simply *nodo di Salomone.*

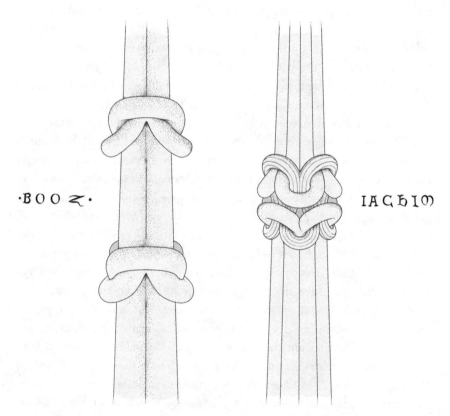

Fig. 6 Solomonic pillars with knots, Würzburg Cathedral, thirteenth century. Drawing by Matilde Grimaldi.

Enhancing this allure, I believe, is the fascination exerted by these sculptures, so skillfully executed as to make one wonder how the artisan could have realized them. There is something mesmerizing about them: the sudden twist of the marble in what should be a linear and fixed vertical makes them something of an enigma in stone.

Knots, then, could be associated with Solomon both in a metaphorical sense (as textual cruxes or problems difficult to solve) and in a technical sense (as exorcism devices or binding "seals"), but also by way of symbolic-architectural analogy (as evocations of the Temple). This short list does not exhaust, as we shall see, the catalogue of possible connections between Solomon and knots, and it does not yet provide distinctive occurrences of our *nodo di Salomone*. Nevertheless, all these examples appear quite meaningful in methodological terms as elements of a semantic constellation that sees Solomon at the center of an entangled net of superimposing meanings, and the examples help explain, at least in part, why so many different threads ended up being woven together in the intricate story of the Solomonic interlaces.

The Knot as a Magic Binding: Impotence

The earliest explicit mention of a *nodo Salamone* in medieval written sources occurs in the *Tenzone* between Dante Alighieri and Forese Donati, a poetic challenge, composed of six sonnets, three written by Dante and three by Forese, in a scathing tit for tat. In the dispute, considered either original and dated around the end of the thirteenth century, or a fifteenth-century fake by Stefano Finiguerri, known as "Za," or by poets of Burchiello's circle, our expression recurs twice, once used by Forese and once by Dante in a cutting retort.

The complex untangling of the metaphorical meaning that the syntagm held for each poet and the overall explanation of the *Tenzone* have been the focus of intense scholarly debate.[27] It will be necessary to briefly recapitulate it, in order to clarify some of the meanings of the knot. In the first sonnet, Dante openly mocks the poverty of Forese's house: the cold and the lack of appropriate cover have made his wife sick.[28] Reading between the lines, however, the scene has been convincingly explained as a disguised accusation of sexual neglect.[29] Forese answers that, while looking for money, he encountered Dante's own father tied up with a knot, the name of which he is not sure about: it might belong to Solomon or to some other sage ("nodo ch'io non saccio 'l nome / se fu di Salamon o d'altro saggio"). Dante's reply, in the third sonnet, opens with the idea of this Solomonic knot as a threat facing his friend if he keeps on eating as he does.

As I see it, in Dante's poem the expression may constitute a sort of superimposition between two notions that are semantically and culturally close, but not identical. The syntagm used by the poet, the conventional but obscure nature of which is often underlined by various scholars, seems to me a sort of pun, linking together the idea—quite technical—of magical constraint (Solomon's seal/sign) with that of sexual impotence (conveyed by the knot), and also, quite probably, an obscene double meaning on the name of Solomon himself (*salamone*, i.e., "giant sausage"), which will become a topos in later comic literature.[30]

By *nodo Salamone*, Dante could mean the well-known sign of Solomon, the five-pointed star, which was variously employed in magical practices, and which had a very strong "binding" effect on the spirits it conjured. It forced the demons to perform a certain act and prevented them from acting contrary to the will of the necromancer. The idea of calling the pentacle a knot was justified from a morphological point of view, since the pentacle could be (and was) seen as an endless knot.[31]

A direct confirmation of the morphological match between the knot and the five-pointed star seems indirectly offered by a later but very explicit gloss by Onofrio Panvinio (1529–1568) in a passage regarding the decoration of certain Roman ancient marble slabs on which were incised, among other things, five-angled patterns, also called "knots of Solomon" ("pentagonorum, quos nodos Salomonis vocant").[32]

The terminological shift between "sign" and "pentacle" toward the idea of a knot could very well have depended not only on the entangled appearance of the shape but also on a parallel, cultural aspect. Among the practices described that would make a man impotent was that of tying knots to a string or some other device, well known in France, where it was called *nouer l'aiguillette*.[33] Although the French expression probably dates to the Renaissance, the notion of magic binding and impotence was widespread and much condemned during the Middle Ages. The impossibility of consummating marriage was one of the reasons that could lead to an annulment, and canon law had legislated on the issue extensively.[34] Charms of hate magic were accused of preventing rightful intercourse between husband and wife.[35] Some of these methods were explicitly performed in the name of Solomon.[36] Thus, it is possible that the knot of Solomon had become a synonym for impotence and a way to vividly evoke the impediment that, through sympathetic magic, constrained the body part in question.

A more technical explanation—which does not exclude but actually strengthens my former hypothesis—would be that the expression was a literal translation of *vinculum Salomonis*, also known as *ligacio spirituum*, a conjuration

formula mentioned in various necromantic books and used as the title of one particular handbook in circulation. There is no way to prove such a thesis, however, since extant manuscripts make no direct mention of the *vinculum* before the mid-fourteenth century.[37] This absence, of course, is not conclusive in itself, since, as we have seen, the idea of a "binding" power had been embedded in exorcism practices since the start and was thus well known to a Christian audience.

The verses "Ben ti faranno il nodo Salamone / Bicci novello, e' petti delle starne," therefore, were probably not meant to evoke the feeling of a lump in Forese's throat caused by stuffing himself with unbridled greed but to say, "Be careful, Bicci; if you keep on like that, you'll have to deal with a knot of Solomon yourself." Through the combined mention of partridges, considered a delicacy at the time,[38] and of the Solomonic knot, Dante created a direct connection between Forese's gluttony and his impotence. In this way, the poet also succeeded in strengthening the original accusation addressed to his friend in the first sonnet. Not only did Bicci fail to satisfy his wife, but his vice could also be the cause for a future, and more serious, physiological impediment.[39]

To close this section of my argument where it began, and to strengthen the interpretation of the knot of Solomon as his *signum*, I would like to compare it with a few other examples, to my knowledge never mentioned, in reference to the *tenzone*. The first is drawn from Lodovico Carbone's *Facezie*, a jest book, collecting more than a hundred jokes, composed around the mid-fifteenth century. The very first jest stages a dialogue between Friar Agostino of Ferrara, known for his doubtful moral behavior, and Pope Nicholas V.[40] The pontiff inquires about Agostino's health, but the friar, who looks pale and emaciated, surprisingly answers that he feels even better than when he was young. In support of this claim, which looks more and more like sarcasm, he mentions that while in the past he could not restrain or control his "indurato, nervoso, indiavolato fratello" (hard, nervous, and devilish brother)—referring, with this periphrasis, to a specific part of his body—he has come to acquire the ability and strength to turn it around and twist it with such ease that he can make "il bel signo Salamone." As jokes do, this line contains more than one layer of meaning. The text seems to play with the idea that the friar had finally tamed his "indiavolato fratello"; I chose to translate "indiavolato" as "devilish," but "possessed" would not be incorrect. The deliberate textual ambiguity here allows us to imagine that Friar Agostino could draw a pentacle on it, thus finally preventing its demonic spirit from relentlessly agitating its abode, but also that he could bend his flaccid "brother" almost into a knot. Clearly, the usual association between Solomon and demonic control is reversed in a comic

key and linked to the notion of knot/impotence.[41] Carbone's "Il bel signo Sal-amone," one could say, represents the best gloss on Dante's verses.

An identical meaning is implicit in the expression used by Paolo Giovio (1483–1552) in a letter to Pietro Aretino, dated 1545. Lamenting the downsides of old age, he says he is dealing with the knot of Solomon that Bartolomeo Saliceto wore around his underwear ("col groppo di Salomone che Bartolomeo Saliceto portava intorno alle mutande"), clearly referring once more to this theme and, again, associating it with the idea of a knot (*groppo*).[42]

At this point it is legitimate to ask whether Forese had attacked Dante's father on the same level by accusing him of impotence as well. Some scholars, convinced of the late composition date of the *Tenzone* and ascribing it both in tone and in content to a vein of coarse comedy more typical of a certain fifteenth-century literature, have advanced an interpretation that insists on a widespread level of obscenity, playing on the theme of sodomy and impotence, thus sustaining precisely this view.[43]

While agreeing that it plays a definite role in this poetic challenge, I have tried to demonstrate that this element is not a consequence of a certain kind of literature but represents a chronological and literary premise justified by an extant cultural tradition. Second, although convinced of the meaning given by Dante to the Solomonic knot in the third sonnet of the *Tenzone*, I am not sure whether Forese was necessarily hinting at the same thing. More likely he was describing a knot that could not be untied.[44] As has been underlined, that could be intended, both physically and metaphorically, as a sign of an unsolved issue, of a binding situation in moral and juridical terms. I think, as has been suggested, that this allusion should be seen in connection with the economic activities of Dante's father as a usurer, although the context of the sonnet cannot help us clarify the exact circumstances.

Token of Love, Bond of Loyalty

Precisely because the term "knot" is endowed with a certain polysemy, and Solomon himself is a polymorphic figure, it appears that the expression retained an entirely different meaning at the time. Fabian Alfie, for instance, has suggested that the Solomonic knot could indicate a feudal obligation, connoting a person's fealty and his strong devotion, depending on a chivalric code.[45] I am convinced that such an interpretation does not apply to the knot tying Dante's father, as Alfie suggests, although it is perfectly valid as a means to explain other textual occurrences of the time. One of these, which Alfie mentions without identifying, is in a passage in Matteo Villani's *Chronicle* regarding the creation of a new

Fig. 7 *Oath Taken by the Knights of the Order of Saint-Esprit on Bible Held by King
Louis of Anjou*, 1352. Paris, Bibliothèque nationale de France, Ms. fr. 4274, fol. 3v.
Photo: BnF.

order of knights in Naples by King Louis of Taranto.[46] The foundation ceremony,
held in 1352, instituted the Ordre du Saint-Esprit au Droit Desir, also known as
the Order of the Knot. The knot characterized both the swords and the vest-
ments of the knights. Villani specifies that it was a *nodo Salamone*, but the

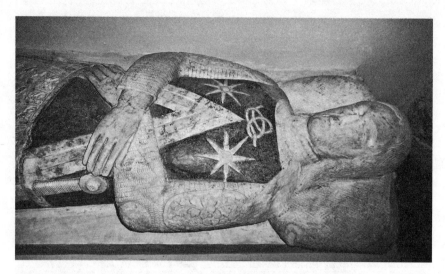

Fig. 8 Tomb of a knight of the Order of Saint-Esprit, after 1352, detail. Church of Santa Chiara, Naples. Photo © Carlo Raso.

statute of the order, while giving great importance to the symbol and explaining how and when it could be tied and untied, never precisely describes it, only mentioning a "nueu de blance soie tout simple sans or perles ne argent" (a knot of while silk, simple, without pearls or silver).[47] Visual evidence of this knot, however, is quite widespread and can be found not only throughout the codex of the statute itself (see, for instance, fols. 1r, 3r–v, 5r–v, 8r–v) but on the tombs of some of the most notable members of the order, erected in various churches in Naples (such as that of Coluccio Bozzuto in the Duomo, Roberto di Diano in S. Chiara, and Cristoforo di Costanzo in S. Pietro Martire).

 Interestingly, while the knights depicted on the various folios are all characterized by what is usually defined as an eight-figure knot (or Savoy knot, for the common use of the shape in the heraldry of the Piedmontese family), some of the *gisants* display on their arms and armor an untied knot in a trilobate shape. This apparent lack of consistency came about because the knights of the order were bound by a sacred oath to perform heroic deeds, but once they accomplished such an act, they were allowed to untie the knot in a public ceremony. The untied knot sculpted on some of the tombs, therefore, likely symbolizes the fact that the knight had succeeded in his goal,[48] while Solomon's knot, in Villani's definition, corresponded, in morphological terms, to what we now call the Savoy (see fig. 5, no. VI).

 An indirect confirmation of this correspondence comes from a later text, describing the canonization process of Duke Amedeo IX of Savoy (1435–1472), published at the end of the seventeenth century. Here the knots are mentioned

in various passages regarding the description of the collar of Our Lady of the Annunciation ("collare Sanctissimae Annunciationis compactum nodis Salomonis"), with which the prince was usually represented according to the standard iconography of the collar, emblem of the order since its foundation by Amedeo VI (1334–1383) in 1364.[49] However, fourteenth-century Savoy sources still called these knots *lacs d'amour* or *lacs du Seigneur* (love-laces or Lord's laces),[50] which means that the merging of the term used by Villani and this heraldic device was not known in French but occurred at a second phase, by virtue of morphological identity.[51]

This cross-reference allows us to conclude that Villani's mention was consistent with respect to the miniature of the knights of Saint-Esprit, although clearly diverging from the original meaning seen in the *Tenzone*. This is probably because the idea of the Solomonic knot acted, almost from the start, in different ways: as a symbol of something particularly intricate, as a magical device, as a decorative pattern. Here we see the trace of a further possible meaning: the knot as a symbol for a strong symbolic covenant, an indissoluble relationship. It is interesting and likely not coincidental that the French *lac d'amour*, or love-lace (later the Savoy knot), corresponds to Villani's Solomonic knot. These two different designations could be seen as two sides of the same coin. The *lac d'amour* seems to derive from the custom, well established among noble ladies, of gifting their sash to their champion as a sign of favor and love. The knight would have worn it during tournaments, tying it to his shield or weapons. The language of courtly love is a reflection of the relationship between feudal lords; it is therefore not surprising that the *lac d'amour* that Amedeo of Savoy allegedly added to his emblem after the gift of the knot by a lady could equally symbolize the fraternal bond between the knights of Saint-Esprit and their king. What is more difficult to understand is its reference to Solomon, unless we attribute to this association (thus to the knot) the character of "infinity," signifying an endless bond of fidelity.

While *nodo Salamone* was understood by Dante as equivalent to a five-pointed star, Villani had no problem in using the expression to indicate an eight-figure knot. The reason for such an abrupt change is not entirely clear to me, though there is no doubt that the Savoy knot should be included among the broad category of Solomonic knots.[52]

Besides what I have already suggested, I can offer a further, tentative explanation that ties together Solomon, love, and the sense of fidelity until (and beyond) death in an evocative way. I suggest that we should see here the strong symbolic and textual influence exerted by a well-known biblical passage: "Set me as a seal upon your heart, as a seal upon your arm; for love is strong as death" (Song of Solomon 8:6). This, the words of the bride to the groom, is one

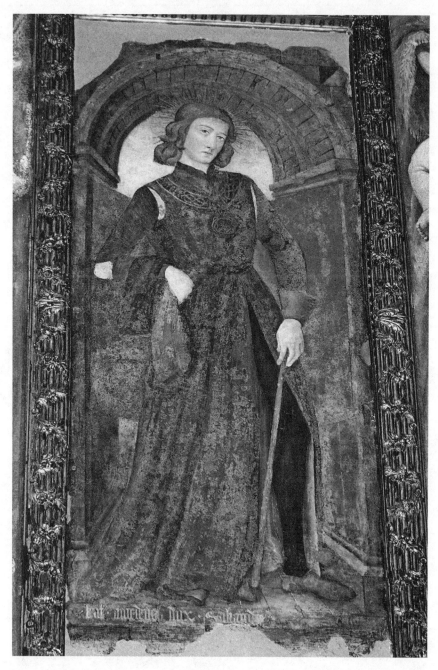

Fig. 9 Antoine de Lonhy, *Amedeo IX of Savoy*, after 1474, detail. Church of San Domenico, Turin. Photo © Simone Bonicatto.

of the texts most commented on in the Middle Ages, a text furthermore attributed to Solomon himself.

I would suggest that the notion of the *signaculum* evoked in these powerful verses—another "seal," after all—must have strongly resonated behind the knots of Solomon that knights carried on their arms into battle and duels. Similarly, the knot of Solomon, mentioned in a letter by Lapo Mazzei (ca. 1400) as a gift of affection, seems a further confirmation of this notion, which, through the agency of courtly love, ended up penetrating common language.[53]

Also interesting is the well-known description of the personal device of Niccolò da Tolentino (ca. 1350–1435), shown in the fresco by Andrea del Castagno in S. Maria del Fiore, in Paolo Uccello's *Battle of San Romano* in the National Gallery in London, and throughout the Mauruzi Palace in Tolentino (see fig. 5, no. VII). Francesco Sansovino (1521–1586), in his *Origine e fatti delle famiglie illustri d'Italia* (1582), describes it as a "groppo di Salomone" (*groppo*, as said, being a perfect synonym for *nodo*) and relates that Niccolò had acquired it in Anghiari after defeating the imperial army, whose main banner displayed this knot. From that moment on, as a token of that victory, it became his personal device.[54] Although Sansovino's account is historically imprecise with respect to the date and circumstances of this event,[55] and the idea of a victorious general taking the vanquished army's banner belongs to the established topoi of heraldry and might not necessarily correspond to an actual event, Tolentino's personal emblem was indeed a knot, although, once again, different from those seen so far.

Knots often appear in conjunction with weapons, shields, helmets, or duels, with a distinct protective function (such as in the mosaics in Ganagobie). One could in fact draw a virtually uninterrupted chain, beginning with the first gems of late antiquity, establishing an association between Solomon, knights, the struggle against evil forces, and, sometimes, special signs like knots. Knots seem to have been important to the Knights Templar, for instance, as appears from the frequent repetition of knot patterns in many of their edifices. This element is probably not coincidental, considering the strong bond between the order and the influence of Bernard of Clairvaux.[56]

In any case, from the overview presented so far, it appears clear that the knot of Solomon had become a recognized pattern (or, better, a recognized type of pattern), deeply associated with the world of chivalry and frequently employed by knights on their emblems, banners, or horse equipment.[57] No doubt, such use went beyond a sheer decorative dimension to evoke both a universe of ideals loosely associated with Jerusalem and its Temple and the fidelity, strength, faith, loyal bond, and fixed determination that every knight

wanted to convey as a sign of his character. It is not surprising to see knots as personal emblems proliferating during this period.[58]

A Metaphorical Knot

Parallel to this development, which retains no point of contact with the earliest meaning of the expression, which was directly linked to a magic binding, the knot could acquire a less physical and more metaphorical dimension, as it does in an often-quoted letter by Marsilio Ficino (1433–1499) to Cosimo de' Medici (1389–1464). The philosopher was replying to his patron, who was worried that Lorenzo of Pisa's monumental *Commentary* on the *Cantico de' Cantici* (Song of Solomon) was still not ready. In defense of his friend's efforts, Marsilio resorted to the metaphor of the intricate Solomonic knot—especially apt considering the attribution of the Canticle of Canticles—to illustrate the poem's obscurity and its allegorical density, which required complex exegetical work: "The more intricate the knot which Solomon tied, the more devices were necessary to unravel it."[59] This passage is useful for us inasmuch as it shows that the knot of Solomon could also be taken as a metaphor for something very intricate, without necessarily implying a definite morphological definition. This is not dissimilar to what we mean by the Gordian knot today and is much in line with the idea, already a biblical topos, as we have seen, of a Solomonic dilemma.

What is especially interesting is that the passage is often quoted in connection with the knot represented on the marble slab of Cosimo de' Medici's tomb in Florence, the design of which is attributed to Verrocchio (1435–1488). However, despite the formal resemblance between Cosimo's knot and the so-called Solomonic knot, there is no need (or actual basis) to posit that Marsilio's play on the textual difficulties posed by the Song of Solomon had anything to do with the iconography of the tomb, as has been suggested.[60] As we have seen, up to this point, we do not have any example establishing a certain and explicit correspondence between Cosimo's knot and Solomon's. I prefer to follow the view advanced by Irving Lavin, who, while defining the knot of Cosimo as a "flattened version of Solomon's knot," drew a parallel with "a particular class of medieval geometric designs . . . based on the Christian cosmology of Isidore of Seville," which could bear particular significance in light of the "resonant and frequently invoked cosmic pun on his name, Cosimo = cosmos."[61] Like Lavin, I am convinced that, for a long time, the double link was handed down and understood within a context of cosmic representations, as a diagrammatic typology symbolizing the eternal cycle of things, the endlessness of time, and

Fig. 10 Andrea del Verrocchio, Tomb of Cosimo il Vecchio with cosmic diagram, 1467. Church of San Lorenzo, Florence. Photo © Marta M. Perilli.

the infinity of the universe, as will appear evident from the examples proposed in the next section.

The Geometry of Infinity: Mazes, Textiles, Canons

A passage in Pietro Aretino's *Ragionamenti* (1534) describes a table's floral composition prepared by two nuns on the occasion of a wedding.[62] Not without irony, Aretino lists various charming compositions: a pierced heart in red roses and carnations, crying eyes in bugloss petals, hands made of jasmine, and, right after a labyrinth realized with elder flowers, a Solomon's knot in wood violets. It is a veritable catalogue of decorative patterns, probably similar to those followed for centuries by women in their sewing.[63] This connection between Solomon's knot and these conventional designs could help us clarify one of its main means of diffusion. If the shape was "indexed" as a Solomon's knot in relation to embroidery and handed down as such, from mother to daughter, from nun to nun, one can be certain that its diffusion was pervasive. What kind of shape did this knot have, then?

Given the context and trying to imagine a floral composition, that is, some-thing endowed with central symmetry, I am tempted to conclude that Aretino had the double link in mind.[64] The association with the labyrinth does not

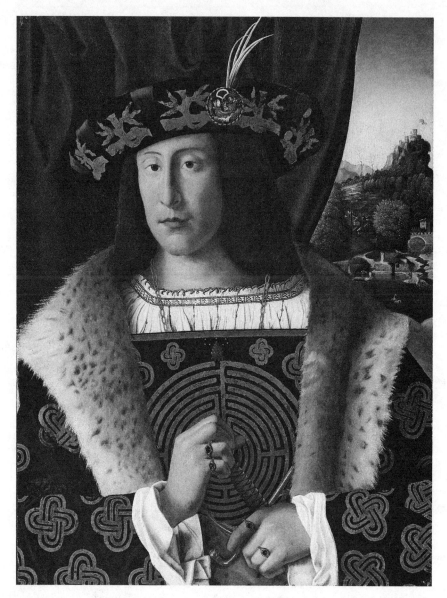

Fig. 11 Bartolomeo Veneto (op. 1502–31), *Portrait of a Man*, ca. 1510–15. Oil on panel.
The Fitzwilliam Museum, Cambridge. Photo © The Fitzwilliam Museum, Cambridge.

seem entirely random: we could in fact imagine the two shapes as a sort of
variation of each other, an occurrence visually known in other contexts as well,
as in a somewhat mysterious painting by Bartolomeo Veneto, where the knots
embroidered on the cloths seem to allude to and enhance the concept of the
maze, providing a sort of visual protection for the sitter.[65]

It is likely that the knot of Solomon enjoyed broad circulation in textile decoration and weaving, given the numerous examples of textiles decorated with knots[66] depicted in paintings and frescoes from that time and before.[67] A very famous example is Jan van Eyck's so-called *Lucca Madonna*, depicted according to the well-established iconography of the *Sedes sapientiae*, which directly recalls the biblical imagery of the lion throne built for the son of David.[68] It would therefore be tempting to see in the decoration of the carpet, full of knots, a distinctive Solomonic echo, meant to strengthen the symbolic overtones of the scene. It is worth noting, however, that the double link generally appears on the cloths of many holy figures: it is depicted, for instance, on the first page of the statutes of the knights of Saint-Esprit, as part of the ornament of the rich cloth of the Trinity. And, as we have noted above, knots were a constant element in textile decorations from late antiquity onward, originally for both aesthetic and apotropaic reasons. In a subsequent phase, they almost certainly acquired symbolic implications, but what kind and in relation to what figures it is not easy to discern. Despite the evocative coincidence, therefore, I think that the knots painted on the Virgin's carpet were deemed important in their capacity as knots, and not necessarily as Solomon-related devices. The examples proposed so far confirm, especially as they refer to morphology, that the expression *nodo Salamone* was merely conventional, as it is now. With the possible exception of its original meaning as a magical constraint, it never really bore any direct relation with Solomon.

A partial and indirect confirmation of such an approach comes from Filippo Baldinucci's *Vocabolario toscano dell'arte del disegno* (1681), where *nodo di Salamone* is defined as "un certo lavoro a guisa di nodo, di cui non apparisce né il capo né il fine,"[69] a decoration with no beginning nor end. This definition applies well to Tolentino's device, for instance. Here the Solomonic knot is nothing but a decorative shape in a continuous loop. Baldinucci does not specify that it had to be realized with a single strand but says that it presented intricacies and, above all, that such a decoration had no interruptions. The definition is especially interesting in that it does not necessarily imply that the knot had to be closed but that the various extremities of the line, thread, or rope had to be invisible and fused in a potentially endless decoration. Baldinucci, directly familiar with practices of art making, was describing a work (*lavoro*) that could be realized not only on a flat surface (like a painting or a drawing) but also in a three-dimensional medium, such as embroidery, where the shape would give the impression of continuity. This description is somewhat broad and could include not only hems with a knotted band, sequences of knots with a different shape but directly linked to each other in a sort of endless chain, but also any self-enclosed knot.

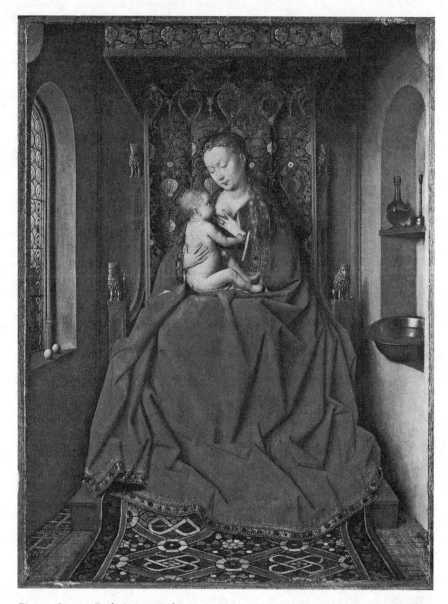

Fig. 12 Jan van Eyck, *Lucca Madonna*, ca. 1437–38. Mixed technique on oakwood. Städel Museum, Frankfurt am Main. Photo © Städel Museum / U. Edelmann / ARTOTHEK.

This definition seems to account for most of the discrepancies remarked on so far, and it is the most precise description of what the Solomonic knot had come to indicate historically: a variety of different knotted shapes that had in common the suggestion of circularity.[70] This element, here outlined in simple morphological terms, seems to constitute the fundamental essence of the knot,

probably because it was on this very feature that its effectiveness depended, at least in the beginning. A late but interesting example, recorded in Goethe's *Faust*, reveals that the *Drudenfuss*—the name by which the five-pointed star was known in Germany—had to be perfectly closed to perform its magic correctly. Any opening—like a crack in a defensive system or a weak link in a chain—would have allowed the demonic entity to escape (or, in this case, to enter the house): "The Drude's foot on your doorstep. . . . Look carefully! It is not drawn correctly."[71] As a sort of prison or labyrinth, the ritual binding worked only when perfectly closed.[72] For this reason, even if the knot of Solomon no longer corresponded to the five-pointed star, it probably retained that layer of meaning, referring to closeness.[73]

The double link, which we now term Solomon's knot, thus seems to be only one—though perhaps, after a certain point, the most famous—among a larger typology of endless or circular knotted decorations. The earliest example known to me in which such a shape is certainly and unmistakably singled out as the knot of Solomon dates to the beginning of the seventeenth century. Two double links, accompanied by two lions, constitute the main decoration of the palace doors of the Salomoni-Alberteschi family in Rome, where a stone knot is also still visible within the inner courtyard. The connection between the name of the family and the emblem is made explicit by a Latin inscription on the lintel of the twin portals ("Domus Salomonia Albertiscorum"), identifying the palace as the house of the Salomoni-Alberteschi.[74] The inscription was probably added between 1613 and 1614 during the renovation work entrusted to architect Giovanni Paolo Maggi after Giovan Francesco Salomoni (d. 1618) added to the property of his wife Olimpia Paloni a new building.[75] The Salomoni-Alberteschi family initially owned another palace at the foot of the Capitolium.[76] Theodor Amayden (1586–1656), who compiled a detailed history of the Roman families, stated that on the façade of the earlier residence one could see the arms of the family and a knot of Solomon carved in stone.[77] Unfortunately, the property seems to have been destroyed during the Fascists' renovation of the area, since there is no trace of it in the quite detailed *Guide rionali*, published in the 1970s.[78] It would have been interesting to see what knot of Solomon appeared on that early palace, since the official coat of arms of the Salomoni—who hailed from Sicily and merged with the Alberteschi of Rome during the fourteenth century[79]—does display a Solomonic knot, but in its earlier form, that is, the usual six-pointed star.[80] Thus, we cannot really be sure what Amayden saw; he notes, however, that it was different from what appeared on the tomb of a member of the family buried in Santa Maria Sopra Minerva, which in fact corresponded to the Sicilian coat of arms.[81] Amayden's remark would constitute an indirect and feeble indication that the Salomoni-Alberteschi had begun to

Fig. 13 Palace of the Salomoni-Alberteschi family (Domus Salomonia Albertiscorum), Rome, ca. 1613–14, detail of the façade with lions and Solomonic knots. Photo © Allegra Iafrate.

employ the double link not with a precise heraldic meaning—since, as seen, the arms of the family were different—but as a sort of visual *impresa*, immediately legible to all passersby, at an even earlier date than 1613. However, without the material remains of the palace, nothing can be stated with certainty.[82]

In addition to the Roman case just discussed, I have found a few slightly later pieces of evidence that point to what seems to be a progressive formalization of the double link as the recognized, more univocal shape of Solomon's knot. Despite the fact that it received scholarly notice only at the end of the nineteenth century, thus finally acquiring a fixed definition, the combination of name and shape was clearly well known in Italy, in widespread use both in popular contexts, from which it resurfaced thanks to the first anthropological and ethnographic studies, and at a very learned level.[83]

A fascinating example is represented by a canon setting the verses of the *Salve Regina*, known as *Illos tuos oculos*, from the first words of the text, published by Pier Francesco Valentini in 1629 and dedicated to doña Isabella Clara Eugenia, infanta of Spain and duchess of Bourgogne and Brabant. The piece was of particular complexity; the composer's intention, as he explained in his introduction to the score, was to match and pay homage to the intrinsic depth and immensity of music, "speculativa, ampla, profonda et bella" (a speculative, broad, deep, and beautiful discipline), which informed the very structure of the

universe.[84] The same concept is repeated and further developed in another passage, where the author briefly mentions the possibility of expanding the canon in an even greater number of permutations (more than two thousand), which he chose not to list for the sake of brevity but also to show, once more, that the depth of music was such that it could not be grasped fully by the human intellect. To visually exemplify such a notion, Valentini concludes the canon with a drawing of our knot and the indication "with 96 voices."[85]

Two years later, as a follow-up, Valentini published the *Canone nel nodo di Salomone a novantasei voci con le sue resolutioni*. The illustration opening it was the same that had concluded the canon *Illos oculos*, but this time the composer not only explicitly identified it as a knot of Solomon right in the title but also explained the numerous combinations that he had not clarified before. In the first leaf he writes that he had inserted the knot of Solomon almost as a caprice ("quasi per capriccio") in the previous composition to give a sense of the infinity of his musical composition, a sort of eternal fugue.[86] Such a choice, far from being just a vagary, as he somewhat rhetorically declared, contained and summarized the deep sense of his entire musical and theoretical effort, according to the taste for musical enigmas and hieroglyphs typical of the time: to render the idea of the infinity of music through a canon, a musical form circular in itself and therefore potentially endless.[87]

Valentini's use of the knot of Solomon is particularly revealing because it is one of the few occurrences where the symbolic implications of the figure are made explicit by the author himself, in his attempt to communicate the synthesis of the key notions that informed the premises of his work. If Baldinucci provides us with an explanation of the Solomonic quality of the knot in morphological terms, Valentini adds that this aspect was not simply decorative, but, as we could have expected, the presence of the knot could, in certain circumstances, resonate with deeper mystic overtones.

Moreover, beside the symbolism that ties together knot, music, and the canon form, a second meaningful nuance can be added, which resounds, this time, with distinctive Marian overtones. Valentini himself dedicated his work to the Virgin[88] and set to music the words of the *Salve Regina*, and this fact may be endowed with deeper religious or liturgical implications. I have in fact found another circumstance in which a knot of Solomon is explicitly mentioned in association with the same prayer, possibly an indirect trace of a specific devotional tradition. The evidence comes from a precise description of a brocade mantle that the nuns of the Florentine convent of SS. Annunziata of Le Murate, in around 1500, wove and donated to the miraculous image of the Virgin of the Impruneta, which never went on procession without being covered by a precious cloth. Through the description handed down by Giovan Battista Cassotti

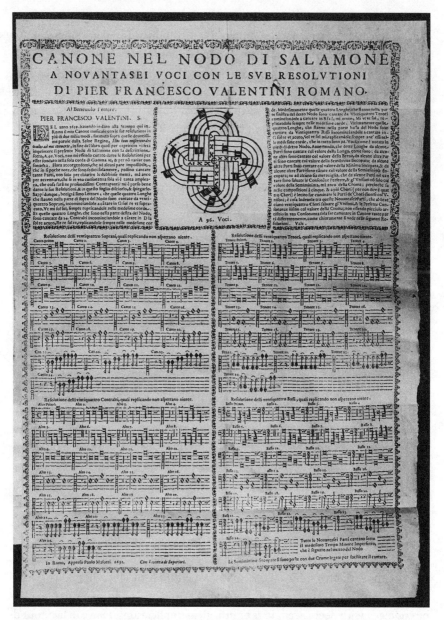

Fig. 14 Pierfrancesco Valentini, *Canone a 96 voci nel nodo di Salomone* (Rome: Paolo Masotti, 1631). Photo: Museo internazionale e biblioteca della musica di Bologna.

in 1714, we know that, among other rich decorations, it displayed a Solomon's knot in gold.[89] What is also interesting is that this mantle was sewn by the nuns while reciting various prayers, in an exercise of spiritual meditation that goes back at least to the end of the fifteenth century. Cassotti adds that the choice of

orations was made by sister Dianora Cinozzi,[90] a nun whose particular devotion to the Virgin is confirmed by earlier sources within the convent.[91] Not only was the mantle sewn while praying, but, once completed, its decoration could be used as a sort of visual breviary, in which all the details were associated with a specific prayer: for the brocade, it was necessary to repeat all the Psalter three times; for the seventy ermine skins, the *Salve Regina* seven thousand times; and so on. Cassotti explicitly says that, for the knot of Solomon, one had to repeat the *Salve Regina* seven hundred times.[92] Unfortunately, unlike other mantles preserved in the treasury of the Sanctuary of the Impruneta, this one has not survived. It would have been very interesting to see what kind of Solomonic knot it displayed. It is also difficult to establish whether the prayers listed by Cassotti really did correspond to those suggested by the nun more than two centuries before. I am inclined to think that the connection between the *Salve Regina* and the knot should be seen as part of a larger phenomenon of Marian devotion, well attested by a rich wave of musical compositions (including Valentini's work) more typical of the early seventeenth century, possibly as a result of the push of the Counter-Reformation.[93]

In any case, at the time when Valentini composed his piece, the tendency to identify the double link with the Solomonic knot seems to have been well established in other learned contexts as well. In the *Vocabolario della Crusca*, the most authoritative dictionary of the Italian language at the time, the knot of Solomon is mentioned under the entry *nodo* in the first edition (1612). Although the definition does not provide any further specification of its morphological appearance[94]—possibly because there was no need for it—a note written by Alessandro Segni (1633–1697), a renowned Florentine scholar and one of the principal authors of the third edition (1691), does, in a different context, specifically mention the knot, thus allowing us to understand what he actually meant by it.

Closely connected to the Medici family, librarian to Cosimo III, preceptor of Francesco Riccardi, among other things, Segni compiled a list of Medicean devices, *Raccolta delle imprese . . . dei personaggi della casa di Toscana*, in which he lists a Solomon's knot with the letter P ("un nodo Salamone colla P").[95] There is no accompanying drawing, but an unmistakable correspondence can be found in several codexes of the Laurenziana belonging to the Plutei series, where the emblem clearly appears, along with others that have been recognized as those of Piero di Lorenzo (1471–1503), hence probably the P.[96] They designate several personal manuscripts of the Medici family, created under the direct patronage of Lorenzo's son.[97] We can therefore conclude that if one of the most well-respected scholars of his time identified our symbol as a knot of Solomon, this should be taken as a truly authoritative view on the matter.

Fig. 15 Personal emblem (P with knot, top center) of Piero di Lorenzo de' Medici (1471–1503), ca. 1490. Fierenze, Biblioteca Medicea Laurenziana, Ms. Plut. 14.23, fol. 2r, detail. Su concessione del MiBACT / E' vietata ogni ulteriore riproduzione con qualsiasi mezzo.

Conclusions

I hope I have clarified that, from a historical perspective, we should be talking not about a single knot of Solomon but a plurality of knots, exemplified both in physical and metaphorical terms. Already in the Bible, Solomon was called on to "solve" a difficult situation, and his later renown as an exorcist would associate him with a specific vocabulary of binding and loosing. Moreover, a visual element that could have added to the widespread notion of complicated and seemingly infinite knots was the decorations in stone that characterized Romanesque architecture from the end of the twelfth century, with a distinctive Solomonic overtone.

However, the first explicitly attested occurrence of *nodo Salamone* in written sources comes at the end of the thirteenth century in Italy, as a synonym for the five-pointed star, one of the most widespread Solomonic symbols used to bind demons. The term continued to be employed in strictly morphological terms to indicate a five-pointed shape or, more commonly and through a progressive shift of usage, in relation to the best-known outcome resulting from such binding: sexual impotence. In this sense, the emphasis was on its function

(particularly in comic literature), rather than on its original shape. However, a trace of that early characterization as an endless knot must have remained attached to it: in order to prove effective, the knot must be closed on itself in an endless shape, since it was both prison and maze for the demons entangled in it. This notion, although not always explicit, was probably always extant and would resurface in its later development.

In addition to this probably original definition, the Italian language registers an association between the *groppo Salamone* and the *lac d'amour*, a token of loyalty and fidelity—both in the feudal relationship and in the language of courtly love—not dissimilar to the indissoluble and, more importantly, endless bond created by the *signaculum* of the Song of Songs, which could perhaps be seen as another Solomonic device.

The knot of Solomon, however, denoted a number of other shapes without distinctive uniformity. This lack of consistency could be explained by the fact that a certain ambiguity was not only tolerated but probably informed the very definition of the knot at some point—a definition that stressed its circular, endless, continuous aspect. This feature made the knot a sort of visual, unsolvable riddle and—even at a popular level—probably reinforced the continuing association with Solomon, the wise king capable of untangling intricated situations, although its origin must have been far more technical.

Given this overall situation, in many cases a simple textual mention is not enough to evoke a precise pattern; similarly, many visual examples of knots remain silent or ambiguous as far as their Solomonic implications are concerned. Unfortunately, I have not been able to clarify when, exactly, our modern definition merges with the ancient double-link pattern. If it is certain that this had occurred by the beginning of the seventeenth century, then the process likely began before then. It is difficult to pinpoint the genesis, however, since the double link was originally put under the ideal rubric of cosmic diagrams, representing infinity in Christian medieval culture, but was also understood during late antiquity as a representation of the sign of the cross.[98] However, we can be sure that this progressive superimposition occurred because the double link bears a strong formal affinity to the six-pointed star, which, as stated at the beginning, was as widespread as, and virtually interchangeable with, the five-pointed star as a Solomonic symbol and could easily be seen as yet another of his knots.

I think, therefore, that shape and name could have begun to be equated in the course of the Middle Ages, although not before the end of the twelfth century and the beginning of the thirteenth century, a period when both the stone knots began to appear on the Solomonic pillars of many Romanesque churches, the symbolism of five- and six-pointed stars acquired distinctive Solomonic

overtones, and the language of courtly love and gestures flourished. The combination between the double link and King Solomon emerged and became established and remains so today, as the recent naming of a newly created synthetic molecule in this shape demonstrates; it is not only an excellent example of the power of Solomon's attraction, but also—and quite appropriately—a further confirmation of the immutable dialectics between the infinitely big and the infinitely small, another suggestive echo of the secret correspondence between the macro- and the microcosm that this pattern has often evoked.[99]

5

Lunaire où cachés vous
cét aimant, qui le fer si puissâment attire?
Lunaire où cachés vous la tenaille qui tire
les fers si dextrement? Lunaire où cachés vous
la Maréchale main, qui arrache les clous
si doucement des piés?
—Guillaume du Bartas, *La Sepmaine, ou Création du monde*

In one of the first issues of the *Philosophical Transactions of the Royal Society of London*, one of the earliest scientific journals in the world, a piece by a M. de la Voye titled "A Relation of a kind of Worms, that eat Out Stones" described a peculiar phenomenon observed in the Benedictine abbey of Caen, in Normandy. Originally addressed to a M. Auzout and appearing in the *Journal des Savants*, the article reported that the stones of the building were full of cavities containing worms that appeared to be feeding off the very walls they lived in, as a subsequent experiment seemed to prove.[1]

De la Voye's description acquired a certain popularity, being quoted in 1707, for instance, in Eberhard Happel's *Relationes Curiosae*, where the entry dedicated to the *Stein Würmer* was further enriched with two notable illustrations.[2] The notice was then inserted, under the rubric *vermes lapidum* or *vers de pierre*, in the *Dictionnaire ou traité universel des drogues simples* (1714) by French chemist Nicolas Lémery,[3] which was translated into Italian in 1721.[4]

These protoscientific observations represent the first analytical attempt to describe the category of rock-boring organisms,[5] creatures capable of eroding rocks for shelter and sometimes food. Not without a certain irony, this small segment of the history of biology—deeply rooted in the direct examination of nature—has ended up providing a popular iconography for a baffling creature

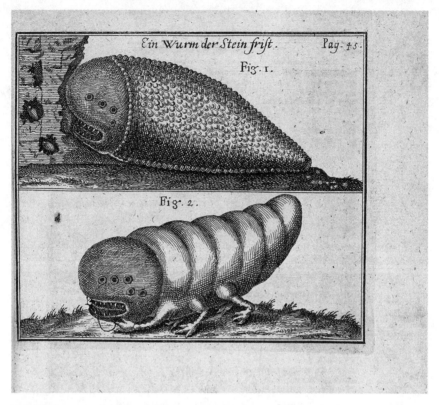

Fig. 16 Eberhard Werner Happel, *Ein Wurm der Stein frisst*, in *Relationes curiosae oder Denckwürdigkeiten der Welt*, vol. 1 (Hamburg: Reumann, 1707), 45. Photo: Heidelberg University Library, B 90 B RES::1.

known for dissolving rocks, made popular mostly through rabbinic commentaries: the so-called *shamir*.

As we shall see, however, the appearance of this worm represents the last metamorphosis of a very elusive entity that, throughout history, has had several embodiments, crossing the mineral, vegetal, and animal world while remaining faithful to one fundamental feature: its ability to cut through stone.[6]

Most of the studies dedicated to the topic have aimed at establishing a precise correspondence between the *shamir* and reality. Several scholars have provided extremely learned comparisons, in-depth analysis of sources, and quite fascinating etiological explanations.[7] Nevertheless, the theme has also often called for very imaginative hermeneutical efforts and for interpretations flawed by methodological faults, often based on imprecise details.[8] The result is a dense, often confused mass of information, difficult to disentangle.

My interest in the story was sparked by the fact that the *shamir* was entrusted, like many other magic devices before it, to the care and power of King Solomon, and was thus included in the rich material composing his legend. This process was completed by the sixth century CE, since the first source to mention Solomon and the *shamir* together is the Babylonian Talmud. In this account, however, and in others that parallel it closely, the *shamir* is never explicitly defined, although some of its traits are described.

For this reason, my approach tackles the protean quality of this "creature" and the fascinating process by which it came to be altered and understood in radically different ways throughout time and cultures, while maintaining a substantial consistency.

Given the intricacy of the matter, I will try to follow chronological order, presenting, summarizing, and reviewing the sources explicitly describing the *shamir*, along with some of the most notable readings that have been proposed. I will introduce the biblical passages first, then the rabbinic examples, and finally the medieval interpretations. In conclusion, in order to facilitate an easy grasp of the material, I will provide a table ordered along a rough taxonomy (mineral, vegetal, animal, unspecified nature of the *shamir*) yet maintaining the chronology of various sources, thus synthesizing the story as it has unfolded through its various metamorphoses (see table 2).

The Biblical *Shamir*: From Stinging Thorn to Piercing Point

The first occurrences of the *shamir* are biblical. The prophet Isaiah (ca. 740 BCE) employs the term eight times in various passages (5:6, 7:23–26, 9:17, 10:17, 27:2–6, 32:12), always in association with the word *shayit*, in a recurring hendiadys. The words are used in descriptions of deserts, uncultivated lands where underbrush grows, and in fact current lexica associate *shamir* with the Aramaic *samur*, which is said to have indicated a tree or bush with thorns, variously identified as species such as *Paliurus aculeatus* or *Daucus aureus*. However, given the difficulty of tracing a precise botanical parallel, the term is broadly defined and translated as a brambly shrub. The term also appears with an identical meaning in Qumran texts (1QH 8.20 and 4Q368 10 ii.5).[9]

However, something called *shamir* also appears in the writings of later prophets (Jeremiah, Ezekiel, and Zechariah) between the seventh and fourth centuries BCE to refer respectively to the extreme rigor and inflexibility in which the gravity of a sin is noted and felt: "The sin of Judah is written with an iron pen, with a diamond [*shamir*] point it is engraved on the tablet of their heart, and on the horns of their altars" (Jer. 17:1); to the impassivity of the

prophet, whose countenance is never altered: "Like the hardest stone [*shamir*], harder than flint, I have made your forehead: do not fear them, do not be dismayed at their looks: for they are a rebellious house" (Ez. 3:9); and to the hard hearts of the people of Israel: "They made their hearts adamant [*shamir*] in order not to hear the law and the words that the Lord of hosts had sent by his spirit through the former prophets. Therefore great wrath came from the Lord of hosts" (Zech. 7:12).

Most extant translations have rendered the term as "diamond" or "adamant," stressing the quality of the material, which is employed metaphorically to underline the concept of hardness. However, these choices are probably inaccurate from a historical point of view. In the examples mentioned, the term is used both to indicate a strong writing surface or support (face and heart as a stone) and a peculiar engraving tool. In this latter case, it appears evident that the *shamir* can be used to pierce, cut, and incise a hard surface. As such, it must have been harder than the hardest material.

I would suggest that between the earliest mention in Isaiah and the uses in later biblical writings, the term had acquired a second meaning through a progressive shift in usage. It is not difficult to see how the notion of a thorn could, by way of analogy, come to indicate a sharp, pointed tool used for incising hard materials. This, in turn, makes clear the subsequent association between the *shamir* and its hardness, since, in all likelihood, such an instrument must actually have been crafted with a point capable of cutting and incising, for use by specialized workers.

In trying to establish the etymology of the term, Samuel Bochart hypothesized that *shamir* was an adaptation of the Greek *smyris/smiris*,[10] the powder of corundum, that is, emery, an abrasive mineral that, reduced to powder or sand, could be used to work gems and jewels and was often employed to polish hard stones and to separate marble slabs.[11]

However, although the meaning of *smiris* is sure, its etymology is unclear and, interestingly, may be pre-Greek. The first occurrences of the term are relatively late, in the Septuagint (second century BCE) and in Dioscorides (40–90 CE).[12] For this reason, while I agree with the fascinating connection between *shamir* and *smiris* proposed by Bochart, I wonder whether it would be possible to reverse the chronological relationship between the two and see in the Greek *smyris* the arrival point of a more ancient tradition, linked to stoneworking, which was already attested in the Bible.

In general, the hypothesis that the *shamir* originally referred to an abrasive crystal is substantially confirmed by what we know of the instruments evidently used for gem cutting during antiquity: a copper (and later iron) tube with a flake of corundum. This tool seems to correspond to the pen mentioned

by Jeremiah. Flint could in theory be employed, but its efficacy was limited to shell, serpentine, and marble, whereas for materials as hard as flint, such as agate, syenite, or quartz crystal, something harder was necessary. The hardest of all, diamond, however, was apparently unknown to the Egyptians, Greeks, and Assyrians and came to be employed only after the conquest of India by Alexander. Early scholarship on the topic stated that corundum, that is, emery in its coarser form, could easily be found in the sands of Ethiopia, on the islands of Naxos and Cyprus, and in Armenia, and that a "tubular drill" for works on a larger scale was known in Egypt as early as 4000 BCE.[13] Despite the certainty with which this hypothesis was put forward in many studies,[14] the use of emery as a working tool in Egypt has been questioned;[15] nevertheless, recent archaeo- logical evidence seems to have definitely settled the question in favor of emery.[16] Its piercing aspect—and thus its hardness, as it emerges in the late prophets— could arguably represent the original or predominant feature of the *shamir*, as the thorns seen in Isaiah seem to indirectly suggest.

In concluding this brief initial survey, it is important to underline two aspects. First of all, the ambiguity surrounding the *shamir* may have its origin already in the Bible, where it appears in two different phases and with two apparently different meanings (thorn/tool/material), in transition, so to speak, between the vegetal and the mineral worlds, although the analogy between the plant and the instrument makes them much more similar than they might appear. Second, there is nothing intrinsically magical in these first occurrences of the term: the *shamir* was probably originally related to piercing and cutting and, as a consequence, associated with a specific working technique, strictly linked to gem cutting (on a small scale) and stone engraving (on a larger one).

The *Shamir* of the Rabbis: A "Creature" of Unspecified Nature

The most ancient rabbinic source to mention the *shamir* seems to be the Mishna (ca. 200 CE), which refers to it twice, very briefly: the first time in Sotah 9.12 (Nashim), which says that it ceased to exist, became annulled (literally "batel"), after the destruction of the second Temple, and the second in Avoth 5.6 (Nezi- kin), which lists it among the first ten things created on the eve of the first Shabbat, right at the close of the work of divine creation.[17] In both passages, the *shamir* is simply named without any specific description or characterization.

A parallel occurrence appears in the Tosefta, in a passage quite similar to Sotah 9.12 (Tosefta 15.1),[18] which collects together the opinion of several rabbis on the matter, thus providing further information on the *shamir*: its peculiar property with respect to hard materials, its special repository (it was wrapped

in wool and kept in a leaden tube full of barley bran, probably because it was considered capable of destroying everything it touched), and the fact that it ceased to operate after the destruction of the second Temple. Furthermore, the Tosefta gives us an insight into the intense discussion concerning its possible use in the construction of the Solomonic Temple: some rabbis believed it had been employed for cutting the stones, while others believed that it had a role in the decoration of the breastplate of the high priest.[19] Not every rabbi, in fact, agreed that it had been employed by Solomon for the construction of the Temple; Rabbi Judah considered it necessary for the cutting of the stones, but Rabbi Nehemiah did not find the textual evidence convincing and proposed a different interpretation that related the *shamir* to a prescription in the book of Exodus (28:9–11) regarding the method taught to Moses for engraving the twelve names of the tribes of Jerusalem on the gems decorating the shoulder straps of the *ephod*, the most precious garment of the high priest. This latter reading seems to agree well with the hypothesis that originally the *shamir* was a sort of stylus with a pointed edge, employed for engraving signets, gems, or hard stones, a possibility that seems to be supported, as seen, by the earliest biblical mentions of the term. Rabbi Nehemia's interpretation also seems indirectly strengthened by the notable fact that in the list of the ten things created before twilight on Friday, the *shamir* comes just before the invention of characters, writing, and the tables, in a progression that holds a certain internal logic: the tool comes before the result produced by it.

This connection between the *shamir* and a technique for writing in intaglio, still extant in rabbinic literature, seems to constitute a resurfacing, a trace of the ancient biblical, prerabbinic tradition, which, as said, originally associated this tool with the act of engraving letters and with a working method that certainly dealt with hard materials both on a small, refined scale and, possibly, also at a more monumental level, as in the case here, in relation to the Temple. Several centuries have passed from the earliest scriptural occurrences, and the use of the term *shamir* appears to have shifted. If in the Bible there was still some lingering ambiguity between the thorn, the tool reminiscent of a thorn (pen), and the material of the tool (diamond/emery), in the commentary the process seems to have come to an end. Whatever it is, the name *shamir* indicates a specific object.

Now, the discussion between the rabbis is directed mostly at clarifying what the specific use of this tool in the context of the Temple construction was, in light of the evidence provided by the text. The main issue seems to be where exactly this kind of instrument was employed (the Temple, the palace, or the precious decoration of the priestly garments), rather than the specific nature of the *shamir*, which is neither questioned nor defined. The friction between the two different

rabbinic views is caused by some logical and textual incongruences and is solved, as is customary, by resorting to other quotations that seem to support one or the other hypothesis.[20] None of the rabbis doubt that the *shamir* is a working tool; what is questioned, indirectly, is its scale and its method of use. The debate develops entirely at an exegetical level; the interest in the *shamir* is an intellectual, theological problem, not a practical question, and it is possible that the rabbis involved didn't have a precise idea of what a working tool employed several centuries before them looked like. Neither was this their concern. What mattered was the description of an object that could satisfy the textual requirements of the Bible. This underlying approach explains also the increasing distance from reality between the rabbinic and the biblical *shamir*. The rabbis knew this tool could cut the hardest things without damaging them, and so they describe the process in a highly poetic way: "These split of their own accord, like a fig which splits open in summer and nothing at all is lost, or like a valley which splits under in the rainy season and nothing at all is lost."[21]

What must have originally been nothing but a metaphorical image is also the first seed, I believe, of a progressive transformation of the *shamir* into a wondrous object. Probably not knowing exactly (and possibly not being too interested in) the real device lingering behind the elusive textual occurrence, but focusing more on its remarkable property, the rabbis emphasized this specific feature and ended up evoking a sort of magical object. These premises are important for what follows.

In a slightly later phase (ca. 500 CE), the same set of notions mentioned in the Mishna and in the Tosefta are repeated in the Babylonian Talmud (or Bavli), in Sotah 48b[22]—where it is also said that the *shamir* was small as a barleycorn—and Avoth 5.6.[23] In these two passages, as one would logically expect considering its textual structure,[24] the Talmud reports the earlier known traditions, following closely and commenting on the most ancient texts. However, in another passage (Gittin 68a–b), the Babylonian Talmud presents us with a new episode, reporting that, in the course of the construction of the Jerusalem Temple, King Solomon was advised to look for the *shamir*, the only tool that he could use without resorting to iron.[25] Following the direction of the demon Ashmedai, he sent his servant to fetch the *shamir*, a special thing belonging to the Prince of the Sea but entrusted to a bird (the *tarnegol bara*, literally "wild cock"). As we saw in the first chapter, the texts describe how, in order to trick the bird, the men of the expedition covered its nest with glass, thus forcing the bird to resort to the *shamir* to cut the glass and free its chicks. Scared by the sudden appearance of human beings, the bird, however, let go of the *shamir* and lost it. Solomon thus had its tool, with which he proceeded in the construction of the Temple.[26]

An interesting aspect is that here the *shamir* appears in a strongly narrative frame, almost a fable or a midrash, quite distant from the exegetical context of the other rabbinic passages seen above. From a textual point of view, in fact, this episode is constructed by tying together at least two separate traditions: the story of the supernatural construction of the Temple with demons, which has its roots in the Testament of Solomon, and the tale of the "blocked nest," which circulated with no direct ties to the Solomonic legend long before the Talmud was compiled. I will now try to analyze more closely these two threads.

The Supernatural Construction of the Temple

The most recent discussion about the chronological and textual relationship between Bavli and the Testament of Solomon finds that the compilers of the Babylonian Talmud could access western (i.e., from Palestine) traditions directly related to it, although not in the form of the Testament of Solomon known to us, and there are several parallel passages that prove that both texts had a common textual ancestry, at least as far as certain sections are concerned.[27]

This seems confirmed even in this specific case. One of the main finds at the core of the Testament of Solomon, in fact, is the inclusion of demons in the building of the Jerusalem Temple, a detail echoed in the Talmud and well analyzed in a comparative perspective by recent scholarship.[28] Thanks to his magic signet ring, Solomon is able to control and employ demons in difficult tasks, such as the repositioning of the cornerstone, raised and moved by the wind demon Ephippas (chap. 23), or the cutting of heavy blocks by other demons such as Ornias (chap. 2).

Nowhere in the Testament of Solomon text, however, do we a find trace of something called a *shamir*, or of any tool or device capable of miraculously cutting hard materials. The recovery of a wonderful green stone, thanks to a demon, is mentioned in Testament of Solomon 10:4–7, but there are no firm textual clues that allow it to be identified with the *shamir*, even if some scholars have unwarrantedly advanced such a hypothesis, thus contributing to the idea that it was an emerald-like gem.[29]

Given that there is no trace of it in the Testament of Solomon, therefore, the story of the *shamir* (that is, its narrative frame) seems to have penetrated the Talmud, and through it the Solomonic legend, thanks to a tradition originating elsewhere. On the one hand, the Talmud appears to be specifically responding to and expanding on the topos of beautiful craftsmanship of the Temple, connected to the almost supernatural difficulty of the task, the excellence of the results obtained, and the biblical claim that no iron tools had to be used for the construction of the holy building (1 Kgs. 6:7). While the Testament of Solomon

solves these issues thanks to the intervention of demons and their powers, the Talmud further elaborates on this notion by including the story of the recovery of a very special tool, whose property is clear but whose nature is never openly declared.

A similar silence applies to all the other rabbinic passages regarding the *shamir* quoted so far. The only, very feeble, lexical hint, as far as I can ascertain, appears in the Tosefta, where it is described as a *birya*, literally a "created being." Since the term is so broad, it is difficult to be sure whether it indicates something living (as opposed to something artificially made) or simply an "entity."

The Blocked Nest

The story of the blocked nest and of a special system to clear it, on the other hand, had been in circulation since at least Hellenistic times. Pliny the Elder (23–70 CE) refers to it in relation to the woodpecker and states, on the basis of an earlier source (a Trebius Niger, probably to be identified with a Trogus dating to the first century BCE),[30] that the bird resorted to a special herb to open its nest if it found it blocked. The effect was quite astonishing: "Trebius informs us that if a nail or wedge is driven with ever so much force into a tree in which these birds have made their nest, it will instantly fly out, the tree making a loud cracking noise the moment that the bird has lighted upon the nail or wedge" (*Natural History* 10.40).

A century afterward, in describing the behavior of the hoopoe (and, in another passage, also that of the woodpecker), Aelian (165/170–235 CE), in his *On the Nature of Animals*, reports a similar story, with some variations. Here, instead of nails and wedges, the hoopoe's nest, carved out "in the deserted part of a fortress, in the cleft of a stone that had split with age," is smeared with mud by the guardian of the place. "When the hoopoe returned and saw itself excluded, it fetched an herb and applied it to the mud. The mud was dissolved; the bird reached its young and then flew off to get food." Noticing the extraordinary power of the herb, the man picked it to "la[y] open treasures that were none of his" (*On the Nature of Animals* 3.26).[31]

Interestingly, the interest in this herb would also travel along more subterranean channels, resurfacing in texts dedicated mostly to the special properties of plants, in contexts of natural and experimental magic, particularly during the thirteenth century, in works such as those attributed to the Pseudo–Albertus Magnus. An early trace of this tradition, for instance, appears in the *Cyranides*, an anonymous collection of magico-medical treatises compiled around the fourth century but attributed to earlier or mythical authors such as Harpocrates

and Hermes Trismegistus. Originally in Greek, it was translated into Latin in 1169 by Paschalis Romanus in Constantinople. Here, too, the text relates in detail the properties of a plant that is credited with the power to dissolve mud, wood, and stone and is employed by the woodpecker to free its nest.[32] We can be sure that this tradition was also well known at a relatively early date in the Jewish world, since a comparable episode is related, with a few small differences, in Midrash Leviticus Rabba (22:4), in relation to the life of Rabbi Simeon ben Halafta, who lived during the second century CE and was renowned for his botanical knowledge. Not wanting the hoopoe, because of its uncleanliness, to build a nest in the sycamore tree in his garden, he tried to dissuade it by destroy-ing its nest several times. Having failed, he finally "brought a board and put it over the cranny of the tree and nailed it in. What did the hoopoe do? It went and brought a certain kind of herb and put it over the nail and burned it. What did R. Simeon b. Halafta do? He said, 'It is best for me to hide away that herb, so that thieves will not learn to do the same thing and destroy the entire world.'"[33] The episode, while maintaining a specific Jewish overtone, is another retelling of the same tradition, with all the usual elements.[34]

This brief survey, which almost certainly does not exhaust the catalogue of extant sources, shows that knowledge of this peculiar plant and its guardian bird had circulated since at least Hellenistic times and was widespread both in the East and the West, being available in Latin, Greek, and Hebrew sources and, quite likely, in Arabic ones.[35]

Given the relative chronology of the sources just mentioned, the bird that was originally associated with this tradition of sudden openings and treasures was almost certainly the woodpecker, an animal capable of breaking open and destroying very hard surfaces. In a world ruled by sympathetic magic, it is not difficult to see how a plant credited with the property of breaking something hard could be entrusted to a bird that could do the same with its beak.

How the hoopoe came to be associated with this tradition is hard to tell, but it is not unlikely that a certain degree of superimposition was aided by the fact that hoopoes often lay their eggs within abandoned nests previously drilled by woodpeckers. Moreover, the influence (or confusion) appears to be somewhat mutual, since the woodpecker also tends to acquire traits that are more typical of the hoopoe.[36] In the above-quoted passage, Aelian says that hoopoes smear their nests with "human excrement, and by dint of its disgusting and evil smell they repel and keep away the creature that is their enemy." This is not a sheer imaginative detail (aside from the employment of human excrement), since the chicks of this bird do actually produce a dark secretion through their uropygial gland, which, along with the liquid contents of their intestine, can be sprinkled onto their enemies in smelly jets.[37] And the confusion sometimes extends to

the bee-eater (*merops* in Latin), which was identified by Conrad von Megenberg in the fourteenth century as the carrier of a similar plant (which he calls *herba meropis*), even if Megenberg himself states that the name of the bird in German is *Paemhaeckel* (modern *Baumhacker*, "woodpecker").[38]

The identification of the actual or original bird of the story, however, is not fundamental for our purposes and is clearly a detail that could be easily altered, depending on the specific tradition handing it down. The Solomonic case shows this point well. The translation of the talmudic *tarnegol bara*, for instance, oscillates between wild cock, woodpecker, "rock splitter," and hoopoe, though the last is the one chosen in most modern translations.[39]

The identification of the bird carrying the plant was in fact not unanimous. Much later, in the tradition inaugurated by Peter Comestor (d. 1180), which will be repeated by several other Western authors during the Middle Ages, the bird becomes an ostrich, while the Arabic author al-Qazwīnī (1203–1283) said it was an eagle ("ʿaqāb"), which retrieved a stone capable of cutting other stones from the Samur mountain ("gebel as-samur");[40] the presence of an eagle (retrieving the *shamir* from Eden this time), as far as I know, is attested among Jewish sources only in the *Yalkut Shimoni*, a collection of midrashic accounts usually dated around the thirteenth century.[41]

A Christian Egyptian tale, translated by Emile Amélinau from Arabic, without, unfortunately, any precise reference to its provenance or dating, mentions instead the *rukh*, a legendary bird of prey with royal features. The story follows a familiar path: The chick was imprisoned under a brass pot and was freed thanks to a piece of wood endowed with special properties, which its mother retrieved from paradise. With it, Solomon's men could finally cut the Temple stones.[42] Unlike the other versions, however, this account has an interesting sequel. The piece of wood was kept in the Temple and decorated with thirty collars of silver until the time of Christ, when the silver became the price for the treason of Judas and the wood the actual material of the cross.[43] Here the *shamir*, which is never openly called by that name, is put in direct relationship with the wood of the cross, which inscribes it within the story of salvation and moves it from a Jewish to a Christian context. This development appears only in this tradition and shows how freely oral traditions could be elaborated—and thus changed—for reasons that found legitimization in narratives of different kinds. It is interesting to remark that this specific version had an influence also on the Ethiopian culture and on the saga of the queen of Sheba.[44] In the table that follows, I have grouped together the textual occurrences discussed in this section.

The analysis of these sources in comparison allows us to advance a hypothesis regarding the different filiations of the tale. Assuming, as seems likely, that

TABLE 1 Main sources for the "blocked nest" (or "entrapped chick")

Source	Kind of bird	Protagonist	Item	Name
Trebius/Trogus (first century BCE)	woodpecker	–	herb	–
Pliny (23–79 CE)	woodpecker	–	herb	–
Aelian (second–third centuries CE)	woodpecker/ hoopoe	–	herb	–
Cyranides (fourth century CE)	woodpecker	–	herb	–
Leviticus Rabba (fifth–sixth century CE)	hoopoe	R. Simeon b. Halafta	herb	–
Bavli (fifth–sixth century CE)	*tarnegol bara (dukhifat / nagar tura)*	Solomon	–	*shamir*
Peter Comestor (?–1180 CE)	ostrich	Solomon	worm blood	*tamir*
Garnier of Rochefort (1140–1225 CE)	ostrich	Solomon	worm blood	*thamir*
Gervase of Tilbury (ca. 1150–1228)	ostrich	Solomon	worm blood	*tamir*
Vincent de Beauvais (1190–1264 CE)	ostrich	Solomon	worm blood	*thamur*
Thomas of Cantimpré (1201–1272 CE)	ostrich	Solomon	worm blood	*thamur vel samier*
Gesta romanorum (thirteenth century CE)	ostrich	Diocletian	worm	*thumare*
Pseudo–Albertus Magnus (thirteenth century CE)	woodpecker	–	herb	–
Al-Qazwīnī (1203–1283 CE)	*'aqāb* (eagle)	Solomon	stone	*samur*
Yalkut Shimoni (thirteenth century CE?)	*nesher* (eagle)	Solomon	–	*shamir*
Speculum humanae salvationis (fourteenth century CE)	ostrich	Solomon	worm blood	–
Hugo von Trimberg (ante 1313 CE)	ostrich	Solomon	worm blood	–
German translation of the *Speculum humanae salvationis* (fourteenth century CE)	ostrich	Solomon	worm blood	–
Heinrich von München (fourteenth century CE)	ostrich	Solomon	worm blood	*thamyr*
Conrad von Megenberg (d. 1374)	*merops*	–	herb	*chora* (or *thora*) / *herba meropis* / woodpecker plant
Egyptian Tale (undated)	*rukh*	Solomon	wood	–

the compilers of the Talmud could access a tradition similar to that reported by Aelian or, even more likely, by the Midrash Leviticus Rabba, the omission of the vegetal nature of what would soon be identified with the *shamir* can be seen as a conscious choice: including it would have somewhat contradicted the scattered notions emerging both from rabbinic discussions and from the Bible (with the exception of Isaiah), which, up until then, had tended to identify it with a hard, cutting substance. Still, the element of relevance in the tale of the bird—namely, the property of the plant to dissolve hard materials—was incorporated and associated with the *shamir*, which already existed in the Jewish tradition and seemed to share the same quality.

Almost the converse occurred with the Egyptian Christian tale translated by Amélinau, whose compilers were more concerned with the royalty of Solomon from a Christian perspective than with the subtleties regarding the nature of the *shamir*. The episode, in fact, mirrors closely that of Bavli (thus implying knowledge of the talmudic story, which, as seen, connected for the first time Solomon and the *shamir*) and was also based on other rabbinic sources.[45] It nonetheless omits the name of the miraculous substance while specifying its vegetal nature, thus demonstrating knowledge of the Aelian tradition as well. Within the context of Christian Egypt, however, identifying the bird's tool with a piece of wondrous wood, rather than with a plant or with an unspecified object, was not an irrelevant detail, considering that it was the same wood that allegedly was later used to make the cross of Christ.

This comparison not only illustrates the freedom with which extant narrative traditions were manipulated and altered for different purposes, but also indirectly demonstrates that the vegetal nature of the *shamir* (as a root, herb, or piece of wood) is clearly the product of a cultural superimposition, having nothing to do with the most widespread and famous interpretation up until then, that of the *shamir* as a hard material. The grafting of the tale of the "blocked nest" onto the *shamir* tradition was eased by way of an analogy, a superficial similarity, in terms of property, between the herb of that originally independent account and the biblical tool.

The reason for this conscious recrafting of two different and initially distant stories depended, among other factors, on the necessity of providing a more solid background for the problematic status of the tools required in the Temple-building process. It is clear that the elaboration and enlargement of the specific episode with the inclusion of the quest for the *shamir* was meant to address and solve the biblical prohibition of iron instruments. In many cultures, this metal had problematic implications and was associated with the sphere of sacredness, since it retained a connection with impurity and evil.[46] Thus, the problem

raised by the scriptural text (and by its underlying ancient taboo) was solved by logically excluding iron from the discussion and welcoming a different material, whose nature was somewhat mysterious. Thus, the original meaning and use of the term *shamir* were flattened and partially altered; what remained was its main feature, cutting rock.

The fact that in some of the sources mentioned the *shamir* is identified as a plant, exactly as it is in Isaiah, seems to me to reflect a historical coincidence and not any sort of subterranean continuity. I would argue, in fact, that the briars of the prophet have nothing to do with the "bursting" plants that open nests or treasury caves, which, on the contrary, find parallels in several other accounts regarding the magic properties of certain herbs and in plant lore.

An interesting survey of this material was carried out a few decades ago by Sabine Baring-Gould,[47] who listed, among others, the unidentified springwort known mainly through German folklore,[48] the forget-me-not, the sesame seed, saxifrage,[49] and caper spurge, to which we could add the Italian *sferracavallo*,[50] all credited with the power of breaking bolts or bars, opening up subterranean caves full of treasure, and repelling iron, to the point of causing horses to lose their shoes whenever they tread on it.[51]

Baring-Gould, in analyzing this varied corpus of occurrences, proposed identifying the bird as a personification of a storm cloud, as occurs in different cultures, and seeing the action of dropping the plant on its nest as the enactment of a thunderbolt. He compared the bursting, almost dramatic quality of this event to the effect caused by lightning on hard surfaces. Although not all the details of his reasoning seem entirely convincing to me, his overall reading is fascinating. Baring-Gould substantially interpreted the tale of the "blocked nest" as the mythical reenactment of a natural phenomenon (a thunderbolt),[52] originally dense with religious, symbolic, and even iconographic implications.[53]

In a recent article, however, the same magic property of these corrosive, destructive plants has been clarified in yet a different way, by resorting to a chemical explanation; the *Dichapetalum cymosum* (Hook) is a plant capable of producing fluoroacetic acid, from which hydrofluoric acid can be obtained.[54]

Beyond the likelihood of these interpretations, what seems beyond doubt is that the specific cultural segment of the story of the "blocked nest," broadly regarding the folklore of plants in association with (mythical) birds, has its origin in something that falls well outside the Bible but has intersected the *shamir* story—in a certain way it has been attracted by it, given some formal analogies—thus enriching it with its own narrative background.

The Medieval *Shamir*

During the Middle Ages, the *shamir* is suddenly transformed into a worm. The metamorphosis probably occurs in the works composed by Rashi (1040–1105 CE). He mentions the *shamir* several times, both in his biblical commentary, where he refers to the ancient meaning of the word in relation to the passage from Ezekiel, and in his talmudic one, where he writes, "The *shamir*—it was like a type of worm and no hard substance could resist disintegrating in front of it, and Solomon built the Temple with it, as described in the tractate *Gittin*."[55]

To describe the *shamir* Rashi does not employ the broad term *birya*, literally "creature," "created being," "entity," which, as seen, had appeared in the Tosefta. Instead, he uses the expression "ka-min tola'at" (a sort of worm). The reason why Rashi interpreted the *shamir* as he did is not entirely clear, although his reasoning likely depended on a slightly ambiguous passage of the Talmud (Sotah 48b), which could have implied that the *shamir* had eyes.[56] However, the text literally says that the *shamir* was shown toward the external part ("mi-ba-ḥutz") of the rock to be cut, and the verb used—*mar'e*—is a present *hifil* of the *resh-alif-hey* root "to see" in a causative form. This action should perhaps be interpreted, then, as a sort of "exposure" to the *shamir*, rather than a physical perception actively carried out by it.

In any case, it is relatively easy to see how, through a quite literal reading, an entity as small as a barleycorn, and possibly capable of seeing, could be identified as a worm. Of course, if we look at the words closely, Rashi did not actually declare that the *shamir* was a worm, but that it was something similar. This subtle lexical distinction, which, I think, should be taken as a tentative suggestion ("a sort of worm") rather than a precise taxonomical definition ("a specific species of worm"), was lost in the long chain of transmission as the *shamir* came to be equated with a worm *tout court*.[57] We do not know whether this interpretation is Rashi's originally or if he was repeating another, unknown source, but, given his great renown, it is almost certain that it was through his writings that it became popular during the Middle Ages. What is certain is that, as Martin Przybilski has shown, the identification of the *shamir* was still a matter of debate among Jewish scholars even during the Middle Ages, and it was far from being settled in a unanimous way.[58]

In the other great commentary of the time, that of Maimonides (1135–1204 CE), there is no explicit mention of any worm. Writing in Arabic, he uses the expression "ḥayawān ṣaghīr" (small living being, small animal) to define the

shamir.[59] *Ḥayawān* implies an idea of life, and, as such, it is applied equally to animals and humans, in the sense of living creatures.[60] To me, it appears not too distant from its Hebrew equivalent, *birya*, usually employed to describe the *shamir* in talmudic sources. Maimonides was probably thinking of this word when he rendered the expression in Arabic. Without context, however, it is easy to see how this gloss could have eventually led to the identification of the *shamir* with an animal.

From a methodological point of view, Rashi's reading has proven quite successful, to the point of influencing modern translations and interpretations of rabbinic texts. Several authors, in commenting on the Mishna, the Tosefta, or the Talmud, have glossed the *shamir* as a worm, as if this view was shared by those who compiled the texts. However, none of the original Hebrew texts I could consult seem to support this point, and we need to stress once more that the *shamir*-worm is an eleventh-century invention, certainly not a late antique one.

According to some scholars, the *shamir*-worm appears also in the writings of certain Arabic writers as early as the eleventh century, first in the Quranic *tafsir* by al-Zamakhsharī (1075–1144) and then in its abridged and partially revised version by al-Bayḍāwī (d. 1286),[61] as well as the account reported by al-Thaʿlabī.[62] However, having checked the sources in question, I believe this conclusion is based on an incorrect inference, and I think we should dismiss it.[63] Al-Zamakhsharī, in commenting on the encounter between Solomon and the queen of Sheba (Qurʾān 27:20), reports that among the gifts she gave to the king was a casket, whose contents he was asked to reveal, without opening it, as a test of his wisdom, intelligence, and prophethood. Solomon correctly answered that the box contained an intact pearl and an onyx bead drilled with a crooked hole (or a bead pierced with a hole, according to al-Thaʿlabī's version). The second part of the challenge, then, consisted of cutting through the pearl and finding a way to pass a thread through the bead, a problem Solomon brilliantly solved by respectively asking a tree worm and a white worm to carry out these two tasks.

While a worm cutting through a pearl is vaguely reminiscent of the *shamir*, the structure, context, and content of the episode are altogether different and do not seem to bear any direct relation to it; additionally, the term *shamir* and its Arabic equivalent *samur* are never explicitly mentioned in the episode. I am therefore inclined to think that the mention of the tree worm and the white worm in relation with Solomon is a coincidence, not part of the *shamir* tradition. Moreover, the presence of a worm in connection with Solomon is not unheard of in the Muslim world; a worm also plays a role also in the episode regarding Solomon's dead body set on his throne. The Qurʾān reports

(34:14) that a worm gnawed the staff on which the seated body leaned, making it fall and revealing that the king had long been dead and no longer ruled over the jinn.

Moreover, if we accept the direct relation between the story of the *shamir* and that of the two worms, we need to account not only for the extreme (and most unlikely) rapidity with which the new interpretation of the *shamir* as a worm reached the Arabic world, but also for its deep metamorphosis. What appears as only a short gloss in Rashi's commentary occurs in al-Zamakhsharī or al-Tha'labī's commentary within an autonomous narrative that has the complexity and flavor of a tale. Thus, I would be cautious about accepting that the *shamir*-worm penetrated early into Muslim religious literature. I would be more inclined to see al-Qazwīnī's account of the eagle, though partially modified, as the first known transmission of the *shamir* story from the Jews to the Muslim world.[64]

However, the *shamir* certainly appears in the writings of several Christian authors at the end of the twelfth century. The most ancient account is handed down by Peter Comestor (d. 1180), who relates that Solomon used the blood of a worm ("sanguinem vermiculi"), called "tamir,"[65] for cutting the stones of the Temple. He had stolen the worm from an ostrich after obstructing its nest.[66] This text is the direct source for a passage in the *Otia imperialia* of Gervase of Tilbury (ca. 1150–1228).[67] A very similar story is related by Vincent of Beauvais (ca. 1190–1264), who calls it "vermis Salomonis."[68] It appears in the anonymous *Gesta romanorum*, with Diocletian as the protagonist,[69] in Thomas of Cantimpré (1201–1272)'s encyclopedia, indexed as "thamur vel samier" in the section dedicated to worms,[70] and in the *Speculum humanae salvationis* (fourteenth century).[71]

Peter Comestor explicitly says that the identification of the *shamir* with a little worm ("vermiculum") goes back to a Jewish source ("fabulantur Judaei"). This agrees well with what is known of the contacts between Jewish and Christian scholars in France during the twelfth century. Peter probably had direct access to firsthand midrashic material in general and to Rashi's works in particular, since he was not only a native of Troyes, like Rashi before him—and could have therefore met and talked to some of his successors, such as the rabbis Tam and Rashbam (Rashi's grandsons), while he was dean of St. Peter's Cathedral between 1147 and 1165—but could have drawn from Rashi's works through the mediation of Hugh of St. Victor and the pupils of his school in Paris, who made constant reference to these Jewish sources in their biblical commentaries.[72] Martin Przybilski, moreover, has shown the wide circulation of this material in German medieval literature, confirming that the *shamir* story penetrated via Jewish contacts but also through the mediation of other

Christian sources, and some texts, such as the *Weltchronik* by Jans der Enikel (thirteenth century), keep traces of this double process in its lexical choice.[73] In this context, it is necessary to posit a certain degree of reelaboration at an oral level, since none of the Christian sources repeat in exactly the same way all the details of the story.[74] Some elements, such as the blood of the worm, appear to be original inventions, typical of this specific transmission branch. Traces of this process appear evident, for instance, in the German poem *Das Lob Salomons*, dated between 1050 and 1150, where it is narrated how Solomon is instructed by a "Wurm" on how to construct with the arteries of an animal living in Lebanon a string capable of cutting all stones.[75] It is interesting to remark that the accent posed on the salvific power of this fluid, a specific feature of Christian authors, will give rise to a textual tradition directly associating the worm blood with that of Christ,[76] as it happens in the work of Garnier of Rochefort (1140–1225),[77] in *Der Renner* by Hugo von Trimberg (*ante* 1313),[78] and in the German translation of the *Speculum humanae salvationis* traditionally attributed to Konrad von Helmsdorf (fourteenth century), which also illustrates it.[79] This theme will become extremely popular in the Western world, and it will give rise to a rich visual tradition, particularly in relation to the *Speculum humanae salvationis*, where the episode of the freeing of the chick by virtue of the salvific blood becomes a prefiguration of Christ's descent into limbo.[80]

Furthermore, even if most known medieval sources aligned with the worm interpretations, we have traces, once more, of the subterranean persistence of older, conflicting ones. The *De animalibus* by Albertus Magnus (1206–1280) contains a brief entry on the *samir* or *thamir*, which "dicunt esse verme quo vitra et lapides dividentur" (is a worm with which—they say—glass and stones can be cut). It is clearly among the "erroribus Judeorum" (a fancy of the Jews), a notion almost certainly transmitted by the tradition inaugurated by Peter Comestor.[81]

In the *De mirabilibus mundi*, however, a work circulating under the name of Albertus but almost certainly apocryphal, the author recommends a fascinating method for bursting chains: one should go in the woods and find the tree where the woodpecker ("pica") has made its nest, block it by whatever means, and wait for the bird to come back with "quadam herba quam ponit ad ligaturam, et statim rumpitur" (a certain herb capable of immediately destroying the obstacle). The description does not explicitly mention Solomon, the Temple, or the *shamir*, suggesting that it is referring back directly to the Trogus–Pliny–Aelian tradition, probably via the transmission of practical magic texts, such as the *Cyranides*, mentioned above,[82] which still enjoyed a certain success during the thirteenth century, as other similar texts seem to confirm.[83] While

De mirabilibus mundi and *De animalibus* were probably not written by the same author, they were in circulation during the same period of time and clearly show the simultaneous survival in the Western world of two independent traditions (blocked nest / *shamir*) that had merged (bird bringing the *shamir*) but would continue to be transmitted independently with the addition of some new features (magic plant / magic worm). Despite the authoritativeness of great scholars such as Rashi, who had established a new identity for the *shamir*, the partial contradictions caused by the historical superimposition of different narrative and cultural threads remained and were destined to multiply further in the following centuries, or to be duplicated within the same source.[84]

Modern Interpretations

De la Voye's letter to Auzout describing a type of worm, small as a barleycorn, that allegedly fed on stones makes no explicit reference to the *shamir*.[85] However, it seems unlikely that the image of the barleycorn, identical to that appearing in the Talmud, was the product of sheer coincidence. De la Voye was very likely trying to provide a solution to the question that had haunted Jewish scholars for centuries. While the writers who quoted his scientific results could hardly have understood the repercussions of that specific observation, that detail of the barleycorn size has not escaped contemporary readers, who, more aware of its implications, have employed the illustrations that were later added to the description to finally give a recognizable shape to the *shamir*.[86]

Following more or less consciously in De la Voye's wake, other scholars have tried to make sense of the *shamir* as a rock-boring organism: Rabbi Moshe Tendler has proposed a *Euchondrus* snail, found in the Negev,[87] while others have suggested the funnel-weaving spider (*Tegenaria domestica*) as a possible match.[88] I am sure that, among the large catalogue of biological entities, one could still find several other possible candidates.

Another type of interpretation, addressing, this time, the field of physics rather than that of biology, was advanced by Immanuel Velikovsky, whose work in general has always been the focus of great controversy. Velikovsky first listed all the features that the sources attributed to the *shamir* and then proposed a solution that could theoretically account for all of them. He listed its green hue (reported in the Testament of Solomon), the way it could engrave gems on breastplates, its "inactivity" after a certain period, and its peculiar receptacle, made of lead. He then argued that it must have been a radioactive substance, such as radium salts, that could have disintegrated other materials without leaving any residual material.[89] Through this hypothesis, he also accounted for

the alleged green hue of the stone (because of the luminescence typically emitted by certain radioactive materials), the "inactivity" of the *shamir* (corresponding to the phase of radioactive decay),[90] and its separate storage in a lead tube with wool (to avoid contamination).

This reading is quite problematic in methodological terms, not only because it assumes a knowledge of radioactive substances in antiquity similar to ours, but, more importantly, because it considers all the elements ascribed to the *shamir* by different sources and at various times on the same level, as if they were a sum of features that could be listed together, without ever taking into account the possibility of a metaphorical, poetic reading of his sources or the intrinsic contradictions of the different rabbis' views.

Such an approach might have been eased—in this and many other cases—by the fact that the *shamir* is actually described and presented as a sum of elements in many easily available modern collections, such as Ginzberg's *The Legends of the Jews*.[91] Ginzberg aimed precisely at collecting legends and narrative material together, resorting to a method of quotation not too different from the one used traditionally by rabbis, who drew on the whole body of their literature and teachings.

Velikovsky's case shows the flaws of an approach that tends to overlook the philological filiation of certain elements; thus, some of his conclusions are based on wrong assumptions (for example, the stone of the Testament of Solomon is almost certainly not the *shamir*), while most of the features taken into consideration are the product of distinct, if not actually conflicting, rabbinic opinions.

Nevertheless, his theory has proven quite successful in opening the way to a series of even more explicit readings in this vein and of several pseudoscientific interpretations.[92]

Conclusions

Table 2 summarizes the main textual occurrences of the *shamir*, either explicitly named as such or recognizable by virtue of its main property. Of course, the Trebius/Trogus–Pliny–Aelian–Leviticus Rabba tradition becomes meaningful for the *shamir* story only *ex post facto*, by virtue of attraction to the Jewish legend, since it almost certainly had an earlier and fully independent origin. As shown, it also maintained an independent transmission chain. However, its presence in the table is relevant for clarifying the relative chronology of these occurrences.

TABLE 2 What is the *shamir*?

	Mineral *shamir*	Vegetal *shamir*	Undefined *shamir*	Animal *shamir*
Eighth century BCE (book redaction around fifth century BCE)		Isa. 5:6; 7:23, etc. (piercing thorn, not associated with any bird)		
Ca. 650–586 BCE (book redaction around fifth century BCE)	Jer. 17:1 (writing tool with a hard point)			
Ca. 620–570 BCE (book redaction around fifth century BCE)	Ez. 3:9 (hard writing surface)			
Fourth century BCE	Zech. 7:12 (hard writing surface)			
First century BCE		Trebius Niger / Trogus (woodpecker herb) *unnamed		
23–79 CE		Pliny (woodpecker herb) *unnamed		
165/170–235 CE		Aelian (woodpecker/ hoopoe herb) *unnamed		
		Midrash Leviticus Rabbah (hoopoe herb) *unnamed		
Ca. 200 CE			Mishna (ceased to exist after the destruction of the Temple; among the first ten things created on the eve of the first Shabbath)	
Ca. 300 CE			Tosefta (wrapped in wool and kept in a leaden tube full of barley bran; use debated among the rabbis; either for cutting the stones of the Temple or for small engravings)	

	Mineral *shamir*	Vegetal *shamir*	Undefined *shamir*	Animal *shamir*
Ca. fourth century CE		*Cyranides* (woodpecker herb) *unnamed		
Third–fifth century CE			Babylonian Talmud (size of a barleycorn; created on the sixth day; entrusted to the "wild cock" / hoopoe)	
1040–1105 CE				Rashi ("a sort of worm," *ka-min tola 'ot*)
1135–1204 CE				Maimonides ("small creature," *ḥayawān ṣaghīr*)
?–1180 CE				Peter Comestor (worm blood)
Ca. 1050–1150 CE				*Das Lob Salomons* (arteries of an animal living in Lebanon)
1140–1225 CE				Garnerius von Rocherfort (worm blood)
1155–1234 CE				Gervase of Tilbury (worm blood)
Ca. 1190–1264				Vincent of Beauvais (worm)
1201–72				Thomas de Cantimpré (worm)
Ca. mid-thirteenth century				Jans der Enikel (worm)
1206–80 CE		Albertus Magnus, *De animalibus* (woodpecker herb) *unnamed		
1206–80 CE		Albertus Magnus, *De vegetabilibus* (*herba meropis*, opens closed locks)		
Thirteenth century CE				Pseudo–Albertus Magnus, De *mirabilibus mundi* (worm)

	Mineral *shamir*	Vegetal *shamir*	Undefined *shamir*	Animal *shamir*
Ca. 1200–54		Rudolf von Ems (herb)		Rudolf von Ems (worm blood)
Thirteenth–fourteenth centuries CE				*Gesta Romanorum* (worm)
Ante 1313				Hugo von Trimberg (worm blood)
Fourteenth century CE				Konrad von Helmsdorf (attr.) (worm blood)
Fourteenth century CE		Heinrich von München (herb)		Heinrich von München (worm blood)
Fourteenth century CE		*Reinfried von Braunschweig* (herb)		*Reinfried von Braunschweig* (worm blood)
Undated		Egyptian tale (*rukh* wood)		
Ca. 1660 CE				de la Voye et al. (rock-boring organisms, snails, spiders, etc.) *unnamed
1663–	Bochart et al. (corundum/ emery)			
1980–	Velikovsky et al. (radioactive substances / alien technology)			
2002		Mangolini (plant releasing acid)		

The analysis of the segment of the story dealing with rabbinic descriptions of the object, in turn, has underlined two main points of interest. First is the presence of distinctive traces of conflicting exegetical interpretations, pointing respectively to the *shamir* as a tool for delicate incision (probably a function much earlier than the other, but, retrospectively, also less successful) and as a device for monumental stonework, directly associated with the topos of the construction of the Temple without iron instruments, and developed later on

in an independent tale, fully related in the Talmud. In turn, this tale is a conflation of motifs of different origins: a frame similar to that of the Testament of Solomon with the addition of a bird legend that includes elements of plant lore, known at least since Hellenistic times.

On a closer look, then, the elusive nature of the *shamir* is the consequence of different exegetical waves and of the superimposition and merging of independent narrative traditions. Throughout a very long historical arc, the only fundamental detail to be transmitted virtually unaltered has been the relationship between the *shamir* and hard materials. The scanty textual details and the likely obscurity of the first biblical occurrences left enough room for speculation: thus, anything that could cut, pierce, or dissolve rocks—or was credited with doing so—could be the *shamir*.

Curiously, this interest in the property of the *shamir* has oriented both more recent scholarship—mostly guided by a positivistic approach aimed at finding a perfect match between texts and reality—and rabbinic and medieval Jewish interpreters alike. In this sense, the story of this very obscure substance is exceptionally consistent, if we consider the methodological approach bringing scholars and erudite people across the centuries to keep posing the same question: What is the *shamir*?

In my contribution, however, I have tried to move the focus of the investigation away from the mere ontological aspect and to problematize, instead, the legend-building process, by showing how this ambiguity arose over time and to avoid the methodological risk inherent in such an approach. Seen from this perspective, the scenario that emerges is much less garbled than the premises would lead one to expect. The Jewish *shamir* "attracted" other traditions that, although originating independently, bore certain similarities to it. In this way, many elements that, either via folklore or through direct observation of something real, shared a *shamir*-like quality (in a very broad sense) came to be associated with it.

At first glance, the chaotic accumulation of details may seem to have created a confused scenario, but if we make distinctions on the basis of the chronology of the occurrences and of the cultural interpretative contexts in which these changes of perspective originated, we can easily identify four consistent strands: (1) a biblical scenario, concerned with a writing tool whose point was made from a very hard substance, probably emery, which could recall certain piercing thorns; (2) the rabbinic debate, where biblical, pseudepigraphic, and Hellenistic traditions merged, creating various inconsistencies and endowing the *shamir* with a magical or supernatural aura; (3) a medieval phase, during which, thanks to the authority of Rashi, it came to be identified as a worm; and (4) a modern phase during which scholars have dealt mostly with the heavily

stratified material at their disposal by trying to make sense of it in a more or less coherent way.

The sum of these interpretative and narrative threads, far from constituting a consistent ensemble, has come down to us as a list of features that are often attributed to the *shamir* without chronological or cultural distinction.[93] This is why certain explanations, however fascinating, are problematic: many scholars mistakenly take such material as a unitary whole, trying to keep all the elements together; in so doing, they risk building an interpretation from a previous interpretation, as clearly happens with Rashi's worm. Consequently, the multiple answers provided to the question "What is the *shamir*?" have really responded to a different issue, which one could more accurately phrase as "How many things in nature have the power to cut through stone?" There has been, I think, a substantial confusion between the synchronic and diachronic development of this tradition.

The story of the *shamir* and of its successive interpretations can thus be read in different ways: as an interest in the development of sophisticated working techniques for hard materials (tool); as a legendary or mythical counterpart to protoscientific observations of unexplained natural phenomena (worm, plant, lightning, etc.); as an instrument for theological or exegetical reasoning (iron taboo). In any case, symbolic and practical elements are often joined together, and it is not always easy nor possible to discern the two levels. Magical or supernatural entities, as they are handed down in ancient accounts, can often serve us as (distorted) lenses for appreciating unexplained natural marvels or transfigured traces of technical progress, as they appeared in the eyes of our predecessors. It would be a mistake to try to extract a single explanation from this rich mess, since it would not mirror the actual historical complexity of these traditions.

For this reason, it is my contention that, given the wealth of material coalescing around this topic over time, almost anything, from acid to diamond drills, from rock-boring organisms to moonwort, from lightning to radioactive metal, can, in theory, rightfully be considered a *shamir*, if we identify the object with its main property, that is, with its effect on other substances. In a way, in fact, the *shamir* has been (or has embodied) all of these things, although none of them continuously. This answer may not reflect its correct and philological origin—which is clarified, I think, by the early corundum hypothesis—but it does mirror the exegetical succession concerned with it, thus having a strong historical and traditional value in itself.

6

CARPETS AND OTHER FLYING DEVICES

Bed, take me to the Isle of Naboombu!

—*Bedknobs and Broomsticks*

The *Clavicula Salomonis*, a Renaissance grimoire of magic attributed to the king of Israel, collects a series of useful operations, among which we find specific instructions in order to "make the magic carpet proper for interrogating the intelligences, so as to obtain an answer regarding whatsoever matter one may wish to learn."[1] The prescription begins, "make a Carpet of white and new wool, and when the Moon shall be at her full, in the Sign of Capricorn and in the hour of the Sun, thou shalt go into the country away from any habitation of man, in a place free from all impurity, and shalt spread out thy Carpet." The charm, moreover, requires that each of its points be directed toward the cardinal directions and that the carpet be enclosed in a circle. Finally, "holding thy wand in the air for every operation, thou shalt call upon Michael, towards the north upon Raphael, towards the west upon Gabriel, and towards the south upon Muriel."

After the angelic invocation, one should raise the four points of the carpet so that they do not touch the ground and pronounce a prayer invoking God: "Agla, Agla, Agla, Agla; O God Almighty Who art the Life of the Universe and Who rulest over the four divisions of its vast form by the strength and virtue of the Four Letters of Thy Holy Name Tetragrammaton, Yod, He, Vau, He."

This preliminary operation first institutes a parallel between the four letters of God's Hebrew name, the points of the rug, and the four cardinal points, but also between the prodigious mantle of Elijah (2 Kgs. 2:1–18), the carpet, and the divine protection provided by the shadow of the Almighty, famously evoked in Psalm 91. The two series of metaphors follow an overriding geometrical criterion, taking into consideration both the linear dimension of the carpet (with its

points) and its whole area (with images recalling its surface). In this way, the piece of cloth is entirely consecrated. "After this thou shalt fold it up, saying these words following: Recabustira, Cabustira, Bustira, Tira, Ra, A; and shall keep it carefully to serve thee at need." Even the progressively shrinking formula that concludes this first phase echoes the very act of folding: the string of letters shortens as the rug becomes smaller.

The object is now ready to be used for interrogation, on a night of a new or full moon, from midnight until daybreak, a proper and clean place having been chosen; "taking thy carpet, thou shalt cover thy head and body therewith." The operation at this point would require the inscription with a dove feather of special characters on a blue piece of parchment and the thorough fumigation of the carpet, accompanied by a lengthy invocation and the special movements of a wand. If all this is done correctly, the text says, "thou shalt hear distinctly the answer which thou shalt have sought."

This peculiar employment of the rug is certainly not what we would likely associate with magical carpets now. And yet, if we consider actual incantation literature, this is probably one of the few technical instances of a specific magic operation directly associated with such an item. The flying rugs that permeate our imaginary,[2] in fact, have another origin altogether, as we will see. Exploring their earliest mentions and the development of the subsequent tradition in relation with Solomon will constitute the main theme of this final chapter.

Carpets Flying in the *Nights*

In 2004, Azhar Abidi published his famous "The Secret History of the Flying Carpet," in which he gave as a source for his discoveries the thirteenth-century manuscript, newly discovered in an Iranian castle, of Jewish scholar Isaac Ben Sherira. The essay, full of surprising revelations, such as that the flying mechanism was based on an advanced knowledge of magnetism, proved to be a successful literary experiment, a spoof of academic writing without any scientific basis, which, nevertheless, became a famous internet urban legend.[3]

For a truly historical approach to the topic, we should instead turn to Marina Warner, who, among other things, has explored the symbolic interpretation of the carpet as a metaphor for the plot (text/textile) and of the role of the omniscient narrator who can see the unfolding of the stories from a privileged bird's-eye view, as if he himself were flying on a magic carpet.[4] Moreover, she has carried out an in-depth analysis of this element in the *Arabian Nights*, where flying devices figure at various moments—although not as often as we might imagine.

Solomon appears on a flying carpet in "The City of Brass," discussed in chapters 2 and 3. The demon Dahesh, imprisoned in a pillar after being defeated by Solomon, describes how the king had led his majestic army in battle while floating in the air, seated on a giant carpet.[5] The wondrous device also appears (without Solomon) in the "Tale of the Prince Ahmed and the Fairy Peri Banou," where Houssain, one of the three brothers in the story, buys a carpet that can bring its owner wherever he wishes.[6]

Neither of these accounts, however, belongs to the most ancient nucleus of the *Nights*. While the former was added in the nineteenth-century version of the tales but has antecedents dating as early as the ninth century, the latter was probably crafted by Antoine Galland himself (1646–1715), the first translator of the tales.[7] The relatively late inclusion of these stories should not necessarily make us doubt the antiquity of some of the motifs they incorporate. As often happens, the *Nights* are a dense repository of themes developed earlier, a point of arrival rather than of departure. The success of the carpet was immediate and long-lasting, and in Western perception it soon became a favorite element of the wonders of the East, probably also owing to the enthusiasm for flying experiments in eighteenth-century Europe, as Warner suggests.[8]

In addition to these two textual occurrences mentioned by the scholar, there is a brief but explicit reference to the Solomonic carpet in the "Tale of Sympathy the Learned," also known as "Abu al-Husn and His Slave-Girl." Tawaddud, the clever slave who shows herself to be wiser than her master, is asked, "What man prayed when he was neither on earth nor in Heaven?" She replies, "Sulaimān prayed upon a carpet hanging in mid-air between heaven and earth."[9] The origin of this tale seems to be as early as the ninth century, although its nucleus was likely crafted in thirteenth-century Egypt.[10]

Despite the chronological uncertainty posed by the tales, the notion that Solomon could travel through the air had been widespread since at least the seventh/eighth century, known through a series of variants in commentaries, legends, and historical accounts and equally penetrating Arabic, Persian, and Jewish lore. As will clearly emerge, the flying carpet is the product of a conflation of motifs originating in different contexts.

Just as in the weaving of an intricate textile, where multiple strings cross and superimpose, the broad theme of human flight encompasses a variety of cultural threads that are not often easy to disentangle. And although it is not always possible to discern the precise filiation and development of this idea in all its variants—since it is most likely a tradition with a polygenetic origin but overlapping borders—it is possible to give a sense of the different thematic nuclei coalescing around the theme, which develops around such recurring or

alternating elements as the wind, the platform/throne/carpet/chariot, and the royal birds (eagles, griffins, vultures, etc.).

The Wind

At the core of this tradition are three Quranic passages explicitly stating how Allah gave Solomon power over the winds: "And to Solomon [We subjected] the wind, blowing forcefully, proceeding by his command toward the land which We had blessed" (Qur'ān 21:81). Another verse adds that, thanks to the wind, he could travel swiftly: "And to Solomon [We subjected] the wind—its morning [journey was that of] a month—and its afternoon [journey was that of] a month" (Qur'ān 34:12). The last one specifies that Solomon could direct the wind wherever he wished to: "So We subjected to him the wind blowing by his command, gently, wherever he directed" (Qur'ān 38:36).

The sacred text makes no specific reference to flying but seems, rather, to imply the possibility of using the natural force of the air to help with sailing, a notion echoed somewhat in the Bible, which reports the great development of maritime trade under Solomon's rule and the extension of his fleet's journeys (1 Kgs. 10:22).[11]

This series of textual mentions may thus represent a further trace of a tradition we have seen resurfacing elsewhere in relation to metalworking techniques and in the story of the entrapping of the wind (both with bottles and with knots).[12] This tradition connects Solomon with the control of a natural element, wielding powers that recall those of archaic sovereigns, who were in charge of primordial forces, as seen in chapter 3. This, in turn, is perfectly paralleled by the perceived nature of jinn,[13] prereligious, elemental powers born of "scorching fire" (Qur'ān 15:27) or "smokeless flame of fire" (often translated also as "born from hot scorching winds," 55:15). The control over winds and over jinn—themselves incorporeal, airy elements—therefore tends to merge.

In light of this dominion over the air, it is not difficult to see how these Quranic passages could subsequently be reinterpreted in a different, more imaginative way. As will be discussed further in the following section, several relatively early Islamic commentaries will describe Solomon as actually riding the wind.

The Platform/Carpet/Chariot/Throne

Despite the Qur'ān's silence on this point, Priscilla Soucek has shown that the idea that Solomon could fly was in circulation in the Islamic world as early as

the seventh/eighth century, reported by commentators and chroniclers such as Wahb Ibn Munabbih (d. 725/737?) and al-Ṭabarī (839–923), who in turn quotes the accounts of such previous authors as Ibn Isḥāq (d. 769), Muhammad b. Ka'b al-Quraẓī (d. 736), and Ibn 'Abbās (ca. 618–88).[14]

The core of these early accounts depicts a flying court, sometimes complete with stables and kitchens and even the full army and the royal concubines, with Solomon seated on his throne ('arsh), surrounded by jinn servants and dignitaries, transported by the wind (or by jinn assuming an aerial form), and often shaded by birds forming a sort of baldachin with their wings. Depending on the version, this imposing retinue is either simply transported by the wind, set on a gigantic wooden platform, as in the versions reported by al-Ṭabarī,[15] or placed on an immense carpet, half green and half red, lifted by the four winds, as in the later account by al-Kisā'ī (eleventh and twelfth centuries). In al-Kisā'ī's description, "no one except God knows how long or wide it was, but it is said that it was six hundred and sixty cubits long. Then he would sit on his throne, borne aloft on a carpet from paradise. The learned men also rode with him, borne with the winds and shaded by the birds. Solomon held the reins of the winds in his hands as one holds the reins of a horse. He would lunch after crossing a distance that would normally have taken a month and would dine after another month's journey."[16]

This description also migrates into midrashim,[17] figuring prominently in modern collections of Jewish tales and legends, where the carpet is sometimes described as a huge cloak/robe.[18] In contrast to the Arabic descriptions, these later Hebrew texts tend to include an element of moral judgment connected to the idea of flight, a sort of meditation on humbleness (or a caveat against excessive royal pride), which, as we will see shortly, is a motif that recurs elsewhere, particularly in the Persian tradition, but does not seem to have been part of the Arabic one at the beginning.[19]

The alternation of the carpet and the wooden platform throughout the different versions of the story is not particularly problematic. These descriptions represent the typical fashioning of a Sasanian courtroom, with its carpentry usually covered by large and sometimes fabulous tapestries. The carpet indicates, as a sort of pars pro toto, the royal space, the throne hall, and, by extension, the whole palace. Choosing to describe the support or its textile cover is just a matter of personal taste.

To illustrate this point, I offer as a comparison the almost legendary description of the Takht-i Ṭāqdīs (Throne of Consecration) of Khosrow II—whose details have been handed down in some versions of the Shāhnāma by Firdawsī (940–1020 CE)[20] and also by al-Tha'ālibī (961–1038).[21] The ensemble, described as a sort of rotating, mechanical planetarium, a precious covered baldachin,

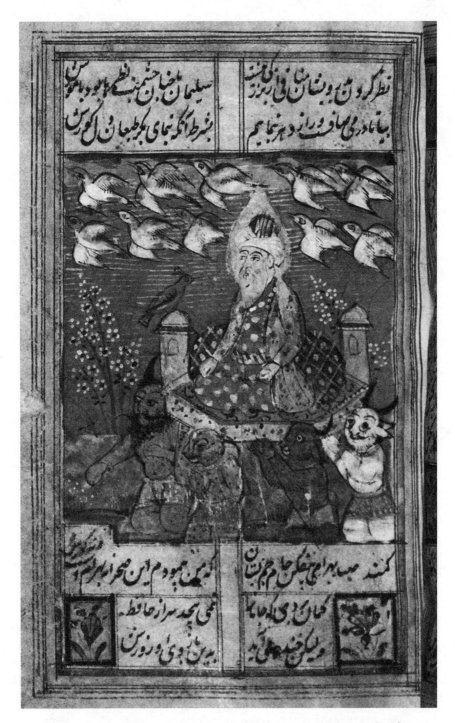

Fig. 17 King Solomon Flying on His Throne Carried by Jinns, in Moḥammad Ḥāfiẓ-i
Shīrāzī (fl. fourteenth century CE), *Dīwān* (manuscript completed 1796). Baltimore,
The Walters Art Museum, Ms. W.636, fol. 125r. Photo © The Walters Art Museum.

combined the technical virtuosity of astronomical knowledge and the sym-
bolic implications of a celestial throne, inscribing the ruler in a dimension of
cosmic kingship.[22]

The attention of scholars has been caught mainly by the representation of
the upper part of this room, its giant, vaulted ceiling, its celestial representa-
tions, the acoustic and dynamic effects of the space, its relationship with clocks
and automata of antiquity. However, for the purposes of this chapter, it is par-
ticularly interesting to focus on the lower part of the throne room, on its size,
its carpentry, and the disposition of its furniture.

Al-Tha'ālibī mentions a throne made of ivory and teakwood, with silver and
golden slabs and railings. He gives a measurement of 180 cubits in length and
130 in width for the platform and adds that on its steps were thrones made of
chestnut and ebony encrusted in gold. The throne of the sovereign itself was
covered by four carpets, woven in golden thread and rubies and embroidered
with golden brocade, each of them representing a season.

A passage appearing in certain versions of the Shāhnāma relates that carpen-
ters from Constantinople, China, Makran, Baghdad, and Iran were employed to
construct the room. Its length was allegedly 170 royal spans, and its width 120.
The text insists on the detail of textiles, saying that each morning new carpets
were laid down to cover it in its entirety. Beside the throne of the sovereign were
three more seats on the steps around it. The lowest, mish sar (ram head), was so
called because of its ram-shaped ornament and was used for the rank of the
decans; the second, ladjwar (blue), had a decoration made in lapis lazuli, for the
knights; the highest, all in turquoise, was for the dastur, responsible for the busi-
ness of the kingdom. And on the king's seat was a fifty-seven-span-long Chinese
brocade with jewels, on which the seven planets were represented, along with
the seven kishwar (regions/climatic areas) of the earth and portraits of the
notables of Iran and Constantinople and of the forty-eight great kings with
their crowns and thrones.

It is evident from both these descriptions that the throne area was consti-
tuted by a broad wooden platform. Al-Tha'ālibī reports that the throne area—
takht being not necessarily just the seat but the whole setting—was 180 cubits
in length (144 meters), 130 in width (104 meters), and 15 in height (18.75 meters).
Firdawsī, instead, gives a figure of 170 royal spans for the length (136 meters)
and a figure of 120 royal spans for the width (96 meters). These imposing pro-
portions—whether or not entirely accurate—can be explained by the need to
accommodate a large entourage placed around the seat of the sovereign accord-
ing to court etiquette.

Moreover, both texts insist on the presence of large carpets covering both
the floor and the throne of the sovereign. There is no need to doubt the accuracy

of such information, or at least of its historical likelihood, since carpets long defined the culture of Sasanian Iran.[23] In his chronicle, al-Ṭabarī mentions another celebrated carpet, whose size and beauty were so legendary that it was given a name, the *Vahār-i Khosrow* (Spring of Khosrow).[24] Said to represent a wonderful garden, it was 140 meters long and 27 meters wide, interwoven with golden and silver threads, precious stones, and silk. In 637, after the fall of Ctesiphon, it was cut into pieces and sold by the Arab conquerors.[25]

It is therefore not difficult to see how the wooden platform sustaining King Solomon's large retinue described by earlier Islamic authors could be turned into a huge carpet: the two things were largely complementary and, in the minds of contemporaries, were part of the same courtly imagery inherited by Sasanian sovereigns.[26]

Thus, the representation of a full display of power, cast according to a Sasanian kingly model, constitutes the second cultural element in the creation of the Solomonic magic carpet—the first being, as seen, the dominion over the wind made explicit in the Qur'ān. These two very distant paradigms of kingship, an archaic and a historically sophisticated one, were probably fused together through the indirect interference of a third factor, "the complex manner in which Solomonic legends and those connected with the Persian ruler Jamshid had interwoven," as underlined by Soucek.[27] In addition to a series of similar civilizing deeds (invention of metalworking, control over demons, construction of buildings, control over the wind, foundation of baths, etc.) common to both characters, already noted by Muslim scholars such as al-Maqdisi (fl. 966),[28] Soucek observes a strong terminological resemblance between Jamshid's flying ʿajala (chariot), as al-Ṭabarī calls it,[29] describing it as a glass throne mounted on a chariot harnessed to demons, and Solomon's own ʿajal, in Ibn Munabbih's account.[30]

The mention of a wooden chariot, yet another incarnation of a flying machine, is not particularly surprising in this context. In fact, the chariot is not simply another variation on the theme but, more likely, one of its first historical embodiments, one of the most ancient symbols of godly (and therefore royal) celestial power, well attested in Babylonian-Assyrian, Aramaic, and Hittite traditions (and also in India),[31] and echoed in Ezekiel's famous vision (Ez. 1:1–28) of Yahweh's cherubim throne-chariot, the *merkava*.[32]

This symbol of power enjoyed great vitality for millennia, resurfacing in Persian history, mythology, and visual culture.[33] As far as Jamshid's story is concerned, this astronomical dimension is made explicit by the different accounts describing the creation of the flying chariot, which appears inextricably linked to the institution of the festival of *Nāwroz*, traditionally linked to the end of winter and the beginning of spring.[34] It is therefore evident that

Solomon's flying vehicle was shaped not just by an image of Sasanian courtly power (platform/carpet), but also by even more ancient reminiscences of divine thrones (chariot).

The memory of a Solomonic flying chariot still lingers in a passage in the *Kebra Nagast*, compiled during the fourteenth century, although some of its nucleus dates as early as the sixth century. The text describes the Solomonic roots of the Ethiopian kingdom and the events regarding the offspring of the king of Jerusalem and the queen of Sheba. The king's son, Bayna-lehkem (Menyelek), by virtue of flying wagons loaded with men and animals, manages to steal the Ark of the Covenant from the Temple and bring it to Ethiopia, fooling his pursuers and his own father.[35] Interrogated by Solomon about the passage of the peculiar convoy, eyewitnesses replied that the wagons "were suspended in the air; and they were swifter than the eagles that are in the sky, and all their baggage travelled with them in wagons above the winds. As for us, we thought that thou hadst, in thy wisdom, made them to travel in wagons above the winds."[36]

Solomon has been tricked by his own device. The flying chariot, a memory of divine and majestic vehicles of ancient gods and deified sovereigns, maintains an indirect connection with the sacred by functioning as a vehicle for the Ark, but it has lost some of its aura, becoming an important element of adventure tales.

Royal Birds

In her analysis of the theme of royal flight among Eastern sovereigns,[37] Anna Caiozzo compares the journey of Jamshid[38] to that of other mythical rulers, such as Kay Kawus,[39] a Persian king described in the *Shāhnāma* and other sources, and Nimrod, king of Babylonia.[40] What all these figures have in common is a celestial journey, made possible thanks to a special vessel, a throne mounted on a chariot/basket/structure sustained by royal birds of prey (typically eagles or vultures, depending on the translation). The birds are induced to fly by large pieces of meat held at the end of long poles or spears protruding from the structure. This tradition is closely echoed in the Western world, both iconographically and textually, by the celebrated flight of Alexander the Great,[41] whose airborne vessel is carried by griffins tricked into flying thanks to the same method. The story is reported in the Greek versions of the *Alexander Romance* in the eighth century, although it may have been in circulation as early as the third century BCE.[42] The motif finds several parallels in various other texts, ranging from the Aramaic collection of sayings known as

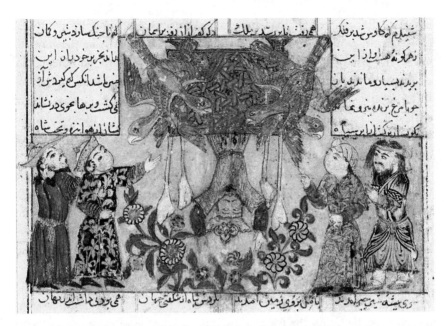

Fig. 18 Kay Kavus Falls from the Sky, folio from a *Shahnama* of Firdausi, ca. 1330–40, detail. The Metropolitan Museum of Art, New York, acc. no. 1974.290.9. Bequest of Monroe C. Gutman, 1974. Photo: The Metropolitan Museum of Art.

Sefer Aḥiqar (fifth century BCE) to the romance *The Life of Aesop* (first century CE.)[43]

The common nucleus of this double, east–west trajectory of flying monarchs with eagles is the idea of surpassing earthly boundaries in the attempt to overcome the limits of human knowledge and reach the sun and moon, in a journey culminating in the exploration of the cosmos and of secrets, or in an open provocation of the gods. Such a desire is considered a form of insane excess, of *hybris*, a challenge to divine dominion—and the destiny of these figures is often marked by tragedy and punishment.

The archetypal model behind these sovereigns seems to be rooted in fact, as Hildegard Lewy has demonstrated in a seminal article.[44] Lewy examined the apparently imaginative details regarding Kay Kawus's vicissitudes, and, through an in-depth textual, historical, and linguistic analysis, traced back to Nabu Naʾid or Nabonidus (r. 556–39 BCE), the predecessor of Cyrus on the throne of Babylon, a series of features (restoration of the cult of Shin, Shamash, and Ishtar, special attention to astronomical observation, creation of ziggurats for this specific purpose and as a privileged point of encounters with the deity, deification process of the sovereign, etc.) that can explain the common elements handed down by later Persian sources.[45] A particularly interesting passage in

her essay discusses the flying throne of Kay Kawus as a symbolic metamorphosis of a typical kingly wish, namely, to have a throne among the stars, to be literally inscribed in the pantheon of divine figures. Even the gods, like their earthly counterparts, moved in a divine chariot across the sky, and a trace of this heavenly vehicle has remained in the nomenclature of that constellation shaped like a wagon: the Big Dipper, or Great Bear, is in fact the Babylonian *mar-gidda*, literally the "long chariot," and still carries traces of that ancient origin in several modern languages, including Charles's Wain in English.[46]

Despite these precedents, Solomon's flight is never explicitly connected to the theme of sinful aspiration in the Arabo-Persian branch of the tradition, though that idea lingered behind the paradigm of cosmic royalty described above and would resurface in some Jewish accounts. Nor does it include, on a strictly morphological level, the element of eagles/vultures/griffins carrying the vessel and led on by meat. His throne is supported by the winds, which he controls.

Nevertheless, the presence of a giant bird of prey is extant, at least from the High Middle Ages onward, within Jewish tradition, where Solomon is often described as flying on the back of an eagle or coming in close contact with them.[47] Given the semantic density regarding the eagle and the prominence of other majestic royal birds (*simurgh, rukh*, or *garuda*) that deeply permeate Indo-European imaginary, one would be tempted to consider them different embodiments of the same recurring myth.[48] Despite some common or similar traits, however, I think it would be wrong to lose sight of their specificity, since, arguably, not all flights have the same narrative or symbolic value. Thus, we should not necessarily equate different flying characters and their birds; Solomon is not Etana, who is brought to heaven looking for the plant of fertility, nor Ganymede, who is kidnapped by Zeus's eagle, although certainly the eagle functions in all these cases as a celestial means of transportation.[49]

The eagle, in fact, is a polysemic symbol, whose apparently unified role depends on the merging of various extant traditions: funerary rites of Egyptian origin, solar cults developing in Syria, the *consecratio* process of imperial Rome, and even an image of resurrection with the advent of Christianity, just to name a few.[50]

Similarly, the corpus of Aramaic and Hebrew texts where the Solomonic eagle appears is not uniform and includes not only references to the bird as simply a means of transportation but more complex descriptions that seem to refer to a sort of celestial sidereal flight, not too different from that above mentioned. Two examples will exemplify the differences.

In the Midrash Ecclesiastes Rabba—written down around the eighth century—the king is said to be transported in one day in the desert thanks to a

huge bird of prey (*nesher gadol*) acting on his command.[51] The passage (2:25),[52] which provides a commentary on 2 Chr. 8:4 ("He built Tadmor in the wilderness and all the storage towns that he built in Hamath"), could represent a reminiscence of cults performed for centuries in Tadmor (that is, Palmyra), dedicated to the sun deity Malakbel and to the heaven god Baʿalshamin, whose main attribute was the eagle.[53] But it could also be influenced by a tradition of traveling and city founding well known and expanded on by Muslim authors, which will be discussed in the next section.

By contrast, in the thirteenth-century *Sefer ha-zohar*, an important kabbalistic text, Solomon flies on a transparent throne carried by an eagle and reaches a mountain, within which he is introduced to secrets and revelations through a mystic vision: an eagle appears on two pillars, one of fire and one of clouds, representing respectively the fallen angels ʿUzza and ʿAzzaʾel, guardians of knowledge.[54] In this context, the eagle is both the physical means through which the king carries out his journey and a metaphor for this initiation process. His flight, although heavily reworked and reconsidered in light of Jewish mystical tradition, reminds us of the typical kingly desire to overcome a limit and to reach a higher level of awareness.

The Italian Hebraist Giulio Busi, who has dedicated some very interesting pages to the eagle, has noted how, during the Middle Ages, the Hebrew *nesher* acquired new traits through the addition of folkloric motifs not originally pertinent to the Jewish tradition, thus combining together the characteristics of the bird-helper and of the guardian of a celestial space. At the same time, ancient solar symbolism, which had deeply characterized the eagle in ancient Eastern religions but had traditionally been opposed by the rabbis, came back *en vogue* through the influence of Arabic accounts and ended up permeating the corpus of Solomonic tales.[55]

While traces of ancient bird lore, transmitted either orally or through texts, may certainly have exerted an influence, another and no less effective element to be considered in the shaping of the relationship between King Solomon and the eagle is the lingering trace of a strong visual memory, recalling the widespread iconography of the sovereign's *consecratio* or apotheosis, which came to be adopted, particularly in the Roman Empire after the death of Augustus, in several funerary representations, partially retrieving the much more ancient Eastern tradition of the eagle as a psychopompos creature.[56] Representations of sovereigns transported into the sky on the back of an eagle were customary between antiquity and late antiquity, in the Mediterranean area as a whole and in Persia, and it is therefore quite possible that this diffusion favored certain imagery.

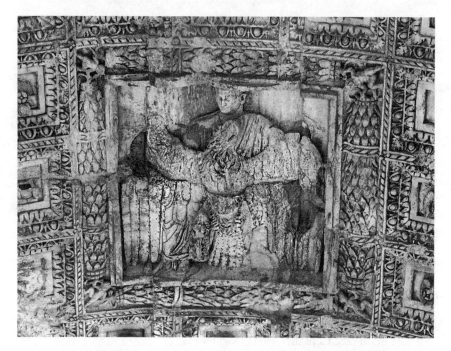

Fig. 19 *Apotheosis of Emperor Titus*, Arch of Titus, Rome, ca. 81–100 CE. Photo © Allegra Iafrate.

Solomon's Flight: A Metaphor for Earthly Dominion

With respect to the tradition of pre-Islamic daring sovereigns outlined above, which partially resurfaced in Jewish medieval texts, Solomonic legends spreading in the Muslim world, while owing much to Jamshid's model, also show some substantial differences and traits specific to an independent development. The theme of Solomon's flight seems to acquire over time a human and political overtone quite different from the sidereal paradigm of cosmic kingship just mentioned, no matter what vehicle it is carried out on. In general, while Kay Kawus's, Nimrod's, and Alexander's flights represent a single enterprise, a once-in-a-lifetime endeavor, Solomon's carpet/platform is described, in all the known accounts, as a distinctive royal habit, his usual and preferred means of transportation. This aspect had measurable historical consequences.

The narrative of the traveling Solomon's household, in fact, ended up being indirectly associated with the positive notion of city-founding and building activity, both deeply rooted in the biblical imaginary (1 Kgs. 9:17–18, 6–7). These old biblical topoi received fresh blood through the development of the newly

founded religion of Islam, whose recently conquered territory spanned from North Africa to Persia and was scattered with the remains of past civilizations, ruins of imposing size and legendary allure. Often, in order to protect their architectural heritage from the destructive fury of the Arab conquerors, or to ennoble it, local inhabitants ascribed the ruins to King Solomon himself, ensuring their survival over time. This is why the popular names of several important monuments reflect this apparently incongruous Solomonic association: places such as Takht-i Sulaymān (Throne of Solomon), Zandān-i Sulaymān (Prison of Solomon), Tawīlah-i Sulaymān (Stable of Solomon), Takht-i Bilqīs (Throne of Bilqis, the queen of Sheba) in northern Iran, or cities such as Palmyra and Baalbek, among many others, were considered to be the fruit of his architectural endeavors.[57]

A very similar method was employed in certain areas in a more refined way, as a peculiar *instrumentum regni* by members of the ruling elite, who emphasized the alleged Solomonic ties of their territory in order to claim a political continuity with the Prophet, hoping to guarantee power and legitimacy, as happened, for instance, in the Fars region, in the area of Shiraz, where Cyrus's tomb in Pasargadae was said to be the funerary monument of Solomon's mother.[58]

The legend of Solomon's flight was reflected in the names not only of urbanized centers or monumental complexes but of natural landscapes; several mountain chains, for instance, were renamed "Throne of Solomon," either because the king was said to have had halted there with his flying retinue, or because their size or height inspired a morphological parallel, calling to mind the gigantic platform/carpet on which he allegedly moved.[59]

All these variations represent different facets and consequences of the legendary flight of the king; if he could travel far and wide at such a speed as the wind allowed him, he could have founded cities from one side of the world to the other, stopping anywhere he wished, including on the highest peaks on earth, leaving behind traces of his long-gone grandeur.[60]

The only discernible moral judgment associated with the theme of Solomon's flying throne in the Muslim world appears as a limitation of this dream of universal dominion, a reflection on the fragility of the human condition. It is deeply connected to the meditation on ruins, a philosophical theme typical of cultivated *adab* literature and poetry: not even the greatest achievements of men, or of kings, can last forever. Allah is greater than all.[61] The mention of the Solomonic throne in this context introduces a sort of melancholic *ubi sunt*, which sounds like a sort of caveat against human pride, as in one of the ghazals of the Persian poet Hafīz (1315–1390).[62]

Conclusions

The magic carpet, which so strongly evokes the East and its marvels, and so deeply penetrates the Western imaginary as the *objet du désir* of exotic escapes, is set within a dense network of cultural threads. It is one of the many embodiments of means of transportation by flying (chariot, throne, platform, eagle) that have marked the long relationship between kingship and its cosmic aspirations, with manifestations including ascent, deification, and apotheosis. But it is a distant echo of more archaic efforts to control the elements of nature (in this case wind). These traditions, similar though not necessarily identical, have ended up merging over time and exerting an influence (or a partial interference) on each other, with the progressive migration, variation, or conflation of originally separate elements. Despite their chronological and cultural specificities, what they all have in common from the start is the direct association between a specific manifestation of power and the figure of the sovereign, whether in a highly sophisticated form or in a more primitive embodiment. This continuity, this cultural handover of royal prerogatives, has favored the superimposition of elements that, no matter how distant or originally unrelated, have equally come to characterize the ruling figure of Solomon, who has inherited the paradigm of the primitive king-priest in control of nature, Babylonian dreams of celestial kingship, Sasanian models of sovereignty, reminiscences of ancient apotheosis, and Islamic ambitions toward an extended earthly domain. These instances of power, while maintaining apparently similar or recursive elements in morphological terms, have been represented or evoked with different nuances and purposes, thus acquiring a sacred, political, learned, adventurous, moral, poetic, mystical, or simply narrative touch.

Before concluding, I should note that in contrast to other traditions, such as those illustrated in the previous chapters, the story of the flying Solomon (and of his carpet) remains substantially a prerogative of the Muslim and Jewish heritage. The Christian West has remained impervious for the most part to its penetration in Solomonic terms, while granting a great deal of space to the myth of royal flight (although not to the carpet, which is a later element) in association with Alexander the Great, particularly between late antiquity and the Middle Ages. However, the theme has not ceased to exert a certain fascination, and it has resurfaced in more recent times, not only in the East, where it has traditionally been known, but also in the West, with broader popularization in quite different contexts.[63] On a strictly literary level,[64] the idea of a flying Solomon figures prominently, for instance, in *Song of Solomon*, the 1977 novel by African American Nobel Prize winner Toni Morrison, thus constituting one of the last knots in this particularly long and iridescent thread.[65]

CONCLUSION:
"OF THE COSMOPOLITAN DESTINY OF MAGICAL OBJECTS"

"Du destin cosmopolite des objets magiques," voilà un titre pour Sarah.
—Mathias Énard, *Boussole*

In recent years, King Solomon has been the object of growing scholarly interest, not only within the traditional context of biblical studies, but more and more as a paradigm for comparative studies across the Mediterranean, a figure with a meaningful influence on cultural history in general. Another very productive angle of research, as seen, has focused on the study of the broad production of pseudepigraphic works related to his name and to the esoteric and magic traditions connected to the field of demonology and history of magic in medieval Europe.

The present work is set at the crossroads of these two different scholarly waves (Mediterranean/magic): the different chapters investigate a series of powerful objects that were attributed to Solomon via extracanonical textual sources and that have interesting parallel developments in Christian, Jewish, and Islamic culture. At the same time, the study has focused on items that are all credited with a sort of supernatural, magical power, and thus can be related to broader themes in the field of folklore and anthropology.

In the following paragraphs, I will therefore try to underline some notable traits that have emerged from the analysis of the five objects collected here. These remarks are not exhaustive or definitive; they are only an attempt to extract some common elements and offer a precipitate of what I have been able to observe with regard to these Solomon-related objects. Further observations could certainly be added based on a different sample, and new insights could emerge from the study of magical tools within the context of more subject matter–oriented texts, such as handbooks of practical magic, recipes, charms, and witchcraft rituals. The very nature of the items grouped here, in most

cases, eludes a strictly technical judgment, since they have been considered from the perspective of the *longue durée*, and according to an approach meant to favor not just a magic-oriented reading, but also their cultural trajectories, in the hope of shedding light on the fascinating Solomonic tradition, from a double—and I hope fruitful—angle.

In the Name of the Magus

A fundamental aspect in the circulation of these pieces is the role of the magus, who often perpetuates the memory of devices of ancient and differentiated origin by giving them new purpose and meaning. We have noted, for instance, how Virgil, Paracelsus, and necromancers in general were attributed with the possession of magic bottles with demons; the strongly resonating archetype of Solomon as an exorcist allowed the transmission of various characterizing features, including part of his technical equipment.

It is not difficult to see how, in J. R. R. Tolkien's novel,[1] Sauron's ring, a powerful tool for subjugation, belongs to the broader tradition of the Testament of Solomon. And, of course, "'Alâ' al-Dîn and the Wonderful Lamp," one of the "orphan" tales of the *Nights*, almost certainly adapted by Antoine Galland himself, is yet another variation on the theme of the imprisoned jinn.[2] Less apparent, perhaps, but no less meaningful is the case of Atlante, the wizard created by the pen of Ludovico Ariosto, who builds two marvelous and unreachable metal palaces by virtue of a legion of demons, one of which is imprisoned under the threshold of the second castle.[3] This strong association goes back, once more, to the idea of Solomon as great architect and master of jinn. The textual precedent, as we have seen, was set in the Testament of Solomon, but it became a literary motif circulating well beyond the field of demonology.[4] Of course, there is no need to posit direct filiation or knowledge of the earlier sources, but it is nonetheless fascinating to follow the distillation of certain ingredients and the successive recrystallization of most of them into solid literary topoi. If the name of the magus can change, his tools tend to be handed down over time.

There is a sort of "law of attraction" at work here. These meaningful devices often need to find a recipient to be endowed with the power of a recognizable name. This is usually a renowned figure whose historical outline, however, tends to become more and more blurred, thus acquiring mythological, legendary, or magic traits and acting as a sort of magnet for a broad variety of themes. This process favors the progressive attraction of both objects and meaning toward certain emblematic figures that, seen in a diachronic perspective, appear

to have subsumed almost all of them. Usually, the more a character is already endowed with powerful or peculiar features, the more he is prone to acquire others over time, in a process that is often aided by a sort of implicit handover between certain figures.

This often occurs at the crossroads of two different cultural traditions, and it requires a long phase of coexistence, which can begin with partial overlaps of function, but which usually ends with a complete transfer of roles, iconographies, and powers. In general, the more a new hero shares certain paradigmatic elements with another existing one, the more he is prone to acquire all his features in due time: a transfer often favored by analogy. A civilization might fall into oblivion, and many of its constituting elements can go through a phase of cultural decay, but all that is deemed functional will live on, in a different shape. Within this discourse, what determines the coefficient of popularity of a figure is often directly proportional to his complexity, to his multifaceted characterization in moral terms, to his substantial ambiguity. Such a constituting feature, in fact, enhances the possibility of survival through time, space, and religions, because it multiplies the chance that a certain element, although negative, might appeal to a different audience or respond to a different need in another time frame or cultural context.

This process is particularly clear within the Solomonic tradition. In many respects, the vicissitudes of the ring of Polycrates, tyrant of Samos, laid the ground for the destiny of Solomon's ring. Solomon is also heir to features typical of archaic king-magi (metalworking techniques, control over the winds, etc.) that he shares with semimythical figures such as Aeolus. Similarly, knots are sometimes associated with a recognizable hero, as in the case of Hercules, whose knot ends up on the Solomonic pillars at the entrance of several medieval churches. Finally, Solomon also "inherits" the flying carpet/platform of the Persian hero Jamshid, who in turn was the heir of a much more ancient tradition, rooted in ancient Babylonia. The power of a recognizable name often helps single out a specific item and save it from oblivion. Thus, in the perpetuation of traditions regarding magical objects, the role of the magus is often fundamental.

Perceiving Magic

As previous scholars have rightly noted, any proposed definition of magic will become elusive and almost always unsatisfying, because it is given in relation to something else, usually religion and science—which, in turn, depend on a certain given system that can hardly be considered in absolute terms. Hence,

magic is, by definition, relative. This, however, does not necessarily mean that it cannot be described or defined. What matters, in the end, is not the definition of these categories, but the perceived gap between them.

Such a paradigm change can always be ascribed to a process of *déplacement*, which translates into a sort of distance, whose nature can change but whose effects are identical. None of the objects analyzed in this collection was born "magical"; they eventually became so in the eyes of different audiences. Such a shift can be chronological, when the passing of time helps remove the object from its original setting, thus making possible a deep recontextualization of its function and meaning; cultural, when the different perception depends on a mutated set of beliefs, or on enhanced or diminished technical knowledge; or linguistic, when a passage occurs from the literal to the metaphorical level, or vice versa. A single factor, or a combination of several factors, produces a different perception, also depending on the partial or total loss of the original context. Let us see how this process specifically applies to our cases.

The Solomonic ring was a truly divine object; it was described as such in the Testament of Solomon, and even if this text is problematic with respect to official religion, the ring was certainly considered a relic by the official clergy of Jerusalem, who showed it to pilgrims, and it would remain divine in the eyes of Jews and Muslims. Eventually, however, the ring lost these religious overtones and became popular as an object of power, even acquiring traits (such as making it possible to understand animal language) that were never mentioned at the beginning of its narrative development.

By contrast, the vessels in which Solomon entrapped the demons were normal, daily bowls/containers when they were first described at a textual level; the sealing of the ring made them accepted objects of veneration in the Christian context, while the prolonged contact with their ambiguous content eventually plunged them into the field of demonology and occult knowledge, finally turning them into distinctive necromancer's devices.

The question of the Solomonic knot is more complicated, since it can take a variety of shapes, each with a long and often untraceable origin. Nonetheless, several shifts seem to have occurred even in this case: the double link may represent a simple decoration, a morphological variant of the Christian cross, but also a diagram of infinity. In all these permutations, it can hardly be labeled "magical," although it shares with other knots a broader mazelike property, which is a helpful apotropaic quality. Five- and six-pointed stars seem to have been initially connected with medicine and wealth symbolism before making a full transition into demonology seals.

The *shamir* was a precision tool until time blurred its original features and poetic language and parallel folkloric traditions enhanced its powers. Different

exegetical views did the rest, causing a series of deep metamorphoses, which ended up investing and mutating its very appearance.

Finally, the carpet was originally a sign of royal status and luxury, but it began to fly once it was connected to Solomon's ability to control the wind, by virtue of a quite literal wave of Quranic exegesis and thanks to cultural transfer from other extant traditions.

All these examples show that, although in different degrees and with varying nuances, change of function or perception of a certain item can lead to an enhancement of its power. In discussing notions of distance, previous scholars have used different approaches, as discussed in chapter 1: Peter Pels, alterity; Bruno Latour, the paradox of modernity; Hannah Baader and Ittai Weinryb, distance; Lucien Lévy-Bruhl, Bronisław Malinowski, and Stanley Tambiah, logic and rationality; and Émile Durkheim, social codes.

However, while the feeling of estrangement is necessary for labeling magic, it is probably not sufficient for fully experiencing it. Distance alone creates judgment, when it does not create skepticism, indifference, or repulsion—and such has always been the reaction of orthodox religious views to certain phenomena, as well as of early ethnographers when confronted with foreign rituals. Magic, by contrast, entails a certain degree of enthusiasm. Here lies an interesting ambiguity, an apparent internal contradiction: magic is a peculiar combination of detachment and adhesion, which implies, at the same time, the acknowledgment of a gap (chronological, social, cultural, ethical, etc.) and the desire to fill it, or at least to get closer to its source. In this sense, the perception of magic, even in its most popular form, contains an inescapable component of freedom, of evasion, of experimentation, of the taste for the prohibited, which manifests itself in different ways. It can be tolerated and accepted either because the power emanating from it is deemed very strong or, to the contrary, very feeble, as I will now try to explain.

The first scenario regards the efforts of those who resort to practices that are usually condemned within a certain religious or cultic setting, when the means available in such a context prove ineffective in attaining a certain expected result. Hoping for more success, one therefore leaves the familiar ground of broadly shared rituals and turns to the exotic, foreign, forgotten, or obscure means of another tradition.

But acceptance of "magic" works also in the opposite direction; a divine object, for instance, can be transformed into a magical one once the original religious context is lost or considered unimportant. The sacredness with which it was originally charged is somewhat diminished, leaving room for more playful outcomes. This is the case, for instance, with magic employed at a literary level; there is no need to believe strictly in what the narrator tells us, as long as

we enjoy the effects produced within a certain conventional frame. In this sense, there can be magic without belief, but not without power: an effect of some sort is always expected.

Thus, magic can be found at both extremities of this ideal gradation line of power. A peculiar dialectics is at work here: one adheres to magic either because one strongly believes (or wants to believe) in it, or because one does not believe in it at all, but nonetheless appreciates the escape from reality it offers.

Objects and Materiality

In the previous section, I underlined the importance of distance and power, and their dialectics, in the perception of magic. Here, I will address the aspect of materiality, which was raised at the beginning of our inquiry. The possibility of investigating a set of objects seemed to offer a privileged observation point.

In the second chapter, dedicated to the story of the Solomonic ring, I focused on the medium in which it was realized, whenever attested. We passed from the electrum of sixth-century Christian sources, whose alchemical and talismanic powers were attested since at least the fourth century, to the Arabic descriptions of the Solomonic khātam, which was known to be impressed on different materials (iron, copper, clay, silver), depending on the intended audience for the message. These descriptions retained traces of historical accuracy, attested both in diplomatic exchanges (silver or golden bullae for royal correspondence) and in talismanic practices (incantations incised on metal sheets). Eventually, this tradition led to a refashioning of the ring at a popular level, and several oral accounts circulating in the Muslim world described Solomon's signet ring as made of iron and copper, which were more effective in controlling jinn and shayṭāns. If the research did not discover direct and unmistakable signs of correspondence between the uses of these materials in the two religious traditions (though possibly a sort of subterranean continuity in terms of metal power), it did show, I think, that the choice of medium was not irrelevant with respect to the coercion the ring was supposed to exert. And even if each tradition chose a different material to bind demons, the material was still a metal. Besides the will of God, as the superior agency that conferred power on the object, it is to the known talismanic or alchemical properties of electrum, iron, or copper that the act of constraint was eventually entrusted. And if the whole context of the story is lost, and with it direct divine involvement, what remains is the down-to-earth, material quality of the signet ring.

My research on the Solomonic bottles tells a similar story. What clearly emerged in the Testament of Solomon was a deep concern about the very materiality of demons. In the presence of protean creatures made respectively of air and water, and thus bodiless, or capable of taking any shape, the real issue was finding a means for physically containing and effectively entrapping them. The choice of a leather inflatable flask and a drinking vessel responded to this need. These containers ended up being transformed over time and losing their initial, highly specific character as they became generic bottles, phials, decanters, ampoules, lamps. Yet they maintained two fundamental features: they could be closed or sealed, and they could hold liquids. The lesson materiality can teach us here is therefore about function.

In chapter 4, I addressed the problematic question of what exactly was meant, historically, by the "knot of Solomon." As my analysis shows, over the centuries several substantially different knots have been termed Solomonic, including the five- and six-pointed star, the figure-eight (or Savoy) knot, and the double link. Their use and meaning appeared to diversify over time as they acquired apotropaic, heraldic, or simply decorative overtones. Despite the lack of significant internal uniformity, or of a univocal relationship between label and patterns, the association with Solomon derived, once more, from the tradition attesting his powers as an exorcist. In several different cultures, knots are recognized as mazelike devices, often employed to entrap or confuse demonic entities. The notion that the king's seal impressed a mark that obtained an identical effect led, over time, to its identification as a closed, intertwined loop, such as that represented by the five- and six-pointed star. All sorts of infinity patterns thus became associated with Solomon, even if their original connection with demonology became lost or altered, or was never really extant. This diversified scenario provided us with yet another clue about the role played by materiality with respect to magic. What is central here is shape, which, though certainly changeable in terms of pattern, guards unaltered the only feature essential to the validity of the entrapment process: closeness.

My analysis of the *shamir* presents some analogies with the previous case. The numerous layers of accretions and interpretations, in combination with the merging of different traditions (biblical, Hellenistic, medieval, etc.), have made it almost impossible to choose a specific identification for this extraordinary cutting tool, whose almost supernatural ability to split the hardest of substances has prompted a rich wave of exegesis identifying the *shamir* with mineral, vegetal, and animal elements. Thus, somewhat as happened with the knot, the label *shamir* ended up referring to a great number of things, apparently making the question of materiality elusive, though not negligible. However, the

very multiplicity of these embodiments, all so different and yet so consistently ascribed to the domain of the *shamir*, has indirectly shown that at least one constant must be present in all of them, something whose nature is both physical and experienceable: the possibility of splitting, abrading, and incising all sort of hard substances. Regardless of the object identified as the *shamir*, its intrinsic power derives from this highly characteristic quality, which we could label as its property.

The last chapter is a borderline case as far as materiality is concerned. The possibility of flying does not seem to depend on the specific physical qualities of the devices (platform, throne, carpet) on which Solomon was said to move through the air. Rather, it is an external power, the wind, subject to Solomon by the will of Allah and usually embodied by the jinn, which guarantees the otherwise impossible outcome. This is the only case, among our magical objects, in which we do not see a clear material index at work, such as those outlined so far (matter, function, shape, property).

Nonetheless, a hint toward materiality can be discerned in the somewhat abrupt passage in the Qur'ān and the subsequent traditions. The sacred text acknowledges Solomon's control over the winds, without implying that this power translated into an ability to fly. Early exegetes, however, did make this claim, presenting the prophet as riding the air from one side of the earth to the other, and using the Scriptures to back up this interpretation. If such a logical and hermeneutical leap was partially based on an overly literal reading of the Quranic passages, the analogy with Jamshid and his flying throne-chariot almost certainly favored this idea, at least initially. Thus, it is within the earlier tradition regarding flying monarchs that one should look in order to find a potential mark of materiality. Kay Kawus, Nimrod, and Alexander were taken on their celestial journeys thanks to vessels pulled by giant birds. Although their flight is presented as extraordinary, their means of transportation was not "magical" but a sort of engineering feat, a daring technological and fully human endeavor. The physical unlikelihood of the outcome does not mean that we should read the episodes as supernatural or magical. Everything is presented as perfectly logical. The birds take off because they are interested in the food the monarchs are using as bait, and the monarchs resort to the propulsive potential of the eagles, their natural ability to fly, in order to ascend. Here, therefore, we have materiality without any hint of magic. The episode, as we have seen, ultimately went back to Nabu Na'id and to his wish to be included in the celestial pantheon. The royal, quite actual, flight undertaken by these figures corresponded to the physical embodiment of Nabu Na'id's aspiration, a sort of crystallization of a metaphor regarding the king's cosmic representation. Thus, materiality was unequivocally extant at a certain point in this

tradition, although it would gradually disappear in favor of magic. The Solomonic carpet, along with all the other devices the prophet was reported to use, was divinely activated and maintained clear religious overtones for a long time. It was only when these objects lost their connection with this sacred agency that magic could be affirmed. That occurred partially in the *Nights*, but even more evidently in the imagery prompted by the reception of these tales, in the widely popular image of the flying rug as a symbol of the East, without any specific connection with Solomon.

And it is here that we can detect another feeble, yet unmistakable, trace left by materiality on magic. In my historical analysis, I have treated the carpet as one, not even the first or more important, object on which Solomon flew. This is because, as I have shown, the throne, the carpet, the chariot, and the platform represented different, but roughly equivalent, symbols of kingship. How is it, then, that the rug was eventually singled out as the ideal means of transportation through the air, erasing the memory of the other devices? At a popular level, nobody would ever talk about a flying throne or a flying giant wooden plank. The answer, I think, resides in the material features of the carpet, whose aerodynamic shape and lightness make it look like a sort of horizontal sail, apt to take the wind and thus ideal for embodying the magical function expected of it. Weight and flexibility are fundamental features of this process. Even if materiality seems to enter the story of the carpet relatively late, it is evident that it *does* play a role.

Marcel Mauss, in describing the laws of sympathetic magic, has noted that magicians were concerned with transferring or choosing single qualities (color, texture, weight, etc.) for their rituals. He has also stated that magic could not thrive in abstraction; it needed the transfer of physical qualities throughout bodies.[5] However, according to his view, the further acknowledgment of a sort of underlying taxonomy, a consistent logical system tying together objects and their power, and all natural elements, eventually became the premise for transforming magical practices into linguistic acts.[6]

I think that my research confirms Mauss's assertions, but it also strengthens the need to consider materiality not just as a precondition of magic but as one of its fundamental conditions of existence and efficacy. I have noted that all the objects analyzed, once deprived of the divine or demonic agency granting their power, keep on exerting a specific function directly depending on a quite tangible index. Of course, the set of metrics that I have singled out is by no means complete, and the list of material features positively responding to magic potentially encompasses as many physical qualities as can be detected in any given item. The enunciation of the laws of sympathetic magic, therefore, should lead us to consider magic not solely in linguistic terms, but also in very tangible

and concrete ones, and without discarding the aspect of logic. In fact, all my examples clearly demonstrate that behind the supernatural effect, the various items prove effective by virtue of some recognized quality that makes sense with regard to the final purpose of the action pursued. There is nothing really obscure in this proceeding; everything is both comprehensible and explicable in very matter-of-fact (and sometimes even naïve) terms.

Conclusions

One of the distinctive features of the Solomonic objects analyzed in this book is their location at a crossroads of different traditions. The degree to which they merged and influenced each other varies, depending on the item under consideration; one of the aims of this research was to follow these itineraries throughout their historical twists and turns, and to offer a more cohesive picture of how they came to intersect. King Solomon has always stood at the center of this intricate pattern, the link between all the tales, legends, and accounts surrounding these objects—sometimes at the end, sometimes at the beginning of these threads, and sometimes only a meaningful knot within this fascinating network.

The ring, originally appearing in the Judeo-Christian context of Palestine, was adopted in the Muslim world, giving origin to an almost independent tradition. The bottles had a very similar destiny, and ironically, it is through the distorted lens of the *Arabian Nights*, true manifestation of Orient and Orientalism, that we are most familiar with them now, although their origin is to be found in late antique Jerusalem. The knot is quite elusive in its multiple apparitions, and while I have outlined a mostly Italian story of its textual and visual occurrences, five- and six-pointed stars figure prominently in both the Jewish and the Muslim world. The story of the *shamir*, which springs from a biblical context, had to be reconstructed mostly through Hebrew and Aramaic sources, although it owes much to independent Hellenistic traditions and resurfaced in Latin and Arabic texts during the Middle Ages, traveling as far as Ethiopia. Finally, the carpet is a distinctive product of Arabo-Persian craft that appeared at a certain point as well in midrashic literature and in the *Kebra Nagast* and entered the Western world relatively late.

In this sense, the "cosmopolitan" destiny of the magical objects outlined in this research, and evoked in the epigraph to this conclusion, seems to represent the final result of multiple historical, geographical, and cultural permutations, from which we can sketch out a variegated and possibly inconsistent picture. Nevertheless, despite the different trajectories of each of these traditions, and

their often independent development, the analogies and points of tangency are many. In the background lingers the memory of Solomon's peculiar relationship with demons, informing and influencing the story of all these objects, which were made for entrapping evil spirits (ring, bottles, knot), known to them (*shamir*), or activated by them (carpet). In different measures, the Testament of Solomon and, more generally, a cultural milieu identifying the king of Israel as a powerful exorcist (and, later on, master of jinn) have abetted the creation of a shared body of traditions, deeply rooted in the common ground of Mediterranean late antiquity.

These concluding remarks resonate quite well, I think, with some considerations expressed by Mathias Énard in his 2015 literary tour de force, the novel *Boussole* (Compass). The scholar protagonist of the book dedicates a few thoughts to the notion of "objets magiques," imagining that his colleague Sarah, always engaged in the study of the interrelation between East and West, would have found them an ideal topic for a research project. The story of such a "cosmopolitan fate" "would include a discussion of genie lamps, flying carpets, and fabulous slippers; she could show how these objects are the result of successive shared efforts, and how what we regard as purely 'Oriental' is in fact, very often, the repetition of a 'Western' element that itself modifies another previous 'Oriental' element, and so on; she could conclude that *Orient* and *Occident* never appear separately, that they are always intermingled, present in each other, and that these words—Orient, Occident—have no more heuristic value than the unreachable directions they designate."[7]

When I read these words, a few months before finishing the writing of this book, I thought there would be no better way to conclude my own work. If magic thrives in the uncertain and unfamiliar ground that lies between us and others, the study of history has the no less fascinating power to make us walk that distance, and to illuminate the way in which things mutate under our eyes in the course of time.

NOTES

SOLOMON'S CABINET OF CURIOSITIES

1. Iafrate, *Wandering Throne of Solomon*.

2. See, for instance, Astell, *Song of Songs in the Middle Ages*; Barbierato, *Nella stanza dei circoli*; Ziolkowski, *Solomon and Marcolf*.

3. Solomon's deep knowledge of plants is described in 1 Kgs. 5:13; later on, actual vegetal species were associated with him. Rahmani, "Byzantine Solomon 'Eulogia' Tokens"; Tameanko, "King Solomon's Seal." A plant known as "seal of Solomon," usually identified as any of several varieties of the genus Polygonatum, entered the Solomonic catalogue, as noted by botanist John Gerard (1545–1612) in his *Herball*, 758. On this, see also Kieckhefer, *Magic in the Middle Ages*, 76–77. Finally, a popular tradition maintains that marijuana, considered the "weed of wisdom," grew on Solomon's grave. Weitzman, *Solomon*, 76.

4. Venzlaff, *Al-Hudhud*. The privileged relationship between Solomon and the ants originates in Qur'ān 27. Curiously, the Linnaean system of biological classification registers a *Formica salomonis*, now known as *Monomorium salomonis*. Linnaeus, *Systema naturae* 1:580.

5. The Bible mentions the *shamir*, but in a completely different context, and it was only thanks to various mentions in the Talmud that this item came to be associated with Solomon.

6. McCown, *Testament of Solomon*; Harding and Alexander, "Dating the Testament of Solomon"; Torijano, *Solomon the Esoteric King*, esp. 76–87; Klutz, "Archer and the Cross"; Busch, *Testament Salomos*; Schwarz, "Building a Book of Spells"; Schwarz, "Reconsidering the *Testament of Solomon*"; Schwarz, review of *Rewriting the "Testament of Solomon"*; Torijano, "Solomon and Magic"; Busch, "Solomon as a True Exorcist."

CHAPTER 1

1. Comparetti, *Virgilio nel Medioevo*; Spargo, *Virgil the Necromancer*; Ziolkowski and Putnam, *Virgilian Tradition*; Frugoni, *Fortuna di Alessandro Magno*; Boitani et al., *Alessandro nel Medioevo occidentale*; Stoneman, *Legends of Alexander the Great*.

2. Weitzman, *Solomon*; Hetzel, "Salomon"; for a strictly historical and archaeological approach, see Handy, *Age of Solomon*; on his "Mediterranean" fortune critique, see Verheyden, *Figure of Solomon*; in more recent years, see also Bacqué-Grammont and Durand, *L'image de Salomon*; on Solomon as patron of esoteric and magical knowledge, see the international conference organized by Fondazione MEIS and AISG, "L'eredità di Salomone: La magia ebraica in Italia e nel Mediterraneo," Ferrara–Ravenna, September 1–2, 2015; Torijano, *Solomon the Esoteric King*; and the works published by Julien Véronèse in the series Salomon latinus (Micrologus). For a recent assessment of the fortune of the king of Israel during the Middle Ages, see the conference papers presented at "Le roi Salomon au Moyen Âge: Savoirs et réprésentations," Colloque du CESFIMA, Orléans, October 18–19, 2018, organized by Jean-Patrice Boudet et al.

3. See the excellent synthesis in Collins, "Magic in the Middle Ages."

4. Brian Schmidt, *Materiality of Power*, 2.

5. Otto and Stausberg, *Defining Magic*; Bremmer, "Birth of the Term 'Magic'"; Collins, *Cambridge History of Magic and Witchcraft*, especially the first section of the volume; Pels, "Introduction."

6. Wilburn, *Materia Magica*. "1) Magic was firmly founded in ritual actions, including spoken or written words and the manipulations of objects. These rituals typically are performed with the expectation of a particular result. 2) Magic may draw on religious traditions for both efficacy and exoticism. 3) Magic is frequently a private or personal activity, although certain practices might be undertaken in the public sphere," Brian Schmidt, *Materiality of Power*, 11.

7. The *shamir* is probably the least known among these objects. It enjoys a certain success, however, as supposedly the product of alien technology, particularly among ufologists.

8. Terminology coined by Kenneth L. Pike in *Language in Relation to a Unified Theory*, to indicate, respectively, the point of view and the interest represented by someone acting within a certain cultural system or by an external viewer.

9. Appadurai, *Social Life of Things*, claimed the importance of studying commodities as having "careers" and "life histories." This notion was explicitly developed by Igor Kopytoff in "Cultural Biography of Things." This approach has enjoyed a certain success and is still widely adopted by scholars in various fields. See Stephenson, *Serpent Column*, or Gerritsen and Riello, *Global Lives of Things*. For a recent discussion on the topic, see Hoskins, "Agency, Biography and Objects"; and Boschung, Kreuz, and Kienlin, *Biography of Objects*.

10. I say "metamorphosis" with the idea of underlining the shift between real and textual, actual and described, likely and imagined. In more theoretical terms, these objects could probably be seen from the perspective of what, since the 1990s, has been termed "intermediality," even if I personally do not wish to make this notion the center of my investigation, nor to stress it as a fundamental category. In general, however, there are a growing number of studies that, under this label, study "all phenomena involving more than one communicative medium," analyzing the "wide range of relationships established among the various media and investigat[ing] how concepts of a more general character find diversified manifestations and reflections in the different media" (presentation of Studies in Intermediality, series published by Brill since 2006, edited by Lawrence Kramer, Hans Lund, Ansgar Nünning, and Werner Wolf). For a critical overview, see Rajewsky, "Intermediality, Intertextuality and Remediation." See also Bruhn, *Intermediality of Narrative Literature*.

11. Bachmann-Medick, *Cultural Turns*; Hicks, "Material-Cultural Turn"; Bräunlein, "Material Turn"; Green, "Cultural History and the Material(s) Turn."

12. Daniel Miller, "Materiality," 4.

13. On the notion of the *Wunderkammer* in general, and its relationship with its content, see the excellent essay by Falguières, "Société des objets"; and also Findlen, *Possessing Nature*.

14. Pamuk, *My Name Is Red*, 3.

15. "I appeared . . . when poet Firdusi completed the final line of a quatrain with the most intricate of rhymes. . . . I was there on the quiver of *Book of Kings* hero Rüstem when he traveled far and wide in pursuit of his missing steed; I became the blood that spewed forth when he cut the notorious ogre in half with his wondrous sword; and I was in the folds of the quilt upon which he made furious love with the beautiful daughter of the king." Ibid., 224.

16. See, among others, Sweeney, *Magic in Medieval Romance*; Heng, *Empire of Magic*; Breuer, *Crafting the Witch*; Olsan, "Enchantment in Medieval Literature"; Saunders, *Magic and the Supernatural*.

17. An interesting perspective has been proposed by Caroline van Eck in *Art, Agency and the Living Presence*, a study of the different responses of the viewer toward art. Her research combines the study of anthropology and that of classical rhetoric, thus also widely discussing the role of ekphrasis in relation to "living images."

18. Expression originally invented by Washington Allston in *Lectures on Art*, 16, then further theorized by T. S. Eliot in "Hamlet and His Problems," 92: "The only way of expressing

emotion in the form of art is by finding an 'objective correlative' . . . a set of objects, a situation, a chain of events which shall be the formula of that *particular* emotion; such that when the external facts, which must terminate in sensory experience, are given, the emotion is immediately evoked."

19. Calvino, *Six Memos for the Next Millennium*, 32.

20. Calvino wrote both an introduction for the 1966 Einaudi edition and a sort of guidebook to the reading of the poem in 1970. Moreover, his novel *The Castle of Crossed Destinies* (1969) can be considered a direct response to Ariosto's poem. In the *Furioso*, these items indeed provide the pretext for the developing of the story but also a quite efficient means of allowing the author to fully display his irony toward the world around him, its underlying system of beliefs, and all human obsessions metaphorically embodied in such objects, from passion to power.

21. Propp, *Morphology of the Folktale*, 44.

22. Ibid., 82.

23. Ibid., 43–50.

24. The final or intended destination of these texts (whether religious, legal, entertaining, etc.) is in fact irrelevant from a strict narratological point of view. Propp himself, in another work, investigated the ties and the similarities between the wonder-tale and religion; see Propp, "Theory and History of Folklore." Moreover, despite the criticisms of Propp's work, his methodology has been applied, even by some of his fiercest critics, to other fields; see, for instance, Lévi-Strauss, "Structural Study of Myth."

25. Duling, "Testament of Solomon," esp. 962; for a translation based on a different manuscript, see also Conybeare, "Testament of Solomon," esp. 15.

26. Duling, "Testament of Solomon," 976.

27. Epstein, *Babylonian Talmud, Seder Nashim*, 4:324–25.

28. Propp, *Morphology of the Folktale*, 51. Italics in original; cross-references omitted.

29. Although in Propp's system the flying carpet is categorized under G, there could be instances within the Solomonic legends in which one should instead place it under F^9 (various characters place themselves at the disposal of the hero: offer of service). In certain accounts, in fact, it is the eagle that proposes taking Solomon around on its wings. Thus, the possibility of flying can evidently be seen both as a magical agent, if there is a certain action taking place between hero and helper, and as a sheer means of transportation, if such activity is subordinated to the research of something else and is not the means in itself.

30. Todorov, *Fantastic*.

31. Ibid., 153. About Marcel Mauss's definition of magic, see below, Sympathetic Magic I.

32. Ibid., 54.

33. French structuralism owed much to Russian formalism. See Todorov, "Héritage méthodologique du formalisme."

34. Todorov himself places the flying carpet under this category: "In the 'Tale of Prince Ahmed' in the Arabian Nights, for instance, the marvelous instruments are, at the beginning: a flying carpet, an apple that cures diseases, and a 'pipe' for seeing great distances; today, the helicopter, antibiotics, and binoculars, endowed with the same qualities, do not belong in any way to the marvelous," Todorov, *Fantastic*, 56. However, one could correctly argue that the flying carpet has still not been realized, although other flying devices are regularly constructed.

35. Ibid.

36. "Poetry and Allegory" and "Discourse of the Fantastic," in ibid., 58–74 and 75–90, respectively.

37. Orlando, *Obsolete Objects*, 2.

38. Ibid., 5.

39. Orlando's approach is reminiscent of Walter Benjamin's description of the Parisian Arcades, an area of the city that the philosopher defined as "a dialectical Fairyland," a sort of enchanted place, not entirely touched by the modern renovation imposed on the city by the Haussmannian changes, where remnants of the past still survived as forgotten magical

objects. On this, see Hanssen, *Walter Benjamin and the Arcades Project*, 3–4; and Buse et al., *Benjamin's Arcades*, 59–62.

40. Orlando, *Obsolete Objects*, 3–4.

41. Ibid., 11–12 and 219.

42. Ibid., 41–42.

43. Ibid., 205 and 281–92.

44. Warner, *Stranger Magic*.

45. Sørensen, *Cognitive Theory of Magic*, especially chapter 2, "Magic in the History of the Social Sciences."

46. In addition to the essays just mentioned, see also Tambiah, *Magic, Science, Religion*; Styers, *Making Magic*; Greenwood, *Anthropology of Magic*.

47. Tylor, *Primitive Culture*, 2:143.

48. De Brosses, *Du culte des dieux fétiches*; Comte, *Positive Philosophy of Auguste Compte*, 2:181–207; Spencer, *Principles of Sociology*, 1:306–29.

49. Tylor, *Primitive Culture*, 2:145.

50. Marx, *Capital*, 163–77; Freud, "Unsuitable Substitutes for the Sexual Object"; Freud, "Fetishism."

51. (1) "Natural objects and phenomena," (2) a material object worshipped not for itself but as the "representative or symbol of a Nature-deity or deified man," (3) a material object identified as "the permanent or temporary abode of a spirit," but also (4) "non-religious magical appliances, charms, or amulets, which have a virtue quite independent of any gods or spirits," or (5) material things that are "sometimes the objects of a make-believe worship." See Aston, "Fetishism," 5:894–98. See also the more recent entry by Mesquitela Lima, "Fetishism," 5:314–17.

52. Van der Leeuw, *Religion in Essence and Manifestation*, 40.

53. For a critical review of fetishism in Hegel and other Western thinkers, see Kocela, *Fetishism and Its Discontents*, 31–60.

54. Hegel, *Philosophy of History*, 94.

55. De Surgy, "Fétiches"; De Surgy, "Fétiches II."

56. De Surgy, "Présentation," 11.

57. Bazin, "Retour aux choses dieux," esp. 511–12.

58. Frazer, *Golden Bough*, 2:6; 3:306, 314; 9:95; 10:92; 11:155.

59. Ibid., 9:1–8.

60. Ibid., 1:52.

61. By "things," Durkheim did not refer solely to objects but, more broadly, to a context also including immaterial elements.

62. Durkheim, *Elementary Forms of Religious Life*, 40–41.

63. Ibid., 212.

64. Ibid., 42.

65. Mauss, *General Theory of Magic*, 79–81.

66. Ibid., 83–86.

67. Ibid., 89–90.

68. "Like produces like; like acts on like; opposite acts on opposite. . . . In the first, we think in terms of the absence of rain, which has to be produced through a symbol; in the second, we think of falling rain which is made to stop through a symbol; in the third, rain is conjured up and then brought to a stop by evoking its opposite through a symbol." Ibid., 89.

69. Ibid., 91–93.

70. Ibid., 95–97.

71. It would be interesting to read this set of modern considerations about language in relation to the speculations already advanced by Athanasius Kircher in his *ars magna sciendi* or by John Dee with respect to his "real Cabala." On this topic, see Lehrich, *Occult Mind*, particularly the chapter dedicated to "The Magic Museum."

72. This list is by no means exhaustive: Lavondès, "Magie et Langage"; Austin, *How to Do Things with Words*; Izutsu, *Language and Magic*; Todorov, "Discours de la magie"; Benjamin, "On Language as Such."

73. Malinowski, "Magic, Science, and Religion," esp. 54–55.

74. Malinowski, *Coral Gardens and Their Magic*, 2:248; Tambiah, *Magic, Science, Religion*, 74–75, 80–81; Tambiah, "The Magical Power of Words"; Tambiah, "Performative Approach to Ritual"; Austin, *How to Do Things with Words*.

75. Evans-Pritchard, *Witchcraft, Oracles, and Magic*.

76. Horton, "African Traditional Thought and Western Science: Part I"; Horton, "African Traditional Thought and Western Science: Part II," 159.

77. Horton, "African Traditional Though and Western Science: Part II," 158–60. It is interesting to note, however, that according to Horton, "the outlook behind magic still remains an intellectual possibility in the scientifically oriented cultures of the modern West" (160). It is usually rejected, Horton states, because of the philosophical consequences of imagining a word ruled by human whim, where there are different realities, all equally manipulable through words, without any anchor or order. Horton therefore suggests that the Western system is not inherently better than the African one, it is just more hopeful and less horrific.

78. Jakobson and Halle, *Fundamentals of Language*, 76 and 80–81.

79. Leach, *Culture and Communication*, 29–30.
"A sorcerer gains possession of a specimen of hair from the head of his intended victim X. The sorcerer destroys the hair to the accompaniment of spells and ritual. He predicts that, as a consequence, the victim X will suffer injury.
". . . The sorcerer treats the hair growing on the head of X as a metonymic sign for X. He further assumes that if he destroys the sign he will damage X. . . . But by the time the hair has come into the sorcerer's possession, the only continuing link with its origin is a verbal label 'this is the hair of X.' The label is now a metonymic sign for the hair, but the hair and X are separated; the link between the label and X is only metaphoric. . . .
"In summary, . . . the sorcerer makes a triple error. He first mistakes a metaphoric symbol (i.e. the verbal label 'this is the hair of X') for a metonymic sign. He then goes on to treat the imputed sign as if it were a natural index, and finally he interprets the supposed natural index as a sign capable of triggering off automatic consequences at a distance" (31).

80. Malinowski, "Problem of Meaning," 256.

81. Ibid., 259.

82. What Lévy-Bruhl terms "the mystic meaning of the causes of success," *Primitive Mentality*, 307–51.

83. Despite the similarity of his approach to evolutionary theories, which envisaged different levels of civilization along an ideal and teleological line of rational development, Lévy-Bruhl did not consider these two mindsets as varying in degree along a progressive scale but tended to view them as substantially different in kind, an approach not dissimilar, in a way, from that proposed by Horton.

84. Lévy-Bruhl, *How Natives Think*, 31.

85. Malinowski, "Problem of Meaning," 267–68. For a discussion of further theories of object perception, see also Sørensen, *Cognitive Theory of Magic*, chapter 3.

86. Piaget, *Child's Conception of the World*, 131–62, 389–94.

87. See the discussion of these and other related theories in Styers, *Making Magic*, 130–36.

88. Freud, *Totem and Taboo*, 99. For a thorough discussion of the "omnipotence of thought" and its impact on subsequent historiography, see Styers, *Making Magic*, 170–76; Werner, *Comparative Psychology of Mental Development*; Zusne and Jones, *Anomalistic Psychology*; Thurschwell, *Literature, Technology and Magical Thinking*.

89. Styers, *Making Magic*, 173–77.

90. Latour, *We Have Never Been Modern*, 59. See also 29–30 and 138–42.

91. Latour, *Pasteurization of France*, 209.

92. Ibid., 180.

93. Law and Lodge, *Science for Social Scientists*.

94. Latour, *Reassembling the Social*, 106.

95. Law, "After ANT," 3.

96. Deleuze and Guattari, *Thousand Plateaus*; see also, more recently, DeLanda, *New Philosophy of Society*.

97. Latour, *Pandora's Hope*, 176-78.

98. Gell, *Art and Agency*, 7.

99. Ibid., 39; see also 71-72, where Gell applies the notion to the Trobrianders.

100. "As we know, the earliest artworks originated in the service of rituals—first magical, then religious. And it is highly significant that the artwork's auratic mode of existence is never entirely severed from its ritual function" (Benjamin, "Work of Art," 24).

101. Gell, *Art and Agency*, 13-21.

102. Ingold, *Perception of Environment*; Ingold, "Materials Against Materiality"; Ingold, "When ANT Meets SPIDER"; Henare, Holbraad, and Wastell, *Thinking Through Things*; Holbraad, "Can the Thing Speak?"

103. See, for instance, Santos-Granero, *Occult Life of Things*.

104. See the publications produced by the "Matière à Penser" (MàP) network, listed at http:// materialreligions.blogspot.it/ 2014/ 09/ food-for-thought-contributions-of.html, and issue no. 58 of *Technique and Culture*, dedicated to *Objets irremplaçables*.

105. Warnier, *Construire la culture matérielle*; Warnier, "Praxeological Approach to Subjectivation"; see also *Material Religions*, a blog edited by David Morgan and Jean-Pierre Warnier, http://materialreligions.blogspot.fr; Material World, www.materialworldblog.com.

106. Albert and Kedzierska-Manzon, "Des objets-signes aux objets-sujets," 13.

107. Sørensen, *Cognitive Theory of Magic*, section 2.3.

108. Lawson and McCauley, *Rethinking Religion*.

109. Evans-Pritchard, *Witchcraft, Oracles and Magic*, 441.

110. Sørensen, *Cognitive Theory of Magic*, section 4.1.

111. Ibid., section 4.1.3.

112. Keane, "Calvin in the Tropics," 13-34.

113. Ibid., 14.

114. Ibid., 23-26.

115. Keane, "Semiotics and the Social Analysis," 411.

116. Ibid., 419.

117. Keane, "Subjects and Objects."

118. Or, as Keane himself states, "Material things index the human productive activity that went into them, they materialize social and cosmological structures that would otherwise elude direct experience, they foster the development of the person's sense of separateness from a world that resists its desires and the self-motivated agency that acts on that resisting world, they serve as stable anchors and instigations for memory, feelings and concepts" (ibid., 201-2).

119. Ibid., 201.

120. Ibid., 200.

121. Bazin, "Retour."

122. Ibid., 508-9.

123. Ibid., 513.

124. Ibid., 510.

125. Heidegger, "Thing," originally a lecture delivered by Heidegger at a conference in 1950. On the still fruitful impact of Heidegger's reflection on art history, see Boetzkes and Vinegar, *Heidegger and the Work of Art History*. See also Foucault, *Order of Things*; Benjamin, "Work of Art"; Baudrillard, *System of Objects*; Bourdieu, *Outline of a Theory of Practice*.

126. Kubler, *Shape of Time*.

127. Freedberg, *Power of Images*; Belting, *Bild und Kult*. See also, Bredekamp, *Theorie des Bildakts*.

128. Bredekamp, "Neglected Tradition?," 418.

129. Gell's work has been particularly influential in this respect; see Pinney and Thomas, *Beyond Aesthetics*, 1–11.

130. Wolf, "Image, Object, Art," 156.

131. On a strong theoretical level, it is important to remember the work of Bill Brown: Brown, "Thing Theory"; Brown, "Objects, Others and Us." See also Daston, *Things That Talk*; Pasztory, *Thinking with Things*; Turkle, *Evocative Objects*.

132. Eck, *Art, Agency and the Living Presence*.

133. Douglas and Isherwood, *World of Goods*; Thomas, *Entangled Objects*; Saurma-Jeltsch and Eisenbeiss, *Power of Things*; Peter Miller, *Cultural Histories of the Material World*; Laviolette and Kannike, *Things in Culture, Culture in Things*; Gerritsen and Riello, *Writing Material Culture History*; Gerritsen and Riello, *Global Lives of Things*.

134. Ton y Bennett, "Exhibitionary Complex"; Karp and Lavine, *Exhibiting Cultures*; O'Neill, "Enlightenment Museums"; Henare, Holbraad, and Wastell, *Thinking Through Things*; Buzard, Childers, and Gillooly, *Victorian Prism*; Dudley, *Museum Objects*; Junod et al., *Islamic Art and the Museum*; MacGregor, *History of the World*; Almqvist and Belfrage, *Museums of the World*; Waterton and Watson, *Palgrave Handbook of Contemporary Heritage Research*.

135. For instance, in 2016, during a postdoctoral fellowship at the Kunsthistorisches Institut in Florence, I attended two different scholarly events that perfectly exemplified some of these tendencies and showed that even within the same institution dedicated to art history the the me can be addressed and explored in different ways, with points of tangency with philosophy or anthropology. The first event was "What Do Contentious Objects Want? Political, Epistemic and Artistic Cultures of Return" (Florence, Kunsthistorisches Institut, October 21–22, 2016, international conference organized by Eva-Maria Troelenberg and Felicity Bodenstein within a broader research project significantly dedicated to *Objects in the Contact Zone: The Cross-Cultural Lives of Things*); the second was "Subject and Subjectivization in Art (History) and Philosophy: A Definition of the Problem" (Florence, Kunsthistorisches Institut, December 2–3, 2016, international workshop organized by Hana Gründler and Maria Teresa Costa).

136. *Images at Work: Image and Efficacy from Antiquity to the Rise of Modernity*, Kunsthistorisches Institut, Florence, September 30–October 2, 2010, organized by Hannah Baader and Ittai Weinryb; Baader and Weinrib, "Images at Work."

137. Berlekamp, "Symmetry, Sympathy, and Sensation."

138. Baader and Weinryb, "Images at Work," 3–6.

139. "The object is initiated into a function beyond its immediate appearance or representation and is charged with this power through the retelling of an aspect or an attribution of that object by an individual who has not witnessed the object or 'image at work'" (ibid., 8).

140. McDannell, *Material Christianity*.

141. The goal of the journal and its methodological approach are further detailed by Meyer et al., "Origin and Mission of Material Religion."

142. Such an approach was already evident in some of Plate's earlier studies, such as *Religion, Art, and Visual Culture*, a reflection on the role of the senses in religion, usually mediated by objects of different kinds; Plate, *History of Religion in 5½ Objects*; Plate, *Key Terms in Material Religion*.

143. Hazard, "Material Turn." She identifies a first approach, the "symbolic," which treats material things and practices as symbols for meanings and ideas, linking it principally to the work done by Clifford Geertz, Arjun Appadurai, and others; a second approach, carried out by Talad Asad and Saba Mahmood, which instead of focusing on the ideas and the beliefs embedded in objects, whose importance, in the wake of Derrida and Foucault, was deemed excessive, reverses the relationship and states that it was objects that could create the condition of possibility for thinking and served as means to discipline human beings; and a third, more phenomenological approach, which emphasizes human experience and perception

through the human body, as shown in the studies by David Morgan and several other scholars, or, with a more cognitive focus, by Antonio Damasio.

144. Deleuze and Guattari, *Anti-Oedipus*; Deleuze and Guattari, *Thousand Plateaus*.

145. Hazard, "Material Turn," 59.

146. Ibid., 64.

147. Ioannides, "Vibrant Sacralities and Nonhuman Animacies," 247.

148. Bennett, *Vibrant Matter*. The dogmatism of this approach appears evident from the fact that she conceives a veritable "creed": "I believe in one matter-energy, the maker of things seen and unseen. I believe that this pluriverse is traversed by heterogeneities that are continually doing things. I believe it is wrong to deny vitality to nonhuman bodies, forces, and forms, and that a careful course of anthropomorphization can help reveal that vitality" (122).

149. Bräunlein, "Thinking Religion." The three proposals are specifically discussed at 23–28.

150. Keane, *Christian Moderns*, 21.

151. Droogers, "As Close as a Scholar Can Get."

152. Bräunlein, "Thinking Religion," 25–26. Bräunlein mentions, among others, the studies of Grieser, "Aesthetics," 1:14–23, and Traut and Wilke, *Religion—Imagination—Ästhetik*.

153. Bremmer, "Preface"; Rider, "Common Magic," 309–10.

154. "Thus, if modern discourse reconstructs magic in terms that distinguish it from modern, this at the same time creates the correspondences and nostalgias by which magic can come to haunt modernity"; see Pels, "Magic and Modernity," 5–6. See also 35–39.

155. Styers, *Making Magic*, 214–17.

156. Bräunlein, "Thinking Religion," 2.

157. Wood, "Image and Thing," esp. 131–32.

158. The formulae *me fecit*, *me pinxit*, and *me celavit*, found on objects of all sorts (chalices, weapons, crosses, textiles, doors, architectural elements, etc.), are a typical feature of the artist's signature, quite widespread from the Middle Ages onward, but attested also during late antiquity. Far from abolishing the memory of the maker behind the artifact, these objects are often the means through which the artisan himself speaks to the holder/viewer/recipient of the object. By "hiding" behind the result of his workmanship, the artist lets his piece speak for himself, a peculiar mix of humbleness and social pride. However, it is also evidently a sort of magical overtone. See, for instance, Kendall, *Allegory of the Church*, esp. 83–91, 172, 182–83. See also Martin, "'Me fecit.'"

159. Bredekamp, *Theorie des Bildakts*, 57–100.

160. Mitchell, *What Do Pictures Want?* 11. See also, Mitchell, "What Do Pictures *Really* Want?"

161. Mitchell, *What Do Pictures Want?* 7–8.

162. Wolf's essay "Image, Object, Art," for instance, is devised as a direct conversation between the scholar and a Chinese jug in its museum case. This rhetorical expedient stresses the fact that, although objects do not really talk, their very presence can spark a debate around them and indirectly raise meaningful questions, thus "engaging" people in conversation. On the methodological debate between history and fiction, evidence and invention, see, for instance, White, *Metahistory*; Ricoeur, *Temps et récit*; Ginzburg, "Prove e possibilità."

163. Strong critical positions have been expressed by, among others, Margaret Archer, Slavoj Žižek, Paul Rekret, and Ian Verstegen.

164. Laurajane Smith expressed this view in a paper titled "Objects, Agency, and Power," delivered during the above-mentioned conference "What Do Contentious Objects Want?" and also in a paper delivered with Gary Campbell at the Association of Critical Heritage Studies Conference in Montreal in 2016, "Keeping Critical Heritage Studies Critical." To a very similar question, Mitchell gave a slightly different answer: "What pictures want in the last instance, then, is simply to be asked what they want, with the understanding that the answer may well be nothing at all" (Mitchell, "What Do Pictures *Really* Want?" 82).

165. Bruno Latour has famously theorized the notion of "hybrid" as the result of an association, including society, as equally composed of human and nonhuman entities. Latour, *We Have Never Been Modern*. The expression "entangled objects" was employed by Thomas, *Entangled Objects*; on "bundling," see Keane, "Subjects and Objects."

166. An interesting and quite recent publication is Leoni and Gruber, *Power and Protection*. Although this catalogue is the product of the study of a historian and an art historian particularly expert in the history of books within Islamic culture, it definitely touches on various technical aspects of magic and divination. See also Delattre, *Objets sacrés, objets magiques*, which collects a series of interesting, although quite disparate, case studies, without any direct confrontation with the ambiguity between sacred and magic, declared openly in the title, but lacking a more definite or programmatic framework.

167. Houlbrook and Armitage, *Materiality of Magic*; Bremmer, "Preface," 8. See also Moser and Knust, *Ritual Matters*.

168. Houlbrook and Armitage, introduction to *Materiality of Magic*, 3.

169. Ibid., 9.

170. Schmidt writes that he intends to seek "the modest goal of exploring magic as manifested in a discrete cultural tradition in time and space," and while acknowledging his intellectual debt toward the "philological analysis aimed at primary source materials, the invocation of comparative data as a means of contextualizing texts . . . the occasional and rather circumspect application of anthropological and literary theory in order to generate heuristic parameters," he also recognizes the obvious limits of such an enterprise (*Materiality*, 5–6).

171. Gen. 2:18–20.

172. See the approach proposed by Coccia, *Bien dans les choses*.

CHAPTER 2

1. Lorenz, *Er redete mit dem Vieh*; Widmann, *Heilige und die Tiere*.

2. Lorenz, *King Solomon's Ring*, xv–xvi.

3. Hoek, Feissel, and Herrmann, "More Lucky Wearers."

4. Josephus, *Antiquitates Judaicae* 8.45–49; on this, see Duling, "Solomon, Exorcism," and Véronèse, "Salomon exorciste."

5. The exorcism was performed thanks to a root set under the ring. Duling, "Solomon, Exorcism." On the association between Solomon and plants with peculiar powers, see Rahmani, "Byzantine Solomon 'Eulogia' Tokens"; Tameanko, "King Solomon's Seal."

6. Boustan and Beshay, "Sealing the Demons."

7. Duling, "Testament of Solomon," 1:962; for a translation based on a different manuscript, see also Conybeare, "Testament of Solomon," 15.

8. On various types of magical rings, see Betz, *Greek Magical Papyri in Translation*, PGM IV.2125–39; PGM V.213–303; PGM V.304–69; PGM V.447–58; PGM VII.628–42; PGM XII.201–69; PDM xii.6–20; PDM xiv.1090–96. PGM = *Papyri Graecae Magicae*; PDM = *Papyri Demoticae Magicae*.

9. Verheyden, *Figure of Solomon*.

10. The interest in the "material approach" is well exemplified by, among others, Raff, *Sprache der Materialen*.

11. Qur'ān 38:34, however, refers to a tradition that indirectly acknowledges its presence.

12. The site is mentioned in John 5:2–18, as the setting of a miracle performed by Jesus.

13. Geyer and Cuntz, "Itinerarium Burdigalense," 598, lines 7–11, 14–15.

14. Cosentino, "Tradizione del re Salomone," 43.

15. A contribution by Augusto Cosentino, specifically dedicated to the cave sanctuary, is expected to be published shortly.

16. Egeria 37.3. The English translation is taken from Wilkinson, *Jerusalem Pilgrims*, 156–57.

17. See the thesis presented by Boustan and Beshay, "Sealing the Demons."

18. Wilkinson, *Jerusalem Pilgrims*, 118 (translating *Breviarius*, version A2). For the full description of the topography of the area, see 361–68.

19. Ibid., 117.

20. Bagatti, "I giudeo-cristani."

21. Isidore of Seville, *Etymologiae* 16.24.

22. Herodotus, *Histories* 1.94, 5.101; Healy, *Mining and Metallurgy*, 201; Healy, "Establishment of Die-Sequences"; Healy, "Greek Refining Techniques."

23. Deroy and Halleux, "À propos du grec ἤλεκτρον."

24. Babylonian Talmud, Ḥagigah 13a, tells the story of a child who was consumed by fire while reading the biblical passage containing the word. As the text further clarifies, the understanding of the word was highly problematic and was very much debated by rabbis. See Bodi, *Book of Ezekiel*, 822–94; Halperin, *Faces of the Chariot*, 506; Dan, *Jewish Mysticism*, 241. A fairly recent contribution proposes that originally the term probably referred to a precious stone such as amethyst. See Black, "Amethysts."

25. "The colour of amber" (King James Bible); "the resemblance of amber" (Douay-Rheims); "the appearance of amber" (1599 Geneva version), etc.

26. Deroy and Halleux, "À propos du grec ἤλεκτρον," 40.

27. Examples of this hermeneutical approach recur frequently in the *Patrologia Latina*. Jerome states that the electrum of Ezekiel's vision represents the union between God's divine nature and man's mortal one, respectively represented by gold and silver, which are connected through a powerful and reciprocal relationship. For the full passage, see Jerome (Hieronymus), *Commentariorum in Ezechielem*, 449c. The first mentions are as early as Tertullian (ca. 155–230), who discusses the symbolic value of electrum in relation to Christ's nature both in *Adversus Praxean* 27 and *Adversus Hermogenem* 25.3. Deroy and Halleux list other occurrences, but the catalogue is broader ("À propos du grec ἤλεκτρον," 43 n. 39).

28. Mommsen, *Corpus iuris civilis*, *Digesta* 30.1.4; 41.1.7.8; Krueger, *Corpus iuris civilis*, *Institutiones* 2.1.27.

29. On Byzantine rings, see Hindman and Scarisbrick, *Golden Marvels of Byzantium*.

30. Avitus of Vienne, *Letters and Selected Prose*, 254–55; for a more detailed discussion of Avitus's ring, see 251–53. See also Kunz, *Rings for the Finger*.

31. To strengthen this suggestion, it is worth mentioning that the entry for electrum in the tenth-century lexicon *The Suda* calls it a mixture of metal and stones ("ēlektron: allótypon chrysíon, memigménon huélō kaí lithía"), a peculiar definition that seems to imply that it was customary to find them always together, probably because gems or transparent materials such as alabaster, glass, or other stones were often set in or associated with this type of alloy. *Suda On Line*, trans. Carl Widsrand, http://www.stoa.org/sol-entries/eta/200. By way of example, *The Suda* proposes a particularly remarkable case: the precious altar commissioned by Justinian (482–565) for the church of Hagia Sophia in Constantinople ("hoías estí kataskeuēs hē tēs hagías Sophías trápeza"), which, as we know from the detailed ekphrasis by Paulus Silentiarius (520?–580?), was in fact made from gold and silver studded with precious stones. Unfortunately, this latter text never specifies that the gold of the trapeza was electrum, but it does repeatedly insist on its peculiar shining quality. The two sources, despite their different chronological phases of composition, are not necessarily in contradiction: the compiler of the lexicon could simply have been more precise in specifying the exact type of gold employed for the work. Paulus Silentiarius, *Descriptio sanctae Sophiae* 720–54; Fobelli, *Tempio per Giustiniano*.

32. Luck, *Arcana Mundi*, 2.

33. Torijano, *Solomon the Esoteric King*, 141 n. 44, 183.

34. Cambridge University Library, MS Mm 6.29. The codex was partially translated into French by Rubens Duval, and the excerpts can be read in Berthelot, *Chimie au Moyen Âge*, 2:260–65. See also Scott, *Hermetica*, 4:104–53, esp. 140–41.

35. Berthelot, *Chimie au Moyen Âge*, 2:262–63.

36. Cizek, "Rencontre de deux 'sages.'"

37. This iconography recurred on both gems and metal amulets. See Schlumberger, "Amulettes byzantins anciens"; Perdrizet, "Sphragis Solomōnos"; Bonner, *Studies in Magical Amulets*; Walter, "Intaglio of Solomon"; Spier, "Medieval Byzantine Magic Amulets"; Nuzzo, "Immagini cristologiche"; Michael, *Magischen Gemmen im Britischen Museum*; Spier, *Late Antique and Early Christian*; Amitai-Preiss and Wolfe, "Amuletic Bronze Rings"; Cosentino, "Tradizione del re Salomone."

38. Maguire, "Magic and Money."

39. This alloy had been broadly employed as a minting material, beginning in Lydia and then spreading to other regions. See Kroll, "Monetary Background of Early Coinage"; Gitler, Lorber, and Konuk, *White Gold*.

40. Von Fritze, "Elektronprägung von Kyzikos"; Paunov, "Introduction to the Numismatics of Thrace," esp. 266–67.

41. Price, *Coins of the Macedonians*, no. 371a; Seldarov, *Macedonia and Paeonia*, no. 468.

42. Electrum was included in the equivalence system, which associated the seven planets with the seven fundamental metals. It was identified as the metal of the planet Jupiter in the sixth-century commentaries to Aristotle's *Meteorologica* by Olympiodorus. This association may have prompted a connection with lightning, considering that Zeus was the god of the thunderbolt. However, a century later, it was replaced by tin (in Stephen of Alexandria's work, for instance), thus disappearing from the canonical series. See Stüve, *Olympiodori in Aristotelis*, 266–67; Crosland, *Historical Studies*, 80.

43. "Among the Egyptians there is a book called *The seven heavens*, attributed to Solomon, against the daemons. . . . These bottles were brought [from Jerusalem] long ago to our [Egyptian] priests. The seven bottles in which Solomon shut up the daemons were made of electrum. . . . The angel ordered Solomon to make these bottles . . . according to the number of the seven planets. . . . Solomon gives a formula of conjuration, and he indicates . . . the bottles of electrum, on the surface of which he inscribed this formula" (Scott, *Hermetica*, 4:140–41).

44. Montgomery, *Aramaic Incantation Texts*; Cyrus Gordon, "Aramaic Magical Bowls"; Isbell, *Corpus of the Aramaic Incantation Bowls*; Geller, "Eight Incantation Bowls"; Shaked, Ford, and Bhayro, *Aramaic Bowl Spells*.

45. Dennis, *Encyclopedia of Jewish Myth*, 55, 287.

46. Jessie Payne Smith, *Compendious Syriac Dictionary*.

47. Robert Payne Smith, *Thesaurus syriacus*.

48. Rubenstein, *History of Sukkot*, 117–31.

49. "Others have demons dwelling with them. . . . When [Solomon] had finished building, he imprisoned the demons in the temple. He placed them into seven waterpots. They remained a long time in the waterpots, abandoned there. When the Romans went up to Jerusalem, they discovered the waterpots, and immediately the demons ran out of the waterpots, as those who escape from prison" (Pearson, "Gnostic Interpretation of the Old Testament," 315).

50. The vessels are reported to be made of silver, not electrum, and their number has been brought to twelve, a choice that would have softened the original planetary connotation and aligned the containers with a more evangelical symbolism.

51. Foss, "Persians in the Roman Near East." Despite its physical disappearance, its presence will be evoked a few times in Christian texts related to exorcism; see, for instance, Franz, *Die Kirchlichen*, 2:587–96 (ninth century), and Vogel, *Pontifical*, 2:217 (tenth century).

52. Klar, "And We Cast"; Tottoli, "Amīna." For an extensive retelling of the story, see the passage reported in *History of al-Ṭabarī*, 3:166–72.

53. Jellinek, *Bet ha-Midrasch*, 2:86–87.

54. Sivertsev, "Emperor's Many Bodies."

55. For a concise list of entries about Solomon drawn from these sources, see Wheeler, *Prophets in the Quran*, 266–79; Tottoli, *Biblical Prophets*.

56. Allan and Sourdel, "Kẖātam, Kẖātim."

57. Ibn Ḥabīb, *Kitāb al-Taʾrīkh*, par. 180, 72–73.

58. The most notable Arabic accounts of the ring have been collected by Salzberger, *Salomo-Sage*, 115–29, who also quotes al-Kisāʾī's Arabic text, based on Berlin MS Mq. 40, fols. 70v–72v.

59. Ibid., 117–20.

60. This early description is probably the basis for the development of later, often anonymous traditions, such as those collected by Knappert, *Islamic Legends*, 1:132, according to which the ring was composed of four different precious stones, one for each aspect of creation.

61. Al-Kisāʾī, *Tales of the Prophets*, 310. This English translation differs at various points from the Arabic text I consulted and commented on above; what Thackston translates as "the Milky Way" is really the *kawkab al-durrī* (on which, see below), while the "four points" are really the four "sides"; finally, in the Thackston translation there is no mention of the musk fragrance of the ring.

62. On the *kawkab al-durrī* in Islamic sources, see Flood, *Great Mosque of Damascus*, 44–47.

63. "There was a woman from Bani Israʿil who was short-statured and she walked in the company of two tall women with wooden sandals in her feet [sic] and a ring of gold made of plates with musk filled in them and then looked up, and musk is the best of scents" (Sahih Muslim 2252a). Similarly, in another ḥadīth it is reported, "The Prophet mentioned a woman who filled her ring with musk and said: 'That is the best of perfume'" (Sunan al-Nasaʿi 5264). The name of the translators of these passages is not indicated; for further reference, please consult www.sunnah.com.

64. A survey of this material, which includes the Solomonic seals handed down in the *corpus bunianum*, a mnemo-technical poem dedicated to Solomon's seal, the tradition of magical squares, that of the inscription of special geometrical figures known as magical carpets, and the so-called Pacts of Solomon, has recently been presented by Jean-Charles Coulon, "Salomon dans les traités." See also his *Magie en terre d'Islam*.

65. See, for instance, the numerous examples collected in Kalus, *Catalogue of Seals and Talismans*.

66. Doutté, *Magie et religion*; Dornseiff, *Alphabet in Mystik und Magie*; Winkler, *Siegel und Charakter*; el-Gawhary, "Gottesnamen im magischen Gebrauch"; Porter, "Use of Arabic Script in Magic," 131–40; Graham, "Comparison of the Seven Seals," 1–54, available on Academia.edu. For the name of God in Jewish tradition, see Wilkinson, *Tetragrammaton*.

67. Gignoux and Kalus, "Formules des sceaux sasanides et islamiques"; Porter, *Arabic and Persian Seals*, 2–3.

68. Porter, *Arabic and Persian Seals*, 2.

69. It is noteworthy, however, that despite a lack of correspondence between the production of contemporary seals and the description of the Solomonic one, with its "sides," one could find a more comparable example in the ancient production of tabloid seals of the Achaemenid Empire (such as the one in Paris, Musée du Louvre, Inv. no. AO2301), whose polygonal shape seems to be more in line with what is recounted by al-Kisāʾī. This would imply that the ring of Solomon was devised by resorting to formal antiquarian models. For an introductory discussion on this corpus of seals, see Poggio, "Impressions of Power." A direct association to Solomon can be found also on the fifteenth- to sixteenth-century talismanic ring, held at the Metropolitan Museum of New York (Accession no. 12.224.6), which bears an inscription around the bezel calling upon Prophet Solomon.

70. On the legends regarding Solomon and the jinn in the Islamic world, see Lebling, *Legends of the Fire Spirits*.

71. Lane, *Arabian Society*, 36–37.

72. Al-Samarqandī, *Baḥr al-ʿulūm*, 2:550.

73. Al-Thaʿlabī, *Al-Kashf wa-l-bayān*, 8:76.

74. Al-Thaʿlabī, *ʿArāʾis al-majālis*, 516.

75. Ibn ʿAsākir, *Taʾrīkh Madīnat Dimashq*, 22:292.

76. The survey of extant sources is by no means complete; however, it can certainly be stated that the detail of the material constituting Solomon's ring represents a minority thread in classical Arabic literature.

77. Most seals were impressed on clay or wax, although in special circumstances the seal was marked on silver or even golden bullae. See Reinaud, *Monuments Arabes, Persanes et Turcs*, 1:111–12.

78. Gager, *Curse Tablets and Binding Spells*; Kotansky, *Greek Magical Amulets*. For an exhaustive bibliographical synthesis on the topic, particularly in the Hebrew world, see the website by Dan Levene, Practical Kabbalah, http://kabbalah.fayelevine.com/amulets/pko16 .php; Schrire, *Hebrew Amulets*; Naveh and Shaked, *Amulets and Magic Bowls*; Skemer, *Binding Words*, 23–30.

79. "The City of Brass" (Madīnat al-nuḥās; see below), collected in the *Arabian Nights*, is known in French as "La ville de cuivre" (copper), while in Italian it is known as both "La città di bronzo" (bronze) and "La città di rame" (copper).

80. Aga-Oglu, "Brief Note on Islamic Terminology"; Allan, *Persian Metal Technology*; La Niece et al., "Medieval Islamic Copper Alloys"; Craddock, "Copper Alloys."

81. Tamari, *Iconotextual Studies*, 83.

82. Gerhardt, *Art of Story-Telling*; Hamori, "Allegory from the Arabian Nights"; Hamori, *On the Art of Medieval Arabic Literature*; Pinault, *Story-Telling Techniques*; Dakhlia, *Divan des rois*, 203–23; Hernández Juberías, *Península imaginaria*, 208–48. On the Solomonic overtones of the tale, see in particular Fudge, "Signs of Scripture."

83. Berlin Staatsbibliotek MS 9183, fols. 195–219, esp. fol. 196r; Tamari, *Iconotextual Studies*, 143.

84. Besides the exact definition of the containers, there is also a second issue: could electrum become *nuḥās*? Certainly not through Latin or Greek, since Arabic would refer to electrum with a quite literal transliteration (*iliktrum*). But maybe through Hebrew. If the original word behind electrum was the problematic term *ḥashmal*, it is possible that it yielded an apparently diverging result in Arabic—*nuḥās* in this case—which also appears to be the standard translation for *ḥashmal* in modern dictionaries. "The City of Brass," therefore, could possibly represent a last feeble trace of a consistent and yet elusive tradition regarding a set of shining and magic Solomonic vessels with talismanic functions.

85. MacDonald et al., "Djinn"; Fahd and Rippin, "Shayṭān."

86. Karpenko, "Systems of Metals in Alchemy."

87. Qadhi, "Kitāb al-Khatām."

88. Goldziher, "Eisen als Schutz gegen Dämonen"; Schienerl, "Eisen als Kampfmittel gegen Dämonen."

89. Lane, *Arabian Society*, 36–37; Doutté, *Magie et religion*, 156–57; Westermarck, *Ritual and Belief in Morocco*, 1:115, 305, 374.

90. Lawrence, "Folk-Lore of the Horseshoe"; Seligmann, *Böse Blick und Verwandtes*, 1:273–76; Seligmann, *Magischen Heil- und Schutzmittel*, 161–69; Jonathan Frazer, *Taboo*, 225–36.

91. Graça da Silva and Tehrani, "Comparative Philogenetic Analyses."

92. Although, as Mircea Eliade has proposed in *Arti del metallo e alchimia*, one cannot rule out the possibility that the supernatural powers of iron derived from a phase in which the metal was known through its meteoric origin and not from its more earthly components, as Qurʾān 57:25 seems to confirm.

93. Al-Ṭabarī, *History*, 15:62–63; al-Ṭabarī, *Annales*, lines 2757–58.

94. Donzel and Schmidt, *Gog and Magog*.

95. On the ability to speak to animals as a folkloric motif, see Róheim, *Fire in the Dragon*, 171.

96. Saintyves, "Anneau de Polycrate"; Labarbe, "Polycrate, Amasis et l'anneau." In general, on the narratives surrounding magic rings and on famous examples, see Jones, *Finger-Ring Lore.*

97. Buddeo, *Historia Ecclesiastica veteris testamentis,* 2:274.

98. The possibility of understanding the language of birds is attested already in the Babylonian Talmud, Gittin 45a. On this theme in Jewish folklore, see Schwartz, *Elijah's Violin,* 47, 59, 95, 156, 174, 203–5.

99. Tlili, *Animals in the Qur'an,* 176–91.

100. Janssens, "Ikhwān aṣ-ṣafā'," esp. 250.

101. On understanding the language of birds as a metaphor for dominion over the world, see Seidenberg, *Kabbalah and Ecology,* 325–26.

CHAPTER 3

1. Thompson, *Motif-Index of Folk Literature.* The motif features prominently in folktales around Europe. See Uther, *Types of International Folktales,* 2:221–22.

2. Grimm and Grimm, *Kinder- und Hausmärchen,* 2:99.

3. Stevenson, "Bottle Imp"; Lesage, *Diable boiteaux;* Vélez de Guevara, *Diablo cojuelo.*

4. Uther, *Types of International Folktales,* 2:221.

5. Traversi, *Elementi di fisica generale,* 6:162–63.

6. Magiotti, *Renitenza certissima,* fig. 6. For the experiment, Magiotti explained that, instead of the usual *areometri,* in this case *caraffelle* (that is, vials; in practice, small cylinders), one could use "figurines." These are usually glass figurines, with the body full of water and the neck full of air. Originally this kind of device was called *ludione* (literally "toy"). The reference to Descartes (as in *il diavoletto di Cartesio,* its current popular name), was attached to it later. For the description of the *ludione* and of its workings, see catalogue entry no. 29 at the end of Torrini et al., *Il Diavolo e il diavoletto,* 187–89, and Belloni, "Schemi e modelli," esp. 282–84.

7. Kircher, *Magnes,* 128–29, 131; Govi, "In che tempo." On the figurative history of the Cartesian diver, see the exhibition "'Danzad, danzad, diablillos': Una visión de la historia del Diablo cartesiano a través de imágenes," organized under the supervision of José Carrasquer Zamora at the Universidad de Zaragoza, http://web-ter.unizar.es/cienciate/expo.

8. This type of container is known as a "Bologna bottle" since it was first described in Bologna during the seventeenth century. See the letter from Iacopo Belgradi to Scipione Maffei, in Belgradi, *Epistolae quatuor de rebus physicis,* 1–12, dedicated to "de sphaeris vitreis magno fragore dissilientibus." See also the entry "Bologna vial" in Cooley, *Cyclopaedia of Six Thousand Practical Receipts,* 124.

9. Professional magician John Mulholland describes the proceeding in his *Beware of Familiar Spirits,* 104.

10. See the description in *Sequel to the Endless Amusement, containing nearly four hundred interesting experiments . . . to which are added recreations with cards* (34–35).

11. Several beer, wine, and liquor brands have in fact employed the image of the devil on their labels.

12. For a long list of parallels in other European countries, see Bolte and Polivka, *Anmerkungen,* 2:414–22.

13. *Vocabolario degli Accademici della Crusca,* 53, 258–59; Tommaseo and Bellini, *Dizionario della lingua italiana.*

14. Albertazzi, *Diavolo nell'ampolla,* 179–94. A full translation of this tale by Traci Andrighetti can be read at http://www.wordswithoutborders.org/article/the-devil-in-the-decanter/.

15. Albertazzi, *Diavolo nell'ampolla,* 180.

16. The painting is indexed as *Evocazione di demoni* by Bellesi, *Diavolerie, magie e incantesimi,* 65–69. More recently, the scene has been identified as Ismen, probably being based on the description of Torquato Tasso's *Gerusalemme Liberata,* book 13, stanza 43. See Morel,

"Figure de la magicienne," esp. 2:323–25. A famous earlier example of witches handling a flask with a demon is Hans Baldung Grien's painting *The Weather Witches*. See Hults, "Hans Baldung Grien's Weather Witches"; Hults, "Baldung and the Witches of Freiburg"; Zika, *Appearance of Witchcraft*, fig. 3.12. Zika posits that besides the usual connection between witches/wizards, the flask in this case could hint at "the illicit involvement of aquavit women in the manufacture of distilled waters for malefic purposes" (84–85, 247 n. 43; see fig. 3.22).

17. The idea of creating life from matter was already attributed to Simon Magus, who, in the *Recognitions*, attributed to Clement (chap. 15), was said to have made a boy out of air. However, this theme is only distantly related to ours. In this experiment, there is no reference to any vessel. For the description in Paracelsus, *De natura rerum*, see Paracelsus, *Sämtliche Werke*, 11:316–17. Even Paracelsus was credited with the possession of a bottled demon; see Bolte and Polivka, *Anmerkungen*, 415.

18. Grazia Biondi, "Quel 'diavolo' di Tassoni."

19. Tassoni describes the glass ball as being as big as a goose egg, perfectly sealed and full of water. Within it, one could see a black, horned devil—also made of glass—which flipped and rolled whenever one inclined the container (*Lettere di Alessandro Tassoni*, 2:125–36, esp. 127–28).

20. Masini, *Sacro Arsenale*, 18.

21. Menghi, *Compendio dell'arte essorcistica*, 77–78.

22. Sixtus V, *Constitutio S. D. N. D.*, 2:515–17. In 1586, the text of the bull was translated into Italian by Cardinal Gabriele Paleotti: *Contra coloro ch'essercitano*, 9. For a detailed study on the text, see Ernst, *Religione, ragione e natura*, 255–79.

23. Albano Biondi, "Streghe ed eretici," esp. 175–76.

24. We know from Ludovico Ariosto, *Satire*, book 7, 94–95, that Carlo Sosena, who taught astrology at the Studium in Ferrara and was astrologer at Duke Ercole's court, made prophecies thanks to a spirit.

25. Cattani da Diacceto, *Discorso sopra la superstizione*, 15–18v.

26. "Et questo per certi spiriti quali io aveva incluso in una ampolina," quoted by Gabotto, *Nuove ricerche e documenti*, 7.

27. The poem, no. 90 (or 46 according to other numeration systems) in the collection of the *Rime*, is a veritable catalogue of false prophets, astrologers, sibyls, heretics, fortune-tellers, dream interpreters, etc., as they were known and attested in 1378. The poet concludes his description by mentioning necromancers with the inevitable bottle. See Sacchetti, *Opere*, 1071–75, vv. 100–104.

28. Lisini and Giacometti, *Cronaca Senese*, book 15, section 6, vol. 1:58.

29. The expression recurs, for instance, in Ariosto's *Satire*, book 7, 9–95; in Firenzuola's comedy *I lucidi*, 183 (act 2, scene 4); in Francesco D'Ambra's comedy *I Bernardi*, 71 (act 4, scene 5); and in Alessandro Tassoni's mock-heroic poem *La secchia*, book 5, stanza 5.

30. It is the discipline traditionally ascribed to *specularii*, of which an extensive description is provided by John of Salisbury, *Policraticus*, chapter 12, 56–72.

31. Zipoli, *Malmantile racquistato*, 294.

32. This aspect does not seem coincidental; on this, see the passages of the Testament of Solomon referring to the prophecies of Enopsigos and Ornias below.

33. A practical *experimentum inclusionis spiritus in ampulla* is recorded in Firenze, Biblioteca Medicea Laurenziana, MS Plut. 89 sup. 38, fols. 124v–5r, which dates to the end of the fifteenth century. Here, Solomon is never mentioned, but a series of detailed instructions are given in order to entrap the demon Gramon, which can be summoned to know the things to come ("quando volueris scire aliquid futurum"). Even the examples provided by Martin Del Rio in his renowned *Disquisitionum Magicarum libri sex*, book 4, chapter 2, question 6, section 4, which often quotes classical sources, are all fairly late in date.

34. Sophie Page, "Magic and the Pursuit of Wisdom." The demon in the bottle could technically belong to the category of *spiritus familiaris*, but not all familiar spirits dwell in vials, which is why, despite various similarities, I prefer not to use *spiritus familiaris*. The

definition is a broad one and originally indicates a *famulus* (i.e., a slave spirit), but it can also acquire the meaning of "familiar," in the sense of intimate. Even Socrates's *daimon* could be considered a *spiritus familiaris*. These spirits are not necessarily evil, but they can exert a function of protection, often assimilated to that performed by guardian angels in the Christian tradition. Such a notion probably became widespread thanks to *Liber Razielis*, a medieval grimoire, originally in Hebrew, compiled around the thirteenth century. On this, see Sophie Page, "Speaking with Spirits." On the tradition of the *Liber Razielis*, see Abate, "Nouvelles lumières." For an interesting exposition of the theme from the early modern era, see Elich, *Daemonomagia*, 194–210, esp. 201.

35. Comparetti, *Virgilio nel Medioevo*, 2:99–105. The earliest examples are the *Reinfried von Braunschweig* and the *Wartburgkrieg* (thirteenth century). Both texts report how Virgil met a famous necromancer, Zabulon, and took away his books thanks to a spirit enclosed in a ring. Even more pertinent to our case is the *Weltbuch*, written by Jans der Enikel, where Virgil, while hoeing the ground, is said to have found a bottle with twelve demons inside. Heinrich von Mügeln versified a similar episode. Felix Hemmerlin, in his *De nobilitate et rusticitate dialogus*, narrates how Virgil controlled the demon enclosed in the bottle thanks to a book attributed to the king of Israel. Solomon himself is said to have entrapped demons in glass bottles ("eos in vasis vitreis inclusisse") in the *Summa confessorum* by Thomas of Chobham (ca. 1160–1233/36), while the idea that he had enclosed some evil spirits in his ring is reported in Peter Comestor's *Historia Scholastica* and in Gervais of Tilbury's *Otia imperialia*; on this, see Véronèse, "Salomon exorciste."

36. See also Bolte and Polivka, *Anmerkungen*, 2:415–16.

37. Schmeling, *Commentary on the Satyrica of Petronius*, 206–7; Cameron, "Sibyl in the Satyricon."

38. As far as Italian literature is concerned, both Vittorio Sereni and Andrea Zanzotto made explicit reference to it in their poetic works. See Orvieto, *Idea del Novecento*, 191. The most famous quotation, however, is that by T. S. Eliot in the epigraph to his poem *The Waste Land*. For analysis, see Bacon, "Sibyl in the Bottle"; Arrowsmith, "Luxury and Death in the Satyricon"; Schmeling and Rebmann, "T. S. Eliot and Petronius." Examples could easily be multiplied; see, for instance, the bibliographical references listed in Roessli, "Vies et métamorphoses de la Sibylle," esp. 264–65.

39. Gowers, "Virgil's Sibyl."

40. Bonner, "Sibyl and Bottle Imps"; see also Veyne, "Sibylle dans la bouteille."

41. The passage of Apuleius mentioned by Roger Pack and added to the list of possible parallels does not seem convincing from a textual point of view. Here, in fact, the poet mentions a sibyl in a lamp, referring to the fact that lamps could be used for divination purposes. Thus, a lamp could, in a figurative way, be considered a sibyl. Pack, "Sibyl in a Lamp."

42. Bonner, "Sibyl and Bottle Imps," 2–3. Of a similar opinion is Richardson, "Trimalchio and the Sibyl."

43. Bonner also mentioned the tradition of magic bowls or incantation bowls, clay vessels with apotropaic functions, often inscribed with Solomonic formulae. However, the corpus of extant pieces, no earlier than the sixth century CE, does not seem to be directly related to the tradition of metal bottles that developed starting in the first century in connection with Solomon. On this type of objects, see chapter 2.

44. Comparetti, *Virgilio nel Medioevo*, 2:103–4.

45. Bonner, "Sibyl and Bottle Imps," 8.

46. On the contractual value of magical characters, see Grévin and Véronèse, "'Caractères' magiques," esp. 354–62.

47. An occurrence of a prophecy occurs in the Testament of Solomon 15:8–9, where the demon Enepsigos mentions the vessels containing the demons and prophesizes about their future destruction and the consequent freedom of all the evil spirits. "Then the (evil) spirit prophesied to me, saying, 'You are doing these things to us now, King Solomon, but after a period of time your kingdom shall be divided. ... Along with these (events), also all the

vessels in which you have entrapped us shall be broken in pieces by the hands of men" (translation from Duling, "Testament of Solomon," 1:975).

48. Testament of Solomon 22:11–13; Duling, "Testament of Solomon," 1:983.

49. "He put the flask on the ground and placed the ring on (its mouth). (The demon) entered the flask and inflated it. . . . He bound up the mouth of the flask in the name of the Lord Sabaoth and the demon stayed inside the flask" (Duling, "Testament of Solomon," 1:984). For a recent translation and commentary, see also Busch, *Testament Salomos*, 257–63.

50. Tritton, "Spirits and Demons in Arabia"; MacDonald et al., "Djinn"; Lebling, *Legends of the Fire Spirits*; Chabbi, *Seigneur des Tribus*.

51. Fiedler, *Antiker Wetterzauber*; Wachsmuth, "Winddämonenkult," vol. 5, col. 1380.

52. Although the use of knots in magic practices is well attested for a variety of activities (such as love binding or general apotropaic functions), it is possible that the Quranic mention of women blowing on knots (113:4) originally referred to a method for raising winds, i.e., demons in the specific cultural context of Arabia, was understood as a dangerous or mischievous activity. On the entangled issue of the so-called Solomonic knot, see chapter 4.

53. Frazer, *Golden Bough*; Rhys, *Celtic Folklore*, 1:26–30, 330–31; Janni, *Miti e falsi miti*, 9–28.

54. Rademacher, "Erzählungen der Odyssee," esp. 18–21; Strömberg, "Aeolus Episode and Greek Wind Magic"; Hampe, *Gleichnisse Homers*, 16–17; Denys Page, *Folktales*, 73–78.

55. Fraser, "Origin of Aeolus."

56. Heubeck and Hoekstra, *Commentary on Homer's Odyssey*, 43–44.

57. Bonner, *Studies in Magical Amulets*, 66–67.

58. Germain, *Genèse de l'Odyssée*, 180, 516–17.

59. Ibid., 182.

60. The ability to control natural elements, such as winds, passes from Aeolus onto his son Salmoneus, who, according to ancient sources, had a chariot with which he faked the noise of thunder and storms, a classical topos of cosmic kingship, derived from the notion of mastering weather. See Germain, *Genèse de l'Odyssée*, 187.

61. Ibid., 189. Bronze mansions have a long history and a broad diffusion. Denys Page, *Folktales*, 73–78.

62. Iafrate, "*Opus Salomonis*."

63. An ancient Pythagorean tradition assimilated the sound produced by resounding bronze to the voice of the demon there enclosed. See Détienne, *Notion de daïmôn*, 50.

64. The witch of Endor is represented holding a sort of flask in a German fifteenth-century print. For a reproduction, see Zika, *Appearance of Witchcraft*, 49–50, fig. 2.12. Zika sees this iconographical detail as a reference to the "cup of abomination," since the whole depiction is a conflation of motifs from the Apocalypse (the prostitute from Babylon) and the Samuel passage. I think that such a hypothesis is very reasonable, although it would have been interesting to explain the presence of the "bottle" on the basis of a rather too literal translation of the term *ob*.

65. Brown, Driver, and Briggs, *Hebrew and English Lexicon*, 15. The issue is well summarized and discussed in Greer, "*Belly-Myther*" *of Endor*, xi–xii.

66. Some scholars in the nineteenth century had suggested "the antiquity of the idea that magicians were wont to imprison in bottles the spirits whom their spells had subdued (hence our 'bottle-imps' and 'bottle-conjurors[')])" (*Chambers's Encyclopaedia*, 4:239).

67. A trace of such a notion seems to appear in the episode in the Gospel of Luke in which Jesus commands the winds and tames the storm. The demonic quality of these winds resurfaces in some medieval manuscripts depicting the episode, even if this is probably "the result of medieval imagination," not a trace of the ancient tradition (Nova, *Book of the Wind*, 49–50). The control over natural elements, perceived as evil forces, appears as a sort of long-standing survival of the discourse outlined above. I also wonder whether the almost proverbial quote by the prophet Hosea, "for they sow the wind, and they shall reap the whirlwind" (8:7), usually interpreted as a prophesy of the vengeance to come, is not in fact a reflection of an actual

practice concerning sympathetic magic employed for the control over winds. Various sources report that sailors, in a dead calm, used to whistle to raise the wind. Such a practice, when not well performed, could transform a gentle breeze into a fierce storm. The reference made by the prophet, then, seems to hint at something not dissimilar. The phrase "seeding wind," here employed as a figure of speech, might ultimately derive from a more specific practice meant to invoke the wind, with consequences not always predictable or easily controllable. On a medieval example of this occurrence, see, for instance, Janni, "Naufragio di Martiniano." In general, on wind during the Middle Ages, see Leguay, *Air et le vent*.

68. Wiggermann, "Four Winds."

69. Ibid., 135–36. The etymology of the name and the whole genealogy of the demon are quite uncertain; some scholars make it derive from a Semitic root meaning "cripple" or "dwarf," and for Pazuzu's father's name the etymology proposed is "the limping one." This aspect is interesting because, by a curious coincidence, several demons in late Western culture are said to be limping.

70. In the Greek ancient conception, for instance, there is a clear connection between the archaic and monstrous Typhon, son of Gaea and Tartarus, and strong winds and storms. Moreover, subterranean winds, which were thought to be the cause of earthquakes, were often represented as demons, given also the ambiguity of the term *pneumata* (Aristotle, *Metaphysics* 2.8.368 and 26–34); see also Hans Lewy, *Chaldaean Oracles and Theurgy*, 259 n. 2. As for the simile between speaking demons and winds, see Coppola, *Anemoi*, 113–19.

71. Enepsigos mentions demons entrapped in vessels in Testament of Solomon 15:8–9, before Solomon actually imprisons them according to that method in chapter 16.

72. Testament of Solomon 16:6–7, trans. Duling, "Testament of Solomon," 976–77; Busch, *Testament Salomos*, 211–14.

73. Rubenstein, *History of Sukkot*, 117–31.

74. Ibid., chapter 4.

75. The site is mentioned by the Gospel of John (5:2–18) as the setting of a miracle performed by Jesus.

76. Geyer and Cuntz, "Itinerarium Burdigalense," 598, 7–11.

77. Benoit, "Découvertes archéologiques," 52–53.

78. Wilkinson, *Jerusalem Pilgrims*, 117.

79. The story emerging from both the Testament of Solomon and the other texts mentioned is echoed by two passages in a late Greek text, a Solomonic diegesis compiled mostly in 1719 and published by McCown as an appendix to his translation of Testament of Solomon 10:2. Once more it is repeated how Solomon had "copper vessels" and "large casks like jars" made and how he "sealed the vessels with the seal of God. And the seals were of silver and the demons were within; and they dared no more go forth" (11:3–4). Interestingly, this account also relates the siege of Jerusalem by King Nebuchadnezzar, the destruction of the Temple, the burning of its roof, and the usual discovery of the abandoned vessels, in a description that echoes quite closely the sack of the city performed by the Romans. For the full passage, see Bonner, "Sibyl and Bottle Imps," 5–7.

80. A depiction of the retrieval of the bottles can be found in a codex compiled in Baghdad in 1388, containing *The Wonders of Creation* by Tūsī Salmānī; see Paris, Bibliothèque Nationale de France, MS Sup. Persan 332, fol. 51v.

81. Gerhardt, *Art of Story-Telling*, 212–13.

CHAPTER 4

1. Sansoni, *Nodo di Salomone*; Lo Cascio, *Nodo di Salomone*. See also Dinkler, "Salomonische Knoten"; and Zischka, *Zur sakralen und profanen Anwendung*, esp. 41–54.

2. Von Schulenburg, "Salomonsknoten." Such a custom among sailors is confirmed by Melissari, *Lineamenti di un percorso demoetnoantropologico*, 28.

3. The earliest written lexica of nautical jargon are unfortunately relatively late; none of them, in any case, registers a Solomon's knot, although they all refer to the *pie' di pollo*, whose use and description perfectly match that noted by Schulenburg. The absence of the Solomonic knot from these early official texts, in any case, is not surprising if we consider the great linguistic regional variety of Italy. The name could have therefore been diffused only in certain Italian areas. On the descriptions of the *pie' di pollo*, see Stratico, *Vocabolario di marina*, 1:ix, 72, 227, 350 (table 12); or Parrilli, *Dizionario di marineria militare*, 2:144. A Solomon's knot is mentioned for the first time in Guglielmotti, *Vocabolario marino e militare*, 572, where the author introduces the topic of knots in general by quoting the not too precise definition from the *Vocabolario della Crusca* (1612), which listed four kinds of knots. The first one—known as Solomon's because, according to the author, it was named by the kabbalists after the king of Israel—was defined as an arcane knot, without beginning or end (col. 1144). At this date, therefore, Guglielmotti defines Solomon's knot as a "knot on paper"—a linear design, not to be actually tied—and the *pie' di pollo* as a physical one, which can be tied by sailors (col. 1145). Guglielmotti also tries to provide an explanation for the etymology of Solomon's knot, stating that it belonged to the repertoire of kabbalists, though this is probably incorrect.

4. Leite de Vasconcelos, *Signum Salomonis*, 107–9.

5. Another scholar at that time mentioned it in relation to wedding traditions of Umbria (Bellucci, *Usi nuziali nell'Umbria*). See also Pitrè, *Medicina popolare siciliana*, 313–44; Pitrè, *Usi e costumi, credenze e pregiudizi*, 1:85.

6. Such as Abbot Scollandus, depicted in an eleventh-century manuscript (Mont-St-Michel, MS Avr. 103, fol. 4v), whose vestments the knot decorates and protects.

7. Kitzinger, "Threshold of the Holy Shrine." An example that seems to strengthen Kitzinger's thesis is recorded in an Ethiopian miniature, dated to the fifteenth century, representing Emperor Constantine holding a sword (Paris, Bibliothèque Nationale, MS Ethiopien d'Abbadie 105, fol. 127v). On his sheath, both crosses and Solomonic knots are depicted in what seems to me an evident morphological variation. Sansoni erroneously identifies this figure with that of Solomon, who is instead represented, almost in an identical way, on fol. 121v. See Sansoni, *Nodo di Salomone*, 174.

8. Rolfsen, *Knots and Links*. The shape of the knot of Solomon is indexed as 4^2_1 (416). However, there is no absolute terminological consistency among mathematicians, either. See, for instance, http://katlas.math.toronto.edu/wiki/L4a1, where it is indicated as L4a1. On the relationship between art and math as far as knots are concerned, see Küchler, "Why Knot?"

9. Pentalfas and hexalfas are renowned and familiar symbols that enjoy a broad visual tradition, shared by different cultures, that came to be openly associated with Solomon from late antiquity through the Middle Ages. See Schouten, *Pentagram as a Medical Symbol*; Winkler, *Siegel und Charakter*, 119–27; Leite de Vasconcelos, *Signum Salomonis*; Klagsbald, "'Comme un lis entre les chardons'"; Herlitz and Elbogen, *Jüdisches Lexikon*, 3:1281–82; Scholem, "Curious History"; Milstein, *Khotam Shlomo*; Caiozzo-Roussel, "Autour de Salomon"; Hasson, "Enamelled Glass Bowl"; Iafrate, "From Wheel of Fortune;" Coulon, "Salomon dans les traités." Although some studies have been published, thorough research in broad comparative terms, encompassing their use in Christian, Muslim, and Jewish sources, along with their precedents in antiquity, is lacking. Lloyd Graham has collected abundant material on the topic. His articles do not appear to have been published in any academic journal but are available on Academia.edu. See, e.g., Graham, "Seven Seals of Judeo-Islamic Magic," and Graham, "Comparison of the Seven Seals."

10. In Islamic culture, the five-pointed star was usually the first of seven symbols representing the so-called Solomon's seal, however it is not uncommon to find it substituted by a six-pointed star in several occurrences.

11. Minervini, *Novelle dilucidazioni*, 131–60.

12. William of Auvergne and Ranulph Higden, for instance, both mention Solomonic seals and rings in their writings. See Hardman, "Gawain's Practice of Piety," 249; see also

Owst, "Sortilegium in English Homiletic Literature" esp. 286–87; Klagsbald, "'Comme un lis entre les chardons.'"

13. Grévin and Véronèse, "'Caractères' magiques au Moyen Âge."

14. On the medieval association between regality and riddles, see Rapisarda, "Enigmi per il principe."

15. Schnetz, *Ravennatis Anonymi Cosmographia*, 26–27.

16. The expression is employed in a similar metaphorical way, centuries later, by Sebastiano Guazzini: "Ideo sum contentus solutionem istius nodi Salomonis aliis curiosis lectoribus et scribentibus relinquere" (*Tractatus ad defensam inquisitorum*, 18).

17. Giversen, "Solomon und die Dämonen"; Duling, "Solomon, Exorcism"; Hiers, "'Binding' and 'Loosing'"; Duling, "Eleazar Miracle and Solomon's Magical Wisdom"; Bowman, "Solomon and Jesus"; Mark Edwards, "Three Exorcisms"; Twelftree, *Jesus the Exorcist*; Cosentino, "Tradizione del re Salomone," 43; Torijano, *Solomon the Esoteric King*; Klutz, "Archer and the Cross"; Torijano, "Solomon and Magic"; Véronèse, "Salomon exorciste." On the history of exorcism in the Christian medieval world, see Chave-Mahir, *Exorcisme des possédés* and Véronèse, "Invoquer et conjurer."

18. Boudet and Véronèse, "Lier et délier." Originally, the Latin terms *ligamentum* and *ligatura* translated the Greek *periapton* and *periamma*, words that indicated the practice of carrying bodily amulets, usually hanging from clothes or body parts. See Kauffmann, "Obtenir son salut," esp. 118.

19. Wolters, "Faden und Knoten als Amulett"; von Bissing, "Aegyptische Knotenamulette"; Clasen, "Überwindung des Bösen"; Day, *Quipus and Witches' Knots*; Gombrich, *Sense of Order*, 262–64; Kitzinger, "Threshold of the Holy Shrine"; Kitzinger, "Interlace and Icons"; Maguire, "Magic and Geometry"; Maguire, *Icons of Their Bodies*, 132–37; Maguire, "Magic and Money"; Donceel-Voûte, "Barrer la route au Malin"; Maguire, "'To Knit the Ravelled Sleeve.'"

20. It is therefore possible that the widespread use of pseudo-Kufic script in religious contexts or as decoration of textiles and carpets could work in a similar way.

21. Hartner, "Pseudoplanetary Nodes"; Azarpay, "Eclipse Dragon"; Caiozzo, "Eclipse ou Apocalypse"; Caiozzo-Roussel, "Autour de Salomon"; Berlekamp, "Symmetry, Sympathy, and Sensation."

22. That an association between Solomon and labyrinths as prisons must have been well established in the East—probably as a result of practices and beliefs extant since late antiquity—is indirectly supported by a discovery made by Adolphe Napoléon Didron during a trip to the monasteries in the Meteora. He reported that on the wall of one of the guest rooms in St. Barlaam he noticed a labyrinth, almost identical to that on the floor of Chartres and similar to those in Rheims and Amiens. He found out it had been drawn by an old monk, since deceased, who had copied it from a manuscript in the library; the drawing was known among the monks as Solomon's prison. See Didron, "Voyage archéologique," 177–78. A further trace of the vitality of this association seems to resurface in the West during the fourteenth century. A collection of alchemy texts depicts a labyrinth, very similar to that of Chartres, accompanied by a text in Greek that describes it as Solomon's creation and provides an allegorical interpretation of it. The text could belong to the same tradition as the lost manuscript of St. Barlaam mentioned by Didron. See Berthelot, *Collection des anciens alchimistes grecs*, 1:39–40; Batschelet-Massini, "Labyrinthzeichnungen in Handschriften."

23. Cosentino, "Tradizione," 43.

24. Tuzi, *Colonne e il Tempio*; Perroni, "Capitelli a 'crochets.'"

25. Cahn, "Solomonic Elements in Romanesque Art."

26. Kalavrezou-Maxeiner, "Byzantine Knotted Column." On Hercules's knot, see Daremberg and Saglio, "Nodus"; Day, *Quipus and Witches' Knots*, 53–63.

27. The bibliography on Dante's *Tenzone* is particularly rich. For a good synthesis, see Meacci, "Nodo Salomone," 25; Alfie, *Dante's "Tenzone"*; Filippi, *Art of Insult*, 14–17; Díaz, "Contested Virilities."

28. For an English translation of the full exchange, see Alfie, *Dante's "Tenzone,"* 34, 38–39.

29. In the very first line, Dante refers to Forese's wife as a "mal fatata," an expression usually glossed as "luckless," "ill-fated," or "born under a bad sign," and understood as meaning that unfortunate circumstances have brought her to live in a dire situation, with a man unable to satisfy her. It could also be interpreted as "bewitched" or "under a curse." The lack of a sexual life among married couples was often ascribed to charms of hate magic, which prevented rightful intercourse between husband and wife. See Rider, *Magic and Impotence*.

30. Italians still use the expression *legare come un salame*, corresponding to the English "truss up like a fowl."

31. The first to suggest such a correspondence between the knot and the *pentangulus* was Cherchi, "Pentangulo, Nodo di Salomone, Pentacolo." Nevertheless, Cherchi did not try clarify the passage in the *Tenzone* in light of his intuition.

32. Panvinio, *De fasti et triumphi Romanorum*, praefatio. It would therefore be tempting to conclude that the "nodos Salomonis" that decorates the silk cope in a 1327 inventory of the treasury of St. Peter, or the golden cup mentioned in a 1389 description of rich ecclesiastical goods in Assisi, was intended as a five-pointed star. The chronological proximity to the *Tenzone* would make it possible, and, at least in the case of the cup, the presence of a vast repertoire of bowls of Islamic origin decorated with such a pattern would not exclude such a possibility a priori. See, respectively, in Sella, *Glossario latino-italiano*, the entries *piviale* (cope): "Pluviale de cataxamito giallo cum aurifrisio de panno serico ad nodos Salomonis, sine fodera, cum caputio de dyaspero giallo cum aliquali frisio" (449); and *tacea* (cup/bowl): "Tacia de auro copercolata laborata ad nodos Salomonis et super coperculo unum rotundum cum dicto nodo in campo albo" (567). However, as we shall see, the morphological correspondence between a knot and a shape associated with it is not always univocal. Thus, without the cup and the textile as evidence, it is not possible to establish it with certainty.

33. An *aiguillette* was a small cord used to fasten men's trousers.

34. Philip Augustus of France (1165–223) repudiated his first wife, Ingeborg of Denmark, under the explicit accusation of *maleficium*—probably a not-too-veiled allusion to the practice of knot-tying—thus declaring the marriage, which allegedly could not be consummated, void. See Conklin, "Ingeborg of Denmark"; Lea, Howland, and Burr, *Materials Toward a History of Witchcraft*, 1:162–70. On the long-standing preoccupation regarding this practice, which was deeply felt well into the seventeenth century, see Entin-Bates, "Montaigne's Remarks on Impotence." See also McLaren, *Impotence*, esp. 25–49.

35. On the topic in general, see Rider, *Magic and Impotence*.

36. I have found an interesting example in the Hebrew medical treatise attributed to Abraham Ibn Ezra (1090–1167). The last section of the eleventh chapter, dedicated to the ways of increasing the semen, for instance, is devoted to the explanation of various binding prescriptions, given on the authority of the wise Solomon. The treatise recommends, among various things, taking wool from a live lamb, making a thread out of it, and tying it in three knots while pronouncing a spell. Afterward, the healer was also supposed to resort to the seal of Solomon for such a practice. See Leibowitz and Marcus, *Sefer Ha-nisyonot*, 74–76. The treatise specificies that it was only the experimenter who could untie such knots.

37. The earliest known mention of the *vinculum* appears in the *Summa sacre magice* (1346) by Berengarius Ganellus (Kassel, Landesbibliothek und Murhardsche Bibliothek der Stadt Kassel, MS 4° astron. 3, vol. 2, fols. 55–61). For a published version of an *experimentum*, where the *vinculum* is evoked, see Kieckhefer, *Forbidden Rites*, 287–91; see also Chave-Mahir and Véronèse, *Rituel d'exorcisme*, 118–27. In general, even if the absence of an earlier manuscript tradition makes it difficult to date the first appearance of the *vinculum* in exorcism literature, evidence *e silentio* is no definite proof that such a tradition did not exist. Most of these magic texts were handed down in secrecy.

38. The reference to these birds in the sonnet calls to mind the *fabliau* of *Les Perdris*, which centers on the desire for partridge breasts. This seems perfectly echoed by Dante's "petti delle starne," or the *Sohait des vez*, where the husband, having eaten and drunk too

much, is unable to satisfy his wife. For the texts of both, see Noomen and van den Boogaard, *Nouveau recueil complet des fabliaux*, 4:8–12; 6:271–72. On this theme, see Sarah Gordon, "Sausages, Nuts and Eggs."

39. In the first sonnet, Dante does not seem to imply that Bicci is impotent but that he does not satisfy her. Such a lack of compliance with his marital obligations could depend on his abstaining from sexual intercourse, but also on the limited size of his penis, possibly alluded to by the verse "merzé del copertoio c'ha cortonese." See Dante Alighieri, *Opere minori*, 395.

40. Carbone, *Facezie e dialogo*, 20.

41. The association between demons and sexual intercourse must have been another well-established topos, if we consider that according to Boccaccio the act was described as putting the devil back in hell ("rimettere in diavolo nell'inferno"). See his tale of Rustico and Alibech, *Decameron*, book 3, 10. See also Guerri, "Elementi del Decamerone," 369.

42. *Lettere volgari di diversi nobilissimi*, 2:65v. It is not clear whether in Saliceto's case the *groppo di Salamone* was a self-imposed chastity measure or an unfortunate occurrence.

43. See, for instance, Cursietti, *Falsa tenzone di Dante*.

44. The implication that the knot could be associated with other famous figures suggests that Forese is referring to Alexander the Great and his Gordian knot, for instance.

45. Alfie, *Dante's "Tenzone,"* 40–42.

46. Villani, *Cronica*, 1:428.

47. *Statuts de l'ordre du St. Esprit*, facsimile reproduction of Paris, Bibliothèque Nationale, MS fr. 4274, fol. 3v. For a recent bibliography on the order, see Bock, "Ordre du Saint-Esprit"; Perriccioli Saggese, "Gli statuti dell'Ordine"; Bräm, "Zeremoniell und Miniatur."

48. Gaglione, *Sculture minori del Trecento*, 24. See also Camera, *Elucubrazioni storico-diplomatiche*, 169–72.

49. Sacred Congregation of Rites, *Processus Canonizationis*. The collar is defined as a golden chain interwoven with Solomon's knots (55). For all the other similar mentions, see *passim* at 36, 45, 49, 50, 51, 54, 58, 62, 139, 142.

50. See Ripart, "Du Cygne Noir," esp. 6 n. 24 and 7 n. 27.

51. The same knots characterize the Order of the Ladies of the Cord, instituted in 1498 by Anne of Brittany (1477–1514). Reportedly, the Order of the Knights of Cyprus, or of the Sword, or of Silence, which was founded around 1192 by Guy of Lusignan, had a collar made of large white silk ribbons, tied together in Solomon's knots and interwoven with a golden R and S, which stood for either *Regium Silentium* or *Regium Secretum*. See de Sainte-Marie, *Dissertazioni storiche e critiche*, 133–34. These knots can be safely identified as Savoy, since they are still in use. Moreover, some sources call them *lacci d'amore*, equivalent to the *lacs d'amour* of the Savoy family. See Cappelletti, *Storia degli ordini cavallereschi*, 330–31; Cuomo, *Ordini cavallereschi antichi e moderni*, 961–62. However, the earliest extant description of the collar (1721) makes no explicit reference to knots. On the history of the order, see Baldan, *Reale Ordine dei Cavalieri*, 105–23. Given the relatively late descriptions of the collar, there is no way to ascertain whether the knots were there from the beginning and what they were called. It seems more likely that the idea of adding this type of knot to the collar derived from the Savoy example was a quite late and not especially relevant addition. Moreover, the Lusignan family has been deeply connected to the Savoy family since the marriage between Ludovico of Savoy (1413–56) and Anne of Lusignan (1419–62) in 1434. Eventually the Savoy family would inherit the kingdom of Cyprus through the Lusignan lineage.

52. We can consider the Savoy knot morphologically pertinent to our catalogue of Solomonic devices if we take the double entwinement of its double loop as a further variation of the two closed shapes that make up the seal of Solomon (six-pointed star).

53. Mazzei, *Lettere di un notaro*, 1:342–43: "And do not take it as praise for me that he wrote it: for I only looked within your heart towards me, which was a great gift and joy to me. Yet you gave me Solomon's knot for the love that I bore you" [intanto che mi deste nodo Salamone alla carità ch'io v'avea]; for, believe me, it is a great present to a lover that the beloved take notice of him." Translation in Alfie, *Dante's "Tenzone,"* 41. As evidence that "nodo

Salamone" should be understood as "love bond," Alfie refers to an anonymous ballad from the thirteenth or fourteenth century. The man pursues the girl, who seems to accept his courting: however, after having gifted him a garland, she leaves him unsatisfied: "Io rimasi tapino / in su quel verde prato / sentendomi legato / col nodo Salamone" (Carducci, "Era tutta soletta," 113–14). In my view, the knot here hints not only at the strong affection that the poet feels for the girl, symbolized by the entwined garland that she gave him as a token of love, but also—and not without a certain irony—at the fact that his desire is bound to remain unsatisfied. The comic vein seems apparent to me here; the girl, well aware of the effect of her beauty on the poet ("Tu se' innamorato / e già no 'l puoi disdire; / ch' i' veggio il tuo disire / in vêr di me acceso"), chooses deliberately to ignore him. Here, the knot of Solomon appears as a conscious parodic element, shifting from symbol of love and fidelity to sign of impotence. While the poet is not technically impaired, the impossibility of satiating his lust makes him helpless, as if he were impotent.

54. Sansovino, *Origine e fatti delle famiglie*, 437.

55. The battle of Anghiari, in which Tolentino did take part, is that of 1425, not 1440. However, he was not successful on that occasion, and none of the shields of the *condottieri* he faced that day displayed any kind of knot as an emblem. It is not possible, therefore, that Sansovino was mistakenly reporting an event that occurred on a different occasion; the chronicler says, in fact, that first Niccolò took the knot and that he was later made count of Stacciola by Malatesta. This, however, happened in 1412 (although Sansovino mistakenly says 1422), and in any case before the date of Anghiari. So it is possible that he gained the emblem on a different occasion. Sansovino's account, however, is not confirmed by any of the earlier known sources on the life of the *condottiero*, for which, see Vittozzi, "Niccolò Mauruzi."

56. Curzi, *Pittura dei Templari*; Curzi, "I graffiti figurativi." Interestingly, in the church of Santa Maria do Olival in Tomar, Portugal, built by the Templars, one of the *oculi* is shaped as a five-pointed star. See Cadei, "Architettura sacra templare," 158, fig. 98. On the Cistercian interest in knots, see Righetti Tosti-Croce, "*Spolia* e modelli altomedievali."

57. Other Solomonic knots resurface here and there in Italian sources. In *Il mambriano*, a chivalric poem composed by Francesco Bello of Ferrara in 1494, a Solomonic knot appears in the description of the retinue of the sultan, among which the poet lists "four giraffes and an Indian horse, which had on its forehead a knot of Solomon / in many colors and among its ears a horn / bigger than that of a unicorn" (Quattro giraffe e un caval indiano / ch'avea nel fronte un groppo Salamone / di più colori e fra le orecchie un corno /maggiore assai di quel d'un Alicorno") (book 35, stanza 10). Here, the knot on the forehead of the Indian horse (possibly a Marwari) was probably part of the head strap of the animal, which must have included a browband decorated with a knot. Bello, *Mambriano*.

58. Several Italian *condottieri* in the fourteenth and the fifteenth centuries chose one or more knots as their personal emblems, including Francesco Broglia; Angelo Broglia da Lavello, known as "Il Tartaglia"; Erasmo da Narni, better known as Gattamelata; Antonio Bocarini Brunori; Pietro Brunoro; Brandolo Brandolini; and Giovanni d'Andrea Minerbetti. On this, see Massimo Predanzani, "Stemmi e imprese."

59. Ficino, *Lettere*, 28. "If you are surprised, Cosimo, that Lorenzo wrote so lengthily when Solomon was so brief, I reply that Lorenzo was obliged to be lengthy because Solomon was so brief. The more intricate the knot which Solomon tied, the more devices were necessary to unravel it" (Ficino, *Letters of Marsilio Ficino*, 1:48).

60. McKillop, "Dante and Lumen Christi," 284. McKillop also states that "the unending complication of Solomon's knot also appears in several folios of the Hours of Laudomia Salviati (London, British Library, MS Yates Thompson 30), the manuscript providing our clearest view of Solomonic imagery in the Early Medici circle" (285). However, even in this case I do not think that McKillop's assertion is quite accurate. Several unending knots do appear in the codex (like those at fols. 66v–67r), but it is hard to tell what Solomonic implications (if any) they hold. For a synthesis of the various positions regarding the interpretation of the tomb and a full bibliography on it, see Dressen, *Pavimenti decorati*, A28, 306–9.

61. Lavin, *Past-Present*, 1–27, esp. 17, 20.

62. Aretino, *Ragionamento*, 30.

63. On the importance of knotted patterns in feminine contexts, as a symbol for weaving activities, see, for instance, Allen, "Wood Knots." See also below, the example of the knot of Solomon sewn on the mantle dedicated to the Virgin by the nuns of the Florentine convent of Le Murate. On the development of and interest in knots, also in relation to sewing activities, see the catalogue by Tagliente, *Esempio di raccammi*. On Renaissance knots and particularly on Leonardo's, with a very rich bibliography on the earlier tradition as well, see Bambach Cappel, "Leonardo, Tagliente and Dürer"; Coomaraswamy, "Iconography of Dürer's 'Knots.'"

64. In the same exact years, the *groppo Salamone* was mentioned in Aretino's correspondence, with an entirely different meaning, clearly showing that the two interpretative lines—both the magical and morphological—could normally coexist.

65. I refer to Victor Stoichita's in-depth analysis in "Faces and Shields," dedicated to the broader theme of attack and defense in the visual arts of the Renaissance. The contents of the conference will be published in a forthcoming volume addressing the power of the gaze in Renaissance art.

66. Already Dante, in describing the monster Gerione, had referred to its skin as a maculated surface, full of knots and circular shapes, which reminds the viewer of an Oriental carpet. *Inferno* 17:12–18. On this point, see also Warner, *Stranger Magic*, chapter 2, section 3.

67. The cope with silk ornaments mentioned in the 1327 inventory, described above in note 32, for instance, could fall into the same category. However, without a visual comparison, it is not clear what kind of pattern the writer had in mind. "Nodi Salamone" appear as characterizing patterns of a velvet cloth and of a silk ornament in two different rooms of the Palazzo Pitti, according to a description published in 1577 by a Venetian ambassador who had sojourned there. See Bertelli, "Palazzo Pitti," 67.

68. Piper, "Maria als Thron Salomos"; Azcárate Luxán and Gonzalez Hernando, "Virgen-trono."

69. Baldinucci, *Vocabolario toscano*, 108.

70. The same meaning is also retained at a popular level. We find a parallel, for instance, in the collection of Sicilian proverbs compiled by Castagnola, which defines the quality of the "gruppu di Salamuni" (*Fraseologia sicolo-toscana*, 474). Once more, this applies to something without beginning or end.

71. "Der Drudenfuss auf Eurer Schwelle. . . . Beschaut es recht! Es ist nicht gut gezogen" (Goethe, *Faust*, vv. 1394–95).

72. However, as Henry Maguire has recently argued, it is certain that knots in general worked in different ways, depending on whether they were open or closed shapes.

73. On the semantic proximity between knots and labyrinths, see the passage of Pietro Aretino's *Ragionamenti* cited above. Moreover, as Henry Maguire has suggested to me, in this interpretation the interlace could not simply work as a trap for demons. Rather, the uncontrolled interlaced elements could in themselves be an expression of evil. The trap in this case could be the symmetrical figure or form within which the threatening disorder of interlace is confined, and one could posit that the controlled interlace, as in a Solomon's knot, acted as a visual metaphor for the imposition of order on the wider world.

74. The two portals open up on via de' Pettinari 81 and 84.

75. Porro, "Palazzo Salomoni Alberteschi."

76. Pietrangeli, *Guide rionali di Roma, Rione VII*, 1:24–25. The author of the guide does not provide any detailed information that can help in identifying its specific whereabouts but only mentions a property at the foot of the Capitolium ("alle falde del Campidoglio"). The reference appears in the description of Regola, where the second palace of the family still exists today.

77. "Part of the original house belongs nowadays to Costanzo Gigli and part to the Cistercian monks. There you can see the coats of arms of marble and a Solomon's knot" (*La casa originale degli Alberteschi era nel rione di Campitello, la quale oggi è parte di Costanzo Gigli e*

parte è deli monaci Cisterciensi. Si vedono le armi di marmo et un nodo di Salomone) (Amayden, *Storia delle famiglie romane*, 1:18). The transcription made by Bertini is not entirely accurate, and the building in question must have belonged to Costantino (not Costanzo) Gigli (1590–1666), a scholar very active in Rome, whose work and biographies have been recently reconstructed by Federici and Garms, "'Tombs of Illustrious Italians at Rome,'" 10 nn. 71, 73.

78. Pietrangeli, *Guide rionali di Roma, Rione X*. I have carried out an on-site survey of the area but was unable to find any trace of such a palace. From the scanty information provided by Amayden, it would seem possible that the palace was built in via Tor de' Specchi (now via Teatro di Marcello), which has been deeply modified by demolitions.

79. Salamone, "Idea del contrato social," 73–88.

80. *Armoriale delle famiglie italiane*, https:// it.wikipedia.org/ wiki/ Armoriale_ delle _famiglie_italiane; and also Salamone, "Idea del contrato social," 80.

81. Salamone, "Idea del contrato social," 83–85.

82. Without a way to verify Amayden's statement, one could even go so far as to hypothesize that he mistakenly referred one of the knots visible on the later palace to the decoration of the earlier building.

83. In his catalogue of watermarks, published in 1907, Briquet unmistakably identifies nos. 11979, 11980, and 11981 as knots of Solomon; they are fourteenth-century Italian examples. The fact that he calls them "noeuds de Salomon," of course, does not necessarily indicate that they were named that way when they were created, but it is another indirect piece of evidence that when Briquet compiled his catalogue the symbol was widely identified as such. See Briquet, *Filigranes*, 3:601–2.

84. Valentini, introduction to *Canone di Pier Francesco Valentini*.

85. Ibid., 155.

86. Valentini, *Canone nel nodo di Salomone*. In the same year he also published *Resolutione seconda del Canone del Nodo di Salomone*.

87. The theoretical complexity of Valentini's piece was deeply appreciated. Even Athanasius Kircher praised it and explained some of the numerous combinations in his *Musurgia universalis*. See Gerbino, *Canoni ed enigmi*. On the genre of enigmatic canons, see Wuidar, *Canons énigmes et hiéroglyphes musicaux*, esp. 124–72.

88. Roma, Biblioteca Apostolica Vaticana, MS Barb. Lat. 4428, fols. 53–8.

89. "For making the said mantle of six yards of rich brocade of gold, lined with seventy ermine skins, embroidered with sixty-three crowns in gold, and eight hundred and eighty-two precious stones, furnished with a garniture of pearls and a golden clasp, with a Solomon's knot in gold, and a button of gems, and spangled with five sorts of flowers, viz. lilies, roses, carnations, jessamines, and hyacinths." Passage quoted in Trollope, *Girlhood of Catherine de' Medici*, 153. For the original passage, see the description of the *Ammanto d'orazzioni* in Cassotti, *Memorie dell'Immagine di Maria Vergine*, 141, 192–94; Parisi, *Panegirico di Lorenzo Parigi*, 12.

90. Cassotti, *Memorie dell'Immagine di Maria Vergine*, 194.

91. The fascinating story of this nun is recorded in the chronicles of the convent written in 1598 by Sister Giustina Niccolini, *Chronicle of Le Murate*, 92–97. Daughter of the convent's doctor, Simone Cinozzi, Dianora was born in 1450 and entered the convent at the age of ten. An invalid from birth, she was unable to walk until the age of eighteen, when she was healed by direct intercession of the Virgin on August 15, 1468, after years of incessant prayers. It appears that the mantle donated to the Virgin of the Impruneta, and the series of prayers accompanying it, was devised by Sister Dianora herself, whose piety (and sewing abilities) was particularly dear to the Virgin, as confirmed by a dream of another nun, in which the Virgin herself appeared to accept with particular pleasure a mantle fashioned by Dianora.

92. Cassotti, *Memorie dell'Immagine di Maria Vergine*, 194–95.

93. Gerbino, *Canoni ed enigmi*, 69–73; Hallman Russel, "'Intendomi chi può,'" 434; Fabbri, *Monteverdi*, 155–56.

94. "Abbiamo diverse sorte di nodi, come quel nodo di Salamone" (*Vocabolario degli accademici della Crusca*, 558).

95. Firenze, Biblioteca Medicea Laurenziana, MS Ashburnham 688, fol. 4v.

96. Firenze, Biblioteca Medicea Laurenziana, MS Plut. 14.23, fol. 2r. Segni describes it as one of the emblems of Piero di Cosimo, but this identification is erroneous and the knot with the P should be referred to Piero di Lorenzo (1471–1503); see Ames-Lewis, "Early Medicean Devices," 139. However, I do not agree with the view expressed by McKillop, "Dante and Lumen Christi," 284, that the P is a Dantesque reference (mentioned in *Purgatorio*, book 9, vv. 112–14, where P stands for *peccato*, i.e., "sin"). Despite the deeply evocative dimension of this hypothesis, given the lack of a specific context, I would suggest that the P simply hints at the first initial of Piero's name.

97. Dillon Bussi and Fantoni, "Biblioteca medicea laurenziana," esp. the tables at 140–48. McKillop, "Dante and Lumen Christi," 284–88.

98. See the discussion above of Cosimo de' Medici's tomb.

99. Pentecost et al., "Molecular Solomon Link." For a less technical description of this achievement, see http://phys.org/news/2007-01-chemists-molecular-king-solomon.html.

CHAPTER 5

1. De la Voye, "Relation of a Kind of Worms."
2. Happel, *Relationes curiosae*, 1:44–46.
3. Lémery, *Dictionnaire*, 565.
4. *Dizionario overo trattato universale*, 343.
5. Yonge, "Animals that Bore Through Rock."
6. Lewysohn, *Zoologie des Talmuds*, 351–52; Hamburger, *Real-Encyclopädie*, 2:1079–80.
7. Cassel, "Schamir"; Grünbaum, "Beiträge zur vergleichenden Mythologie," esp. 204–13, substantially republished in *Gesammelte Aufsätze zur Sprach- und Sagenkunde* in 1901; Grünbaum, *Neue Beiträge zur Semitischen Sagenkunde*, 227, 288, 289; for a good, extensive overview, see also Bacher and Blau, "Shamir."
8. A case in point is Immanuel Velikovsky's essay on the *shamir*, https://www.varchive.org/ce/shamir/shamir.html.
9. Botterweck, Fabry and Ringgren, *Theological Dictionary of the Old Testament*, 15:237–38.
10. Bochart, *Hierozoicon*, part 2, book 2, chapter 31, 346–49; book 6, chapter 11, pp. 841–43; Cassel, "Schamir," 63–66. The connection to the Greek *smiris* is still visible in languages such as Italian (*smeriglio*) or German (*Smergel*) that maintain a trace of the ancient root.
11. Pliny the Elder, *Natural History* 36.9. See Pliny the Elder, *Complete Works*.
12. Frisk, *Griechisches etymologisches Wörterbuch*, 2:751; Beekes, *Etymological Dictionary of Greek*, 2:1370.
13. Ward, *Seal Cylinders of Western Asia*, 9–10; Middleton, *Engraved Gems of Classical Times*, 104–8.
14. Gorelick and Gwinnett, "Ancient Egyptian Stone Drilling"; Heimpel, Gorelick, and Gwinnett, "Philological and Archaeological Evidence"; Gorelick and Gwinnett, "Minoan Versus Mesopotamian Seals"; Lazzarini, "I vasi in pietra minoici."
15. Lucas, *Ancient Egyptian Materials and Industries*, 66–67; Stocks, *Experiments in Egyptian Archaeology*, 105–11.
16. Serotta and Carò, "Use of Corundum Abrasive at Amarna."
17. Along with the mouth of the earth, the mouth of the well, the mouth of the she-ass, the rainbow, the manna, the rod (of Moses), the text, the writing and the tables. It is interesting to note that the Talmud, in commenting on the same passage, mentions the "writing and the writing instruments." See Epstein, *Babylonian Talmud: Seder Mo'ed*, 2:264–65.
18. For recent assessments of the textual relationship between the Tosefta and the Mishna, see Friedman, "Primacy of Tosefta to Mishnah"; and Friedman, *Tosefta Atiqta, Pesaḥ Rishon*.
19. Tosefta 15.1:

"It is a creature from the six days of Creation.

"When they put it on stones or beams, they are opened up before it like pages of a notebook. And not only so, but when they put it on iron, [the iron] is split and falls apart before it. And nothing can stand before it.

"How is it kept? They wrap it in tufts of wool and put it in a lead tube full of barley-bran."

"And with it Solomon built the Temple, as it is said, *There was neither hammer, nor axe, nor any tool of iron heard in the house, while it was being built* (1 Kings 6:7)," the words of R. Judah.

R. Nehemiah says, "They sawed with a saw outside, as it is said, *All these were of costly stones . . . sawed with saws in the house and outside* (1 Kings 7:9).["]

"Why does Scripture say, *Inside the house and outside?* Inside the house they were not heard, for they prepared them outside and brought them inside."

Said Rabbi, "The opinion of R. Judah seems to me preferable in regard to the stones of the sanctuary, and the opinion of R. Nehemiah in regard to the stones of [Solomon's] house." (Neusner, *Tosefta*, 1:890)

The edition I consulted reproduces the full text of the six-volume publication (New York: KTAV, 1977-86). This translation, however, does not seem to be entirely accurate because at some points it explicitly defines the *shamir* as a worm, which is a later gloss, not extant in the original Hebrew text. See the discussion below. For the standard critical edition of the text, see Lieberman, *Tosefta Ki-fshuta*, 757-58.

20. One of the questions regards the prohibition of iron tools in building the Temple (1 Kgs. 6:7); however, the biblical text seems to contradict itself in mentioning blocks cut with saws in another passage (1 Kgs. 7:9). One of the rabbis solved the contradiction by proposing that the *shamir* therefore had to be employed in the context of the Temple paraphernalia, for cutting the gems of the ephod without notching them, as it was required (Exod. 28:11), while another suggested that 1 Kgs. 6:7 referred to the Temple, where no iron was allowed, and 1 Kgs. 7:9 must regard another Solomonic building, his royal palace.

21. Epstein, *Babylonian Talmud: Seder Nashim*, 3:261.

22. Ibid., 3:260-61.

23. Epstein, *Babylonian Talmud: Seder Nezikin*, 4:62-64.

24. The Mishna, a compendium of oral law, was put together around 200 CE. In the following centuries, it was commented on and discussed, and the result of this intense effort at elucidation was the so-called Gemara, whose thematic organization usually follows that of the Mishna. Mishna and Gemara together constitute the Talmud. However, "Talmud" can also refer only to the Gemara.

25. Epstein, *Babylonian Talmud: Seder Nashim*, 4:322-23.

26. Ibid., 4:324-25.

27. Kalmin, *Migrating Tales*, 107-13.

28. Boustan and Beshay, "Sealing the Demons."

29. Cosentino, "Testamento di Salomone," 59.

30. Cichorius, *Römische Studien*, 96-102, a section specifically dedicated to establishing more firmly the chronology of Trebius Niger.

31. Translation from Aelian, *On the Characteristics of Animals* 1:188-89.

32. Delatte, *Textes latins et vieux français*, 37-38 and 155. *Cyranides* 1; *Elementum* 4; see also *Cyranides* 3, *Elementum* δ.

33. Neusner, *Judaism and Scripture*, 405.

34. The text itself is difficult to date, but its compilation is usually dated to around the fifth to sixth century.

35. I have found an indirect mention of this fact in the writings of Albertus Magnus, who mentions a *herba meropis*, which is said to open locks. Among his sources, he refers to the writings of Qusta ibn Luqa (820-912) "in libris Costabenlucae philosophi." Qusta was an extremely learned figure who translated Greek scientific works into Arabic for the caliphs of Baghdad.

See Albertus Magnus, *Alberti Magni de vegetabilibus et plantis*, 338 (book 5, tractate 2, chapter 6, 118).

36. Aelian, for example, reports the same story of the blocked nest for the woodpecker (*On the Characteristics of Animals* 1.45).

37. Martín-Platero et al., "Characterization of Antimicrobial Substances."

38. Von Megenberg, *Das Buch der Natur*, 413, lines 12–19. He also says that it was called "thora" (or "chora"?) in certain unspecified magical books. See Dawson, "Bee-Eater."

39. On the identification of the bird, see Grünbaum, "Beiträge," 206–13. The bird mentioned in the Talmud, the *tarnegol bara*, literally "wild cock," should be identified with the *dukhifat*, "hoopoe," as indirectly suggested by a gloss included in Gittin 68a–b: "This is what the Targum means by *nagar tura*." The compiler of the text was almost certainly referring to a passage of Targum Onkelos commenting on Lev. 11:19, which lists a series of unclean birds. The Targum employs the Aramaic expression *nagar tura*, literally "rock splitter," in relation to the *dukhifat*, "hoopoe," which, given its crest, could certainly be identified as a "wild cock." See also Talshir, "Shemot Ba'alei ha-Hayyim," 146, who shows that the terms *dukhifat* and *tarnegol bara* had a different geographical diffusion but were substantially synonyms. On this, see the synthesis presented in the lectures on the weekly Torah posted online by the faculty of Bar-Ilan University in Ramat Gan, Israel, in particular the one dedicated to Parashat Re'eh 5759/1999 about the *dukhifat* or hoopoe by Raron Seri, http://www.biu.ac.il/JH/Parasha/eng/reeh/ser.html. On Solomon and the hoopoe in the Muslim world, see Qur'ān 27:20–22; Venzlaff, *Al-Hudhud*.

40. Bochart, *Hierozoichon*, 2:347; Grünbaum, "Beiträge," 213. For the Arabic text, see al-Qazwīnī, *Kosmographie*, 1:218.

41. Shimon, *Yalkut Shimoni*, 2:749.

42. Amélineau, *Contes et romans*, 1:144–46. The passage is also included in the introduction of the *Kebra Nagast*, the national saga of Ethiopia, in Wallis Budge, *Queen of Sheba*, xxxii–xxxiii, and xxxv–xxxviii, although more accurate editions of the same texts do not make any reference to this specific episode, which is to be considered apocryphal with respect to this text.

43. Amélineau, *Contes et romans*, 1:146 and 151–52.

44. Caquot, "Reine de Saba."

45. The compilers must have been familiar with the rabbinic debate, since the text specifies that the piece of wood at some point was no longer active, a detail that parallels Soṭah 9:10.

46. Lawrence, "Folk-Lore of the Horseshoe"; Seligmann, *Böse Blick und Verwandtes*, 1:273–76; Seligmann, *Magischen Heil- und Schutzmittel*, 161–69; Frazer, *Taboo*, 225–36.

47. Baring-Gould, *Curious Myths of the Middle Ages*, 386–416, esp. 410: "It bursts locks, and shatters stones, it opens in the mountains the hidden treasures hitherto concealed from men, or it paralyzes, lulling into a magic sleep, or, again, it restores to life. I believe the varied fables relate to one and the same object—and that, the lightning."

48. On this, see also Grimm, *Teutonic Mythology*, 3:970–74.

49. Saxifrage (Lat. *saxifraga*, literally "rock-breaker") does not belong to the same tradition of the plants just mentioned. Its name dates back to Dioscorides, who used it for *Saxifraga granulata*; now it indicates the whole genus. Despite its name, it does not grow in crevices or rocky environments; its etymology can be explained by the bulbils at the base of its stem, which bear a certain similarity to kidney stones. The plant was consequently believed to be effective in treating urinary calculi. According to the doctrine of signatures, certain external "marks" could give insight into the inner properties of an object. Paul Kennet, http://www.saxifraga.org/plants/articles/rock_breakers.asp.

50. Polito, "Sferracaddhu."

51. Folkard, *Plant Lore, Legends and Lyrics*, 113, lists a few more plants with similar properties (like the mistletoe) but does not provide specific sources.

52. This natural phenomenon could have also partially explained why iron nails are said to jump out of the cavities in which they have been inserted, as a result of ferromagnetic attraction, as well as the opening of cracks in the ground or in tree trunks after a lightning strike.

53. A bird depicted with a thunderbolt in its claws was common iconography for the eagle both for the Greeks and the Romans; this symbolism, however, seems to be much more ancient and widespread.

54. Mangolini, "Vera natura del 'magico Shamìr.'"

55. Rashi on Talmud *Pesaḥim* 54a. This quotation is from Slifkin, *Sacred Monsters*, 195–206. Rashi mentioned the biblical *shamir* in various occasions, particulary commenting on 1 Kgs. 6:7; Isa. 5:6–7; 7:25; 9:17; 27:4; 32:13; Jer. 17:1; Ez. 3:9; Zech. 7:12.

56. Ginzberg, *Legends of the Jews*, 5:53.

57. The Talmudic tradition, however, continued to circulate in parallel; in the demonological treatise contained in Paris, Bibliothèque Nationale de France, ms. héb. 765, dated to the fifteenth century, the *shamir* is mentioned without any specific identification at fol. 11r.

58. Przybilski, *Kulturtransfer*, 231–32.

59. Maimonides, *Commentary to the Mishnah*, Avoth 5:6.

60. Pellat et al., "Ḥayawān."

61. The entry in the *Jewish Encyclopedia* by Bacher and Blau reports this view, quoting the Arabic sources on the basis of Grünbaum, *Neue Beiträge*, 218, and putting them in direct relationship with the *shamir* tradition. However, the inference appears to be based on very fragile textual basis. Similarly, Bacher and Blau state that "the belief was still current in the Middle Ages, since it is found in the Cabala (Zohar, i.74; see story of Solomon in Jellinek, 'B.H., ii.86)." By "belief," though it is not perfectly clear, they probably mean that the existence of the *shamir* was restated well into the Middle Ages. In this sense, it is true that the *Sefer ha-Zohar* mentions it, but the text never explicitly describes it as a worm (or as anything more specific) and simply reports the usual version, according to which the *shamir* could cut through things without noise and without the need of other tools. Similarly, the account collected in the *Bēt ha-midrāsh* mentions the *shamir* very briefly, and the description closely echoes that of the Tosefta and of the Babylonian Talmud. See Jellinek, *Bēt ha-midrāsh*. For an English translation of the full episode, see Mehlman and Limmer, *Medieval Midrash*, 90–94.

62. Al-Thaʿlabī, *ʿArāʾis al-majālis*, 530.

63. Zamakhsharī, *Al-Kashshāf*, 454.

64. The account by al-Qazwīnī is substantially identical to that by Bavli, Gittin 68b, with a few differences: the name of the *shamir* and of the chief demon have been Islamicized; the *shamir* is needed not because of the iron prohibition—a concern felt specifically by the Jewish community—but because the construction process is particularly noisy and a more silent tool is needed; the bird is an eagle and not a hoopoe; the *samur* itself is not a plant but a stone, to be found in the mountains of Morocco.

65. A mistake likely because of the paleographical similarity between "s" and "t" in Gothic script, I think, or, alternatively, a misreading of the letter *shin* and *tet* of the Hebrew alphabet, as Przybilski suggests in *Kulturtransfer*, 232 n. 227.

66. Peter Comestor, *Historia Scholastica*, 3 Regum 8, De operariis Templi, 1353–54.

67. Gervase of Tilbury, *Otia imperialia* 104 (*de pullo strutionis et vase vitreo*).

68. Vincent of Beauvais, *Speculum Naturale* 20.170 (*de thamur et tabula*).

69. Swan, *Gesta Romanorum*, 1:lxiv.

70. Thomas of Cantimpré, *De naturis rerum*, ch. 19.

71. Lutz and Perdrizet, *Speculum*, 2:54.

72. Hailperin, "Hebrew Heritage"; Hailperin, *Rashi and the Christian Scholars*, 111; Feldman, *Studies in Hellenistic Judaism*, 317–21; recently, the theme of Rashi as a source for the scholars of St. Victor has been discussed by Stamberger, "Rashi in the School of St Victor."

73. In his work, he refers to the *shamir*, calling it both *Tantyr* and *Zomer*, which shows that he was familiar both with the "thamir" of Christian authors and with the Askhenazi pronounciation of the term; Przybilski, *Kulturtransfer*, 239.

74. See also Cassel, "Schamir," 77–80.

75. "Das Lob Salomons" is handed down in Vorau, Augustiner-Chorherrenstift, cod. 276, fols 98v–99v. For a discussion on the transmission of this motif from Jewish sources to Middle High German literature, see Przybilski, *Kulturtransfer*, 229–41.

76. Przybilski, *Kulturtransfer*, 241–46.

77. D. Garnerii Lingonensis episcopi, *Sermo XX. In ascensione Domini*, see Przybilski, *Kulturtransfer*, 233.

78. Hugo von Trimberg, *Der Renner* (vv. 18901–912); see Przybilski, *Kulturtransfer*, 238.

79. *Weltchronik* (vv. 2455–66); see Przybilski, *Kulturtransfer*, 238.

80. For the illustrations, see the impressive repertoire assembled by the Warburg Institute: https:// iconographic.warburg.sas.ac.uk/ vpc/ VPC_ search/ subcats.php?cat_ 1=14&cat_2=812&cat_3=2903&cat_4=5439&cat_5=13111&cat_6=10156&cat_7=3431&cat_8=1648.

81. Albertus Magnus, *De animalibus*, book 26, in the paragraph dedicated to the *vermis*. Munich, Bayerische Staatsblibliothek Ink A-143–GW 588, fol. 623 (last page).

82. Pseudo-Albertus Magnus, *De secretis mulierum*, 225.

83. See the usual description of the magical herb, related by Almandel (not to be confused with the title of the most famous pseudo-Solomonic work) in a text known only through a fifteenth-century manuscript but possibly composed during the thirteenth, after the success of the works of Albertus Magnus. See Pack, "'Almandel' auctor pseudonymous," 165.

84. Such is the case, for instance, of the *Weltchronik* by Rudolf von Ems (ca. 1200–1254), of the *Weltchronik* by Heinrich von München (fourteenth century), of the *Reinfried von Braunschweig* (fourteenth century), where the two traditions, that of the plant and that of the worm, are reported together; Przybilski, *Kulturtransfer*, 239–40.

85. "These worms are enclosed in a shell which is grayish, and of the size of a barley-corn, sharper at one end than the other. By means of an excellent microscope I have observed that this shell is all overspread with little stones and small greenish eggs: and that there is at the sharpest end a little hole, by which these creatures discharge their excrement; and the other end a somewhat larger hole, through which they put out their heads and fasten themselves to the stones they gnaw." De la Voye, "Relation of a Kind of Worms," 322.

86. See, for instance, the illustrations by Karl Shuker, February 24, 2014, http://karlshuker.blogspot.it/2014/02/the-*shamir*-and-stone-worm.html.

87. Quoted by Slifkin, *Sacred Monsters*, 200.

88. Such a hypothesis has been advanced by Karl Shuker, who defines himself "a cryptozoologist."

89. Velikovsky, "Stone of Shamir."

90. This detail could be explained in many different ways, depending on the exegetical angle employed; if we consider the *shamir* to be a small corundum crystal, for instance, it is not difficult to see that it could cease to be effective once its abrasive surface had been consumed. On the other hand, from a religious point of view, the *shamir* makes sense only within the Temple context; thus, after its destruction, its symbolic and physical efficacy would cease.

91. Ginzberg, *Legends of the Jews*, 1:33–34.

92. Jueneman, *Raptures of the Deep*, 66–75; Heinsohn, "Shamir"; Salkeld, "Shamir"; Agrest, "Ancient Miraculous Device." These publications tend to identify the *shamir* with a tool from outer space, produced by alien technology—a notion often repeated on various ufology blogs and in similar publications.

93. The popularization of the theme mostly through online nonacademic publications has contributed to the transmission of several incorrect elements, without any substantial textual basis.

CHAPTER 6

1. MacGregor Mathers, *Key of Solomon the King*, 49–50.

2. On the poetics of Eastern carpets, see Bettini, "Poetica del tappeto orientale"; Campo, *Gli imperdonabili*, 61–70.

3. Abidi, "Secret of the Magic Carpet."

4. Warner, *Stranger Magic*; Warner, "Riding the Carpet."

5. Warner, *Stranger Magic*, chapter 2; Mardrus and Mathers, *Book of the Thousand Nights*, 3:206–28, 146–50.

6. Burton, *Book of the Thousand Nights*, 13:208–54; Warner, *Stranger Magic*, chapter 2; May, "D'où vient le tapis magique?"

7. Gerhardt, *Art of Story-Telling*; Marzolph and van Leeuwen, *Arabian Nights Encyclopedia*, 1:80–81, 146–50.

8. Warner, *Stranger Magic*, chapter 3.

9. Mardrus and Mathers, *Book of the Thousand Nights*, 1:163.

10. Marzolph and van Leeuwen, *Arabian Nights Encyclopedia*, 1:408–10.

11. In the Bible, riding on the winds is more of a divine prerogative. See, for instance, Ps. 104:3–4: "You make the clouds your chariot / you ride on the wings of the wind / you make the winds your messengers, / fire and flame your ministers." This passage probably refers to the notion, quite widespread in Mesopotamian religions, that gods traveled on airborne chariots. This theme is treated in the section dedicated to "Royal Birds."

12. It does not seem a coincidence that Qur'ān 21:80 makes reference to the art of making coats of mail, while control over wind and metals is reported, even more explicitly, within the same passage, 34:12. This is strongly reminiscent of the association between wind control and metalworking technique, already discussed in chapter 3 with reference to those powerful figures, the archaic king-magi.

13. On the nature of jinn, see Chabbi, *Seigneur des Tribus*, 185–211, bibliography at 530 n. 272; MacDonald et al., "Djinn"; Lory, *La Dignité*.

14. Soucek, "Solomon's Throne / Solomon's Bath," esp. 112–13.

15. Al-Ṭabarī relates several versions on the basis of earlier sources: "It would be set upon [the wood], and people, draft animals, weapons of war, everything, was loaded on it. As soon as it carried what he wanted, he commanded the violent wind to enter under the wood and raise it up. When it had been lifted, he commanded the light breeze, which carried them [the distance of] one month in one morning, to wherever he wished." The chronicler also describes Solomon's army, which "spread one hundred parasangs: twenty-five of them consisted of humans, twenty-five of jinn, twenty-five of wild animals, and twenty-five of birds. He possessed one thousand houses of glass on the wooden [carpet], in which there were three hundred wives and seven hundred concubines." All this retinue could be lifted by the wind and transported. Moreover, "Solomon . . . had six hundred thrones set out. The noblest humans would come and sit them near him, then the noble jinn would come and sit near the humans. . . . Then he would call the birds, who would shade them, then he would call the wind, which would carry them" (al-Ṭabarī, *History*, 3:53–55).

16. Al-Kisā'ī, *Tales of the Prophets*, 308.

17. "[God] gave him a magnificent robe upon which he sat. And it was made of green silk woven with fine gold and [embroidered] with all forms of designs in the world. It was sixty miles long and sixty miles wide. Solomon had four ministers: one human minister, a second minister from the demons, a third minister from the beasts, and a fourth from the birds. . . . [Solomon] only travelled by means of [the robe carried by] the wind. He would eat breakfast in Damascus and dinner in Media, that is to say in the East and West." For the full text of this medieval midrash and others, see Mehlman and Limmer, *Medieval Midrash*, 89–106, esp. 97–98. See also Hirsch et al., "Solomon."

18. The story of the flying cloak, or magic carpet, recurs in a dozen different modern collections. See Elswit, *Jewish Story Finder*, 68–69.

19. "One day, [Solomon] was boasting, saying, 'There is no one like me in the world, whom the Holy One has given wisdom and knowledge. . . .' At that very moment, the wind was stirred, and 40,000 human beings fell from off the robe. When Solomon saw this, he yelled at the wind and said to the wind, 'Return, O wind, return!' And the wind responded, 'You return to your God, and do not boast, and I will return with you.' In that moment, Solomon was shamed by the words of the wind" (Mehlman and Limmer, *Medieval Midrash*, 98).

20. A detailed description appears in Jules Mohl's French edition. See Firdousi, *Livre des rois*, 7:249–55. The passage is almost certainly spurious and is not included in the more accurate English edition of the text, Ferdowsi, *Shahnameh*. A similar throne description should also appear in Ferdowsi, *Šāh-nāma*, 9:220–22, but I could not access the text.

21. Al-Tha'ālibī, *Histoire de rois de Perse*, 698–700. Both sources were quoted by Herzfeld, "Thron des Khosro," esp. 1–3, in his discussion of the legendary throne of Khosrow II.

22. Herzfeld, "Thron des Khosro"; Saxl, "Frühes Christentum und spätes Heidentum"; Ackermann, "Throne of Khusraw"; Lehmann, "Dome of Heaven"; Alföldi, "Geschichte des Throntabernakels"; Polak, "Charlemagne and the Marvels of Constantinople," esp. 164–67; Caiozzo, "Entre prouesse technique, cosmologie et magie," 251–52, 257–58; Anderson, *Cosmos and Community*, 19–26.

23. See, for instance, Erdmann, *Seven Hundred Years of Oriental Carpets*; Gilles, *Espelhos do Paraíso-tapetes*; A. Cecil Edwards, *Persian Carpet*; Spallanzani, *Carpet Studies*.

24. Citati, *Primavera di Cosroe*.

25. Al-Ṭabarī, *History*, 12:29–36.

26. Gabrieli, "Etichetta di corte e costumi sasanidi"; Bier, "Sasanian Palaces and Their Influence"; Winter, "Seat of Kingship." See also the interest sparked by the "Book of the crown," a ceremonial handbook compiled during Abbasid rule, which draws prominently from Sasanian courtly ceremonials (Pellat, *Livre de la couronne*). On the imagery of power derived from the poem and its body of illustrations, see Caiozzo, *Le roi glorieux*.

27. Soucek, "Solomon's Throne," 116.

28. Ibid.

29. "Jamshēd then ordered the manufacture of a glass chariot. He harnessed the Satans to it, mounted it, and went on it through the air from his place, in Dunbāwand, to Bābil in one day" (al-Ṭabarī, *History*, 1:350).

30. Soucek, "Solomon's Throne," 116; Khoury, *Wahb b. Munabbih*, 114–15.

31. See Herzfeld, "Thron des Khosro"; L'Orange, *Studies on the Iconography*, 48–63; Bussagli, "'Frontal' Representation of the Divine Chariot."

32. Peterson, *Ezekiel in Context*, 116–27.

33. Herzfeld dedicates a section to the topic "Der Typus des Sonnen- und Mondwagens in der sassanidischen Kunst" (Herzfeld, "Thron des Khosro," 105–36). See also L'Orange, *Studies on the Iconography*, 75–79, 124–33.

34. "Because of the miracle people saw him perform on that occasion, they established the day as New Year's Day (nawroz). He ordered them to establish this day and the following five days as a festival and to celebrate it joyously" (al-Ṭabarī, *History*, 1:350). "Although Jamshid had accomplished all these things, he strove to climb even higher. With his royal farr he constructed a throne studded with gems, and had demons raise him aloft from the earth into the heavens; there he sat on his throne like the sun shining in the sky. The world's creatures . . . called this day the New Day, or No-Ruz. This was the first day of the month of Favardin, at the beginning of the year" (Ferdowsi, *Shahnameh*; see the chapter dedicated to "The Festival of No-Ruz").

35. The description includes a series of metaphors to describe the flight: "And every one travelled in the wagons like a ship on the sea when the wind bloweth, and like a bat through the air when the desire of his belly urgeth him to devour his companions, and like an eagle when his body glideth above the wind" (Wallis Budge, *Queen of Sheba*, 66–67).

36. Ibid., 75.

37. Caiozzo, *Réminiscences de la royauté cosmique*, 42–44.

38. According to al-Thaʿālibī, Jamshid makes the jinn build an ivory and teak throne, covered in brocade, and then orders the demons to make it fly (*Histoire*, 13).

39. The lengthy passage describes how Kay was tempted by demons and lured into trying to discover the mysteries of the universe: "The sun still keeps its secrets from you; how it turns in the heavens, and who it is that controls the journeys of the moon and the succession of night and day, these are as yet unknown to you." He therefore embarked on a foolish enterprise: "Kavus had a throne constructed of aloes wood and gold, and at each corner he had a lance attached. From the lances, he suspended lamb's meat; next he bound four eagles tightly to the structure." His adventurous journey ended in shame, when the eagles' strength faded and the kingly chariot-throne crashed to the ground. The king survived but was deeply humiliated. See Ferdowsi, *Shahnameh*; see the section "Kavus Is Tempted by Eblis." See also al-Ṭabarī, *History*, 4:6; al-Thaʿālibī, *Histoire*, 166.

40. "Nimrod, master of the eagles, ordered a chest brought. He was placed in it, and placed another man in it with him. Then he commanded the eagles and they carried him aloft" (al-Ṭabarī, *History*, 2:108). The chronicler also relates another version, according to which "he starved them [the eagles] and sat in the chest with another man. Then he raised a staff in the chest, with meat at its top end, and the eagles ascended" (109). In both accounts, the flight turns into a manifestation of the king's excessive pride, through the contemplation of the entire world beneath him. See also al-Thaʿlabī, *Arāʾis al-majālis*, 162–63.

41. Caiozzo, *Réminiscences*, 46–49; Millet, "Ascension d'Alexandre"; Frugoni, *Historia Alexandri*; Schmidt, *Legend and Its Image*; Stoneman, Erickson, and Netton, *Alexander Romance*.

42. Stoneman, *Alexander the Great*, 116.

43. Other figures flying in vessels carried by eagles are listed by Lowin, "Narratives of Villainy," esp. 284–85 n. 53.

44. Hildegard Lewy, "Babylonian Background."

45. Ibid., 42–43, 92–94, and 98–109.

46. In Italian, the constellation Ursa Major is also known as the *gran carro* (great chariot). On the correspondence between the celestial chariot of the gods and archaeological findings that directly connect them with royal vehicles, see Brown, *Researches into the Origin*, 1:266–70; Burrows, "Constellation of the Wagon." On the transmission of star names between the Babylonian and the Greek system, see Szemerényi, "Principles of Etymological Research," esp. 190; West, *East Face of Helicon*, 29–31; Brown, *Semitic Influence in Hellenic Mythology*, 168–69, 188–90.

47. A well-known episode is that of the mysterious palace of the eagles, where the birds stand as guardian figures; the story is narrated in a midrash collected by Jellinek in *Bet ha-Midrasch*, 5:22–26, and is commented on and translated by Melmahn and Limmer, *Medieval Midrash*, 99–105.

48. Aro, "Anzu and Sīmurgh"; Schmidt, "Senmurv"; Mitra, "Bird and Serpent Myth"; Kruk, "Of Rukhs and Rooks"; Failla, *Garuda e i Naga*; Wilson, *Legend of Etana*; Horowitz, *Mesopotamian Cosmic Geography*, 43–66; Caiozzo, *Réminiscences*, 52–54; Caiozzo, "Entre dragon et simurgh."

49. Even in this case, the eagle has a place in the sky; as a constellation, it is recognized by several distinct cultures that attribute to it a mythical role. See Boll, *Sphaera*, 114–16; Berio, "Celestial River"; Barentine, *Lost Constellations*, 35, 38, 47, 49–52, 54, 57–62, 116, 148, 181, 357, 385, 425, 469. The list could be extended to Indian, Chinese, Japanese, and several other traditions.

50. See the overview proposed by Cantone, "*Renovabitur sicut aquilae Juventus tua*," tables 231–32, esp. 12–15.

51. While the most common translation for *nesher* is "eagle," "vulture" would be more accurate here. Iafrate, *Wandering Throne of Solomon*, 167–68 n. 17; Busi, *Simboli del pensiero ebraico*, 254 n. 731.

52. Solomon flying on an eagle appears also in various Jewish legends. See, for instance, the tale "How the Hoopoe Got Its Crest," collected by Hayym Nahman Bialik in *And It Came to Pass*, in which it is related how King Solomon was flying on an eagle when he suddenly

fainted under the hot sun and was then helped by the hoopoe, to which he eventually gifted its crest.

53. Busi, *Simboli del pensiero ebraico*, 257.

54. *Sefer ha-Zohar*, book 2, 112a–b; book 3, 233a–b; see the passage discussed by Giller, *Reading the Zohar*, 62–63; Busi, *Simboli del pensiero ebraico*, 257–60. The passage is also commented on by Elhanan, *'Emeḳ ha-Melekh*, fols. 5d, 112c, 147a.

55. Busi, *Simboli del pensiero ebraico*, 254–58.

56. Mokri, *Chasseur de dieu*, 23–43; Cumont, "Aigle funéraire des Syriens"; Cumont, *Études Syriennes*, 35–118; Wehrhahn-Stauch, "Aquila-Resurrectio"; Wehrhahn-Stauch, "Adler"; Lucchesi-Palli, "Observations sur l'iconographie de l'aigle"; Zanker, *Apotheose der römischen Kaiser*.

57. For an overview of this material, see Iafrate, *Wandering Throne of Solomon*, 184–212. There I wrote that in the Qur'ān Solomon is described as flying. However, as I explain in this chapter, that statement is inaccurate.

58. Melikian-Chirvani, "Royaume de Salomon," 1:1–41; Bagči, "New Theme."

59. Such as the sacred rock in Osh, Kyrgyzstan, the highest peak in the Sulaymān chain of mountains, which borders the west bank of the Indus River in modern-day Pakistan, or a sacred hill in Srinagar (Kashmir).

60. Mottahedeh, "Eastern Travels of Solomon."

61. Miquel, *Géographie humaine*, 1:165–66; Dakhlia, *Divan des rois*, 169–89; Touati, *Islam et voyage au Moyen Âge*.

62. Saberi, *Divan of Hafez*, 121.

63. In the course of "Operation Magic Carpet" (officially known as "Operation on Wings of Eagles"), about fifty thousand Yemenite Jews were secretly airlifted to Israel between 1949 and 1950, thanks to a series of American and British flights. See Parfitt, *Road to Redemption*; Ahroni, *Jewish Emigration from the Yemen*; Meir-Glitzenstein, *"Magic Carpet" Exodus*. Under the same code name, the War Shipping Administration of the United States conducted an operation it termed necessary to repatriate eight million American military personnel in 1945 and 1946. See Gault, "Operation Magic Carpet." In both cases, the name of the operation echoes quite accurately the earliest textual descriptions of the Solomonic carpet, which could transport thousands of people.

64. Experiments on rug wrinkles and gravitational properties are currently being carried out by various scientists; Kolinski, Aussillous, and Mahadevan, "Shape and Motion of a Ruck"; Vella, Boudaoud, and Adda-Bedia, "Statics and Inertial Dynamics."

65. I had the chance to meet Toni Morrison and to ask her personally whether the legend related to King Solomon and his magic flights had been a source of inspiration for her book, and she confirmed it. See Iafrate, *Wandering Throne of Solomon*, 279, n. 51.

CONCLUSION

1. Tolkien, *Lord of the Rings*.

2. Marzolph and van Leeuwen, *Arabian Nights Encyclopedia*, 1:82–85.

3. Ariosto, *Orlando Furioso*, book 2, stanza 42. The demon responsible for the second magical palace is actually sealed off under the main door; see book 22, stanza 18. The direct textual precedent is Matteo Maria Boiardo's *Orlando Innamorato*, book 3, stanza 27. On this, see Rajna, *Fonti dell'Orlando Furioso*, 117–21.

4. To my knowledge, Atlante has never been considered from this perspective. However, the Muslim landscape of the *Orlando Furioso* has been the focus of "Ariosto and the Arabs: Contexts of the *Orlando Furioso*; An International Conference," held at Villa I Tatti on October 18–19, 2017.

5. Mauss, *General Theory of Magic*, 92.

6. Ibid., 95–98.

7. Énard, *Compass*, 210.

BIBLIOGRAPHY

Abate, Emma. "Nouvelles lumières sur la tradition du Sefer Raziel." *La règle d'Abraham* 39 (2017): 1–14.

Abidi, Azhar. "The Secret History of the Magic Carpet." *Southwest Review* 91 (2006): 28–35.

Ackermann, Phyllis. "The Throne of Khusraw (the *Takht-i-Taqdis*.)" *Bulletin of the American Institute for Iranian Art and Archaeology* 5 (1937): 106–9.

Aelian (Claudius Aelianus). *On the Characteristics of Animals.* Translated by A. F. Scholfield. 3 vols. London: Heinemann, 1958–59.

Aga-Oglu, Mehmet. "A Brief Note on Islamic Terminology for Bronze and Brass." *Journal of the American Oriental Society* 64 (1944): 218–23.

Agrest, Matest. "The Ancient Miraculous Device: Shamir." Paper delivered at Ancient Astronaut Society, 24th Anniversary World Conference, Orlando, Fla., August 4, 1997.

Ahroni, Reuben. *Jewish Emigration from the Yemen, 1951–98: Carpet Without Magic.* London: Routledge, 2001.

Albert, Jean-Pierre, and Agnieszka Kedzierska-Manzon. "Des objets-signes aux objets-sujets." *Archives de sciences sociales des religions* 174 (2016): 13–25.

Albertazzi, Adolfo. *Il diavolo nell'ampolla.* Milan: Treves, 1918.

Albertus Magnus. *Alberti Magni de vegetabilibus et plantis.* Edited by Ernst Meyer and Karl Jessen. Berlin: Georg Reimer, 1867.

———. *De animalibus.* Mantua: Paulus de Butzbach, 1479.

Alfie, Fabian. *Dante's "Tenzone" with Forese Donati: The Reprehension of Vice.* Toronto: University of Toronto Press, 2011.

Alföldi, Andreas. "Die Geschichte des Throntabernakels." *Nouvelle Clio* 10 (1950): 537–66.

Allan, James W. *Persian Metal Technology, 700–1300 A.D.* Oxford: Oxford University Press, 1979.

Allan, James W., and Dominique Sourdel. "Khātam, Khātim." In *Encyclopaedia of Islam.* 2nd ed. Leiden: Brill Online, 2016. http://dx.doi.org/10.1163/1573-3912_islam_SIM _4232.

Allen, Joanne. "Wood Knots: Interlacing Intarsia Patterns in the Renaissance Choir Stalls of San Zaccaria in Venice." In *Linea II: Giochi, metamorfosi, seduzioni della linea*, edited by Marzia Faietti and Gerhard Wolf, 117–33. Florence: Giunti, 2012.

Allston, Washington. *Lectures on Art.* Edited by Richard Henry Dana Jr. New York: Baker and Scribner, 1840.

Almqvist, Kurt, and Louise Belfrage. *Museums of the World: Towards a New Understanding of a Historical Foundation.* Stockholm: Axel and Margaret Ax:son Johnson Foundation, 2015.

Amayden, Theodor. *La storia delle famiglie romane con note e aggiunte del Comm. Carlo Augusto Bertini.* 2 vols. Bologna: Forni, 1910.

Amélineau, Émile, ed. and trans. *Contes et romans de l'Egypte chrétienne.* 2 vols. Paris: Leroux 1888.

Ames-Lewis, Francis. "Early Medicean Devices." *Journal of the Warburg and Courtauld Institutes* 42 (1979): 122–43.

Amitai-Preiss, Nitzan, and L. Alexander Wolfe. "Amuletic Bronze Rings from the Arab-Byzantine Transitional Period." *Israel Numismatic Research* 6 (2011): 175–86.

Anderson, Benjamin. *Cosmos and Community in Early Medieval Art*. New Haven: Yale University Press, 2017.

Appadurai, Arjun, ed. *The Social Life of Things: Commodities in Cultural Perspective*. Cambridge: Cambridge University Press, 1988.

Aretino, Pietro. *Ragionamento della Nanna e della Antonia, fatto in Roma sotto una ficaia.* In *Sei giornate*, edited by Giovanni Aquilecchia. Bari: Laterza, 1975.

Ariosto, Ludovico. *Orlando Furioso*. Edited by Cesare Segre. Milan: Mondadori, 1990.

———. *Satire*. Edited by Guido Davico Bonino. Milan: Rizzoli, 1990.

Aro, Jussi. "Anzu and Sīmurgh." In *Kramer Anniversary Volume: Cuneiform Studies in Honor of Samuel Noah Kramer*, edited by Barry L. Eichler, 25–28. Kevelaer: Butzon and Bercker, 1976.

Arrowsmith, William. "Luxury and Death in the *Satyricon*." *Arion* 5 (1966): 304–31.

Astell, Ann. *The Song of Songs in the Middle Ages*. Ithaca: Cornell University Press, 1990.

Aston, W. G. "Fetishism." In *Encyclopedia of Religion and Ethics*, 5:894–98. Edinburgh: T & T Clark, 1912.

Austin, John. *How to Do Things with Words*. Edited by J. O. Urmson and Marina Sbisà. Cambridge: Harvard University Press, 1962.

Avitus of Vienne. *Letters and Selected Prose*. Translated and edited by Danuta Shanzer and Ian Wood. Liverpool: Liverpool University Press, 2002.

Azarpay, Guitty. "The Eclipse Dragon on an Arabic Frontispiece-Miniature." *Journal of the American Oriental Society* 98 (1978): 363–74.

Azcárate Luxán, Matilde, and Irene Gonzalez Hernando. "La Virgen-trono en el occidente medieval." In *Estudios de historia del arte en memoria de la profesora Micaela Portilla*, edited by José Javier Vélez Chaurri, Pedro Luis Echeverría Goñi, and Felicitas Martínez de Salinas, 35–44. Vitoria-Gasteiz: Diputación Foral de Álava, 2008.

Baader, Hannah, and Ittai Weinryb. "Images at Work: On Efficacy and Historical Interpretation." *Representations* 133 (2016): 1–19.

Bacher, Wilhelm, and Ludwig Blau. "Shamir." In *Jewish Encyclopedia*. New York: Funk and Wagnalls, 1901–1906. http://www.jewishencyclopedia.com/articles/13497-shamir.

Bachmann-Medick, Doris. *Cultural Turns: Neuorientierungen in den Kulturwissenschaften*. Reinbeck: Rowohlt Verlag, 2006.

Bacon, Helen. "The Sibyl in the Bottle." *Virginia Quarterly Review* 34 (1958): 262–76.

Bacqué-Grammont, Jean-Louis and Jean-Marie Durand, eds. *L'image de Salomon, sources et postérités*. Louvain: Peeters, 2007.

Bagatti, Bellarmino. "I giudeo-cristiani e l'anello di Salomone." *Recherches de science religieuse* 60 (1972): 151–60.

Bagči, Serpil. "A New Theme of the Shirazi Frontispiece Miniatures: The Divan of Solomon." *Muqarnas* 12 (1995): 101–11.

Baldan, Sergio. *Il reale Ordine dei cavalieri di Cipro detto della spada e del silenzio*. Venice: Marsilio, 2002.

Baldinucci, Filippo. *Vocabolario toscano dell'arte del disegno*. Florence: Per Santi Franchi al segno della Passione, 1681.

Bambach Cappel, Carmen. "Leonardo, Tagliente and Dürer: 'La scienza del far di groppi.'" *Achademia Leonardi Vinci: Journal of Leonardo Studies and Bibliography of Vinciana* 4 (1991): 72–110.

Barbierato, Federico. *Nella stanza dei circoli: Clavicula Salomonis e libri di magia a Venezia nei secoli XVII e XVIII*. Milan: Sylvestre Bonnard, 2002.

Barentine, John C. *The Lost Constellations: A History of Obsolete, Extinct, or Forgotten Star Lore*. Heidelberg: Springer, 2016.

Batschelet-Massini, Werner. "Labyrinthzeichnungen in Handschriften." *Codices Manuscripti* 4 (1978): 33–65.

Baudrillard, Jean. *The System of Objects.* Translated by James Benedict. London: Verso, 1968.

Bazin, Jean. "Retour aux choses dieux." In *Des clous dans la Joconde: L'anthropologie autrement,* 493–520. Toulouse: Anacharsis, 2008.

Beekes, Robert. *Etymological Dictionary of Greek.* 2 vols. Leiden: Brill, 2010.

Belgradi, Iacopo. *Epistolae quatuor de rebus physicis & antiquis monumentis sub retina recens inventis.* Venice: Jo. Baptiste Pasquali, 1749.

Bellesi, Sandro. *Diavolerie, magie e incantesimi nella pittura barocca fiorentina.* Florence: Giovanni Pratesi Antiquario, 1997.

Bello, Francesco (il Cieco da Ferrara). *Il Mambriano.* 7 vols. Venice: Antonelli, 1840.

Belloni, Luigi. "Schemi e modelli della macchina vivente nel Seicento, con ristampa della lettera di R. Magiotti *Renitenza certissima dell'acqua alla compressione* (Il 'Diavoletto di Descartes')." *Physis* 5 (1963): 259–98.

Bellucci, Giuseppe. *Usi nuziali nell'Umbria.* Perugia: Tipografia umbra, 1895.

Belting, Hans. *Bild und Kult: Eine Geschichte des Bilds vor dem Zeitalter der Kunst.* Munich: C. H. Beck, 1990.

Benjamin, Walter. "On Language as Such and on the Language of Man." In *One-Way Street, and Other Writings,* translated by Edmund Jephcott and Kingsley Shorter, 107–23. London: NLB, 1979.

———. "The Work of Art in the Age of Its Technological Reproducibility: Second Version." In *The Work of Art in the Age of Its Technological Reproducibility, and Other Writings on Media,* translated by Edmund Jephcott and Harry Zohn, edited by Michael W. Jennings, Brigid Doherty, and Thomas Y. Levin, 19–55. Cambridge, Mass.: Belknap Press, 2008.

Bennett, Jane. *Vibrant Matter: A Political Ecology of Things.* Durham: Duke University Press, 2010.

Bennett, Tony. "The Exhibitionary Complex." *New Formations* 4 (1988): 73–102.

Benoit, Pierre. "Découvertes archéologiques autour de la piscine de Béthesda." In *Jerusalem Through the Ages: The Twenty-Fifth Archaeological Convention, October 1967,* edited by P. W. Lapp, 48–57. Jerusalem: Israel Exploration Society, 1968.

Berio, Alessandro. "The Celestial River: Identifying the Ancient Egyptian Constellations." *Sino-Platonic Papers* 253 (2014): 1–58.

Berlekamp, Persis. "Symmetry, Sympathy, and Sensation: Talismanic Efficacy and Slippery Iconographies in Early Thirteenth-Century Iraq, Syria, and Anatolia." *Representations* 133 (2016): 59–109.

Bertelli, Sergio. "Palazzo Pitti dai Medici ai Savoia." In *La corte di Toscana dai Medici ai Lorena,* edited by Anna Bellinazzi and Alessandra Contini, 11–109. Rome: Ministero per i beni e le attività culturali, Direzione generale per gli archivi, 2002.

Berthelot, Marcelin. *La chimie au Moyen Âge.* 3 vols. Paris: Imprimerie Nationale, 1893.

———. *Collection des anciens alchimistes grecs.* 3 vols. Paris: Georges Steinheil, 1887.

Bettini, Sergio. "Poetica del tappeto orientale." In *Tempo e forma. Scritti 1935–1977,* 159–76. Macerata: Quodlibet, 1996.

Betz, Hans Dieter, ed. *The Greek Magical Papyri in Translation, Including the Demotic Spells.* Chicago: University of Chicago Press, 1996.

Bialik, Hayyim Nahman. *And It Came to Pass: Legends and Stories About King David and King Solomon.* New York: Hebrew Publishing Company, 1938.

Bier, Lionel. "The Sasanian Palaces and Their Influence in Early Islam." *Ars Orientalis* 23 (1993): 57–66.

Biondi, Albano. "Streghe ed eretici nei domini estensi all'epoca di Ariosto." In *Il Rinascimento nelle corti padane: Società e cultura,* edited by Paolo Rossi, 165–99. Bari: De Donato, 1975.

Biondi, Grazia. "Quel 'diavolo' di Tassoni: Una disavventura con l'Inquisizione di Modena." In *Alessandro Tassoni: Poeta, erudito, diplomatico nell'Europa dell'età moderna,*

edited by Maria Cristina Cabani and Duccio Tongiorgi, 191–209. Modena: Franco
Cosimo Panini, 2017.

Bissing, Friedrich Wilhelm von. "Aegyptische Knotenamulette." *Archiv für Religionswissen-
schaft* 8 (1905): 23–26.

Black, Jeremy. "Amethysts." *Iraq* 63 (2001): 183–86.

Bochart, Samuel. *Hierozoicon, sive bipertitum opus de animalibus Sacrae Scripturae.* Lon-
don: Martyn, 1663.

Bock, Nicolas. "L'Ordre du Saint-Esprit au Droit Désir: Enluminure, cérémonial et idéologie
monarchique au XIVᵉ siècle." In *Art, cérémonial et liturgie au Moyen Âge,* edited by
Nicolas Bock, Peter Kurmann, Serena Romano, and Jean-Michel Spieser, 415–60.
Rome: Viella, 2002.

Bodi, Daniel. *The Book of Ezekiel and the Poem of Erra.* Göttingen: Vandenhoeck & Ruprecht,
1991.

Boetzkes, Amanda, and Aron Vinegar, eds. *Heidegger and the Work of Art History.* Farn-
ham: Ashgate, 2014.

Boiardo, Matteo Maria. *Orlando Innamorato.* Edited by Aldo Scaglione. Turin: Utet, 1974.

Boitani, Pietro, Corrado Bologna, Adele Cipolla, and Mariantonia Liborio, eds. *Alessandro
nel Medioevo occidentale.* Milan: Mondadori, 1997.

Boll, Franz. *Sphaera: Neue griechische Texte und Untersuchungen zur Geschichte der Stern-
bilder.* Leipzig: Teubner, 1903.

Bolte, Johannes, and Georg Polivka. *Anmerkungen zu den Kinder- und Hausmärchen der
Brüder Grimm.* 2 vols. Leipzig: Theodor Weicher, 1915.

Bonner, Campbell. "The Sibyl and Bottle Imps." In *Quantulacumque: Studies Presented to
Kirsopp Lake by Pupils, Colleagues, and Friends,* edited by Robert P. Casey, Silva
Lake, and Agnes K. Lake, 1–8. London: Christophers, 1937.

———. *Studies in Magical Amulets, Chiefly Graeco-Egyptian.* Ann Arbor: University of
Michigan Press, 1950.

Boschung, Dietrich, Patrick-Alexander Kreuz, and Tobias Kienlin, eds. *Biography of Objects:
Aspekte eines kulturhistorischen Konzepts.* Paderborn: Fink, 2015.

Botterweck, Johannes G., Heinz-Josef Fabry, and Helmer Ringgren, eds. *Theological Diction-
ary of the Old Testament* (translation of *Theologisches Worterbuch zum Alten Testa-
ment*). 15 vols. Grand Rapids, Mich: William B. Eerdmans, 2006.

Boudet, Jean-Patrice, and Julien Véronèse. "Lier et délier: De dieu à la sorcière." In *La légiti-
mité implicite,* edited by J.-Ph. Genet, 1:87–119. Paris: Editions de la Sorbonne, 2015.

Bourdieu, Pierre. *Outline of a Theory of Practice.* Translated by Richard Nice. Cambridge:
Cambridge University Press, 1977.

Boustan, Raʿanan, and Michael Beshay. "Sealing the Demons, Once and For All: The Ring of
Solomon, the Cross of Christ, and the Power of Biblical Kingship." *Archiv für Reli-
gionsgeschichte* 16 (2015): 99–129.

Bowman, John. "Solomon and Jesus." *Abr-Nahrain* 23 (1984–85): 1–13.

Bräm, Andreas. "Zeremoniell und Miniatur im Neapel der Anjou: Die Statuten vom Orden
des Heiligen Geistes des Ludwig von Tarent; Paris, Bibliothèque nationale de France,
ms. 4274." *Römisches Jahrbuch der Bibliotheca Hertziana* 36 (2005): 45–92.

Bräunlein, Peter J. "Material Turn." In *Dinge des Wissens: Die Sammlungen, Museen und
Gärten der Universität Göttingen,* 30–44. Göttingen: Wallstein Verlag, 2012.

———. "Thinking Religion Through Things: Reflections on the Material Turn in the Scientific
Study of Religion/s." *Method and Theory in the Study of Religion* 28 (2016): 365–99.

Bredekamp, Horst. "A Neglected Tradition? Art History as *Bildwissenschaft*." *Critical
Inquiry* 29 (2003): 418–28.

———. *Theorie des Bildakts.* Berlin: Suhrkamp, 2010.

Bremmer, Jan N. "The Birth of the Term 'Magic.'" In *The Metamorphosis of Magic from Late
Antiquity to the Early Modern Period,* edited by Jan N. Bremmer and Jan R. Veenstra,
1–11. Leuven: Peeters, 2002.

———. "Preface: The Materiality of Magic." In *The Materiality of Magic*, edited by Jan N. Bremmer and Dietrich Boschung, 7–8. Paderborn: Wilhelm Fink, 2015.

Breuer, Heidi. *Crafting the Witch*. London: Routledge, 2009.

Briquet, Charles-Moïse. *Les filigranes: Dictionnaire historique des marques du papier dès leur apparition vers 1282 jusqu'en 1600.* 2nd ed. 4 vols. Leipzig: Hiersemann, 1923.

Brosses, Charles de. *Du culte des dieux fétiches ou parallèle de l'ancienne religion de l'Egypte avec la religion actuelle de Nigritie.* Paris, 1760.

Brown, Bill. "Objects, Others and Us (The Refabrication of Things)." *Critical Inquiry* 36 (2010): 183–217.

———. "Thing Theory." *Critical Inquiry* 28 (2001): 1–22.

Brown, Francis, S. R. Driver, and Charles Briggs, eds. *A Hebrew and English Lexicon of the Old Testament: With an Appendix Containing the Biblical Aramaic.* Oxford: Clarendon Press, 1906.

Brown, Robert. *Researches into the Origin of the Primitive Constellations of the Greeks, Phoenicians and Babylonians.* 2 vols. London: Williams and Norgate, 1899.

———. *Semitic Influence in Hellenic Mythology.* Eugene, Oreg.: Wipf and Stock, 2006.

Bruhn, Jørgen. *The Intermediality of Narrative Literature: Medialities Matter.* London: Palgrave Macmillan, 2016.

Buddeo, Giovan Francesco. *Historia Ecclesiastica Veteris Testamenti. A Samuele usque ad Christum natum.* 2 vols. Halle an der Saale: Impens orphanotrophei, 1721.

Burrows, Eric. "The Constellation of the Wagon and Recent Archaeology." *Analecta Orientalia* 12 (1935): 34–40.

Burton, Richard. *The Book of the Thousand Nights and a Night: A Plain and Literal Translation of the Arabian Nights Entertainments.* 16 vols. London: Printed by the Burton Club, 1887.

Busch, Peter, ed. "Solomon as a True Exorcist: The Testament of Solomon in Its Cultural Setting." In *The Figure of Solomon*, edited by Joseph Verheyden, 183–95. Leiden: Brill, 2012.

———. *Das Testament Salomos: Die älteste christliche Dämonologie, kommentiert und in deutscher Erstübersetzung.* Berlin: Walter de Gruyter, 2006.

Buse, Peter, Ken Hirschkop, Scott McCracken, and Bertrand Taithe, eds. *Benjamin's Arcades: An Unguided Tour.* Manchester: Manchester University Press, 2006.

Busi, Giulio. *Simboli del pensiero ebraico: Lessico ragionato in settanta voci.* Turin: Einaudi, 1999.

Bussagli, Mario. "The 'Frontal' Representation of the Divine Chariot: Similarities Between the Figurative Arts in the East and West." *East and West* 6 (1955): 9–25.

Buzard, James, Joseph W. Childers, and Eileen Gillooly, eds. *Victorian Prism: Refractions of the Crystal Palace.* Charlottesville: University of Virginia Press, 2007.

Cadei, Antonio. "Architettura sacra templare." In *Monaci in armi. L'architettura sacra dei Templari attraverso il Mediterraneo*, edited by Goffredo Viti, Antonio Cadei, and Valerio Ascani, 15–173. Florence: Certosa di Firenze, 1998.

Cahn, Walter. "Solomonic Elements in Romanesque Art." In *The Temple of Solomon: Archaeological Fact and Medieval Tradition in Christian, Islamic, and Jewish Art*, edited by Joseph Gutmann, 45–72. Missoula, Mont.: Scholars Press, 1976.

Caiozzo, Anna. "Eclipse ou Apocalypse: Remarques autour du noeud du dragon dans les miniatures des *Commentaires de l'Apocalypse* de Beatus de Liébana." *Médiévales* 65 (2013): 125–54.

———. "Entre dragon et *simurgh*, perdre ou sauver son âme." In *Créatures mythiques animals, écriture et signes figuratifs*, edited by Nathalie Beaux and Xiaohong Li, 59–74. Paris: You-Feng, 2014.

———. "Entre prouesse technique, cosmologie et magie: L'automate dans l'imaginaire de l'orient medieval." In *La Fabrique du corps humain: La machine modèle du vivant*, edited by Véronique Adam and Anna Caiozzo, 247–78. Grenoble: CNRS MSH-Alpes, 2010.

————. *Réminiscences de la royauté cosmique dans les représentations de l'Orient médiéval.* Cairo: Institut français d'archéologie orientale, 2011.

————. *Le Roi glorieux. Les imaginaires de la royauté d'après les enluminures du Shāh Nāma de Firdawsī – Époque timouride et turkmène.* Paris: Geuthner, 2018.

Caiozzo-Roussel, Anna. "Autour de Salomon: Remarques sur l'image d'un genie protecteur dans les manuscrits enluminés de l'Orient médiéval." In *Culture Européenne et Kabbale,* edited by Yona Dureau and Monique Burgada, 49–72. Paris: L'Harmattan, 2008.

Calvino, Italo. *The Castle of Crossed Destinies.* Translated by William Weaver. London: Secker and Warburg, 1977.

————. *Six Memos for the Next Millennium.* Translated by Patrick Creagh. New York: Vintage Books, 1993.

Camera, Matteo. *Elucubrazioni storico-diplomatiche su Giovanna I, regina di Napoli e Carlo III di Durazzo.* Salerno: Tipografia Nazionale, 1889.

Cameron, H. D. "The Sibyl in the *Satyricon.*" *Classical Journal* 65 (1970): 337–39.

Campbell, Gary, and Laurajane Smith. "Keeping Critical Heritage Studies Critical: Why 'Post-Humanism' and the 'New Materialism' Are Not So Critical." Paper delivered with Gary Campbell at the Association of Critical Heritage Studies Conference, Montreal, 2016. https://www.academia.edu/26027979/Keeping_Critical_Heritage_Studies_Critical_Why_Post-Humanism_and_the_New_Materialism_Are_Not_So_Critical.

Campo, Cristina. *Gli imperdonabili.* Milan: Adelphi, 1987.

Cantone, Valentina. "*Renovabitur sicut aquilae Juventus tua*: L'iconografia dell'aquila nella cultura monastica altomedievale." In *Le arti a confronto con il sacro: Metodi di ricerca e nuove prospettive di indagine interdisciplinare,* edited by Valentina Cantone and Silvia Fumian, 11–18. Padua: CLEUP, 2009.

Cappelletti, Licurgo. *Storia degli ordini cavallereschi.* Leghorn: Forni, 1904.

Caquot, André. "La reine de Saba et le bois de la croix, selon une tradition éthiopienne." *Annales d'Ethiopie* 1 (1955): 137–47.

Carbone, Ludovico. *Facezie e dialogo de la partita soa.* Edited by Gino Ruozzi. Bologna: Commissione per i testi di lingua, 1989.

Carducci, Giosuè, ed. "Era tutta soletta." In *Cantilene e ballate, strambotti e madrigali nei secoli 13. e 14.* Pisa: Nistri, 1871.

Carrasquer Zamora, José, María Victoria Álvarez Sevilla, and Adrián Ponz Miranda, eds."Danzad, danzad, diablillos": Una visión de la historia del Diablo cartesiano a través de imágenes.* Saragoza: Grupo Beagle de Investigación en Didáctica de las Ciencias Naturales, Universidad de Zaragoza, 2014.

Cassel, Paul. "Schamir: Ein archäologischer Beitrag zur Natur- und Sagenkunde." In *Denkschrift der Königlichen Akademie Gemeinnütziger Wissenschaften in Erfurt,* 48–112. Erfurt, 1854.

Cassotti, Giovan Battista. *Memorie dell'Immagine di Maria Vergine dell'Impruneta, parte prima.* Florence: Giuseppe Manni, 1713.

Castagnola, Michele. *Fraseologia sicolo-toscana.* Catania: Galatola, 1863.

Cattani da Diacceto, Francesco. *Discorso sopra la superstizione dell'arte magica.* Florence: Valente Panizzi & Marco Peri C., 1567.

Chabbi, Jacquelin. *Le Seigneur des Tribus: L'Islam de Mahomet.* Paris: Noêsis, 1997.

Chambers's Encyclopaedia: A Dictionary of Universal Knowledge for the People. 10 vols. London: W. and R. Chambers, 1874.

Chave-Mahir, Florence. *L'exorcisme des possédés dans l'Eglise d'Occident (X*e*–XIV*e* siècle).* Turnhout: Brepols, 2011.

Chave-Mahir, Florence, and Julien Véronèse. *Rituel d'exorcisme ou manuel de magie? Le manuscript Clm 10085 de la Bayerische Staatsbibliothek de Munich (début du XV*e* siècle).* Florence: SISMEL Edizioni del Galluzzo, 2015.

Cherchi, Paolo. "Pentangulo, Nodo di Salomone, Pentacolo." *Lingua Nostra* 39 (1978): 33–36.

Cichorius, Conrad. *Römische Studien*. Leipzig: Teubner, 1922.

Citati, Pietro. *La primavera di Cosroe*. Milan: Adelphi, 2006.

Cizek, Alexandre. "La rencontre de deux 'sages': Salomon le 'Pacifique' et Alexandre le Grand dans la légende hellénistique et médiévale." In *Images et signes de l'Orient dans l'Occident médiéval*, 75–99. Aix-en-Provence: Publications du CUER MA, Université de Provence; Marseille: J. Laffitte, 1982.

Clasen, Karl-Heinz. "Die Überwindung des Bösen." In *Neue Beiträge deutscher Forschung: Wilhelm Worringer zum 60. Geburtstag*, edited by Erich Fidder, 13–36. Königsberg: Kanter, 1943.

Coccia, Emanuele. *Le bien dans les choses*. Paris: Rivages, 2013.

Collins, David J., ed. *The Cambridge History of Magic and Witchcraft in the West, from Antiquity to the Present*. Cambridge: Cambridge University Press, 2015.

———. "Magic in the Middle Ages: History and Historiography." *History Compass* 9 (2011): 410–22.

Comparetti, Domenico. *Virgilio nel Medioevo*. 2 vols. Leghorn: Francesco Vigo, 1872.

Comte, Auguste. *The Positive Philosophy of Auguste Compte*. Translated by Harriet Martineau. 2 vols. London: John Chapman, 1855.

Conklin, George. "Ingeborg of Denmark, Queen of France, 1193–223." In *Queens and Queenship in Medieval Europe*, edited by Anne J. Duggan, 39–52. Woodbridge: Boydell Press, 1997.

Con

eare, Frederick Cornwallis. "The Testament of Solomon." *Jewish Quarterly Review* 11 (1898): 1–46.

Cooley, Arnold James, ed. *A Cyclopaedia of Six Thousand Practical Receipts and Collateral Information in the Arts, Manufactures, and Trades.* Boston: D. Appleton, 1854.

Coomaraswamy, Ananda K. "The Iconography of Dürer's 'Knots' and Leonardo's 'Concatenation.'" *Eye of the Heart* 4 (2009): 11–40.

Coppola, Daniela. *Anemoi: Morfologia dei venti nell'immaginario della Grecia arcaica.* Naples: Liguori, 2010.

Cosentino, Augusto, ed. and trans. *Il Testamento di Salomone.* Rome: Città Nuova, 2013.

———. "Il Testamento di Salomone: Dall'ambiente giudaico (o giudeo-cristiano) alla riscrittura araba." *Quaderni di studi indo-mediterranei* 6 (2013): 53–70.

———. "La tradizione del re Salomone come mago ed esorcista." In *Gemme gnostiche e cultura ellenistica,* edited by Attilio Mastrocinque, 41–59. Bologna: Pàtron, 2002.

Coulon, Jean-Charles. *La magie en terre d'Islam au Moyen Âge.* Paris: Éditions du CTHS, 2017.

———. "Salomon dans les traités de magie islamiques médiévaux." Paper delivered on the occasion of *Le roi Salomon au Moyen Âge: Savoirs et répresentations,* Colloque du CESFIMA, Orléans, October 18–19, 2018.

Craddock, P. T. "The Copper Alloys of the Medieval Islamic World—Inheritors of the Classical Tradition." *World Archaeology* 11 (1979): 68–79.

Crosland, Maurice. *Historical Studies in the Language of Chemistry.* Mineola: Dover, 1962.

Cumont, Franz. "L'aigle funéraire des Syriens et l'apothéose des empereurs." *Revue de l'histoire des religions* 42 (1910): 119–64.

———. *Études Syriennes. L'aigle funéraire d'Hiérapolis et l'apothéose des empereurs.* Paris: Picard, 1917.

Cuomo, Raffaele. *Ordini cavallereschi antichi e moderni.* Milan: De Angelis & Bellisario, 1984.

Cursietti, Mauro. *La falsa tenzone di Dante con Forese Donati.* Anzio: De Rubeis, 1995.

Curzi, Gaetano. "I graffiti figurativi: Una lettura simbolica." In *Graffiti templari: Scritture e simboli medievali in una tomba etrusca di Tarquinia,* edited by Carlo Tedeschi, 115–54. Rome: Viella, 2012.

———. *La pittura dei Templari.* Milan: Silvana, 2002.

Dakhlia, Jocelyne. *Le divan des rois: Le politique et le religieux dans l'Islam.* Paris: Aubier, 1998.

D'Ambra, Francesco. *I Bernardi.* Florence: Giunti, 1564.

Dan, Joseph. *Jewish Mysticism: Late Antiquity.* Northvale: Jason Aronson, 1998.

Dante Alighieri. *Opere minori, Vita Nuova, Rime.* Edited by Gianfranco Contini and Domenico De Robertis. Milan: Società dantesca italiana, 1995.

Daremberg, Charles Victor, and Edmond Saglio. "Nodus." In *Dictionnaire des antiquités grecques et romaines, d'après les textes et les monuments,* 4:87–88. Paris: Hachette, 1828–1911.

Daston, Lorraine, ed. *Things That Talk: Object Lessons from Art and Science.* Cambridge, Mass.: Zone Books, 2004.

Dawson, Warren R. "The Bee-Eater (*Merops apiaster*) from the Earliest Times, and a Further Note on the Hoopoe." *Ibis* 67, no. 3 (1925): 590–94.

Day, Cyrus Lawrence. *Quipus and Witches' Knots: The Role of the Knot in Primitive and Ancient Cultures, with a Translation and Analysis of Oribasius' "De Laqueis."* Lawrence: University of Kansas Press, 1967.

DeLanda, Manuel. *A New Philosophy of Society: Assemblage Theory and Social Complexity.* London: A & C Black, 2006.

Delatte, Louis. *Textes latins et vieux français relatifs aux Cyranides.* Liège: Droz, 1942.

Delattre, Charles, ed. *Objets sacrés, objets magiques: De l'Antiquité au Moyen Âge.* Paris: Picard, 2007.

Deleuze, Gilles, and Félix Guattari, *Anti-Oedipus: Capitalism and Schizophrenia*. Minneapolis: University of Minnesota Press, 1983.

———. *A Thousand Plateaus: Capitalism and Schizophrenia*. Minneapolis: University of Minnesota Press, 1987.

Del Rio, Martin. *Disquisitionum Magicarum libri sex*. Moguntiae: Petri Henningii, 1617.

Dennis, Geoffrey W. *The Encyclopedia of Jewish Myth, Magic, and Mysticism*. Woodbury, Minn.: Llewellyn, 2007.

Deroy, Louis, and Robert Halleux. "À propos du grec ἤλεκτρον 'ambre' et 'or blanc.'" *Glotta* 52 (1974): 36–52.

Détienne, Marcel. *Le notion de daïmôn dans le pythagorisme ancien: De la pensée religieuse à la pensée philosophique*. Paris: Les Belles Lettres, 1963.

Díaz, Sarah E. "Contested Virilities: Constructing Masculinity in Dante's *Tenzone* with Forese." *Italian Culture* 32 (2014): 1–19.

Didron, Adolphe Napoléon. "Voyage archéologique dans la Grèce chrétienne." *Annales archéologiques* 1 (1844): 173–79.

Dillon Bussi, Angela, and Anna Rita Fantoni. "La biblioteca medicea laurenziana negli ultimi anni del Quattrocento." In *All'ombra del lauro: Documenti librari della cultura in età laurenziana*, edited by Anna Lenzuni, 135–48. Milan: Silvana, 1992.

Dinkler, Erich. "Der Salomonische Knoten in der Nubischen Kunst und die Geschichte des motivs." In *Études nubiennes: Colloque de Chantilly, 2–6 juillet 1975*, 73–86, tables xiv–xxi. Cairo: Institut français d'archéologie orientale, 1978.

Dizionario overo trattato universale delle droghe semplici. Venice: Giovanni Gabriele Hertz, 1721.

Donceel-Voûte, Pauline. "Barrer la route au Malin: Une typologie des stratégies utilisées; Images et signes à fonctionnement sécuritaire sur support fixe dans l'Antiquité tardive." In *The Levant: Crossroads of Late Antiquity; History, Religion and Archaeology*, edited by Ellen Bradshaw Aitken and John M. Fossey, 347–99. Leiden: Brill, 2014.

Donzel, Emeri van, and Andrea Schmidt, eds. *Gog and Magog in Early Syrian and Islamic Sources*. Leiden: Brill, 2009.

Dornseiff, Franz. *Das Alphabet in Mystik und Magie*. Leipzig: Teubner, 1925.

Douglas, Mary, and Baron Isherwood. *The World of Goods: Toward an Anthropology of Consumption*. New York: Basic Books, 1979.

Doutté, Edmond. *Magie et religion dans l'Afrique du Nord*. Algers: Adolphe Jourdan, 1908.

Dressen, Angela. *Pavimenti decorati del Quattrocento in Italia*. Venice: Marsilio, 2001.

Droogers, André. "As Close as a Scholar Can Get: Exploring a One-Field Approach to the Study of Religion." In *Religion: Beyond a Concept*, edited by Hent de Vries, 448–63. New York: Fordham University Press, 2008.

Dudley, Sandra. *Museum Objects: Experiencing the Properties of Things*. London: Routledge, 2012.

Duling, Dennis C. "The Eleazar Miracle and Solomon's Magical Wisdom in Flavius Josephus's *Antiquitates Judaicae* (8, 42–49)." *Harvard Theological Review* 78 (1985): 1–25.

———. "Solomon, Exorcism, and the Son of David." *Harvard Theological Review* 68 (1975): 235–52.

———, trans. "Testament of Solomon." In *The Old Testament Pseudepigrapha*, edited by James H. Charlesworth, 1:935–88. Garden City, N.Y.: Doubleday, 1983–85.

Durkheim, Émile. *The Elementary Forms of Religious Life*. Translated by Karen E. Fields. New York: Free Press, 1995.

Eck, Caroline van. *Art, Agency and the Living Presence: From the Animated Image to the Excessive Object*. Leiden: Leiden University Press, 2015.

Edwards, A. Cecil. *The Persian Carpet*. New York: Overlook Press, 2017.

Edwards, Mark J. "Three Exorcisms and the New Testament World." *Eranos* 87 (1989): 117–26.

Elhanan, Naphtali b. Jacob. *'Emeḳ ha-Melekh*. Amsterdam: Fuks, 1648.

Eliade, Mircea. *Arti del metallo e alchimia*. Turin: Bollati Boringhieri, 1980.

Elich, Philipp Ludwig. *Daemonomagia*. Frankfurt: Conradi Nebenii, 1607.

Eliot, T. S. "Hamlet and His Problems." In *The Sacred Wood*. London: Methuen, 1920.

Elswit, Sharon Barcan. *The Jewish Story Finder: A Guide to 668 Tales Listing Subjects and Sources*. Jefferson, N.C.: McFarland, 2012.

Énard, Mathias. *Compass*. Translated by Charlotte Mandell. London: Fitzcarraldo Editions, 2017.

Entin-Bates, Lee R. "Montaigne's Remarks on Impotence." *MLN* 91 (1976): 640–54.

Epstein, Isidore, ed. *The Babylonian Talmud: Seder Mo'ed*. 4 vols. London: Soncino Press, 1938.

———, ed. *The Babylonian Talmud: Seder Nezikin*. 4 vols. London: Soncino Press, 1935.

———, ed. *The Babylonian Talmud: Seder Nashim*. 4 vols. London: Soncino Press, 1936.

Erdmann, Kurt. *Seven Hundred Years of Oriental Carpets*. Edited by Hanna Erdmann, translated by May H. Beattie and Hildegard Herzog. Berkeley: University of California Press, 1970.

Ernst, Germana. *Religione, ragione e natura: Ricerche su Tommaso Campanella e il tardo Rinascimento*. Milan: Franco Angeli, 1991.

Evans-Pritchard, E. E. *Witchcraft, Oracles and Magic Among the Azande*. Oxford: Clarendon Press, 1937.

Fabbri, Paolo. *Monteverdi*. Turin: EDT, 1985.

Fahd, Toufiq, and Andrew Rippin. "Shayṭān." In *Encyclopaedia of Islam*. 2nd ed. Leiden: Brill Online, 2016. http://dx.doi.org/10.1163/1573-3912_islam_COM_1054.

Failla, Donatella. *Garuda e i Naga: Immagini, forme e simboli di antiche storie di ratto*. Genoa: Alkaest: 1982.

Falguières, Patricia. "La société des objets." Introduction to Julius von Schlosser, *Les cabinets d'art et de merveilles de la Renaissance tardive*, 7–54. Paris: Macula, 2012.

Federici, Fabrizio, and Jörg Garms. "'Tombs of Illustrious Italians at Rome': L'Album di disegni RCIN 970334 della Royal Library di Windsor." *Bollettino d'Arte*. Florence: L. Olschki, 2011.

Feldman, Louis H. *Studies in Hellenistic Judaism*. Leiden: Brill, 1996.

Ferdowsi, Abolgasem. *Šāh-nāma*. Edited by Evgenil Eduardovich Bertels. 9 vols. Moscow: Izdatel'stvo Nauka, 1966–71.

Ferdowsi, Abolqasem. *Shahnameh*. Translated by Dick Davis. New York: Penguin, 2016.

Ficino, Marsilio. *Lettere: Epistolarum familiarum liber I*. Edited by Sebastiano Gentile. Florence: Leo Olschki, 1988.

———. *The Letters of Marsilio Ficino*. Translated by members of the Language Department of the School of Economic Science. 9 vols. London: Shepheard-Walwyn, 1975–2012.

Fiedler, Wilhelm. *Antiker Wetterzauber*. Stuttgart: Kohlhammer, 1931.

Filippi, Rustico. *The Art of Insult*. Translated by Fabian Alfie. Cambridge: MHRA New Translations, 2014.

Findlen, Paula. *Possessing Nature: Museums, Collecting, and Scientific Culture in Early Modern Italy*. Berkeley: University of California Press, 1994.

Firdousi, Abou'lkasim. *Le livre des rois*, edited by Jules Mohl. 7 vols. Paris: Imprimerie Nationale, 1838–71.

Firenzuola, Agnolo. *I lucidi*. Florence: Giunti, 1552.

Flood, Finbarr Barry. *The Great Mosque of Damascus: Studies on the Makings of an Umayyad Visual Culture*. Leiden: Brill, 2001.

Fobelli, Maria Luigia. *Un tempio per Giustiniano: Santa Sofia di Costantinopoli e la descrizione di Paolo Silenziario*. Rome: Viella, 2005.

Folkard, Richard. *Plant Lore, Legends and Lyrics: Embracing the Myths, Traditions, Superstitions and Folk-Lore of the Plant Kingdom*. London: Folkard and Sons, 1884.

Foss, Clive. "The Persians in the Roman Near East (602–30 AD)." *Journal of the Royal Asiatic Society* 13 (2003): 149–70.

Foucault, Michel. *The Order of Things: An Archaeology of the Human Sciences*. London: Tavistock, 1970.

Franz, Adolph. *Die Kirchlichen Benediktionen im Mittelalter*. 2 vols. Graz: Akademische Druck und Verlagsanstalt, 1960.

Fraser, A. D. "The Origin of Aeolus." *Classical Journal* 28 (1933): 364–66.

Frazer, James George. *The Golden Bough: A Study in Magic and Religion*. 3rd ed. 12 vols. London: Macmillan, 1906–15.

Frazer, Jonathan. *Taboo and the Perils of the Soul*. London: Macmillan, 1911.

Freedberg, David. *The Power of Images: Studies in the History and Theory of Response*. Chicago: University of Chicago Press, 1989.

Freud, Sigmund. "Fetishism." In *The Standard Edition of the Complete Psychological Works of Sigmund Freud*, translated by James Strachey, 21:149–57. London: Hogarth Press, 1961.

———. *Totem and Taboo: Some Points of Agreement Between the Mental Lives of Savages and Neurotics*. Translated and edited by James Strachey. New York: W. W. Norton, 1989.

———. "Unsuitable Substitutes for the Sexual Object: Fetishism." In *The Standard Edition of the Complete Psychological Works of Sigmund Freud*, translated by James Strachey, 7:153–55. London: Hogarth Press, 1953.

Friedman, Shamma. "The Primacy of Tosefta to Mishnah in Synoptic Parallels." In *Introducing Tosefta: Textual, Intratextual, and Intertextual Studies*, edited by Harry Fox and Tirzah Meacham, 99–121. Hoboken: KTAV, 1999.

———. *Tosefta Atiqta, Pesaḥ Rishon: Synoptic Parallels of Mishna and Tosefta Analyzed, with a Metholodological Introduction*. Ramat gan: Bar-Ilan University Press, 2002.

Frisk, Hjalmar. *Griechisches etymologisches Wörterbuch*. 2 vols. Heidelberg: Carl Winter Universitätsverlag, 1970.

Fritze, Hans von. "Die Elektronprägung von Kyzikos." *Nomisma* 7 (1912): 1–38.

Frugoni, Chiara. *La fortuna di Alessandro Magno dall'antichità al Medioevo*. Florence: La Nuova Italia, 1978.

———. *Historia Alexandri elevati per griphos ad aerem. Origine, iconografia e fortuna di un tema*. Rome: Istituto Storico Italiano per il Medio Evo, 1973.

Fudge, Bruce. "Signs of Scripture in 'The City of Brass.'" *Journal of Qur'anic Studies* 8 (2006): 88–118.

Gabotto, Fernando. *Nuove ricerche e documenti sull'astrologia alla corte degli Estensi e degli Sforza*. Turin: La Letteratura, 1891.

Gabrieli, Franco. "Etichetta di corte e costumi sasanidi nel Kitāb Aḫlāq al-Mulūk di al-Ġāḥiẓ." *Rivista degli studi orientali* 11 (1926–28): 292–305.

Gager, John. *Curse Tablets and Binding Spells from the Ancient World*. Oxford: Oxford University Press, 1992.

Gaglione, Mario. *Sculture minori del Trecento conservate in Santa Chiara a Napoli ed altri studi*. Naples: Arte Tipografica, 1995.

Gault, Owen. "Operation Magic Carpet." *Sea Classics* (September 2005).

Gawhary, Mohamed el-. "Die Gottesnamen im magischen Gebrauch in den al-Buni zugeschriebenen Werken." Ph.D. diss., Rheinische Friedrich-Wilkhelms-Universität Bonn, 1968.

Gell, Alfred. *Art and Agency: An Anthropological Theory*. Oxford: Clarendon Press, 1998.

Geller, Markham J. "Eight Incantation Bowls." *Orientalia Lovaniensia Periodica* 17 (1986): 101–17.

Gerard, John. *Herball, or Generall Historie of Plantes*. London: John Norton, 1597.

Gerbino, Giuseppe. *Canoni ed enigmi: Pier Francesco Valentini e l'artificio canonico nella prima metà del Seicento*. Rome: Torre d'Orfeo, 1995.

Gerhardt, Mia I. *The Art of Story-Telling: A Literary Study of the Thousand and One Nights*. Leiden: Brill, 1963.

Germain, Gabriel. *Genèse de l'Odyssée: Le fantastique et le sacré*. Paris: PUF, 1954.

Gerritsen, Anne, and Giorgio Riello, eds. *The Global Lives of Things: The Material Culture of Connections in the Early Modern World*. London: Routledge, 2016.

———, eds. *Writing Material Culture History*. London: Bloomsbury, 2015.

Gervase of Tilbury. *Otia imperialia: Recreation for an Emperor*. Edited by S. E. Banks and J. W. Binns. Oxford: Clarendon Press, 2002.

Geyer, Paul, and Otto Cuntz, eds. "Itinerarium Burdigalense." In *Itineraria et alia geographica*. Corpus Christianorum, Series Latina CLXXV. Turnhout: Brepols, 1965.

Gignoux, Philippe, and Ludvik Kalus. "Les formules des sceaux sasanides et islamiques: Continuité ou mutation?" *Studia Iranica* 11 (1982): 123–53.

Giller, Pinchas. *Reading the Zohar: The Sacred Text of the Kabbalah*. Oxford: Oxford University Press, 2001.

Gilles, Roland. *Espelhos do Paraíso-tapetes do Mundo Islâmico, séc. XV–XX*. Paris: Institut du monde arabe, 2005.

Ginzberg, Louis. *Legends of the Jews*. Translated by Henrietta Szold. 7 vols. Philadelphia: Jewish Publication Society of America, 1909.

Ginzburg, Carlo. "Prove e possibilità: In margine a *Il ritorno di Martin Guerre* di Natalie Zemon Davis." In Natalie Zemon Davis, *Il ritorno di Martin Guerre: Un caso di doppia identità nella Francia del Cinquecento*, 131–54. Turin: Einaudi, 1984. Reprinted in Carlo Ginzburg, *Il filo e le tracce: Vero falso finto*, 295–316. Milan: Feltrinelli, 2006.

Gitler, Haim, Catharine Lorber, and Koray Konuk, eds. *White Gold: Studies in Electrum Coinage; Proceedings of the International Conference Held in Jerusalem 25–28 June 2012*. New York: American Numismatic Society, 2017.

Giversen, Søren. "Solomon und die Dämonen." In *Essays on the Nag Hammadi: Texts in Honour of Alexander Böhling*, edited by M. Krause, 16–21. Leiden: Brill, 1972.

Goldziher, Ignaz. "Eisen als Schutz gegen Dämonen." *Archiv für Religionswissenschaft* 10 (1907): 41–46.

Gombrich, Ernst Hans. *The Sense of Order: A Study in the Psychology of Decorative Art*. Ithaca: Cornell University Press, 1979.

Gordon, Cyrus. "Aramaic Magical Bowls in the Istanbul and Baghdad Museums." *Archiv Orientální* 6 (1934): 319–34.

Gordon, Sarah. "Sausages, Nuts and Eggs: Food Imagery, the Body and Sexuality in the Old French Fabliaux." In *Sexuality in the Middle Ages and Early Modern Times: New Approaches to a Fundamental Cultural-Historical and Literary-Anthropological Theme*, edited by Albrecht Classen, 503–16. Berlin: Walter de Gruyter, 2008.

Gorelick, Leonard, and A. John Gwinnett. "Ancient Egyptian Stone-Drilling." *Expedition* 25 (1983): 40–47.

———. "Minoan Versus Mesopotamian Seals: Comparative Methods of Manufacture." *Iraq* 54 (1992): 57–64.

Govi, Gilberto. "In che tempo e da chi siano stati inventati i ludioni detti ordinariamente: Diavoletti cartesiani." *Rendiconto dell'Accademia delle Scienze fisiche e matematiche* 18 (1879): 291–96.

Gowers, Emily. "Virgil's Sibyl and the 'Many Mouths' Cliché (Aen. 6.625-7)." *Classical Quarterly* 55 (2005): 170–82.

Graça da Silva, Sara, and Jamshid J. Tehrani, "Comparative Philogenetic Analyses Uncover the Ancient Roots of Indo-European Folktales." *Royal Society Open Science* 3 (2016): 1–11.

Graham, Lloyd D. "A Comparison of the Seven Seals in Islamic Esotericism and Jewish Kabbalah." Academia.edu.

———. "The Seven Seals of Judeo-Islamic Magic: Possible Origins of the Symbols." Academia.edu.

Green, Harvey. "Cultural History and the Material(s) Turn." *Cultural History* 1 (2012): 61–82.

Greenwood, Susan. *The Anthropology of Magic*. New York: Berg, 2009.

Greer, Rowan. *The "Belly-Myther" of Endor: Interpretations of 1 Kingdoms 28 in the Early Church*. Atlanta: Society of Biblical Literature, 2007.

Grévin, Benoît, and Julien Véronèse. "Les 'caractères' magiques au Moyen Âge (XIIᵉ–XIVᵉ siècle)." *Bibliothèque de l'École des Chartes* 162 (2004): 305–79.

Grieser, Alexandra. "Aesthetics." In *Vocabulary for the Study of Religion*, edited by Robert A. Segal and Kocku von Stuckrad. 3 vols. Leiden: Brill, 2015.

Grimm, Jacob. *Teutonic Mythology*. Translated by James Steven Stallybrass. 4 vols. Cambridge: Cambridge University Press, 1883.

Grimm, Jacob, and Wilhelm Grimm. *Kinder-und Hausmärchen*. 3 vols. Vienna: Verlag von Martin Gerlach, 1812–50.

Grünbaum, Max. "Beiträge zur vergleichenden Mythologie aus der Hagada." *Zeitschrift der Deutschen Morgenländischen Gesellschaft* 31 (1877): 183–359; substantially reprinted in *Gesammelte Aufsätze zur Sprach- und Sagenkunde*, edited by Franz Perles, 31–43. Berlin: S. Calvary, 1901.

———. *Neue Beiträge zur Semitischen Sagenkunde*. Leiden: Brill, 1883.

Guazzini, Sebastiano. *Tractatus ad defensam inquisitorum, carceratorum, reorum et condemnatorum*. Antwerp, 1668.

Guerri, Domenico. "Elementi del *Decamerone* nel primo sonetto d'Alighiero con Bicci." In *La corrente popolare nel Rinascimento: Berte, burle e baie nella Firenze del Brunellesco e del Burchiello*. Florence: Sansoni, 1931.

Guglielmotti, Alberto. *Vocabolario marino e militare*. Milan: Mursia, 1889.

Hailperin, Herman. "The Hebrew Heritage of Medieval Christian Biblical Scholarship." *Historia Judaica* 5 (1943): 133–54.

———. *Rashi and the Christian Scholars*. Pittsburgh: University of Pittsburgh Press, 1963.

Hallman Russel, Lucy. "'Intendomi chi può . . .' ovvero l' 'obbligo di cantare la quinta parte' in Frescobaldi." In *Girolamo Frescobaldi nel IV centenario della nascita*, edited by Sergio Durante and Dinko Fabris, 425–42. Florence: L. Olschki, 1986.

Halperin, David. *The Faces of the Chariot: Early Jewish Responses to Ezekiel's Vision*. Tübingen: Mohr Siebeck, 1988.

Hamburger, Jacob. "Schamir." In *Real-Encyclopädie für Bibel und Talmud*. 3 vols. Strelitz: Selbstverlag des Verfasser, 1878–83.

Hamori, Andras. "An Allegory from the Arabian Nights: The City of Brass." *Bulletin of the School of Oriental and African Studies, University of London* 34 (1971): 9–19.

———. *On the Art of Medieval Arabic Literature*. Princeton: Princeton University Press, 1974.

Hampe, Roland. *Die Gleichnisse Homers und die Bildkunst seiner Zeit*. Tübingen: Niemeyer, 1952.

Handy, Lowell, ed. *The Age of Solomon: Scholarship at the Turn of the Millennium*. Leiden: Brill, 1997.

Hanssen, Beatrice, ed. *Walter Benjamin and the Arcades Project*. London: Continuum, 2006.

Happel, Eberhard Werner. *Relationes curiosae oder Denckwürdigkeiten der Welt*. 2 vols. Hamburg: Reumann, 1707.

Harding, James, and Loveday Alexander. "Dating the Testament of Solomon." Lecture, May 28, 1999. http://www.st-andrews.ac.uk/divinity/rt/otp/guestlectures/harding/.

Hartner, Willy. "The Pseudoplanetary Nodes of the Moon's Orbit in Hindu and Islamic Iconographies." *Ars Islamica* 5 (1938): 113–15.

Hasson, Rachel. "An Enamelled Glass Bowl with 'Solomon's Seal': The Meaning of a Pattern." In *Gilded and Enamelled Glass from the Middle East*, edited by Rachel Ward, 41–44, 174–75, pl. F. London: British Museum Press, 1998.

Hazard, Sonia. "The Material Turn in the Study of Religion." *Religion and Society: Advances in Research* 4 (2013): 58–78.

Healy, John. "The Establishment of Die-Sequences in Greek 'White Gold' and Electrum Coin Series." *Numismatic Chronicle* 11 (1971): 31–36.

———. "Greek Refining Techniques and the Composition of Gold-Silver Alloys." *Revue Belge de Numismatique et de Sigillographie* 120 (1974): 19–33.

———. *Mining and Metallurgy in the Greek and Roman World.* London: Thames and Hudson, 1978.

Hegel, Georg Wilhelm Friedrich. *The Philosophy of History.* Translated by J. Sibree. Mineola, N.Y.: Dover, 2012.

Heidegger, Martin. "The Thing." In *Poetry, Language, Thought,* 163–86. Translated by Albert Hofstadter. New York: Harper and Row, 1971.

Heimpel, Wolfgang, Leonard Gorelick, and A. John Gwinnett. "Philological and Archaeological Evidence for the Use of Emery in the Bronze Age Near East." *Journal of Cuneiform Studies* 40, no. 2 (1988): 195–210.

Heinsohn, Phillip. "Shamir." *C & C Review* 1 (1996): 27.

Henare, Amiria, Martin Holbraad, and Sari Wastell, eds. *Thinking Through Things: Theorizing Artefacts Ethnographically.* London: Routledge, 2007.

Heng, Geraldine. *Empire of Magic.* New York: Columbia University Press, 2003.

Herlitz, Georg, and Ismar Elbogen, eds. *Jüdisches Lexikon: Ein enzyklopädisches Handbuch des jüdischen Wissens.* 4 vols. Berlin: Jüdische Verlag, 1927–30.

Hernández Juberías, Julia. *La península immaginaria.* Madrid: CSIC, 1999.

Herodotus. *Histories.* Translated by A. D. Godley. 4 vols. Cambridge: Harvard University Press, 1981–90.

Herzfeld, Ernst. "Der Thron des Khosro: Quellenkritische und ikonographische Studien über Grenzgebiete der Kunstgeschichte des Morgen- und Abendlandes." *Jahrbuch der Preussischen Kunstsammlungen* 41 (1920): 1–24 and 103–47.

Hetzel, Aurélia, "Salomon." In *La Bible dans les littératures du monde,* edited by Sylvie Parizet, 2:1947–55. Paris: Les Éditions du Cerf, 2016.

Heubeck, Alfred, and Arie Hoekstra. *A Commentary on Homer's Odyssey (Books IX–XVI).* Oxford: Clarendon Press, 1989.

Hicks, Dan. "The Material-Cultural Turn: Event and Effect." In *The Oxford Handbook of Material Culture Studies,* edited by Mary Beaudry and Dan Dicks, 1–45. Oxford: Oxford University Press, 2010.

Hiers, Richard H. "'Binding' and 'Loosing': The Matthean Authorizations." *Journal of Biblical Literature* 104 (1985): 233–50.

Hindman, Sandra, and Diana Scarisbrick, eds. *Golden Marvels of Byzantium: A Millennium of Finger-Rings (3rd–13th Centuries).* Paris: Les Enluminures, 2017.

Hirsch, Emil G., Ira Maurice Price, Wilhelm Bacher, M. Seligsohn, Mary W. Montgomery, and Crawford Howell Toy. "Solomon." In the *Jewish Encyclopedia.* 12 vols. New York: Funk and Wagnalls, 1900–1906. http://www.jewishencyclopedia.com/articles/13842 -solomon.

Hoek, Annewies van den, Denis Feissel, and John J. Herrmann Jr. "More Lucky Wearers: The Magic of Portable Inscriptions." In *The Materiality of Magic,* edited by Jan N. Bremmer and Dietrich Boschung, 309–56. Paderborn: Wilhelm Fink, 2015.

Holbraad, Martin. "Can the Thing Speak?" Open Anthropology Cooperative Press, Working Papers Series 7, 2011. http://openanthcoop.net/press/http:/openanthcoop.net/ press/wp-content/uploads/2011/01/Holbraad-Can-the-Thing-Speak2.pdf.

Horowitz, Wayne. *Mesopotamian Cosmic Geography.* Winona Lake, Ind.: Eisenbrauns, 1998.

Horton, Robin. "African Traditional Thought and Western Science: Part I. From Tradition to Science." *Africa: Journal of the International African Institute* 37, (1967): 50–71.

———. "African Traditional Thought and Western Science: Part II. The 'Closed' and 'Open' Predicaments." *Africa: Journal of the International African Institute* 37, no. 2 (1967): 157–87.

Hoskins, Janet. "Agency, Biography and Objects." In *Handbook of Material Culture*, edited by Christopher Tilley, Webb Keane, Susanne Kuechler, Mike Rowlands, and Patricia Spyer, 74–84. London: Sage, 2006.

Houlbrook, Ceri, and Natalie Armitage, eds. *The Materiality of Magic: An Artefactual Investigation into Ritual Practices and Popular Beliefs*. Oxford: Oxbow Books, 2015.

Hults, Linda. "Baldung and the Witches of Freiburg: The Evidence of Images." *Journal of Interdisciplinary History* 18 (1987): 249–76.

———. "Hans Baldung Grien's *Weather Witches* in Frankfurt." *Pantheon* 40 (1982): 124–30.

Iafrate, Allegra. "From Wheel of Fortune to Inviolable Threshold: An Iconographic Case-Study of the La Seu Vella Capital." *Iconographica* (forthcoming, 2018).

———. "*Opus Salomonis*: Sorting Out Solomon's Scattered Treasure." *Medieval Encounters* 22, no. 4 (2016): 326–78.

———. *The Wandering Throne of Solomon: Objects and Tales of Kingship in the Medieval Mediterranean*. Leiden: Brill, 2015.

Ibn ʿAsākir, Abū l-Qāsim ʿAlī ibn al-Ḥasan. *Taʾrīkh Madīnat Dimashq*. 80 vols. Beirut: Dār al-fikr, 1995.

Ibn Ḥabīb, ʿAbd al-Malik. *Kitāb al-Taʾrīkh*. Edited by Jorge Aguadé. Madrid: CSIC, 1991.

Ingold, Tim. "Materials Against Materiality." *Archaeological Dialogues* 14, no. 1 (2007): 1–16.

———. *The Perception of Environment: Essays on Livelihood, Dwelling and Skills*. London: Routledge, 2000.

———. "When ANT Meets SPIDER: Social Theory for Arthropods." In *Being Alive: Essays on Movement, Knowledge and Description*, 89–97. London: Routledge, 2011.

Ioannides, George. "Vibrant Sacralities and Nonhuman Animacies: The Matter of New Materialism and Material Religion." *Journal for the Academic Study of Religion* 26, no. 3 (2013): 234–53.

Isbell, Charles. *Corpus of the Aramaic Incantation Bowls*. Missoula, Mont.: Society of Biblical Literature, 1975.

Isidore of Seville. *The Etymologies of Isidore of Seville*. Edited by Stephen A. Barney, W. J. Lewis, J. A. Beach, Oliver Berghof, and Muriel Hall. Cambridge: Cambridge University Press, 2006.

Izutsu, Toshihiko. *Language and Magic: Studies in the Magical Function of Speech*. Rev. ed. Kuala Lumpur: The Other Press, 2012.

Jakobson, Roman, and Morris Halle. *Fundamentals of Language*. The Hague: Mouton, 1956.

Janni, Pietro. *Miti e falsi miti: Luoghi comuni, leggende, errori sui Greci e sui Romani*. Bari: Dedalo, 2004.

———. "Il naufragio di Martiniano." In *Curiositas: Studi di cultura classica e medievale in onore di Ubaldo Pizzani*, edited by Alessandra Di Pilla, Antonino Isola, and Enrico Menestò, 311–14. Naples: ESI, 2002.

Janssens, Jules. "The *Ikhwān aṣ-ṣafāʾ* on King-Prophet Solomon." In *The Figure of Solomon in Jewish, Christian and Islamic Tradition: King, Sage and Architect*, edited by Joseph Verheyden, 241–53. Leiden: Brill, 2012.

Jellinek, Adolph. *Bet ha-Midrasch: Sammlung kleiner Midraschim und vermischter Abhandlungen aus der ältern jüdischen Literatur*. 6 vols. Leipzig: F. Nies, 1853–57; Vienna: Brüder Winter, 1873–77.

Jerome (Hieronymus). *Commentariorum in Ezechielem prophetam libri quatuordecim*. Vol. 25 of *Patrologia Latina*, edited by Jacques-Paul Migne. Paris, 1845.

John of Salisbury. *Policraticus*. Edited by K. S. B. Keats-Rohan. Turnhout: Brepols, 1993.

Jones, William. *Finger-Ring Lore*. London: Chatto and Windus, 1898.

Josephus (Titus Flavius Josephus). *Antiquities of the Jews*. Translated by H. St. J. Thackeray. 9 vols. Cambridge: Harvard University Press, 1961.

Jueneman, Frederic B. *Raptures of the Deep: Essays in Speculative Science*. Des Plaines, Ill.: Cahners, 1995.

Junod, Benoît, Georges Khalil, Stefan Weber, and Gerhard Wolf, eds. *Islamic Art and the Museum: Approaches to Art and Archaeology of the Muslim World in the Twenty-First Century*. London: Saqi Books, 2012.

Kalavrezou-Maxeiner, Ioli. "The Byzantine Knotted Column." In *Byzantine Studies in Honor of Milton V. Anastos*, edited by Speros Vryonis Jr., 95–103. Malibu: Undena, 1985.

Kalus, Ludvik. *A Catalogue of Seals and Talismans Housed at the Ashmolean from the 8th to the 19th Century Islamic world*. Oxford: Oxford University Press, 1986.

Karp, Ivan, and Steven Lavine, eds. *Exhibiting Cultures: The Poetics and Politics of Museum Display*. Washington, D.C.: Smithsonian Institution Press, 1991.

Karpenko, Vladimir. "Systems of Metals in Alchemy." *Ambix* 50 (2003): 208–30.

Kauffmann, Sophie. "Obtenir son salut: Quel objet choisir? La réponse du christianisme." In *Objets sacrés, objets magiques: De l'Antiquité au Moyen Âge*, edited by Charles Delattre, 117–40. Paris: Picard, 2007.

Keane, Webb. "Calvin in the Tropics: Objects and Subjects at the Religious Frontier." In *Border Fetishisms: Material Objects in Unstable Spaces*, edited by Patricia Spyer, 13–34. London: Routledge, 1998.

———. *Christian Moderns: Freedom and Fetish in the Mission Encounter*. Berkeley: University of California Press, 2007.

———. "Semiotics and the Social Analysis of Material Things." *Language and Communication* 23 (2003): 409–25.

———. "Subjects and Objects." In *Handbook of Material Culture*, edited by Christopher Tilley, Webb Keane, Susanne Kuechler, Mike Rowlands, and Patricia Spyer, 197–202. London: Sage, 2006.

Kendall, Calvin B. *The Allegory of the Church: Romanesque Portals and Their Verse Inscriptions*. Toronto: University of Toronto Press, 1998.

Khoury, Raif Georges. *Wahb b. Munabbih*. Wiesbaden: Harrassowitz, 1972.

Kieckhefer, Richard. *Forbidden Rites: A Necromancer's Manual of the Fifteenth Century*. University Park: Penn State University Press, 1997.

———. *Magic in the Middle Ages*. Cambridge: Cambridge University Press, 1989.

Kircher, Athanasius. *Magnes, sive de arte magnetica*. Rome: Vitalis Mascardi, 1654.

———. *Musurgia universalis*. Rome: Francesco Corbelletti, 1650.

Kisā'ī, Muḥammad ibn 'Abd Allah al-. *The Tales of the Prophets of al-Kisa'i*. Translated by William M. Thackston Jr. Chicago: Kazi Books, 1997.

Kitzinger, Ernst. "Interlace and Icons: Form and Function in Early Insular Art." In *Studies in Late Antique Byzantine and Medieval Western Art*, 2:801–26. London: Pindar Press, 2002–3.

———. "The Threshold of the Holy Shrine: Observations on Floor Mosaics at Antioch and Bethlehem." In *Studies in Late Antique Byzantine and Medieval Western Art*, 1:244–59. London: Pindar Press, 2002–3.

Klagsbald, Victor. "'Comme un lis entre les chardons': De la symbolique de la fleur de lis aux origines du Magen Dawid." *Revue des études juives* 150, no. 1–2 (1991): 133–50.

Klar, Marianna O. "And We Cast upon His Throne a Mere Body: A Historiographical Reading of Q. 38:34." *Journal of Qur'anic Studies* 6 (2004): 103–26.

Klutz, Todd E. "The Archer and the Cross: Chronographic Astrology and Literary Design in the Testament of Solomon." In *Magic in the Biblical World: From the Rod of Aaron to the Ring of Solomon*, edited by Todd E. Klutz, 219–44. London: T & T Clark, 2003.

Knappert, Jan. *Islamic Legends: Histories of the Heroes, Saints and Prophets of Islam*. 2 vols. Leiden: Brill, 1985.

Kocela, Christopher. *Fetishism and Its Discontents in Post-1960 American Fiction*. New York: Palgrave Macmillan, 2010.

Kolinski, John, Pascale Aussillous, and Lakshminarayanan Mahadevan. "The Shape and Motion of a Ruck in a Rug." *Physical Review Letters* 103 (2009).

Kopytoff, Igor. "The Cultural Biography of Things: Commoditization as Process." In *The Social Life of Things*, edited by Arjun Appadurai, 64–91. Cambridge: Cambridge University Press, 1988.

Kotansky, Roy. *Greek Magical Amulets: The Inscribed Gold, Silver, Copper and Bronze Lamellae*, part 1, *Published Texts of Known Provenance*. Cologne: Westdeutscher Verlag, 1994.

Kroll, John. "The Monetary Background of Early Coinage." In *The Oxford Handbook of Greek and Roman Coinage*, edited by William Metcalf, 33–42. Oxford: Oxford University Press, 2012.

Kruk, Remke. "Of Rukhs and Rooks, Camels and Castles." *Oriens* 36 (2001): 288–98.

Kubler, George. *The Shape of Time: Remarks on the History of Things*. New Haven: Yale University Press, 1962.

Küchler, Susanne. "Why Knot? Toward a Theory of Art and Mathematics." In *Beyond Aesthetics: Art and the Technologies of Enchantment*, edited by Christopher Pinney and Nicholas Thomas, 57–77. Oxford: Berg, 2001.

Kunz, George Frederick. *Rings for the Finger*. Philadelphia: J. B. Lippincott, 1917.

Labarbe, Jules. "Polycrate, Amasis et l'anneau." *Antiquité Classique* 53 (1984): 15–34.

Lane, Edward. *Arabian Society in the Middle Ages*. London: Chatto and Windus, 1883.

La Niece, Susan, Rachel Ward, Duncan Hook, and Paul Craddock. "Medieval Islamic Copper Alloys." In *Scientific Research on Ancient Asian Metallurgy*, edited by Paul Jett, Blythe McCarthy, and Janet J. Douglas, 248–54. London: Archetype, 2012.

Latour, Bruno. *Pandora's Hope: Essays on the Reality of Science Studies*. Cambridge: Harvard University Press, 1999.

———. *The Pasteurization of France*. Translated by Alan Sheridan and John Law. Cambridge: Harvard University Press, 1988.

———. *Reassembling the Social: An Introduction to Actor-Network-Theory*. Oxford: Oxford University Press, 2005.

———. *We Have Never Been Modern*. Translated by Catherine Porter. Cambridge: Harvard University Press, 1993.

Lavin, Irving. *Past-Present: Essays on Historicism in Art from Donatello to Picasso*. Berkeley: University of California Press, 1993.

Laviolette, Patrick, and Anu Kannike, eds. *Things in Culture, Culture in Things*. Tartu: University of Tartu Press, 2013.

Lavondès, Henry. "Magie et langage: Note à propos de quelques faits malgaches." *L'Homme* 3, no. 3 (1963), 109–17.

Law, John. "After ANT: Complexity, Naming and Topology." *Sociological Review* 47 (1999): 1–14.

Law, John, and Peter Lodge. *Science for Social Scientists*. London: Palgrave Macmillan, 1984.

Lawrence, Robert. "The Folk-Lore of the Horseshoe." *Journal of American Folklore* 9 (1896): 288–92.

Lawson, E. Thomas, and Robert N. McCauley. *Rethinking Religion: Connecting Cognition and Culture*. Cambridge: Cambridge University Press, 1990.

Lazzarini, Lorenzo. "I vasi in pietra minoici di Festòs: primi dati sulla natura e provenienza dei materiali lapidei." In *I cento anni dello scavo di Festòs*, 575–96. Rome: Accademia Nazionale dei Lincei, 2001.

Lea, Henry Charles, Arthur C. Howland, and George Lincoln Burr. *Materials Toward a History of Witchcraft*. 3 vols. Philadelphia: University of Pennsylvania Press, 1957.

Leach, Edmund. *Culture and Communication: The Logic by Which Symbols Are Connected*. Cambridge: Cambridge University Press, 1976.

Lebling, Robert. *Legends of the Fire Spirits: Jinn and Genies from Arabia to Zanzibar*. London: Palgrave Macmillan, 2010.

Leguay, Jean-Pierre. *L'air et le vent au Moyen Âge*. Rennes: Presses Universitaires de Rennes, 2011.

Lehmann, Karl. "The Dome of Heaven." *Art Bulletin* 27 (1945): 1–27.

Lehrich, Christopher I. *The Occult Mind: Magic in Theory and Practice.* Ithaca: Cornell University Press, 2007.

Leibowitz, Joshua, and Shlomo Marcus, eds. and trans. *Sefer Ha-nisyonot = The Book of Medical Experiences Attributed to Abraham Ibn Ezra; Medical Theory, Rational and Magical Therapy; A Study in Medievalism.* Jerusalem: Magnes Press, 1984.

Leite de Vasconcelos, José. *Signum Salomonis, a Figa, a Barba em Portugal: Estudos de etnografia comparativa.* Lisbon: Publicações Dom Quixote, 1918.

Lémery, Nicolas. *Dictionnaire ou traité universel des drogues simples.* 3rd ed. Amsterdam: Dépense de la Compagnie, 1716.

Leoni, Francesca, and Christiane Gruber. *Power and Protection: Islamic Art and the Supernatural.* Oxford: Ashmolean Museum, 2016.

Lesage, André-René. *Le Diable boiteaux.* Paris, Veuve Barbin, 1707.

Lettere volgari di diversi nobilissimi huomini et eccellentissimi ingegni. 3 vols. Venice: Aldus, 1564.

Levene, Dan. "Metal Amulets." Practical Kabbalah, January 18, 2008. http://kabbalah.faye levine.com/amulets/pk016.php.

Lévi-Strauss, Claude. "The Structural Study of Myth." *Journal of American Folklore* 68 (1955): 428–44.

Lévy-Bruhl, Lucien. *How Natives Think.* Translated by Lilian A. Clare. London: Washington Square Press, 1926.

Lewy, Hans. *Chaldaean Oracles and Theurgy: Mysticism, Magic and Platonism in the Later Roman Empire.* Edited by Michel Tardieu. 3rd ed. Paris: Madan, 1978.

Lewy, Hildegard. "The Babylonian Background of the Kay Kâûs Legend." *Archiv Orientální* 17 (1949): 28–109.

Lewysohn, Ludwig. *Die Zoologie des Talmuds.* Frankfurt am Main: Selbstverlag des Verfassers, 1858.

Lieberman, Saul. *Tosefta Ki-fshuta: A Comprehensive Commentary on the Tosefta.* 12 vols. 2nd repr. ed. Part VIII, *Order Nashim.* New York: Jewish Theological Seminary of America, 1995.

Linnaeus, Carl. *Systema naturae: Regnum animale.* 10th ed. 2 vols. Stockholm: W. Engelmann, 1758.

Lisini, Alessandro, and Fabio Giacometti, eds. *Cronaca Senese di autore anonimo del secolo XIV.* In *Rerum Italicarum Scriptores.* Bologna: Nicola Zanichelli, 1931.

Lo Cascio, Pippo. *Il nodo di Salomone: Il simbolo millenario della storia dell'uomo.* Palermo: Edizioni del mirto, 2014.

L'Orange, H. P. *Studies on the Iconography of Cosmic Kingship in the Ancient World.* Oslo: H. Aschehoug, 1953.

Lorenz, Konrad. *Er redete mit dem Vieh, den Vogeln und den Fischen.* Vienna: Verlag Dr. G. Borotha-Schoeler, 1949.

———. *King Solomon's Ring.* New York: Routledge, 2002.

Lory, Pierre. *La Dignité de l'homme face aux anges, aux animaux et aux djinns.* Paris: Albin Michel, 2018.

Lowin, Shari L. "Narratives of Villainy: Titus, Nebuchadnezzar, and Nimrod in the Ḥadith and *Midrash Aggadah*." In *The Lineaments of Islam: Studies in Honor of Fred McGraw Donner,* edited by Paul M. Cobb, 261–96. Leiden: Brill, 2012.

Lucas, Alfred. *Ancient Egyptian Materials and Industries.* 4th ed., rev. and enlar. by John Richard Harris. London: Edward Arnold, 1962. Reprint, Mineola, N.Y.: Dover, 1999.

Lucchesi-Palli, Elisabetta. "Observations sur l'iconographie de l'aigle funéraire dans l'art copte et nubien." In *Études nubiennes, Colloque, Chantilly 1975,* 175–91. Cairo: Institut français d'archéologie orientale du Caire, 1978.

Luck, Georg. *Arcana Mundi: Magic and the Occult in the Greek and Roman Worlds.* Baltimore: Johns Hopkins University Press, 1985.

Lutz, Jules, and Paul Perdrizet, eds. *Speculum humanae salvationis*. 2 vols. Mulhouse: Meininger, 1907.

MacDonald, D. B., H. Massé, P. N. Boratav, K. A. Nizami, and P. Voorhoeve. "Djinn." In *Encyclopaedia of Islam*. 2nd ed. Leiden: Brill Online, 2016. http://dx.doi.org/10.1163/1573-3912_islam_COM_0191.

MacGregor Mathers, S. Liddell, ed. and trans. *The Key of Solomon the King*. London: George Redway, 1889.

MacGregor, Neil. *A History of the World in 100 Objects*. London: Allen Lane, 2010.

Magiotti, Raffaello. *Renitenza certissima dell'acqua alla compressione dichiarata con varij scherzi in occasion d'altri problemi curiosi*. Rome: Francesco Moneta, 1648.

Maguire, Henry. *The Icons of Their Bodies: Saints and Their Images in Byzantium*. Princeton: Princeton University Press, 1996.

———. "Magic and Geometry in Early Christian Floor Mosaics and Textiles." *Jahrbuch der österreichischen Byzantinistik* 44 (1994): 265–74.

———. "Magic and Money in the Early Middle Ages." *Speculum* 72 (1997): 1037–54.

———. "'To Knit the Ravelled Sleeve of Care': Observations on the Role of Knots in Floor Mosaics, Carpets, and Clothing During Late Antiquity." Paper delivered at the workshop "Stromata: The Carpet as Artifact, Concept and Metaphor in Literature, Science and the Arts," organized by Vera-Simone Schulz and Gerhard Wolf, Kunsthistorisches Institut, Florence, November 3–5, 2014.

Malinowski, Bronisław. *Coral Gardens and Their Magic: A Study of the Methods of Tilling the Soil and of Agricultural Rites in the Trobriand Islands*. 2 vols. London: George Allen and Unwin, 1966.

———. "Magic, Science, and Religion." In *Magic, Science, and Religion and Other Essays*, edited by Robert Redfield, 1–71. Boston: Beacon Press, 1948.

———. "The Problem of Meaning in Primitive Language." In *Magic, Science, and Religion, and Other Essays*, edited by Robert Redfield, 228–76. Boston: Beacon Press, 1948.

Mangolini, Lia. "La vera natura del 'magico Shamìr.' A proposito di un'antichissima tecnologia per la lavorazione della pietra senza l'uso di strumenti metallici." *Episteme* 6 (2002): 22–62. http://docplayer.it/1981183-Episteme-physis-e-sophia-nel-iii-millennio-an-international-journal-of-science-history-and-philosophy.html.

Mardrus, Joseph Charles, and Powys Mathers, trans. *The Book of the Thousand Nights and One Night*. 4 vols. London: Routledge, 1990.

Martelli, Matteo. "Gli scritti alchemici pseudo-democritei nella tradizione indiretta greca e nelle traduzioni siriache." Ph.D. diss., Università degli Studi di Pisa, 2008.

Martin, Therese, ed. "'Me fecit': Making Medieval Art (History)." Special issue, *Journal of Medieval History* 42 (2016).

Martín-Platero, Antonio, E. Valdivia, M. Ruiz-Rodriguez, J. J. Soler, M. Martin-Vivaldi, M. Maqueda, and M. Martinez-Bueno. "Characterization of Antimicrobial Substances Produced by *Enterococcus faecalis* MRR 10–3, Isolated from the Uropygial Gland of the Hoopoe (*Upupa epops*)." *Applied and Environmental Microbiology* 72, no. 6 (2006): 4245–49.

Marx, Karl. *Capital: A Critique of Political Economy*. Vol. 1, *The Process of Capitalist Production*. Translated by Ben Fowkes. London: Vintage Books, 1977.

Marzolph, Ulrich, and Richard van Leeuwen. *Arabian Nights Encyclopedia*. 2 vols. Santa Barbara: ABC-CLIO, 2004.

Masini, Eliseo. *Sacro Arsenale ouero Prattica dell'officio della Santa Inquisizione*. Genoa: Sebastiano Zecchini, 1653.

Mauss, Marcel. *A General Theory of Magic*. Translated by Robert Brain. London: Routledge, 2001.

May, Georges. "D'où vient le tapis magique? Fantaisie et érudition dans 'Les Mille et une nuits' de Galland." In *Studies in French Fiction in Honour of Vivienne Mylne*, edited by Robert Gibson, 191–207. London: Grant and Cutler, 1988.

Mazzei, Lapo. *Lettere di un notaro a un mercante del sec. XIV*. Edited by Cesare Guasti. 2 vols. Florence: Successori Le Monnier, 1880.

McCown, Chester, ed. and trans. *The Testament of Solomon*. Leipzig: J. C. Hinrichs, 1922.

McDannell, Colleen. *Material Christianity: Religion and Popular Culture in America*. New Haven: Yale University Press, 1995.

McKillop, Susan. "Dante and Lumen Christi." In *Cosimo 'il Vecchio' de' Medici, 1389–1464*, edited by Frances Ames-Lewis, 245–301. Oxford: Clarendon Press, 1992.

McLaren, Angus. *Impotence: A Cultural History*. Chicago: University of Chicago Press, 2007.

Meacci, Giordano. "Il nodo Salomone: Una figura biblica nella scrittura comica." *Studi e testi italiani—Semestrale del Dipartimento di Italianistica e Spettacolo dell'Università di Roma "La Sapienza"* 19 (2007): 25–39.

Megenberg, Konrad von. *Das Buch der Natur*. Edited by Robert Luff and Georg Steer. Tübingen: Niemeyer, 2003.

Mehlman, Bernard H., and Seth M. Limmer. *Medieval Midrash: The House for Inspired Innovation*. Leiden: Brill, 2016.

Meir-Glitzenstein, Esther. *The "Magic Carpet" Exodus of Yemenite Jewry: An Israeli Formative Myth*. Brighton: Sussex Academic Press, 2014.

Melikian-Chirvani, Assadoulah Souren. "Le royaume de Salomon: Les inscriptions persanes des sites achéménides." Vol. 1 and pp. 1–41. In *Le monde Iranien et l'Islam*, edited by Jean Aubin, 1:1–41. Geneva: Droz, 1971.

Melissari, Renata. *Lineamenti di un percorso demoetnoantropologico*. Cosenza: Pellegrini, 2004.

Menghi, Girolamo. *Compendio dell'arte essorcistica et possibilita delle mirabili et stupende operationi delli demoni et dei malefici*. Bologna: Giovanni Rossi, 1586.

Mesquitela Lima, Augusto Guilherme. "Fetishism." In *The Encyclopedia of Religion*, edited by Mircea Eliade, 5:314–17. New York: Macmillan, 1987.

Meyer, Birgit, David Morgan, Crispin Paine, and S. Brent Plate. "The Origin and Mission of Material Religion." *Religion* 40 (2010): 207–11.

Michael, Simone, ed. *Die magischen Gemmen im Britischen Museum*. 2 vols. London: British Museum Press, 2001.

Middleton, John Henry. *The Engraved Gems of Classical Times*. Cambridge: Cambridge University Press, 1891.

Miller, Daniel. "Materiality: An Introduction." In *Materiality*, edited by Daniel Miller, 1–50. Durham: Duke University Press, 2005.

Miller, Peter N., ed. *Cultural Histories of the Material World*. Ann Arbor: University of Michigan Press, 2013.

Millet, Gabriele. "L'Ascension d'Alexandre." *Syria* 4 (1923): 85–133.

Milstein, Rachel, ed. *Khotam Shlomo = Khatam Suleiman* [The Seal of Solomon]. Jerusalem: Migdal David, ha-muze'on le-toldot, 1995.

Minervini, Giulio. *Novelle dilucidazioni sopra un antico chiodo magico*. Naples: V. Priggiobba, 1846.

Miquel, André. *La géographie humaine du monde musulman jusqu'au milieu du 11 siècle*. 4 vols. Paris: Mouton, 1967–80.

Mitchell, W. J. T. "What Do Pictures *Really* Want?" *October* 77 (1996): 71–82.

———. *What Do Pictures Want? The Lives and Loves of Images*. Chicago: University of Chicago Press, 2005.

Mitra, Kalipadra. "The Bird and Serpent Myth." *Quarterly Journal of the Mythic Society* 16 (1925–26): 79–92, 180–200.

Mokri, Mohammad, ed. and trans. *Le chasseur de dieu ou le mythe du roi-aigle*. Wiesbaden: O. Harassowitz, 1967.

Mommsen, Theodor, and Paul Krueger, eds. *Corpus iuris civilis*. Berlin: Weidmann, 1908.

Montgomery, James. *Aramaic Incantation Texts from Nippur*. Philadelphia: University Museum, 1913.

Morel, Philippe. "La figure de la magicienne de l'Orlando Furioso à l'art florentin entre Cinquecento et Seicento." In *L'Arme e gli amori: Ariosto, Tasso and Guarini in Late Renaissance Florence*, edited by Massimiliano Rossi and Fiorella Gioffredi Superbi, 2:297–325. Florence: Olschki, 2004.

Moser, Claudia, and Jennifer Knust, eds. *Ritual Matters: Material Remains and Ancient Religions*. Ann Arbor: University of Michigan Press, 2017.

Mottahedeh, Roy. "The Eastern Travels of Solomon: Reimagining Persepolis and the Iranian Past." In *Law and Tradition in Classical Islamic Thought: Studies in Honor of Professor Hossein Modarressi*, edited by Michael Cook, Najam Haider, Intisar Rabb, and Asma Sayeed, 247–67. New York: Palgrave Macmillan, 2013.

Mulholland, John. *Beware of Familiar Spirits*. New York: Charles Scribner's Sons, 1938.

Naveh, Joseph, and Shaul Shaked. *Amulets and Magic Bowls: Aramaic Incantations of Late Antiquity*. Jerusalem: Magnes Press, 1985.

Neusner, Jacob. *Judaism and Scripture: The Evidence of Leviticus Rabbah*. Eugene, Oreg.: Wipf and Stock, 2003.

———, ed. *The Tosefta: Translated from the Hebrew with a New Introduction*. 2 vols. Peabody, Mass.: Hendrickson, 2002.

Niccolini, Giustina. *The Chronicle of Le Murate*. Edited and translated by Saundra Weddle. Toronto: Centre for Reformation and Renaissance Studies, 2011.

Noomen, Willem, and Nico van den Boogaard, eds. *Nouveau recueil complet des fabliaux*. 10 vols. Assen: Van Gorcum, 1983–98.

Nova, Alessandro. *The Book of the Wind: The Representation of the Invisible*. Montreal: McGill-Queen's University Press, 2011.

Nuzzo, Donatella. "Immagini cristologiche negli amuleti di Salomone cavaliere." *Bessarione* 10 (1993): 101–15.

Olsan, Lea T. "Enchantment in Medieval Literature." In *The Unorthodox Imagination in Late Medieval Britain*, edited by Sophie Page, 166–92. Manchester: Manchester University Press, 2010.

O'Neill, Mark. "Enlightenment Museums: Universal or Merely Global?" *Museum and Society* 2 (2004): 190–202.

Orlando, Francesco. *Obsolete Objects in the Literary Imagination: Ruins, Relics, Rarities, Rubbish, Uninhabited Places, and Hidden Treasures*. Translated by Gabriel Pihas and Daniel Seidel, with Alessandra Grego. New Haven: Yale University Press, 2006.

Orvieto, Paolo. *Un'idea del Novecento: Dieci poeti e dieci narratori*. Rome: Salerno, 1984.

Otto, Bernd-Christian, and Michael Stausberg, eds. *Defining Magic: A Reader*. Sheffield, UK: Equinox, 2013.

Owst, G. R. "Sortilegium in English Homiletic Literature of the Fourteenth Century." In *Studies Presented to Sir Hilary Jenkinson*, edited by J. C. Davies, 272–303. London: Oxford University Press, 1957.

Pack, Roger. "'Almandel' auctor pseudonymus: De firmitate six scientiarum." *Archives d'histoire doctrinale et littéraire du Moyen Âge* 42 (1975): 147–81.

———. "The Sibyl in a Lamp." *Transactions and Proceedings of the American Philological Association* 87 (1956): 190–91.

Page, Denys L. *Folktales in Homer's Odyssey*. Cambridge: Harvard University Press, 1972.

Page, Sophie. "Magic and the Pursuit of Wisdom: The 'Familiar' Spirit in the *Liber Theysolius*." *Corónica: A Journal of Medieval Hispanic Languages, Literatures and Cultures* 36 (2007): 41–70.

———. "Speaking with Spirits in Medieval Magic Texts." In *Conversations with Angels: Essays Towards a History of Spiritual Communication, 1100–1700*, edited by Joad Raymond, 125–49. London: Palgrave Macmillan, 2011.

Paleotti, Gabriele. Constitutione della santita di n.s. Sisto papa quinto. *Contra coloro ch'essercitano l'arte dell'astrologia giudiciaria, & qualunque altra sorte di divinationi,*

sortilegij, superstitioni, strigarie, incanti. . . . Rome: Stampatori camerali, 1586. Reprint, Bologna: Alessandro Benaci, 1586.

Pamuk, Orhan. *My Name Is Red.* Translated by Erdağ M. Göknar. New York: Alfred A. Knopf, 2002.

Panvinio, Onofrio. *De fasti et triumphi Romanorum a Romulo usque ad Carolum V.* Venice: Impensis Iacobi Stradae Mantuani, 1557.

Paracelsus. *Sämtliche Werke. Medizinische, naturwissenschaftliche und philosophische Schriften.* Edited by Karl Sudhoff. 14 vols. Munich: R. Oldenbourg, 1927.

Parfitt, Tudor. *The Road to Redemption: The Jews of the Yemen, 1900–1950.* Leiden: Brill, 1996.

Parisi, Lorenzo. *Panegirico di Lorenzo Parigi sopra un dono fatto dalle rev. monache delle Murate di Firenze alla sereniss. d.m. Maddalena arciduchessa d'Austria.* Florence: Giunti, 1613.

Parrilli, Domenico. *Dizionario di marineria militare italiano-francese e francese-italiano.* 2 vols. Naples: P. Androsio, 1846–47.

Pasztory, Esther. *Thinking with Things: Toward a New Vision of Art.* Austin: University of Texas Press, 2005.

Paunov, Evgeni I. "Introduction to the Numismatics of Thrace, ca. 530 BCE–46 CE." In *A Companion to Ancient Thrace,* edited by Julia Valeva, Emil Nankow, and Denver Graninger, 265–91. Chichester: John Wiley and Sons, 2015 .

Payne Smith, Jessie, ed. *A Compendious Syriac Dictionary.* Oxford: Clarendon Press, 1903.

Payne Smith, Robert, ed. *Thesaurus syriacus.* 2 vols. Oxford: Clarendon Press, 1879.

Pearson, Birger A. "Gnostic Interpretation of the Old Testament in the 'Testimony of Truth' (NHC IX,3)." *Harvard Theological Review* 73 (1980): 311–19.

Pellat, Charles, trans. *Le livre de la couronne.* Paris: Belles Lettres, 1954.

Pellat, Charles, Janine Sourdel-Thomine, L. P. Elwell-Sutton, and Pertev Naili Boratav. "Ḥayawān." In *Encyclopaedia of Islam.* 2nd ed. Leiden: Brill Online, 2016. http://dx.doi.org/10.1163/1573-3912_islam_COM_0279/.

Pels, Peter. "Introduction: Magic and Modernity." In *Magic and Modernity: Interfaces of Revelation and Concealment,* edited by Peter Pels and Birgit Meyer, 1–38. Stanford: Stanford University Press, 2003.

Pentecost, Cari D., Kelly S. Chichak, Andrea J. Peters, Gareth W. V. Cave, Stuart J. Cantrill, and J. Fraser Stoddart. "A Molecular Solomon Link." *Angewandte Chemie International Edition* 46 (2007): 218–22.

Perdrizet, Paul. "Sphragis Solomōnos." *Revue des études grecques* 16 (1903): 42–61.

Perriccioli Saggese, Alessandra. "Gli statuti dell'Ordine dello Spirito Santo o del Nodo: Immagine e ideologia del potere regio a Napoli alla metà del Trecento." In *Medioevo: Immagini e ideologie,* ed. Arturo Carlo Quintavalle, 519–24. Milan: Electa, 2005.

Perroni, Adriano. "Capitelli a 'crochets' (cornua) e colonne ofitiche (con nodi): Questioni di lessico e interpretazione." In *Progettare le arti,* edited by Lorenzo Carletti and Cristiano Giometti, 3–11. Pisa: Mnemosyne, 2013.

Peter Comestor. *Historia Scholastica.* Vol. 198 of *Patrologia Latina,* edited by Jacques-Paul Migne. Paris, 1855.

Peterson, Brian Neil. *Ezekiel in Context: Ezekiel's Message Understood in Its Historical Setting of Covenant Curses and Ancient Near Eastern Mythological Motifs.* Eugene, Oreg.: Pickwick, 2012.

Piaget, Jean. *The Child's Conception of the World.* Translated by Joan Tomlinson and Andrew Tomlinson. New York: Harcourt, Brace, 1929.

Pietrangeli, Carlo. *Guide rionali di Roma, Rione VII–Regola.* 2 vols. Rome: Palombi, 1980.

———. *Guide rionali di Roma, Rione X–Campitelli.* 4 vols. Rome: Palombi, 1975.

Pike, Kenneth L. *Language in Relation to a Unified Theory of the Structure of the Human Behaviour.* Glendale, Calif.: Summer Institute of Linguistics, 1954.

Pinault, David. *Story-Telling Techniques in the Arabian Nights.* Leiden: Brill, 1992.

Pinnery, Christopher, and Nicholas Thomas, eds. *Beyond Aesthetics: Art and the Technologies of Enchantment.* Oxford: Berg, 2001.

Piper, Ferdinand. "Maria als Thron Salomos und ihre Tugenden bei der Verkündigung." *Jahrbücher für Kunstwissenschaft* 5 (1872): 97–137.

Pitrè, Giuseppe. *Medicina popolare siciliana.* Florence: Barbera, 1949.

———. *Usi e costumi, credenze e pregiudizi del popolo siciliano.* 4 vols. S. G. La Punta: Clio, 1993.

Plate, S. Brent. *A History of Religion in 5½ Objects: Bringing the Spiritual to Its Senses.* Boston: Beacon Press, 2015.

———, ed. *Key Terms in Material Religion.* London: Bloomsbury Academic, 2015.

———, ed. *Religion, Art, and Visual Culture: A Cross-Cultural Reader.* New York: Palgrave, 2002.

Pliny the Elder. *Complete Works.* Translated by John Bostock and Henry Thomas Riley. Hastings, UK: Delphi Classics, 2015.

Poggio, Alessandro. "Impressions of Power: 'Greco-Persian's Seals in Perspective." In *Cultural and Material Contacts in the Ancient Near East: Proceedings of the International Workshop, 1–2 December 2014,* edited by Enrico Foietta, Carolina Ferrandi, Eleonora Quirico, Francesca Giusto, Mattia Mortarini, Jacopo Bruno, and Lorenzo Somma, 157–63. Sesto Fiorentino: Apice, 2014.

Polak, Lucie. "Charlemagne and the Marvels of Constantinople." In *The Medieval Alexander and Romance Epic,* edited by Peter Noble, Lucie Polak, and Claire Isoz, 159–71. New York: Kraus International, 1982.

Polito, Armando. "Sferracaddhu, un'erba tra scienza e leggenda." Fondazione terra d'Otranto, December 12, 2012. http://www.fondazioneterradotranto.it/2012/02/12/sferracaddhu-unerba-tra-scienza-e-leggenda/.

Porro, Daniela. "Il palazzo Salomoni Alberteschi nei documenti dell'Archivio di Stato di Roma." *Acta. Bollettino dell'associazione dei diplomati della scuola di archivistica palegrafia e diplomatica di Roma. A.C.T.U.M. Numero unico,* 18–21. Rome: Alumni Clarissimi Tabularii Urbis Maximae, 1985.

Porter, Venetia, ed. *Arabic and Persian Seals and Amulets in the British Museum.* London: British Museum Press, 2011.

Porter, Venetia, Liana Saif, and Emilie Savage Smith. "Medieval Islamic Amulets, Talismans, and Magic." In *A Companion to Islamic Art and Architecture,* ed. Finbarr Barry Flood and Gülru Necipoğlu, 1:521–55. Hoboken: John Wiley & Sons, 2017.

Predanzani, Massimo. "Stemmi e imprese della battaglia di Anghiari dipinta sul fronte di cassone conservato alla National Gallery di Dublino." Stemmieimprese.it.

Price, Martin. *The Coins of the Macedonians.* London: British Museum, 1974.

Propp, Vladimir. *Morphology of the Folktale.* 2nd ed. Edited by Louis A. Wagner. Austin: University of Texas Press, 1968.

———. "Theory and History of Folklore." Translated by Ariadna Y. Martin and Richard P. Martin. Edited by Anatoly Libermann. Special issue, *Theory and History of Literature* 5 (1984).

Przybilski, Martin. *Kulturtransfer zwischen Juden und Christen in der deutschen Literatur des Mittelalters.* Berlin: Walter de Gruyter, 2010.

Pseudo-Albertus Magnus. *De secretis mulierum . . . Item de mirabilibus mundi.* Strasbourg: Per Lazarum Zetznerum, 1601.

Qadhi, Yaser, trans. "Kitāb al-Khatām." In *Sunan Abu-Dawūd,* book 29, ḥadīth 4211. http://hadithcollection.com/abudawud/261-Abu%20Dawud%20Book%2029.%20Signet-Rings/17987-abu-dawud-book-029-hadith-number-4211.html.

Qazwīnī, Zakariyya al- (el-Cazwini, Zakarija Ben Muhammed Ben Mahmud). *Kosmographie.* Edited by Ferdinand Wüstenfeld. 2 vols. Göttingen: Verlag der Dieterichschen Buchhandlung, 1848–49.

Rademacher, Ludwig. "Die Erzählungen der Odyssee." *Sitzungsberichte der Kais. Akademie der Wissenschaft in Wien* 178 (1916): 1–59.

Raff, Thomas. *Die Sprache der Materialen: Anleitung zur eine Ikonologie der Werkstoffe.* Münster: Waxmann, 2008.

Rahmani, Levi Yizhaq. "The Byzantine Solomon 'Eulogia' Tokens in the British Museum." *Israel Exploration Journal* 49 (1999): 92–104.

Rajewsky, Irina O. "Intermediality, Intertextuality and Remediation: A Literary Perspective on Intermediality." *Intermédialités* 6 (2005): 43–63.

Rajna, Pio. *Le fonti dell'Orlando Furioso.* Florence: G. C. Sansoni, 1876.

Rapisarda, Stefano. "Enigmi per il principe: Dal 'Secretum secretorum' al 'Conde Lucanor' di Juan Manuel." In *Medioevo romanzo e orientale: Macrotesti fra Oriente e Occidente,* edited by Giovanna Carbonaro, Eliana Creazzo, and Natalia Tornesello, 343–74. Catanzaro: Soveria Mannelli, 2003.

Reinaud, Joseph-Toussaint. *Monuments Arabes, Persanes et Turcs du cabinet du duc de Blacas.* 2 vols. Paris: Imprimerie royale, 1828.

Rhys, John. *Celtic Folklore: Welsh and Manx.* 2 vols. Oxford: Clarendon Press, 1901.

Richardson, L., Jr. "Trimalchio and the Sibyl at Cumae." *Classical World* 96 (2002): 77–78.

Ricoeur, Paul. *Temps et récit.* Paris: Seuil, 1983.

Rider, Catherine. "Common Magic." In *The Cambridge History of Magic and Witchcraft in the West, from Antiquity to the Present,* edited by David J. Collins, 303–31. Cambridge: Cambridge University Press, 2015.

———. *Magic and Impotence.* Oxford: Oxford University Press, 2006.

Righetti Tosti-Croce, Marina. "*Spolia* e modelli altomedievali nella scultura cistercense con una nota sul nodo di Salomone." In *Medioevo: Immagini e ideologie,* edited by Arturo Carlo Quintavalle, 644–56. Milan: Electa, 2005.

Ripart, Laurent. "Du Cygne Noir au Collier de Savoie: Genèse d'un ordre monarchique de chevalerie (milieu XIVᵉ–début XVᵉ siècle)." In *L'affermarsi della corte sabauda: Dinastie, poteri, élites in Piemonte e Savoia fra tardo medioevo e prima età moderna,* edited by Luisa Clotilde Gentile and Paola Bianchi, 93–113. Turin: Zamorani, 2006.

Robinson, James M., ed. *The Nag Hammadi Library in English.* Leiden: Brill, 1984.

Roessli, Jean-Michel. "Vies et métamorphoses de la Sibylle: Notes critiques." *Revue de l'histoire des religions* 224 (2007): 253–71.

Róheim, Géza. *Fire in the Dragon and Other Psychoanalytic Essays on Folklore.* Edited by Alan Dundes. Princeton: Princeton University Press, 1992.

Rolfsen, Dale. *Knots and Links.* 1976. Reprinted with corrections. Providence: AMS Chelsea, 2003.

Rubenstein, Jeffrey. *The History of Sukkot in the Second Temple and Rabbinic Periods.* Atlanta: Scholars Press, 2006.

Saberi, Reza. *The Divan of Hafez: A Bilingual Text, Persian-English.* Lanham: University Press of America, 2002.

Sacchetti, Franco. *Opere.* Edited by Carlo Borlenghi. Milan: Rizzoli, 1957.

Sacred Congregation of Rites. *Processus Canonizationis beati Amedei Sabaudiae Ducis III.* Rome: Ex Typographia Rever. Cam. Apostolicae, 1676.

Sainte-Marie, Honoré de. *Dissertazioni storiche e critiche sopra la cavalleria antica e moderna.* Brescia: Rizzardi, 1761.

Saintyves, Paul. "L'anneau de Polycrate: Essai sur l'origine liturgique du thème de l'anneau jeté à la mer et retrouvé dans le ventre d'un poisson." *Revue d'histoire des religions* 66 (1912): 49–80.

Salamone, María Antonietta. "La idea del contrato social en Mario Salamone de Alberteschi: Sus vínculos con la escuela de Salamanca y el constitucionalismo inglés." Ph.D. diss., Universidad Complutense de Madrid, 2005.

Salkeld, David. "Shamir." *C & C Review* 1 (1997): 18–23.

Salzberger, Georg. *Die Salomo-Sage in der semitischen Literatur: Ein Beitrag zur vergleichen-den Sagenkunde*. Berlin: Max Harrwitz, 1907.

Samarqandī, Abū al-Layth al-. *Baḥr al-ʿulūm*. 3 vols. Beirut: Dār al-Kutub al-ʿIlmiyya, 1993.

Sansoni, Umberto. *Il nodo di Salomone. Simbolo e archetipo d'alleanza*. Milan: Electa, 1998.

Sansovino, Francesco. *Origine e fatti delle famiglie illustri d'Italia*. Venice: Combi e La Nou, 1582.

Santos-Granero, Fernando. ed. *The Occult Life of Things: Native Amazonian Theories of Materiality and Personhood*. Tucson: University of Arizona Press, 2009.

Saunders, Corinne J. *Magic and the Supernatural in Medieval English Romance*. Cambridge: D. S. Brewer, 2010.

Saurma-Jeltsch, Lieselotte E., and Anja Eisenbeiss, eds. *The Power of Things and the Flow of Cultural Transformations: Art and Culture Between Europe and Asia*. Berlin: Deutscher Kunstverlag, 2010.

Saxl, Fritz. "Frühes Christentum und spätes Heidentum in ihren künstlerischen Ausdrucks-formen." *Wiener Jahrbuch für Kunstgeschichte* 16 (1923): 63–121.

Schienerl, Peter. "Eisen als Kampfmittel gegen Dämonen: Manifestationen des Glaubens an seine magische Kraft im islamischen Amulettwesen." *Anthropos* 75 (1980): 468–522.

Schlumberger, Gustave. "Amulettes byzantins anciens destinés à combattre les malefices et maladies." *Revue des études grecques* 5 (1892): 74–75.

Schmeling, Gareth. *A Commentary on the Satyrica of Petronius*. Oxford: Oxford University Press, 2011.

Schmeling, Gareth, and David Rebmann. "T. S. Eliot and Petronius." *Comparative Literature Studies* 12 (1975): 393–410.

Schmidt, Brian B. *The Materiality of Power: Explorations in the Social History of Ancient Israelite Magic*. Tübingen: Mohr Siebeck, 2016.

Schmidt, H. P. "The Senmurv: Of Birds and Dogs and Bats." *Persica* 9 (1980): 1–85.

Schmidt, Victor Michael. *A Legend and Its Image: The Aerial Flight of Alexander the Great in Medieval Art*. Gröningen: Egbert Forsten, 1995.

Schnetz, Joseph, ed. *Ravennatis Anonymi Cosmographia et Guidonis Geographica*. Stuttgart: B. G. Teubner, 1990.

Scholem, Gershom. "The Curious History of the Six-Pointed Star: How the 'Magen David' Became the Jewish Symbol." *Commentary* 8 (1949): 243–351.

Schouten, Jan. *The Pentagram as a Medical Symbol: An Iconological Study*. Nieuwkoop: De Graaf, 1968.

Schrire, Theodore. *Hebrew Amulets: Their Decipherment and Interpretation*. London: Rout-ledge and Kegan Paul, 1966.

Schulenburg, M. W. von. "Der Salomonsknoten." *Mittheilungen der anthropologischen Gesellschaft in Wien* 19 (1889): 40–42.

Schwartz, Howard. *Elijah's Violin and Other Jewish Fairy Tales*. New York: Oxford University Press, 1994.

Schwarz, Sarah. "Building a Book of Spells: The So-Called *Testament of Solomon* Reconsid-ered." Ph.D. diss., University of Pennsylvania, 2005.

———. "Reconsidering the *Testament of Solomon*." *Journal for the Study of the Pseudo-epigrapha* 16 (2007): 203–37.

———. Review of *Rewriting the "Testament of Solomon": Tradition, Conflict and Identity in a Late Antique Pseudoepigraphon*, by Todd E. Klutz. *Journal for the Study of Pseudo-epigrapha* 17 (2007): 57–78.

Scott, Walter, ed. and trans. *Hermetica: The Ancient Greek and Latin Writings Which Con-tain Religious or Philosophic Teachings Ascribed to Hermes Trismegistus*. 4 vols. Oxford: Clarendon Press, 1936.

Seidenberg, David Mevorach. *Kabbalah and Ecology: God's Image in the More-than-Human World*. New York: Cambridge University Press, 2015.

Seldarov, Nikola. *Macedonia and Paeonia: Seldarov Collection*. Skopje: Narodna Banka na Republika Makedonija, 2003.

Seligmann, Siegfried. *Der böse Blick und Verwandtes*. 2 vols. Berlin: Herman Barsdorf, 1910.

———. *Die magischen Heil- und Schutzmittel aus der belebten Natur*. Stuttgart: Strecker und Schroeder, 1927.

Sella, Pietro. *Glossario latino-italiano*. Vatican City: Biblioteca Apostolica Vaticana, 1944.

A Sequel to the Endless Amusement, containing nearly four hundred interesting experiments . . . to which are added recreations with cards. London: Thomas Boys, 1825.

Seri, Yaron. "Parashat Re'eh 5759/1999: The *Dukhifat* or Hoopoe." Bar-Ilan University's Parashat Hashavua Study Center. http://www.biu.ac.il/JH/Parasha/eng/reeh/ser.html.

Serotta, Anna, and Federico Carò. "The Use of Corundum Abrasive at Amarna." *Horizon: The Amarna Project and Amarna Trust Newsletter* 14 (2014): 2–4.

Shaked, Shaul, James Nathan Ford, and Siam Bhayro. *Aramaic Bowl Spells: Jewish Babylonian Aramaic Bowls*. Leiden: Brill, 2013.

Shimoni, Rabbeinu. *Yalkut Shimoni*. 2 vols. Jerusalem: Makor, 1973.

Sivertsev, Alexei. "The Emperor's Many Bodies: The Demise of Emperor Lupinus Revisited." In *Hekhalot Literature in Context: Between Byzantium and Babylonia*, edited by Ra'anan Boustan, Martha Himmelfarb, and Peter Schäfer, 65–84. Tübingen: Mohr Siebeck, 2013.

Sixtus V. *Constitutio S. D. N. D. Sixti Papae Quinti contra exercentes astrologiae iudiciariae artem*. In *Magnum Bullarium Romanum*. 24 vols. Lyon: Laur. Arnaud & Petri Borde, 1692.

Skemer, Don. *Binding Words: Textual Amulets in the Middle Ages*. University Park: Penn State University Press, 2006.

Slifkin, Natan. *Sacred Monsters: Mysterious and Mythical Creatures of Scripture, Talmud, and Midrash*. Brooklyn: Zoo Torah, 2007.

Smith, Laurajane. "Objects, Agency, and Power: The Pragmatic Politics of Heritage." Paper delivered at "What Do Contentious Objects Want? Political, Epistemic, and Artistic Cultures of Return," Florence, Kunsthistorisches Institut, October 21–22, 2016, international conference organized by Eva-Maria Troelenberg and Felicity Bodenstein.

Sørensen, Jesper. *A Cognitive Theory of Magic*. Lanham, Md.: Altamira Press, 2007.

Spallanzani, Marco. *Carpet Studies: 1300–1600*. Genova: SAGEP, 2016.

Spargo, John Webster. *Virgil the Necromancer: Studies in Virgilian Legends*. Cambridge: Cambridge University Press, 1934.

Spencer, Herbert. *The Principles of Sociology*. 3rd rev. ed. 3 vols. New York: D. Appleton, 1898.

Spier, Jeffrey. *Late Antique and Early Christian Gems*. Wiesbaden: Reichert Verlag, 2007.

———. "Medieval Byzantine Magic Amulets and their Tradition." *Journal of the Warburg and Courtauld Institutes* 56 (1993): 25–62.

Stamberger, Ralf. "Rashi in the School of St Victor." Paper delivered at "Latin and Vernacular Translations of Hebrew Texts in the 12th and 13th Century," workshop, Käte Hamburger Kolleg, Bochum, September 20–21, 2012, organized by Görge Hasselhoff.

Statuts de l'ordre du St. Esprit au droit desir ou du noeud, étably par Louis d'Anjou roy de Naples et de Sicile en 1352, 1353 et 1354. Paris, 1899.

Stephenson, Paul. *The Serpent Column: A Cultural Biography*. New York: Oxford University Press, 2016.

Stevenson, Robert Louis. "The Bottle Imp." *New York Herald*, February–March 1891.

Stocks, Denys. *Experiments in Egyptian Archaeology: Stoneworking Technology in Ancient Egypt*. London: Routledge, 2003.

Stoichita, Victor. "Faces and Shields." Paper delivered February 16, 2017, Berenson Lectures, Florence, Villa I Tatti, January–March 2017.

Stoneman, Richard. *Alexander the Great: A Life in Legend*. New Haven: Yale University Press, 2008.

———. *The Legends of Alexander the Great*. London: I. B. Tauris, 2012.

Stoneman, Richard, Kyle Erickson, and Ian Netton, eds. *The Alexander Romance in Persia and the East*. Groningen: Barkhuis, 2012.

Stratico, Simeone. *Vocabolario di marina in tre lingue: italiano, francese, inglese*. 3 vols. Milan: Dalla Stamperia reale, 1813–14.

Strömberg, Reinhold. "The Aeolus Episode and Greek Wind Magic." *Symbolae Philologicae Gotoburgenses* 56 (1950): 71–84.

Stüve, Wilhelm, ed. *Olympiodori in Aristotelis Meteora Commentaria*. Berlin: Typis et imprensis Georgii Reimeri, 1900.

Styers, Randall. *Making Magic: Religion, Magic, and Science in the Modern World*. Oxford: Oxford University Press, 2004.

Suda On Line: Byzantine Lexicography. Edited by David Whitehead. http://www.stoa.org/sol/.

Surgy, Albert de, ed. "Fétiches: Objets enchantés, mots réalisés." Special issue, *Systèmes de pensée en Afrique noire* 8 (1987).

———, ed. "Fétiches II: Puissances des objets: Charmes des mots." Special issue, *Systèmes de pensée en Afrique noire* 12 (1993).

———. "Présentation." Special issue, *Systèmes de pensée en Afrique noire* 8 (1987): 7–11.

Swan, Charles, ed. *Gesta Romanorum*. 2 vols. London: R. Gilbert, 1887.

Sweeney, Michelle. *Magic in Medieval Romance*. Dublin: Four Courts Press, 2000.

Szemerényi, Oswald. "Principles of Etymological Research in the Indo-European Languages." *Innsbrucker Beiträge zur Kulturwissenschaft* 15 (1962): 175–212.

Ṭabarī, Abū Jaʿfar Muḥammad ibn Jarīr al-. *Annales quod scripsit Abu Djafar Mohammaed Ibn Djarir al-Tabari*. Edited by Michael Jan de Goeje. Leiden: Brill, 1893.

———. *The History of al-Ṭabarī*. Edited by Ehsan Yarshater. 40 vols. Albany: SUNY Press, 1985–2007.

Tagliente, Antonio. *Esempio di raccammi*. Venice: Giovanni Antonio di Nicolini da Sabio, 1530.

Talshir, David. "Shemot Baʿalei ha-Hayyim ba-Targum ha-Arami shel ha-Shomronim." Ph.D. diss., University of Jerusalem, 1981.

Tamari, Shemuel. *Iconotextual Studies in the Muslim Ideology of Umayyad Architecture and Urbanism*. Wiesbaden: Harrassowitz, 1996.

Tambiah, Stanley Jeyaraja. *Culture, Thought, and Social Action*. Cambridge: Harvard University Press, 1985.

———. "The Magical Power of Words." In *Culture, Thought, and Social Action*, 17–59. Cambridge: Harvard University Press, 1985.

———. *Magic, Science, Religion and the Scope of Rationality*. Cambridge: Cambridge University Press, 1990.

———. "A Performative Approach to Ritual." In *Culture, Thought, and Social Action*, 123–66. Cambridge: Harvard University Press, 1985.

Tameanko, Marvin. "King Solomon's Seal on Coin-Like Pilgrim Tokens." *Shekel* 36 (2003): 25–29.

Tassoni, Alessandro. *Le lettere di Alessandro Tassoni, tratte da autografi e da copie e pubblicate per la prima volta nella loro interezza da Giorgio Rossi*. 2 vols. Bologna: Romagnoli–Dall'Acqua, 1910.

———. *La secchia, poema eroicomico d'Androvinci Melisone*. Paris: Tussan du Bray, 1622.

Tertullian. *Opera Omnia*. Vol. 2 of *Patrologia Latina*, edited by Jacques-Paul Migne. Paris, 1844.

Thaʿlabī, Abū Isḥāq Aḥmad ibn Muḥammad al-. *ʿArāʾis al-majālis fā qiṣaṣ al-anbiyā*, or *Lives of the Prophets*. Translated by W. Brinner. Leiden: Brill, 2002.

———. *Al-Kashf wa-l-bayān ʿan tafsīr al-Qurʾān*. 8 vols. Beirut: Dār Ihyā al-turāth al-ʿArabi, 2002.

Thaʿālibī, Abū Manṣūr ʿAbd al-Malik b. Muḥammad b. Ismāʾīl al-. *Histoire de rois de Perse*. Translated by Herman Zotenberg. Paris: Imprimerie Nationale, 1900.

Thomas, Nicholas. *Entangled Objects: Exchange, Material Culture, and Colonialism in the Pacific*. London: Harvard University Press, 1991.

Thomas of Cantimpré. *Liber de natura rerum*. Edited by Helmut Boese. Berlin: De Gruyter, 1973.

Thompson, Stith. *Motif-Index of Folk Literature: A Classification of Narrative Elements in Folktales, Ballads, Myths, Fables, Mediaeval Romances, Exempla, Fabliaux, Jest-Books, and Local Legends*. Helsinki: Suomalainen tiedeakatemia, 1932–36.

Thurschwell, Pamela. *Literature, Technology and Magical Thinking, 1880–1920*. Cambridge: Cambridge University Press, 2001.

Tlili, Sarra. *Animals in the Qur'an*. Cambridge: Cambridge University Press, 2012.

Todorov, Tzvetan. "Le Discours de la magie." *L'Homme* 13, no. 4 (1973): 38–65.

———. *The Fantastic: A Structural Approach to a Literary Genre*. Translated by Richard Howard. Ithaca: Cornell University Press, 1975.

———. "L'héritage méthodologique du formalisme." *L'Homme* 5, no. 1 (1965): 64–83.

Tolkien, J. R. R. *The Lord of the Rings*. 3 vols. London: Allen and Unwin, 1954–55.

Tommaseo, Niccolò, and Bernardo Bellini. *Dizionario della lingua italiana*. 8 vols. Turin: Utet, 1865–79. http://www.tommaseobellini.it/#/.

Torijano, Pablo A. "Solomon and Magic." In *The Figure of Solomon in Jewish, Christian and Islamic Tradition: King, Sage and Architect*, edited by Joseph Verheyden, 107–25. Leiden: Brill, 2012.

———. *Solomon the Esoteric King: From King to Magus; Development of a Tradition*. Leiden: Brill, 2002.

Torrini, M., M. Tani, M. Checchi, A. Zagli, and F. Casi, eds. *Il diavolo e il diavoletto: Raffaello Magiotti; Uno scienziato di Montevarchi alla corte di Galileo*. Montevarchi: Accademia Valdarnese del Poggio, 1997.

Tottoli, Roberto. "Amīna." In *Encyclopaedia of Islam*. 2nd ed. Leiden: Brill Online, 2016. http://dx.doi.org/10.1163/1573-3912_islam_SIM_0600.

———. *Biblical Prophets in the Qur'an and Muslim Literature*. New York: Routledge, 2002.

Touati, Houari. *Islam et voyage au Moyen Âge: Histoire et anthropologie d'une pratique lettrée*. Paris: Seuil, 2000.

Traut, Lucia, and Annette Wilke, eds. *Religion—Imagination—Ästhetik: Vorstellungs- und Sinnenswelten in Religion und Kultur*. Göttingen: Vandenhoeck & Ruprecht, 2015.

Traversi, Antonio Maria. *Elementi di fisica generale*. 7 vols. Venice: Antonio Curti, 1822.

Tritton, A. S. "Spirits and Demons in Arabia." *Journal of the Royal Asiatic Society of Great Britain and Ireland* 66 (1934): 715–27.

Trollope, Thomas Adolphus. *The Girlhood of Catherine de' Medici*. London: Chapman and Hall, 1856.

Turkle, Sherry, ed. *Evocative Objects: Things We Think With*. Cambridge: MIT Press, 2007.

Tuzi, Stefania. *Le colonne e il Tempio di Salomone: La storia, la leggenda, la fortuna*. Rome: Gangemi, 2002.

Twelftree, Graham H. *Jesus the Exorcist: A Contribution to the Study of the Historical Jesus*. Tübingen: Mohr Siebeck, 1993.

Tylor, Edward B. *Primitive Culture: Researches into the Development of Mythology, Philosophy, Religion, Language, Art and Custom*. 2 vols. New York: Henry Holt, 1874.

Uther, Hans-Jörg. *The Types of International Folktales*. 3 vols. Helsinki: Suomalainen tiedeakatemia, 2004.

Valentini, Pier Francesco. *Canone di Pier Francesco Valentini romano con le sue resolutioni in più di duemila modi, a due, a tre, a quattro et a cinque voci*. Rome: Paolo Masotti, 1629.

———. *Canone nel nodo di Salomone a 96 voci*. Rome: Paolo Masotti, 1631.

———. *Resolutione seconda del Canone del Nodo di Salomone a cinquecento dodici voci in cento ventiotto chori, quale anco si può estendere in infinito con voci innumerabili et infinite*. Rome: Paolo Masotti, 1631.

Van der Leeuw, Gerardus. *Religion in Essence and Manifestation*. Translated by J. E. Turner, with additions of Hans Penner. New York: Harper and Row, 1963.

Vélez de Guevara, Luis. *El Diablo cojuelo*. Madrid: Emprenta del Reyno, 1641.

Velikovsky, Immanuel. "The Stone of Shamir." *Kronos* 6, no. 1 (1980): 48–50.

Vella, Dominic, Aretzki Boudaoud, and Mokhtar Adda-Bedia. "Statics and Inertial Dynamics of a Ruck in a Rug." *Physical Review Letters* 103 (2009).

Venzlaff, Helga. *Al-Hudhud: Eine Untersuchung zur kulturgeschichtlichen Bedeutung des Wiedehopfs im Islam*. Frankfurt am Main: Peter Lang, 1994.

Verheyden, Joseph, ed. *The Figure of Solomon in Jewish, Christian and Islamic Tradition: King, Sage and Architect*. Leiden: Brill, 2012.

Vernot, Nicolas. *Quand le décor fait signe. Sémiologie de la maison rurale française (XVᵉ–XIXᵉ siècle)*, Paris: Éditions du Patrimoine: Centre des Monuments nationaux (forthcoming, 2020).

Véronèse, Julien. *L'Almandal' et L'Almadel' latins au Moyen Âge: Introduction et éditions critiques*. Florence: Edizioni del Galluzzo, 2012.

———. *L'ars notoria au Moyen Âge. Introduction et édition critique*. Florence: Edizioni del Galluzzo, 2007.

———. "Invoquer et conjurer les démons à la fin du Moyen Âge." Unpublished manuscript.

———. "Salomon exorciste et magicien dans l'Occident médiéval." Paper delivered on the occasion of *Le roi Salomon au Moyen Âge: Savoirs et répresentations*, Colloque du CESFIMA, Orléans, October 18–19, 2018.

Veyne, Paul. "La Sibylle dans la bouteille." In *Hommages à J. Bayet*, edited by Marcel Renard and Robert Schilling, 718–21. Collection Latomus 70. Brussels: Latomus, 1964.

Villani, Matteo. *Cronica con la continuazione di Filippo Villani*. Edited by Giuseppe Porta. 3 vols. Parma: Fondazione Pietro Bembo, 1995.

Vincent of Beauvais. *Speculum Naturale*. Venice: Hermannus Liechtenstein, 1494.

Vittozzi, Elvira. "Niccolò Mauruzi." In *Dizionario Biografico degli Italiani*, vol. 72. Rome: Treccani, 1925–. http://www.treccani.it/enciclopedia/niccolo-mauruzzi_(Dizionario-Biografico)/.

Vocabolario degli Accademici della Crusca. Venice: Giovanni Alberti, 1612.

Vogel, Cyrille, and Reinhard Elze, eds. *Le Pontifical Romano-Germanique au Xème siècle*. 3 vols. Città del Vaticano: Biblioteca Apostolica Vaticana, 1963.

Voye, de la. "A Relation of a Kind of Worms, that Eat Out Stones." *Philosophical Transactions* 1 (1665): 321–23.

Wachsmuth, Dietrich. "Winddämonenkult." In *Der kleine Pauly*, edited by Konrat Ziegler, vol. 5, col. 5. Stuttgart: Druckenmüller, 1964–75.

Wallis Budge, E. A., trans. *The Queen of Sheba and Her Only Son Menyelek (Kebra Nagast)*. Ethiopian Series. Cambridge, ON: In Parentheses, 2000.

Walter, Christopher. "The Intaglio of Solomon in the Benaki Museum and the Origins of the Iconography of the Warrior Saints." *Deltion tēs Christianikēs Archaiologikēs Etaireias* 4 (1989–90): 32–42.

Ward, William Hayes. *The Seal Cylinders of Western Asia*. Washington: Carnegie Institution of Washington, 1910.

Warner, Marina. "Riding the Carpet: The Vehicle of Stories in the Arabian Nights." In *The Power of Things and the Flow of Cultural Transformations: Art and Culture Between Europe and Asia*, edited by Lieselotte E. Saurma-Jeltsch and Anja Eisenbeiss, 248–65. Berlin: Deutscher Kunstverlag, 2010.

———. *Stranger Magic: Charmed States and the Arabian Nights*. London: Chatto and Windus, 2011.

Warnier, Jean-Pierre. *Construire la culture matérielle*. Paris: Presses universitaires de France, 1999.

———. "A Praxeological Approach to Subjectivation in a Material World." *Journal of Material Culture* 6 (2001): 5–24.

Waterton, Emma, and Steve Watson, eds. *The Palgrave Handbook of Contemporary Heritage Research*. London: Palgrave Macmillan, 2015.

Wehrhahn-Stauch, Liselotte. "Adler." In *Lexikon der Christliche Ikonographie*, edited by Engelbert Krischbaum and Wolfgang Braunfels, 1:70–76. Rome: Herder, 1868–76.

———. "Aquila-Resurrectio." *Zeitschrift des Deutsches Vereins für Kunstwissenschaft* 21 (1967): 105–27.

Weitzman, Steven. *Solomon: The Lure of Wisdom*. New Haven: Yale University Press, 2011.

Werner, Heinz. *Comparative Psychology of Mental Development*. New York: International Universities Press, 1957.

West, Martin. *The East Face of Helicon: West Asiatic Elements in Greek Poetry and Myth*. Oxford: Clarendon Press, 1997.

Westermarck, Edward. *Ritual and Belief in Morocco*. 2 vols. London: Macmillan, 1926.

Wheeler, Brannon. *Prophets in the Quran: An Introduction to the Quran and Muslim Exegesis*. London: A & C Black, 2002.

White, Hayden. *Metahistory: The Historical Imagination in Nineteenth-Century Europe*. Baltimore: Johns Hopkins University Press, 1975.

Widmann, Joseph Viktor. *Der Heilige und die Tiere*. Frauenfeld: Huber, 1918.

Wiggermann, Frans A. M. "The Four Winds and the Origins of Pazuzu." In *Das geistige Erfassen der Welt im Alten Orient*, edited by Claus Wilcke, 125–65. Wiesbaden: Harrassowitz, 2007.

Wilburn, Andrew T. *Materia Magica: The Archaeology of Magic in Roman Egypt, Cyprus, and Spain*. New Texts from Ancient Cultures. Ann Arbor: University of Michigan Press, 2012.

Wilkinson, John. *Jerusalem Pilgrims Before the Crusades*. Rev. ed. Warminster: Aris and Phillips, 2002.

———. *Tetragrammaton: Western Christians and the Hebrew Name of God*. Leiden: Brill, 2015.

Wilson, Kinnier. *The Legend of Etana*. Chicago: Bolchazy-Carducci, 1985.

Winkler, Hans Alexander. *Siegel und Charakter in der muhammedanischen Zauberei*. Berlin: Walter de Gruyter, 1930.

Winter, Irene J. "'Seat of Kingship' / 'A Wonder to Behold': The Palace as a Construct in the Ancient near East." *Ars Orientalis* 23 (1993): 27–55.

Wolf, Gerhard. "Image, Object, Art: Talking to a Chinese Jar on Two Human Feet." *Representations* 133 (2016): 152–59.

Wolters, Paul. "Faden und Knoten als Amulett." *Archiv für Religionswissenschaft* 8 (1905): 1–22.

Wood, Christopher S. "Image and Thing: A Modern Romance." *Representations* 133 (2016): 130–51.

Wuidar, Laurence. *Canons énigmes et hiéroglyphes musicaux dans l'Italie du 17ᵉ siècle*. Brussels: Peter Lang, 2008.

Yonge, Charles Maurice. "Animals that Bore Through Rock." *New Scientist* 328 (1963): 468–71.

Zamakhsharī, Maḥmūd ibn ʿUmar. *Al-Kashshāf ʿan ḥaqāʾiq ghawāmiḍ al-tanzīl wa-ʿuyūn al-aqāwīl fī wujūh al-taʾwīl*. Al-Riyāḍ: Maktaba al-ʿĀbidīn, 1998.

Zanker, Paul. *Die Apotheose der römischen Kaiser: Ritual und städtische Bühne*. Munich: Carl Friedrich von Siemens Stiftung, 2004.

Zika, Charles. *The Appearance of Witchcraft*. London: Routledge, 2007.

Ziolkowski, Jan M. *Solomon and Marcolf*. Cambridge: Harvard University Press, 2008.

Ziolkowski, Jan M., and Michael C. J. Putnam, eds. *The Virgilian Tradition: The First Fifteen Hundred Years*. New Haven: Yale University Press, 2008.

Zipoli, Perlone (Lorenzo Lippi). *Il Malmantile racquistato colle note di Puccio Lamoni (Paolo Minucci)*. Florence: Michele Nestenus, 1731.

Zischka, Ulrike. *Zur sakralen und profanen Anwendung des Knotenmotivs als magisches Mittel, Symbol oder Dekor*. Munich: Tuduv Verlagsgesellschaft, 1977.

Zusne, Leonard, and Warren H. Jones. *Anomalistic Psychology: A Study of Magical Thinking*. Hillsdale, N.J.: Erlbaum, 1989.

INDEX

actor-network theory, 25

Aelian, Claudius, on "blocked nest" story, 117, 118, 120, 121, 126, 128, 129, 188 n. 36

Aeolus
king-magi, features shared with, 73, 79
metalworking, dominion over, 73, 151
Solomon, features shared with, 73–74, 79
wind, control over, 73, 177 n. 60
and winds in a sack motif, 72, 73, 177 n. 60

agency
abduction of, 26
and art, 26, 30
Gell on, 26–27, 30
and magical objects, 16–17, 25–27, 40
in works of art, Latour on, 30

Aladdin's lamp
and demons in bottles, 150
in Solomonic tradition, 2
See also demons in bottles; entrapping of demons

Albert, Jean-Pierre, on magical objects, 27

Albertazzi, Adolfo, "Il diavolo nell'ampolla," 63

Alexander the Great
Alexander Romance, 142
coins of, 47–48
electrum, associated with, 47–49
flight of, 142, 146, 148, 156
and Gordian knot, 182 n. 44
legend regarding, 4, 47
in Qur'ān, 56
and Solomonic tradition, 47

Amedeo IX of Savoy, 94
canonization of, 92
lac d'amour in emblem of, 93

Anghiari, battle of, 95, 183 n. 55

Arabian Nights, 157
bottles of Solomon in, 158
"The City of Brass," 54, 73
"The Fisherman and the Bottle," 76
flying carpet in, 135–37
magic in, 16
manuscript tradition of, 54
origin of, 136
"Tale of Sympathy the Learned," 136

"Tale of the Prince Ahmed and the Fairy Peri Banou," 136

Aretino, Pietro, 90, 184 n. 64,
Ragionamenti, 97, 184 n. 73

art history
magical objects, subject in, 31–32
and materiality, 30–32

Asklepios, and Solomon, 77

Aston, W. G., on fetish, 18

Austin, John, on performative utterances, 22

Baring-Gould, Sabine, on "blocked nest" story, 122, 188 n. 47

Baudrillard, Jean, on materiality, 30

Bazin, Jean
on fetish, 19, 29–30
on magical objects, 29–30

Benjamin, Walter, 26
on materiality, 30
on Parisian Arcades, 163–64 n. 39

Bennett, Jane, on materiality, 33

Bethesda, pools of
demons bound in cave near, 43, 77
as healing site, 77

Bildwissenschaft, 30–31

binding of demons, 67
with ring of Solomon, 42, 70, 154
with sign of Solomon, 88, 106

birds
eagle. See eagles
flight via. See birds, flight via
griffin, 137, 142, 144
hoopoe. See hoopoe
language of. See language of birds
merops (bee-eater), 119, 120
ostrich, 119, 120, 125
partridge, 29, 89, 181 n. 38
royal, 142–45
rukh, 119, 120, 131, 144
vulture. See vulture
wild cock. See wild cock
woodpecker. See woodpecker
See also "blocked nest" story; language of animals